Perceiving the Arts

AN INTRODUCTION TO THE HUMANITIES

Ninth Edition

DENNIS J. SPORRE

PEARSON

Prentice
Hall

Upper Saddle River, New Jersey 07458

Library of Congress Cataloging-in-Publication Data

Sporre, Dennis J.
 Perceiving the arts : an introduction to the humanities / Dennis J. Sporre.—9th ed.
 p. cm.
 Includes index. 2007043886
 ISBN 978-0-13-604569-4 (pbk.)
 1. Arts—Philosophy. 2. Aesthetics. I. Title.

BH39.S66 2009
700.1—dc22

Editor in Chief: Sarah Touborg
Senior Editor: Amber Mackey
Assistant Editor/Project Manager: Alexandra Huggins
Editorial Assistant: Carla Worner
Director of Marketing: Brandy Dawson
Executive Marketing Manager: Marissa Feliberty
Marketing Assistant: Irene Fraga
Senior Managing Editor: Mary Rottino
Production Liaison: Jean Lapidus
Composition/Full-Service Project Management: GGS Book Services
Senior Production Editor: Kelly Keeler
Text Permissions Researcher: Kelly Keeler
Manager, Visual Research: Beth Brenzel
Image Permission Coordinator: Nancy Seise
Photo Research: Julie Tesser
Senior Art Director: Pat Smythe
Color Insert: Jill Little
Senior Operations Supervisor: Brian Mackey
Cover Design: Bruce Kenselaar
Printer/Binder: R.R.D. Donnelley/Harrisonburg
Cover/Insert Printer: R.R.D. Donnelley/Harrisonburg

For my wife Hilda

"If we, citizens, do not support our artists, then we sacrifice our imagination on the altar of crude reality and we end up believing in nothing and having worthless dreams."

Yann Martel, *Life of Pi*

Pearson Education LTD., London
Pearson Education North Asia Ltd
Pearson Education Singapore, Pte. Ltd
Pearson Educación de Mexico, S.A. de C.V.
Pearson Education, Canada, Ltd

Pearson Education Malaysia, Pte. Ltd
Pearson Education–Japan
Pearson Education, Upper Saddle River, New Jersey
Pearson Education Australia PTY, Limited

PEARSON
Prentice
Hall

10 9 8 7 6 5
ISBN 0-13-604569-3
ISBN 978-0-13-604569-4

Contents

Preface

Perceiving the Arts introduces the arts and literature to individuals who wish to know what to look and listen for in works of art. The goal of this book is to show students how accessible the arts are and how easily our common perceptual skills can translate into a means of engaging with them. The results will lead to confidence (empowerment) in developing a lifetime relationship with the arts. I hope that the text will foster enriching classroom discussion and a deeper understanding of the aesthetic experience. Its brief format makes it flexible enough to serve a variety of classroom approaches.

Approaching the arts can take a variety of channels. I have adapted aesthetician Harry Broudy's formulation of aesthetic response. Specifically, we can ask four questions about an art or an artwork: (1) What is it? (a formal response); (2) How is it put together? (a technical response); (3) How does it appeal to the senses? (an experiential response); and (4) What does it mean? (a contextual and personal response). These questions give us a workable organization for approaching the various arts disciplines, and the first three questions form the outline for each of the chapters of the book.

The book introduces definitions and concepts in a basic manner, recognizing at the same time that some ideas can be complex and others steeped in historical connotations. Further, most artists do not paint, sculpt, compose, or write to neatly fixed formulas. Introducing the aesthetic experience by asking response-oriented questions and by using terminology is advocated by the College Board's statement on "Academic Preparation for College," which emphasizes use of "the appropriate vocabulary" as fundamental. This book stands on the premise that vocabulary isolates characteristics in works of art and helps focus perceptions, responses, and communication about them.

With regard to the ninth edition, here are some highlights of the revision. The art program has been improved by including twenty-one new images. To expand an already wide-ranging collection, more examples represent works from around the world as well as a greater variety of ethnic groups. This follows the expressed wishes of many of our reviewers who are seeking greater diversity in the illustrations. In addition, coverage of the disciplines includes new discussions of jazz, dance, film, and digital media. For example, the music chapter has an exciting new section on jazz as a musical form, and students can sense the beat of their own times through a relationship with digital media and contemporary films such as *Shrek 2* and *Ocean's Eleven* and contemporary dance references. The text now discusses all the musical selections found on the Music for the Humanities CD, which is available separately and can be packaged with the book.

A continuing feature, "A Matter of Style," now has greater visual and intellectual appeal through more detailed treatment and the inclusion of an image or example in each one. At the end of each chapter I have added a very brief sample of how readers might write a critical analysis of a work from the text using the terms from the chapter as an outline. This type of concrete model will help students develop written analytical criticism of their own. Finally, with regard to organization, I have redesigned the placement of chapters so as to make the flow of subjects more logical.

I would like to thank the following reviewers whose observations and suggestions formed the core of this revision: Amy S. Hickman, Collins College; Adrien Cuellar-McGuire, Brookhaven College; William Duncan, University of Maine at Presque Isle; Laura J. Peterson, St. Bonaventure University; and Tracy Spenser, Lamar Institute of Technology.

D. J. S.

Introduction

WHAT ARE THE ARTS AND HOW DO WE RESPOND TO AND EVALUATE THEM?

A colleague came into my office and placed on my desk a very expensive book about architecture. "From an appreciative student," he said.

"Before or after grades?" I replied, jokingly, of course.

He gave me a withering look of displeasure, and after a dramatic pause for effect, he told me "Sam's" story.

Sam, a construction worker, took my colleague's course "Introduction to the Arts" as a night student. After the semester ended (and after grades were posted!) Sam brought the book to my colleague. At the time, the book probably cost perhaps as much as a fourth of Sam's weekly paycheck.

"Why?" my colleague asked Sam.

"Because you changed my life," Sam replied. "Before this course, I poured concrete day in and day out. It was concrete—you know, cement, sand, and gravel—just concrete. After taking this course, I can't see just bland concrete anymore. Whenever I walk onto a job site, I see patterns, colors, lines, and forms. Whenever I look at a building, I see history. I go to places I'd never dreamed of going before, and I can't believe how dull my life really was without all the

1

things I now see and hear. I just never knew there was so much out there.

My colleague said to me, "You know, this construction worker, a real tough guy— a man's man—had tears in his eyes; he was so taken by what he'd found out about life through art."

Sam's discoveries have happened to other people—countless people—in the past and will happen again and again in the future to people who choose to let it happen to them.

Artworks make some people uncomfortable, probably because dealing with an artwork represents stepping into unfamiliar territory. Unfortunately, some artists and a few sophisticates try to keep the arts confusing and hidden to all but a select few. Nonetheless, this book seeks to empower its readers—to access works of art comfortably and with the understanding that art and life intertwine irrevocably. Knowledgeable interaction with works of art makes life better: We see more of what can be seen, and we hear more of what can be heard. Our entire existence grows richer and deeper.

Recognizing the artistic principles and influences all around us makes our world more interesting and habitable. The arts are elements of life with which we can and must deal and to which we must respond every day. We live with the arts because their principles permeate our existence. Specifically, the aesthetic experience provides a way of knowing and communicating in and of itself, separate from other ways of knowing and communicating.

The arts play important roles in making the world around us a more interesting and habitable place. Artistic ideas join with *conventions* to make everyday objects attractive and pleasurable to use. The term *convention* appears repeatedly in this text. A convention is a set of rules or mutually accepted conditions such as the keyboard and tuning of a piano.

An example of how art infiltrates life appears in the Volkswagen shown in Figure 1.1. Here repetition of form reflects a concern for unity, one of the fundamental characteristics of art. The design of the Volkswagen used strong repetition of the oval. The latest reincarnation of the VW Beetle also has repetition of circular form. We need only to look at the rear of the Bug to see variation on this theme as applied in the window, motor-compartment hood, taillights, fenders, and bumper. Later

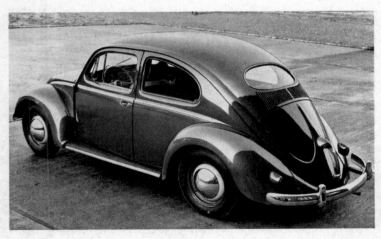

FIGURE 1.1 *Volkswagen Beetle (1953).*
Source: Courtesy of Volkswagen of America, Inc.

models of the Volkswagen differed from this version and reflect the intrusion of conventions, again, into the world of design. As safety standards called for larger bumpers, the oval design of the motor-compartment hood flattened so a larger bumper could clear it. The rear window was enlarged and squared to accommodate the need for increased rear vision. The intrusion of these conventions changed the design of the Beetle by breaking down the strong unity of the original composition.

Edwin J. Delattre gives us another view of the relationship of the arts and life when he compares the purpose for studying technical subjects to the purpose for studying the humanities or the arts. "When a person studies the mechanics of internal combustion engines, the intended result is that he should be better able to understand, design, build, or repair such engines, and sometimes he should be better able to find employment because of his skills, and thus better his life. . . . When a person studies the humanities [the arts], the intended result is that he should be better able to understand, design, build, or repair a life—for living is a vocation we have in common despite our differences.

"The humanities provide us with opportunities to become more capable in thought, judgment, communication, appreciation, and action." Delattre goes on to say that these provisions enable us to think more rigorously and to imagine more abundantly. "These activities free us to possibilities that are new, at least to us, and they unbind us from portions of our ignorance about living well. . . . Without exposure to the cultural . . . traditions that are our heritage, we are excluded from a common world that crosses generations."* The

*Edwin J. Delattre, "The Humanities Can Irrigate Deserts," *The Chronicle of Higher Education,* October 11, 1977, p. 32.

poet Archibald MacLeish is more succinct: "Without the Arts, how can the university teach the Truth?"

The information in this text helps us understand the elements that comprise works of art, which we can respond to and which make our experiences and our lives more rewarding.

USING THIS TEXT

Before engaging in discussions about art, however, let's note two issues about this text: (1) finding art examples on the Internet and (2) using the pronunciation prompts.

WORLD WIDE WEB

Throughout the body of this text and at the end of each chapter, you will find URLs to connect with the World Wide Web. These serve as springboards for further investigation. On one hand, they lead to actual artworks, and these can further illustrate the principles discussed and illustrated in the text. On the other hand, many of the Web sites yield more detailed information about artists, styles, periods, general history, and so on. With regard to URLs, however, observe the following: First, things change. A Web site active when this book went to press may no longer exist. Second, an initial attempt to link to a site may prove unsuccessful: "Unable to connect to remote host." A rule of thumb suggests trying to connect to the site three successive times before trying another URL. Be careful to type the URL exactly. Any incorrect character will cause the connection to fail.

In addition to the specific Web addresses listed in the text, some general sites can provide a wealth of additional information. A vast reference for visual art

and architecture resides at Artcyclopedia at http://www.artcyclopedia.com/index.html. An excellent source for architecture is Great Buildings Online at http://www. greatbuildings.com/gbc.html. Music tends to be problematic because difficulties in securing production rights to performances have not, as yet, been solved by Web providers of classical music. Classical Music Archives at http://www.classicalarchives. com/index_1.html contains a vast instrumental, digitally synthesized music library. A good source for literature and drama texts resides at Project Gutenberg, http://www. gutenberg.net/. Again, the problem of rights leaves the site vacant with regard to contemporary works.

PRONUNCIATION

The study of art brings us face to face with many challenging terms (many of them in a foreign language) and names. To assist acquaintanceship, a pronunciation guide follows each term or name not pronounced exactly as it appears. This guide has two features. First, it uses familiar English consonant and vowel representations rather than International Phonetics. The system used in this book sometimes looks awkward. For example, the long I sound (which comprises a diphthong of ah and ee), such as in *die, eye,* and *by,* is indicated by the letter Y when the syllable stands alone or precedes a consonant. The letter Y prior to a vowel maintains its yuh sound, as in *young* (yuhng). The letter G, when sounded "hard" as in *go* or *guard,* is presented as GH. Again, it appears odd in some cases, such as ghoh-GHAN (Gauguin). Nonetheless, when one remembers that GH equals a hard G sound, the appearance yields to successful pronunciation.

Principal stress in a word or name is indicated by capitalization. For example, the pronunciation of *fable* would be indicated as FAY-buhl. Typically, words comprising three or more syllables also have at least one syllable of secondary stress. These are not indicated in this text. More often than not, if the primary stress is identified, the secondary stresses fall almost automatically into place.

Here is a guide to the system used in this book:

A	cat
Ah	cot
Aw	awe
Air	air, pair
Awr	core
Ay	bay
Eh	bet
Ee	see
Gh	go
Ye	ye
Ih	bit
Ihng	sing
Oh	foe
Oo	food
Ow	wow
Oy	boy
Uh	bug
U	wood,
Zh	pleasure
Z	zip

We should note that pronunciations, like definitions, can be complicated and arguable issues. I have used standard encyclopedia and dictionary pronunciations as my guides, but this does not guarantee universal agreement. Some names may be commonly Anglicized, whereas I provide a pronunciation agreeable to the native tongue—and vice versa.

OVERVIEW

For centuries, scholars, philosophers, and aestheticians have debated without general resolution a definition of "art." The challenging range of arguments encompasses, among other considerations, opposing points of view that insist on one hand that "art" must meet a criterion of functionality—that is, be of some societal use—and, on the other hand, that "art" exists for its own sake. In this text, we survey rather than dispute. Thus, in these pages, we will not solve the dilemma of art's definition, despite the energizing effect that such a discussion might engender. We can, however, examine some characteristics of the arts that enhance our understanding.

Art has and has had profound effect on the quality of human life as the pages of this text will assist us to understand, and its study requires seriousness of purpose. Having said that, however, we must not confuse seriousness of purpose in the study of art with a sweeping sanctification of works of art. Some art is serious, some art is profound, and some art is highly sacred. On the other hand, some art is light, some humorous, and some downright silly, superficial, and self-serving for its artists. Which is which may be debatable, but eventually we will desire to make judgments, and once again this text will help sort out the details.

THE ARTS AND WAYS OF KNOWING

Humans are a creative species. Whether in science, politics, business, technology, or the arts, we depend on our creativity almost as much as anything else to meet the demands of daily life. Any book about the arts comprises a story about us: Our perceptions of the world as we have come to see and respond to it and the ways we have communicated our understandings to each other since the Ice Age, more than 15,000 years ago (Figure 1.2, cave chamber at Lascaux).

Our study in this text focuses on vocabulary and perception. First, however, we need to have an overview of where the arts fall within the general scope of human endeavor.

We live in buildings and listen to music constantly. We hang pictures on our walls and react like personal friends to characters in television, film, and live dramas. We escape to parks, engross ourselves in novels, wonder about a statue in front of a public building, and dance through the night. All these situations involve forms called "art" in which we engage daily. Curiously, as close to us as these "art" activities are, in many ways they remain mysteries. How do they, in fact, fit into the larger picture of the human reality that we experience?

We have learned a great deal about our world and how it functions since the human species began, and we have changed our patterns of existence. However, the fundamental characteristics that make us human—that is, our ability to intuit and to symbolize—have not changed. Art, the major remaining evidence we have of our earliest times, reflects these unchanged human characteristics in inescapable terms and helps us to understand the beliefs of cultures, including our own, and to express the universal qualities of humans.

As we begin this text, learning more about our humanness through art, let us start where we are. That means two things. First, it means relying on the perceptive capabilities we already have. Applying our current abilities to perceive develops confidence in approaching works of art. Second, starting where we are means learning how art fits into the general scheme of the way

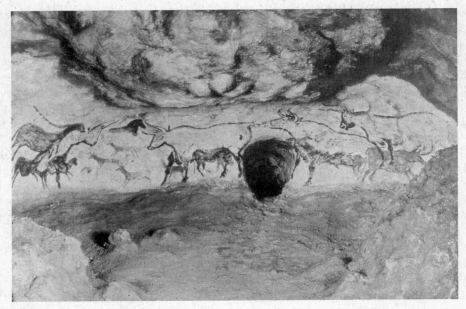

FIGURE 1.2 *General view of cave chamber at Lascaux, France, from the early Stone Age (c. 15,000 b.c.e.).*
Source: Archiv fur Kunst und Geschichte, Berlin.

people examine, communicate, and respond to the world around them. A course in the arts, designed to fulfill a requirement for a specified curriculum, means that the arts fit into an academic context that separates the way people acquire knowledge. Consequently, our first step in this exploration of the arts places them in some kind of relationship with other categories of knowledge. Visual art, architecture, music, theatre, dance, literature, and cinema belong in a broad category of pursuit called the "humanities." The terms *arts* and *humanities* fit together as a piece to a whole. The humanities constitutes a larger whole into which the arts fit as one piece. So, when we use the term *humanities*, we automatically include the arts. When we use the term *arts*, we restrict our focus. The arts disciplines— visual art (drawing, painting, printmaking, photography), performing art (music, theatre, dance, cinema), and architecture (including landscape architecture)—typically arrange sound, color, form, movement, and/or other elements in a manner that affects our sense of beauty (see p. 8) in a graphic or plastic (capable of being shaped) medium. The humanities include the arts but also include disciplines such as philosophy, literature, and, sometimes, history, which comprise branches of knowledge that share a concern with humans and their cultures. We begin our discussion with a look at the humanities.

The humanities, as opposed, for example, to the sciences, can very broadly be defined as those aspects of culture that look into what it means to be human. The sciences seek essentially to describe reality whereas the humanities seek to express humankind's subjective experiences of

reality, to interpret reality, to transform our interior experience into tangible forms, and to comment upon reality, to judge and evaluate. But despite our desire to categorize, few clear boundaries exist between the humanities and the sciences. The basic difference lies in the approach that separates investigation of the natural universe, technology, and social science from the search for truth about the universe undertaken by artists.

Within the educational system, the humanities traditionally have included the fine arts (painting, sculpture, architecture, music, theatre, dance, and cinema), literature, philosophy, and, sometimes, history. These subjects orient toward exploring humanness, what human beings think and feel, what motivates their actions and shapes their thoughts. Many answers lie in the millions of artworks all around the globe, from the earliest sculpted fertility figures to the video and cyber art of today. These artifacts and images comprise expressions of the humanities, not merely illustrations of past or present ways of life.

In addition, change in the arts differs from change in the sciences, for example, in one significant way: New scientific discovery and technology usually displaces the old; but new art does not invalidate earlier human expression. Obviously, not all artistic approaches survive, but the art of Picasso cannot make the art of Rembrandt a curiosity of history the way that the theories of Einstein did the views of William Paley. Nonetheless, much about art has changed over the centuries. Using a spectrum developed by Susan Lacy in *Mapping the Terrian: New Genre Public Art* (1994), we learn that at one time an artist may be an *experiencer*; at another, a *reporter*; at another, an *analyst*; and at still another time, an *activist*. Further, the nature of how art historians see art has changed over the centuries—for example, today we do not credit an artist's biography with all of the motivations for his or her work, and we now include works of art from previously marginalized groups such as women and minorities. These shifts in the disciplines of arts history itself suggest important considerations as we begin to understand the nature of art.

In addition, we can approach works of art with the same subtleties we normally apply to human relationships. We know that we cannot simply categorize people as "good" or "bad," as "friends," "acquaintances," or "enemies." We relate to other people in complex ways. Some friendships remain pleasant but superficial, some people are easy to work with, and others (but few) become lifelong companions. Similarly, when we have gone beyond textbook categories and learned how to approach art with this sort of sensitivity, we find that art, like friendship, has a major place in the growth and quality of life.

THE CONCERNS OF ART

Among other concerns, art has typically concerned creativity, aesthetic communication, symbols, and the fine arts and crafts. Let's look briefly at each of these.

CREATIVITY

Art has always evidenced a concern for creativity—that is, the act of bringing forth new forces and forms. We do not know for sure how creativity functions. Nonetheless, something happens in which humankind takes chaos, formlessness, vagueness, and the unknown and crystallizes them into form, design, inventions, and ideas. Creativity underlies our existence. It allows scientists to

intuit a possible path to a cure for cancer, for example, or to invent a computer. The same process allows artists to find new ways to express ideas through processes in which creative action, thought, material, and technique combine in a medium to create something new, and that "new thing," often without words, triggers human experience— that is, our response to the artwork.

AESTHETIC COMMUNICATION

Art usually involves communication. Arguably, artists need other people with whom they can share their perceptions. When artworks and humans interact, many possibilities exist. Interaction may be casual and fleeting, as in the first meeting of two people, when neither wishes a relationship. Similarly, an artist may not have much to say, or may not say it very well. For example, a poorly written or produced play will probably not excite an audience. Similarly, if an audience member's preoccupations render it impossible to perceive what the play offers, then at least that part of the artistic experience fizzles. On the other hand, all conditions may be optimum, and a profoundly exciting and meaningful experience may occur: The play may treat a significant subject in a unique manner, the production artists' skills in manipulating the medium may be excellent, and the audience may be receptive. Or the interaction may fall somewhere between these two extremes.

Throughout history, artistic communication has involved *aesthetics* (ehs-THEH-tihks). Aesthetics is the study of the nature of beauty and of art and comprises one of the five classical fields of philosophical inquiry—along with epistemology (the nature and origin of knowledge), ethics (the general nature of morals and of the specific moral choices to be made by the individual in relationship with others), logic (the principles of reasoning), and metaphysics (the nature of first principles and problems of ultimate reality). The term *aesthetics* (from the Greek for "sense perception") was coined by the German philosopher Alexander Baumgarten (1714–62) in the mid-eighteenth century, but interest in what constitutes the beautiful and in the relationship between art and nature goes back at least to the ancient Greeks. Plato saw art as *imitation* and beauty as the expression of a universal quality. For the Greeks, the concept of "art" embraced all handcrafts (see page 9), and the rules of symmetry, proportion, and unity applied equally to weaving, pottery, poetry, and sculpture. In the late eighteenth century, the philosopher Immanuel Kant (kahnt; 1724–1804) revolutionized aesthetics in his *Critique of Judgment* (1790) by viewing aesthetic appreciation not simply as the perception of intrinsic beauty, but as involving a judgment—subjective, but informed. Since Kant, the primary focus of aesthetics has shifted from the consideration of beauty per se to the nature of the artist, the role of art, and the relationship between the viewer and the work of art.

SYMBOLS

Art also concerns symbols. Symbols usually involve tangible emblems of something abstract: a mundane object evoking a higher realm. Symbols differ from signs, which suggest a fact or condition. Signs are what they indicate. Symbols carry deeper, wider, and richer meanings. Look at Figure 1.3 (Greek cross?). Some people might identify this figure as a plus sign in arithmetic. But the figure might also be a Greek cross, in which case it becomes a symbol because it suggests many images, meanings, and implications. Artworks use a variety of symbols, and

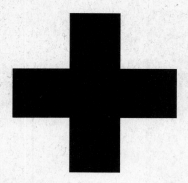

FIGURE 1.3 *Greek cross?*

symbols make artworks into doorways leading to enriched meaning.

Symbols occur in literature, art, and ritual. Symbols can involve conventional relationships such as a rose standing for courtly love in a medieval romance. A symbol can suggest physical or other similarities between the symbol and its reference (the red rose as a symbol for blood) or personal associations—for example, the Irish poet William Butler Yeats's use of the rose to symbolize death, ideal perfection, Ireland, and so on. Symbols also occur in linguistics as arbitrary symbols and in psychoanalysis where symbols, particularly images in dreams, suggest repressed, subconscious desires and fears. In Judaism, the contents of the feast table and the ceremony performed at the Jewish Passover seder (a feast celebrating the exodus from slavery in Egypt) symbolize events surrounding the Israelites' deliverance from Egypt. In Christian art, the lamb, for example, symbolizes the sacrifice of Christ.

FINE AND APPLIED ART

One last consideration in understanding art's concerns involves the difference between *fine art* and *applied art*. The "fine arts"—generally meaning painting, sculpture, architecture, music, theatre, dance, and in the twentieth century, cinema—are prized for their purely aesthetic qualities. During the Renaissance (roughly the 14th through 16th centuries), these arts rose to superior status because Renaissance values lauded individual expression and unique aesthetic interpretations of ideas. The term *applied art* sometimes includes architecture and the "decorative arts" and refers to art forms that have a primarily decorative rather than expressive or emotional purpose. The decorative arts include handcrafts by skilled artisans, such as ornamental work in metal, stone, wood, and glass, as well as textiles, pottery, and bookbinding. The term may also encompass aspects of interior design. In addition, personal objects such as jewelry, weaponry, tools, and costumes represent the decorative arts. The term may expand, as well, to mechanical appliances and other products of industrial design. Nonetheless, even the most common of objects can have artistic flair and provide pleasure and interest. The lowly juice extractor (Fig. 1.4), an example of industrial design, brings a sense of pleasantry to a rather mundane chore. Its two-part body sits on colored rubber feet and reminds us, perhaps, of a robot. Its cream and brown colors are soft and warm, comfortable rather than cold and utilitarian. Its plumpness holds a friendly humor, and we could imagine talking to this little device as an amicable companion rather than regarding it as a mere machine. The term *decorative art* first appeared in 1791. Many decorative arts, such as weaving, basketry, or pottery, are also commonly considered "crafts," but the definitions of the terms remain somewhat arbitrary and without sharp distinction.

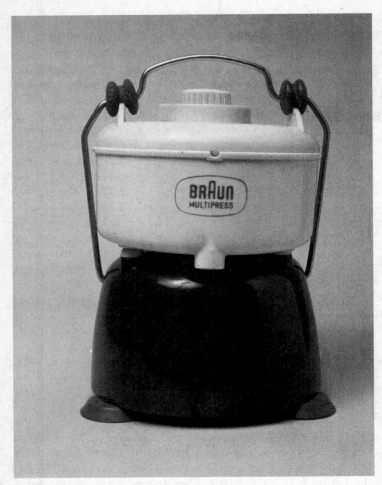

FIGURE 1.4 *Designer Unknown, "Juice Extractor, Multipress" 1950–1958. Plastic, aluminum, rubber, zinc. 18.6 × 27.6 × 19.2 cm. Braun AG.*

Source: Braun Product Design, Germany. Multipress Juice Extractor, 1950-1958. Plastic, aluminum, rubber, zinc. Produced by Braun AG. 18.6 x 27.6 x 19.2 cm. The Montreal Museum of Fine Arts, Liliane and David M. Stewart Collection, gift of the American Friends of Canada through the generosity of Barry Friedman and Patricia Pastor. Photo: Giles Rivest (Montreal).

THE PURPOSES AND FUNCTIONS OF ART

PURPOSES

Another way we can expand our understanding of art involves examining some of its purposes and functions. In terms of the former—that is, art's purposes—we ask, *What does art do?* In terms of the latter—that is, art's functions—we ask, *How does it do it?* Among a plethora of purposes, art can: (1) provide a record; (2) give visible or other form to feelings; (3) reveal metaphysical or spiritual truths; and (4) help people see the world in new or innovative ways. Art can do any or all of these. They are not mutually exclusive.

Until the invention of the camera, one of art's principal purposes involved enacting a record of the world. Although we cannot know for sure, very likely cave art of earliest times did this. And so it went through

history. Artists undertook to record their times on vases, walls, canvases, and so on—as in the case of the eighteenth-century Italian painter Canaletto (can-ah-LAY-toh), in highly naturalistic *verdute* (vair-DOO-tay; Italian for "views") that he sold to travelers doing the grand tour of Europe. Examples of Canaletto's work appear at http://www.artcyclopedia.com/artists/ canaletto. html.

Art can also give visible form to feelings. Perhaps the most explicit example of this aspect of art comes in the Expressionist style of the early twentieth century (see Glossary). Here feelings and emotions of the artist toward content formed a primary role in the work. In terms of art that reveals metaphysical or spiritual truths, we can turn to the great Gothic cathedrals of Europe (Fig. 4.27, *Chartres Cathedral*), whose light and space perfectly embodied medieval spirituality. The rising line of the cathedral reaches, ultimately, to the point of the spire, which symbolizes the release of earthly space into the unknown space of heaven. A tribal totem, such as a Bakota ancestor figure (Fig. 3.4) deals almost exclusively in spiritual and metaphysical revelation. Finally, most art, if well done, can assist us in seeing the world around us in new and surprising ways. Art that has no representational content may reveal a new way of understanding the interaction of life forces.

FUNCTIONS

In addition to its purposes—what it does—art also has many functions—how it does what it does—including (1) enjoyment, (2) political and social commentary, (3) therapy, and (4) artifact. Again, one function is no more important than the others. Nor are they mutually exclusive; one artwork may fill many functions. Nor are the four functions just mentioned the only ones. Rather, they serve as indicators of how art has functioned in the past and can function in the present. Like the types and styles of art that have occurred through history, these four functions and others provide options for artists and depend on what artists wish to do with their artworks.

Works of art can provide escape from everyday cares, treat us to a pleasant experience, and engage us in social occasions. Works of art that provide enjoyment may perform other functions as well. The same artworks we enjoy may also create insights into human experience. We can also glimpse the conditions of other cultures, and we can find healing therapy in enjoyment. An artwork in which one individual finds only enjoyment may function as a profound social and personal comment to another. Grant Wood's painting, *American Gothic* (Fig. 1.5) may amuse us, and/or provide a detailed commentary about rural midwestern America, and/or move us deeply. The result depends on the artist, the artwork, and us.

Art may have political or social function, such as influencing the behavior of large groups of people. It has functioned thus in the past and continues to do so. Eugène Delacroix's (deh-lah-KWAH) painting, *Liberty Leading the People* (July 28, 1830), illustrates this concept (http://www.louvre.fr/anglais/collec/peint/rf0129/peint_f. htm). In July 1830, for three days known as the Trois Glorieuses (the Glorious Three), the people of Paris took up arms to bring in the parliamentary monarchy of Louis-Philippe in hopes of restoring the French Republic. Eager to celebrate July 28, Delacroix painted the allegorical figure of Liberty waving the tricolor flag of France and storming the corpse-ridden barricades with a young combatant at her side. The painting was reviled by conservatives, but purchased by Louis-Philippe in

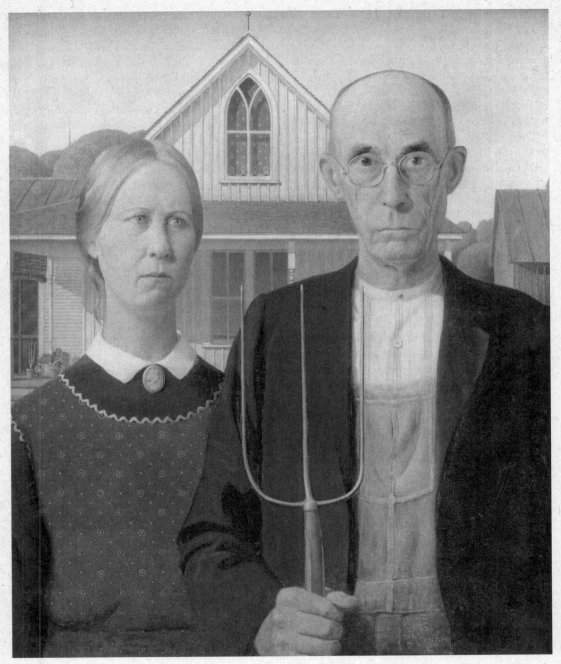

FIGURE 1.5 *Grant Wood, American (1891–1942), American Gothic (1930). Oil on beaver board, 30$^{11}/_{16}$ × 25$^{11}/_{16}$ in. (78 × 65.3 cm.) unframed. Friends of American Art Collection. 1930.934. Reproduction, The Art Institute of Chicago. Photography © The Art Institute of Chicago.*

1831. Soon after, it was hidden for fear of inciting public unrest.

The Greek playwright Aristophanes (air-ih-STAH-fuh-neez) used comedy in such plays as *The Birds* to attack the political ideas of the leaders of ancient Athenian society. In *Lysistrata*, he attacked war by creating a story in which all the women of Athens go on a sex strike until Athens rids itself of war and warmongers. In nineteenth-century Norway, playwright Henrik Ibsen used *An Enemy of the People* as a platform for airing the issue of whether a government should ignore pollution in order to maintain economic well-being. In the United States today, many artworks act as vehicles to advance social and political causes, or to sensitize viewers, listeners, or readers to particular cultural situations like racial prejudice and AIDS.

In a therapeutic function, creating and experiencing works of art may address individuals with a variety of illnesses, both physical and mental. Role-playing, for example, used frequently as a counseling tool in treating dysfunctional family situations, often called psychodrama, has mentally ill patients act out their personal circumstances in order to find and cure the cause of their illness. Here the individual forms the focus. However, art in a much broader context acts as a healing agent for society's general illnesses as well. In hopes of saving us from disaster, artists use artworks to illustrate the failings and excesses of society. In still another vein, the laughter caused by comedy releases endorphins, chemicals produced by the brain, which strengthen the immune system.

Art also functions as an *artifact.* A product of a particular time and place, an artwork represents the ideas and technology of that specific time and place. Artworks often provide not only striking examples but occasionally the only tangible records of some peoples. Artifacts, like paintings, sculptures, poems, plays, and buildings, enhance our insights into many cultures, including our own. Consider, for example, the many revelations we find in a sophisticated work like the Igbo-Ukwu (IGH-boh OOK-woo) roped pot on a stand (Fig. 1.6). This ritual water pot from the village of Igbo-Ukwu in eastern Nigeria utilizes the *cire perdue* (seer pair-DOO; see p. 79) or "lost wax" process and reveals great virtuosity. It tells us much about the vision and technical accomplishment of this ninth- and tenth-century African society.

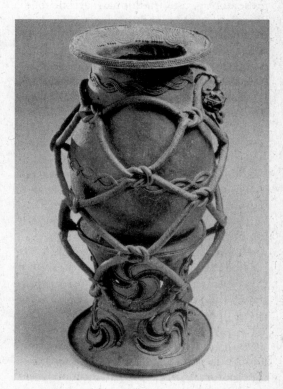

FIGURE 1.6 *Roped pot on a stand, from Igbo-Ukwu (ninth or tenth century). Leaded bronze, height 12½".*
Source: The National Museum, Lagos, Nigeria.

The Igbo-Ukwu pot, as exemplary of art in a context of cultural artifact, raises the issue of religious *ritual*. Music, for example, when part of a religious ceremony, has a ritual function (the same musical piece comprises a work of art), and theatre—if seen as an occasion planned and intended for presentation—would include religious rituals as well as events that take place in theatres. Often, as a survey of art history would confirm, we cannot discern when ritual stops and secular production starts. For example, Ancient Greek tragedy seems clearly to have evolved from and maintained ritualistic practices. When ritual, planned and intended for presentation, uses traditionally artistic media like music, dance, and theatre, we can legitimately study ritual as art, and see it also as an artifact of its particular culture.

Having said all that about purposes and functions, we must also state that sometimes art just exists—for its own sake. In the late nineteenth century, a philosophical artistic thrust occurred called aestheticism, characterized by the slogan "art for art's sake." Those who championed this cause reacted against Victorian notions that a work of art must have uplifting, educational, or otherwise socially or morally beneficial characteristics. Proponents of aestheticism held that artworks stand independent and self-justifying, with no reason for being other than being beautiful. The playwright Oscar Wilde said in defense of this viewpoint: "All art is quite useless." His statement meant that exquisite style and polished device had greater importance than utility and meaning. Thus, form rides victorious over function. The aesthetes, as proponents of aestheticism were called, disdained the "natural," organic, and homely in art and life and viewed art as the pursuit of perfect beauty and life—a quest for sublime experience.

AESTHETIC PERCEPTION AND RESPONSE

The question of how we go about approaching the arts, or how we study them, presents another challenge. We must choose one of the myriad methods available and carry on from there. We assume those who are interested in this book have had only limited exposure to the arts. So we have chosen a method of study that can act as a springboard into the arts and literature, as a point of departure from the realm of the familiar into the unknown. Inasmuch as we live in a world of facts and figures, weights and measures, it seems logical to begin our study by dealing with some concrete characteristics. In other words, from mostly an intellectual point of view, what can we see and what can we hear in the arts and literature?

To put that question in different terms, how can we sharpen our aesthetic perception?

- First of all, we must identify those items that can be seen and heard in works of art and literature.
- Second, we must learn—just as we learn any subject—some of the terminology relating to those items.
- Third, we must understand why and how what we perceive relates to our response.

After all, our *response* to an artwork provides our major interest. We can *perceive* an object. We *choose* to *respond* to it in aesthetic terms.

We need to employ a consistent method as we pass from one art discipline to another. We will ask three questions: (1) What is it? (2) How is it put together? (3) How does it stimulate our senses? We will study these questions in each of the art disciplines. As we

will see, these are also the basic questions we can ask about individual artworks.

When we respond to the question *What is it?*, we recognize that we perceive the two-dimensional space of a picture, the three-dimensional space of a sculpture or a piece of architecture, or perhaps time in sound, or time and space in dance. We also recognize the form of the item—for example, a still life, a human figure, a tragedy, a ballet, a concerto, a narrative film, a park, or a residence. The term *form* is a broad one: There are *art forms*, *forms* of arts, and *forms* in art.

When we respond to the question *How is it put together?*, we identify and respond to the technical elements of the artwork. We recognize and respond to, for instance, the fact that the picture has been painted in oil, made by a printmaking technique, or created as a watercolor. We also recognize and respond to the elements that constitute the work, the items of composition—line, form or shape, mass, color, repetition, harmony—and the unity that results from all of these. What devices have been employed, and how does each part relate to the others to make a whole? A concerto consists of melody, harmony, timbre, tone, and more; a tragedy utilizes language, mise-en-scène, exposition, complication, denouement; a ballet has formalized movement, mise-en-scène, line, idea content, and so on.

Moving to the third question, we examine *how the work stimulates our senses*—and why. In other words, how do the particular formal and technical arrangements (whether conscious or unconscious on the part of the artist) elicit a sense response from us? Here we deal with physical and mental properties. For example, our response to sculpture can be physical. We can touch a piece of sculpture and sense its smoothness or its hardness. In contrast, we experience essentially mental sense responses. For example, upright triangles give us a sense of solidity. When we perceive the colors green and blue we call them "cool"; reds and yellows, "warm." Pictures that are predominantly horizontal or composed of broad curves stimulate "soft" or placid responses. Angular, diagonal, or short, broken lines stimulate a sense of movement. Music that utilizes undulating melodic contours can be "smooth"; highly consonant music (see Glossary) can be "warm" or "rich." These and other sense responses reflect universals; most individuals respond in similar fashion to them.

We also can ask a fourth question about a work of art: *What does the work mean?* We may answer that question in strictly personal terms; for example, a painting may remind us of some personal experience. However, we cannot dismiss the question *What does it mean?* as a reference to purely personal experience. Meaning in a work of art implies much more. The ultimate response, meaning, and experience of an artwork could go beyond opinion to encompass an attempt to understand contextual matters (see p. 25). Taking a contextual approach to a painting such as Parmigianino's *Madonna with the Long Neck* (http://cgfa.sunsite.dk/p/p-parmigi1.htm) would reveal artistic and cultural conditions and give us an enriched understanding of the painting's appearance that would exceed the purely personal. Sometimes meaning in an artwork derives from cultural or historical contexts, including biography. Sometimes artworks spring from purely aesthetic necessity. Sometimes it is difficult to know which case applies or whether both cases apply.

In this book, we delve into only the first three questions (What is it? How is it put together? How does it stimulate our senses?) because the fourth involves a great deal more exploration than our space allows.

STYLE IN THE ARTS

The manner in which artists express themselves constitutes their *style.* Style is like the personality of an artwork. Style gives us that body of characteristics that identifies an artwork with an individual, a historical period, a school of artists, or a nation, for example, realism, expressionism, abstract, and so on. For an overview of some important styles, refer to the "A Question of Style" boxes throughout the text. Applying the term means assimilating materials and drawing conclusions.

Therefore, determining the style of any artwork requires analysis of how the artist has arranged the characteristics applicable to his or her medium. If the usage appears similar to others, we might conclude they exemplify the same style. For example, Bach and Handel typify the *baroque* style in music; Haydn and Mozart, the *classical.* Listening to works by these composers leads to the conclusion that the ornate melodic developments of Bach are like those of Handel, and quite different from the precise concern for structure and clearly articulated motifs of Mozart and Haydn. The precision and symmetry of the Parthenon (Fig. 4.2) compared with the ornate opulence of the Palace of Versailles (Figs. 4.26 and 4.31) suggest that in line and form the architects of these buildings treated their medium differently. Yet the design of the Parthenon suggests visual companionship, stylistically, to Mozart and Haydn; Versailles reflects an approach to design similar to that of Bach and Handel.

We can take our examination one step further and try some stylistic analysis with four paintings. The first three of these paintings reflect three different artists and styles; the fourth, one of those three. By stylistic analysis we will determine the painter of the fourth painting. Inasmuch as we have not yet dealt with definitions in composition, our analysis will remain as nontechnical as possible. We use three characteristics only: *line, palette,* and *brush stroke.*

In the first painting (Fig. 1.7), *A View Near Volterra,* Corot has used curvilinear line primarily, and that line (which creates the edges of the forms or shapes in the painting) appears somewhat softened: Many of the forms—the rocks, trees, clouds, and so on—do not have crisp, clear edges. Color areas tend to blend with each other, giving the painting a somewhat fuzzy or out-of-focus appearance. Corot's use of *palette* (PA-leht) heightens that comfortable effect. Palette, as we note later, encompasses the total use of color and contrast. As with his use of line, Corot maintains a subtle value contrast—that is, a subtle relationship of dark and light. He moves gradually from light to dark, and he avoids stark contrasts. He employs a limited range of colors, but does so without calling attention to their positioning. He uses apparent *brush stroke*: If we look carefully, we can see brush marks, individual strokes where paint has been applied. Even though the objects in the painting appear lifelike, Corot has not pretended that his picture has not been painted. We can tell he created the foliage by stippling (by dabbing the brush to the canvas as you would dot an "i" with a pencil). Likewise, we can see marks made by the brush throughout the painting. The overall effect of the painting seems lifelike, but we can see in every area the spontaneity with which it was executed.

We hardly need be an expert to tell that the second painting, Picasso's *Guernica* (ghair-NEE-kuh; Fig. 1.8), reflects a different style from Corot's *A View Near Volterra.* Picasso has joined curved lines and straight lines, placing them in such relationships

FIGURE 1.7 *Jean-Baptiste-Camille Corot, French (1796–1875),* A View Near Volterra *(1838). Canvas, 0.695 × 0.951 (27½ × 37½ in.).*
Source: National Gallery of Art, Washington, D.C. Chester Dale Collection.

FIGURE 1.8 *Pablo Picasso,* Guernica *(mural) 1937. Oil on canvas, 11'6" × 25'8".*
Source: Museo Nacional Centro de Arte Reina Sophia, Madrid © 2004 Estate of Pablo Picasso/Artists Rights Society (ARS), New York.

that they create movement and dissonance. The edges of color areas and forms reflect sharpness and remain distinct; nothing here appears soft or fuzzy. Likewise, the value contrasts are stark and extreme. Areas of the highest value—that is, white—slam against areas of the lowest value—black: a range of tonalities far less broad than in the previous work. Mid or medium (gray) tones exist, but they play a minor role in the effect of the palette. In palette, the work remains limited to blacks, whites, and grays. Brush stroke reinforces the starkness of the work by its near *absence* of effect. Tonal areas are flat, and few traces of brush exist.

The third painting (Fig. 1.9), van Gogh's (van GHOH) *The Starry Night*, uses highly active, although uniformly curvilinear line. Forms and color areas employ both hard and soft edges, and van Gogh, like Picasso, uses outlining to strengthen his images and reduce their reality. Overall, line

creates a sweeping and undulating movement, highly dynamic and yet far removed from the starkness of the Picasso. In contrast, van Gogh's curvilinearity and softened edges differ in effect from the relaxed quality of the Corot. Van Gogh uses very broad but moderate value contrasts. He ranges from darks to lights, all virtually equal in importance. Even when movement from one area to another crosses a hard edge to a highly contrasting value, it results in moderate (not soft, nor stark) effects. Brush stroke gives the painting its unique personality. We can see thousands of individual brush marks where the artist applied paint to canvas. The nervous, almost frenetic use of brush stroke makes the painting come alive.

Now that we have examined three paintings in different styles and by different artists, can you determine by style which of the three painted Figure 1.10? First, examine the use of line. Note the hard form and

FIGURE 1.9 *Vincent van Gogh, (1853–1890),* The Starry Night *(1889). Oil on canvas, 29″ × 36¼″ (73.7 × 92.1 cm).* Source: © Collection, The Museum of Modern Art Licensed by Scala—Art Resource, NY. Acquired through the Lillie P. Bliss Bequest (472.1941). The Museum of Modern Art, New York. U.S.A. Digital Image © The Museum of Modern Art/Licensed by SCALA/Art Resource, NY.

profile

Pablo Picasso

Pablo Picasso (1881–1973), born in Malaga, on the Mediterranean coast of Spain, studied at the Academy of Fine Arts in Barcelona but having already mastered realistic technique, had little use for school. At 16, he had his own studio in Barcelona. In 1900, he first visited Paris, and in 1904 he settled there. His personal style began to form in the years from 1901 to 1904, a period often referred to as his blue period because of the pervasive blue tones he used in his paintings at that time. In 1905, as he became more successful, Picasso altered his palette, and the blue tones gave way to a terra-cotta color, a shade of deep pinkish red. At the same time his subject matter grew less melancholy and included dancers, acrobats, and harlequins. The paintings he did during the years between 1905 and 1907 belong to his rose period.

Picasso played an important part in the sequence of different movements in the twentieth century. He said that repeating oneself went against "the constant flight forward of the spirit." Primarily a painter, he also became a fine sculptor, engraver, and ceramist. In 1917, Picasso went to Rome to design costumes and scenery for Sergei Diaghilev's (sair-GAY dee-AH-ghee-lehf) *Ballets Russes*. This work stimulated another departure in Picasso's work, and he began to paint the works now referred to as belonging to his classic period, which lasted from about 1918 until 1925.

At the same time as he designed for the ballet, Picasso also continued to develop the cubist technique (see Fig. 1.10 and Plate 4), making it less rigorous and austere.

His painting *Girl Before a Mirror* (Fig. 1.10 and Plate 4) gives us an opportunity to study his use of color in contrast to form. The painting depends greatly on form, and yet, if we compare Figure 1.10 with Plate 4, we understand how color gives meaning to this work. For example, Picasso chose red and green perhaps because they are complementary colors and perhaps, as the art historian H. W. Janson suggests, because Picasso intended the green spot in the middle of the forehead of the mirror's image as a symbol of the girl's psyche, or inner self, which she confronts with apparent anguish.

Guernica (Figs. 1.8 and 2.38), his moving vision of the Spanish Civil War, also depends on curved forms. In this painting, however, he intends the forms as fundamental because Picasso uses no color, only whites, grays, and black. *Guernica*, a huge painting, formed Picasso's response to the 1937 bombing by the Germans an behalf of the Fascist forces of the small Basque town of Guernica. In it distortions of form approach surrealism (See Glossary), but Picasso never called himself a surrealist. Picasso continued to work with incredible speed and versatility—as painter, ceramist, sculptor, designer, and graphic artist—into his nineties.

color edges and use of outlining. Curved and straight lines *juxtapose* against each other yielding an active and stark effect. By comparison, use of line does not suggest Corot, perhaps van Gogh, and definitely Picasso. Next, examine palette. Darks and lights contrast broadly yielding strong contrast—the darkest darks against the lightest lights. This is not like Corot, a bit like van Gogh, and most like Picasso. Finally,

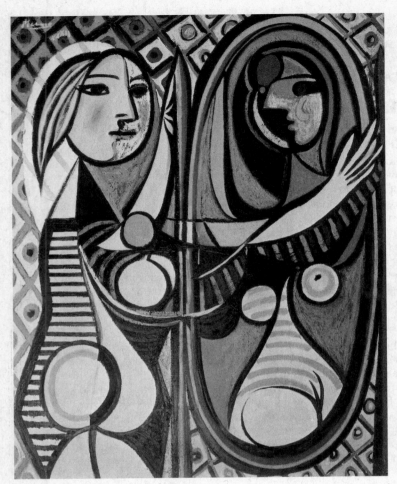

FIGURE 1.10 *Example painting. See color insert Plate 4 for identificationn. Pablo Picasso (1881-1973), "Girl Before A Mirrow". Oil in canvas, 64 x 51 1/4' (162.3 x 130.2 cm). Gift of Mrs. Simon Guggenheim. (2.1938) The Museum of Modern Art, New York, NY, USA. Digital Image © The Museum of Modern Art/SCALA/Art Resource, NY. © 2004 Estate of Pablo Picasso/Artists Rights Society (ARS), New York.*

brush stroke remains generally unobtrusive with mostly flat tonal areas: definitely not a van Gogh and probably not a Corot. Three votes out of three go to Picasso, and the style is so distinctive you probably had no difficulty deciding, even without the analysis. However, could you have been so certain if asked whether Figure 1.11 represented the same style or painter? So some differences in style appear obvious; some unclear. Distinguishing the work of one artist from another who designs in a similar fashion

becomes even more challenging. However, the analytical process we just completed is indicative of how we can approach artworks to determine *how* they exemplify a given style, or what style they reflect.

EVALUATING ART

Inevitably we want to conclude if an artwork is "any good." Whatever the form or medium, judgments about the quality of the work often

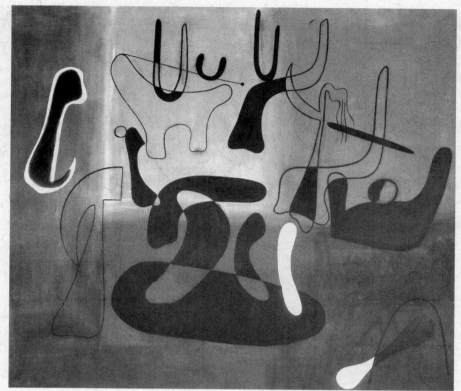

FIGURE 1.11 *Example painting. See color insert Plate 2 for identification. Joan Miro (1893-1983) " Painting"1933. Oil in canvas, 68 1/2" x 65 1/4" (174x196.2cm). Loula D. Laska Bequest (by exchange).(229. 1937) The Museum of Modern Art, New York, NY, USA. Digital Image © The Museum of Modern Art/SCALA/Art Resource, NY. © 2004 Successio Miro/ Artists Rights Society (ARS), NewYork/ADAGP. Paris.*

vary from one extreme to another, ranging from "I like it" and "interesting," to specific reasons why we think the artwork is effective or ineffective.

Criticicism *should entail* a *detailed process of analysis to gain understanding and appreciation.* Identifying the formal elements of an artwork—learning what to look for—represents the first step. We *describe* an artwork by examining its many facets and then try to understand how they work together to create meaning or experience. We then try to state what that meaning or experience is. Only after completing that process should we attempt judgment.

Professional critics usually bring to the process a set of standards developed from personal experience. Application of personal standards, however, complicates the process of criticism. First of all, knowledge of the art form may be shallow. Second, perceptual skills may be faulty; and, finally, the range of personal experience may be limited. In addition, the application of personal standards proves problematic if judgment involves preestablished criteria: If someone believes that "beauty" and/or usefulness, as examples, represent essential elements of a work of art, then any work that does not meet those criteria will be judged as faulty,

FIGURE 1.12 *Samuel Beckett,* Waiting for Godot, *Utah Shakespearean Festival (1990). Director: Tom Marlens.*

despite other qualities that may make the work unique and profound. Preestablished criteria often deny critical acclaim to new or experimental approaches in art.

History resounds with examples of new artistic attempts that received terrible receptions from so-called experts, whose ideas of what an artwork ought to be could not allow for experimentation or departures from accepted practice. In 1912, when Vaslav Nijinsky (vah-SLAHF nuh-JIHN-skee) choreographed the ballet *Rite of Spring* to music by Igor Stravinsky, the unconventional music and choreography actually caused a riot: Audiences and critics could not tolerate that the ballet did not conform to accepted musical and ballet standards. Today, most people consider both the music and the choreography masterpieces.

Similarly, Samuel Beckett's *Waiting for Godot* (1953) (Fig. 1.12) does not have a plot, characters, or ideas expressed in a conventional manner. In *Godot,* two tramps wait beside the road by a withered tree for the arrival of someone named Godot. The tramps tell stories to each other, argue, eat some food, and are interrupted by a character named Pozzo leading a slave, Lucky, by a rope. After a brief conversation, Lucky and Pozzo leave. At the end of the first act, a boy enters to announce that Godot will not come today. In Act 2, much the same sequence of events occurs. Then, Lucky leads in a blind Pozzo. The tree has sprouted a few leaves. The play ends as the young boy returns to indicate Godot will not arrive that day either. If your standards require a successful play to have a carefully fashioned plot wrapped

around fully developed characters and a clear message, then *Waiting for Godot* cannot possibly be a good play. Some people agree with such an assertion; others disagree vehemently. What, then, do we conclude? What if my criteria do not match yours? What if two experts disagree on the quality of a movie? Does that make any difference to our experience of it?

Value judgments involve intensely personal standards, but some opinions are more informed than others and represent more authoritative judgment. However, sometimes even knowledgeable people disagree. Disagreements about quality, however, can enhance our experience of a work of art when they lead us to think about why the differences exist. In this way, we gain a deeper understanding of the artwork. Nonetheless, we can do *criticism* without involving any judgment. We can thoroughly dissect any work of art and describe what it comprises—for example, we can describe and analyze line, color, melody, harmony, texture, plot, character, and/or message. We can observe how all of these factors affect people and their responses. We can spend a significant amount of time doing this and never pass a value judgment at all.

Does this discussion mean all artworks are equal in value? Not at all. It means that in order to understand what criticism involves, we must separate descriptive analysis, which can be satisfying in and of itself, from the act of passing value judgments. We may not like the work we have analyzed, but we may have understood something we did not understand before. Passing judgment may play no role whatsoever in our understanding of an artwork. But we are still involved in *criticism*.

As an exercise in understanding, criticism is necessary. We must investigate and describe. We must experience the need to know enough about the process, product, and experience of art if we are to have perceptions to share.

Now that we have examined briefly what criticism is and why we might do it, what criteria or approaches can we use?

APPROACHES TO CRITICISM

To put our earlier discussion in succinct form, criticism makes a range of inquiries about works of art, focusing primarily on three questions: (1) What is it? (2) What does it do? (3) What is it worth? Ultimately for us, the process of criticism yields enhanced meaning. Meaning, however, takes many forms and depends upon what type of criticism or philosophy of criticism we employ. The reason for this is simple. As the authors of *Janson's History of Art* (7th edition, p. xxv) contend, "Art is never an empty container; rather, it is a vessel loaded with meaning, subject to multiple interpretations, and always representing someone's point of view." So, by inquiring about a particular work, we can employ a variety of approaches—some fairly straightforward, and others complex and esoteric. In a moment, we will illustrate how we might want to approach an artwork using two basic methods, formal criticism and contextual criticism. We will leave the more esoteric methods for another time and place. First, however, let's digress into a bit of history.

In Western culture, the critical tradition began with Plato (428/427–348 BCE). Plato's models for criticism focused principally on an artwork's moral qualities, and he attacked poets, for example, on the grounds that their art merely imitated nature and that it appealed to the worst rather than the best of human nature. In contrast, Aristotle (c. 450–388 BCE), one of Plato's students, argued for the value of imitation (he found

moral value in tragedy, for example, because of its capacity to purge humans of pity and fear), focusing, however, on logical and formal approaches rather than moral ones.

Since the Renaissance, Western criticism has tended to tackle the factors of the moral worth of art and its relationship to nature. By the late twentieth century, however, criticism had undergone a tumultuous upheaval with regard to traditional approaches to criticism. All of this began in the early part of the century and resulted in a splintered series of approaches including some that questioned the importance of the artist altogether, particularly with regard to determining meaning or meanings in works of art. Meaning, for example, for some approaches derives not from artistic intent but from wider forces such as structures of language, in the case of literature, theatre, and cinema, and culture. It seems as though every political, social, philosophical, and psychological movement has also generated an approach to criticism, giving rise to such "schools" of criticism as feminist criticism, Freudian criticism, practical criticism, Marxist criticism, structuralism, deconstruction, reader-response criticism, and so on.

Moving now to how we can undertake to "criticize" a work of art, we will withdraw to two broad and basic types of criticism: *formal* criticism and *contextual* criticism. Once we have these concepts in hand, we will follow with some thoughts on making judgments about works of art we might encounter.

FORMAL CRITICISM

Formal criticism applies no external conditions or information. We analyze the artwork just as we find it: If it is a painting, we look only within the frame; if it is a play, we analyze only what we see and hear. Formal criticism approaches the artwork as an entity within itself. As an example, consider this brief analysis of Molière's comedy *Tartuffe* (tohr-TOOF; 1664) (Fig. 1.13):

> Orgon, a rich bourgeois, has allowed a religious con man, Tartuffe, to gain complete control over him. Tartuffe has moved into Orgon's house, and tries to seduce Orgon's wife at the same time he is planning to marry Orgon's daughter. Tartuffe is unmasked, and Orgon orders him out. Tartuffe seeks his revenge by claiming title to Orgon's house and blackmailing him with some secret papers. At the very last instant, Tartuffe's plans are foiled by the intervention of the king, and the play ends happily.

We have just described a story. Were we to go one step further and analyze the plot, we would look, among other things, for points at which *crises* occur and cause important decisions to be made by the characters; we would also want to know how those decisions moved the play from one point to the next. In addition, we would try to locate the extreme crisis, the *climax*. Meanwhile, we would discover auxiliary parts of plot such as *reversals*—for example, when the other characters unmask Tartuffe and become aware of the true situation. Depending on the detail of our criticism, we could work our way through each and every aspect of the plot. We might then devote some time to describing and analyzing the driving force—the *character*—of each person in the play and how the characters relate to each other. Has Molière created fully developed characters? Are they types or do they seem to behave more or less like real individuals? In examining the *thematic* elements of the play, we would no doubt conclude the play deals with

FIGURE 1.13 *Jean-Baptiste Molière,* Tartuffe, *University of Arizona Theatre Arts Department (1990). Director: Dianne J. Winslow, Scene Designer: Charles O'Connor.*

religious hypocrisy and that Molière had a particular point of view on that subject.

In this formal approach, information about the playwright, previous performances, historic relationships, and so on, remain irrelevant. Thus, the formal approach helps us analyze how an artwork operates and helps us decide why the artwork produces the responses it does. We can apply this form of criticism to any work of art and come away with a variety of conclusions. Of course, knowledge about how artworks are put together, what they are, and how they stimulate the senses enhances the critical process. Knowing the basic elements that comprise formal and technical elements of the artwork (which are the subjects of the succeeding chapters of this book) gives us a ready outline on which to begin a formal analysis.

CONTEXTUAL CRITICISM

Another general approach, contextual criticism, seeks meaning by adding to formal criticism an examination of related information outside the artwork, such as facts about the artist's life, his or her culture, social and political conditions and philosophies, public and critical responses to the work, and so on. These can all be researched and applied to the work in order to enhance perception and understanding. Contextual criticism views the artwork as an artifact generated from particular contextual needs, conditions, and/or attitudes. If we carry our criticism of *Tartuffe* in this direction, we would note that certain historical events help clarify the play. For example, the object of Molière's attention probably was the Company of the Holy Sacrament, a secret,

conspiratorial, and influential religious society in France at the time. Like many fanatical religious sects—including those of our own time—the society sought to enforce its own view of morality by spying on the lives of others and seeking out heresies—in this case, in the Roman Catholic church. Its followers were religious fanatics, and they had considerable impact on the lives of the citizenry at large. If we were to follow this path of criticism, we would pursue any and all contextual matters that might illuminate or clarify what happens in the play. Contextual criticism may also employ the same kind of internal examination followed in the formal approach.

MAKING JUDGMENTS

Now that we have defined criticism and noted some approaches we might take in pursuit of understanding and enjoying a work of art, we can move on to the final step: making value judgments.

Several approaches to the act of judgment present themselves. Two characteristics, however, apply to all artworks: Artworks are *crafted,* and they *communicate* something to us about our experiences as humans. Making a judgment about the quality of an artwork should address each of these characteristics.

Artisanship

Is the work well made? To make this judgment, we first need some understanding of the medium in which the artist works. For example, if the artist proposes to give us a realistic vision of a tree, does the artist's handling of the paint yield a tree that looks like a tree? Of course, if artisanship depended only on the ability to portray objects realistically,

judgment would be quite simple. However, we must remember that judgments about the artisanship of an artwork require some knowledge about the techniques and styles of its medium. Although we may not yet be ready to make judgments about all of the aspects of artisanship in any art form, we can apply what we know. Good artisanship means the impact of the work will have clarity and not be confusing. It also means the work will hold our interest (given basic understanding and attention on our part). If the artwork does not appear coherent or interesting, we may wish to examine whether the fault lies in the artwork or in ourselves before rendering judgment. Beyond that, we are left to learn the lessons that this book seeks to teach. Each chapter gives us enhanced tools to evaluate the artisanship of a work of art.

Communication

Evaluating what an artwork tries to say offers more immediate opportunity for judgment and less need for expertise. Johann Wolfgang von Goethe (ghuhr-tuh), the nineteenth-century poet, novelist, and playwright, set out a basic, commonsense approach to evaluating communication. Because Goethe's approach provides an organized means for discovering an artwork's communication by progressing from analytical to judgmental functions, it helps us to end our discussion on criticism. Goethe suggests that we approach the critical process by asking three questions: What is the artist trying to say? Does he or she succeed? Was the artwork worth the effort? These three questions focus on the artist's communication by making us identify first what was being attempted, and then on the artist's success in that attempt. The third question, whether or not the project was worth the

effort, raises other issues, such as uniqueness or profundity. This question asks us to decide if the communication offered important or unique perceptions (as opposed to the trivial or inane). A well-crafted work of art that merely restates obvious insights about the human condition lacks quality in its communicative component. One that offers profound and unique insights exhibits quality.

Pictures

DRAWING, PAINTING, PRINTMAKING, AND PHOTOGRAPHY

Pictures of family, friends, rock and sports stars, copies of artistic masterpieces, and original paintings and prints adorn our personal spaces. Dorm rooms, bedrooms, living rooms, and other places where we live seem coldly empty and depersonalized without pictures of some kind in them. Pictures have always been important to us. People who lived in caves 20,000 years ago drew pictures on their walls. In this chapter, we'll learn about the many ways pictures can be made and how artists use two-dimensional qualities to speak to us.

WHAT IS IT?

Pictures such as drawings, paintings, photographs, and prints differ primarily in the technique of their execution. Two dimensional, their subject might be a landscape, seascape, portrait, religious picture, nonobjective (nonrepresentational) or abstract (see Glossary) picture, still life, or something else. So, at first glance our response seems to constitute simple and straightforward observation—what we identify as subject matter. That, however, can lead us into a world- and style-wide

exploration. For example, were the work a landscape, we might think of the many applications artists have chosen by which to portray outdoor scenes. Corot's *A View Near Volterra* (Fig. 1.7) contrasts with Van Gogh's *The Starry Night* (Fig. 2.4), and these, divergent styles of Western art, take distinctly different attitudes than Hiroshige's *Maple Leaves at Mama . . .* (see color insert Plate 5). These works certainly differ technically, as we would surmise from the discussion that follows, but they also differ philosophically and culturally in the way they regard nature. And yet, they share a generic appellation—landscape. Any of the other seemingly straightforward formal, generic identifications also could lead us toward complex understandings.

HOW IS IT PUT TOGETHER?

MEDIUM

Our technical level of identification and response entails some very detailed information, first of all, relative to the medium used by the artist to execute the work.

Drawing

Drawing, considered the foundation of two-dimensional art, utilizes a wide variety of materials traditionally divided into two groups: dry media and wet media. In the discussion that follows we will note the dry media of chalk, charcoal, graphite, and pastel, and the wet media of ink and wash and brush.

Dry Media

Chalk. Chalk developed as a drawing medium by the middle of the sixteenth century. Artists first used it in its natural state, derived from ocher hematite, white soapstone, and black carbonaceous shale, placing it in a holder and sharpening it to a point. Chalk, a fairly flexible medium, creates a wide variety of tonal areas with extremely subtle transitions between areas. Applied with a heavy or light pressure, chalk can be worked with the fingers once on the paper to create the exact image the artist desires, as exemplified by Alberti Cherubino's (chair-oo-BEE-no) *Prudence* (National Gallery of Art, Washington D.C., http://www.nga.gov/cgi-bin/pinfo? Object =72239+0+none).

Charcoal. Charcoal, a burnt wood product (preferably hardwood), like chalk, requires a paper with a relatively rough surface—tooth—for the medium to adhere. Charcoal has a tendency to smudge easily, which dampened its early use as a drawing medium. It found wide use, however, as a means of drawing details, for example, on walls and for murals that were eventually painted or frescoed. Today, resin fixatives sprayed over charcoal drawings eliminate the tendency to smudge, and charcoal has become a popular medium because artists find it extremely expressive. Like chalk, charcoal can achieve a variety of tonalities. The medium can be manufactured in a variety of shapes and densities, for example, in sharpened sticks that work like pencils, either hard or soft as seen in George Bellows, *Study for Nude with Hexagon* (National Gallery of Art, Washington, D.C., http://www.nga.gov/cgi-bin/pinto? Object=68302+0+none).

Graphite. Graphite, a form of carbon, like coal, and most familiar as pencil lead, can be manufactured in various degrees of hardness. The harder the lead, the lighter and more delicate its mark, as seen in Oscar F. Bluemner's *Study for a Painting* (National Gallery of Art, Washington, D.C.,

http://www.nga.gov/cgi-bin/pinfo?Object= 56861+0+none).

Pastel. Pastel, essentially a chalk medium in which colored pigment and a nongreasy binder have been combined, typically comes in sticks about the diameter of a finger and with a myriad hardness: soft, medium, hard. Hardness increases by adding more binder, with the result that the harder the stick, the less intense its color. In fact, the name "pastel" implies pale, light colors. Artists find soft pastels quite difficult to work with, although intense colors require soft pastels. A special ribbed paper helps to grab the powdery pastel, and a sprayed fixative holds the powder in place permanently on the paper. Beverly Buchanan's *Monroe County House with Yellow Datura* (Fig. 2.34) illustrates not only the breadth of color intensity possible with pastels, but also the intricacy with which they can be applied by a skilled hand.

Liquid Media

Pen and Ink. Pen and ink comprises a fairly flexible medium compared to graphite, for example. Although linear, pen and ink gives the artist the possibility of variation in line and texture. Shading, for example, results from diluting the ink, and the overall quality of the drawing achieves fluidity and expressiveness, as we can see in Rembrandt's *Lot and His Family Leaving Sodom* (National Gallery of Art, Washington, D.C., http://www.nga.gov/ cgi-bin/pinfo?Object=1854+0+none).

Wash and Brush. Ink, diluted with water and applied with a brush, creates a wash similar in characteristics to watercolor, which we discuss in the next section on painting media. Difficult to control, wash and brush yields effects nearly impossible to achieve in any other medium. Because it must be worked

quickly and freely, it has a spontaneous and appealing quality, as suggested in Chu Ta's (choo-tah) *Lotus* (Fig. 2.1).

FIGURE 2.1 *Zhu Da (Bada Shanren), Chinese, 1625–c. 1705. Lotus, 1705, Ink on paper, 61½" × 28".*
Source: Palmer Museum of Art, The Pennsylvania State University, 77.15.

In addition to the media we have just described (and which may be combined in infinite variety), there exists a wide range of possibilities of experimental and innovative nature. These include the computer, which can be used as an electronic sketchpad.

Painting

Like drawing media, painting media each have their own particular characteristics, and to a great extent, this dictates what the artist can or cannot achieve as an end result. In the following section, we will examine five painting media: oils, watercolor, tempera, acrylics, and fresco.

Oils

Oils, perhaps the most popular of the painting media since their development near the beginning of the fifteenth century, gain their popularity principally from the great variety of opportunity they give the painter. Oils offer a wide range of color possibilities; because they dry slowly, they can be reworked; they present many options for textural manipulation; and they are durable. If we compare two oils, van Gogh's *The Starry Night* (Fig. 2.4) and Giovanni Vanni's *Holy Family with Saint John* (see color insert Plate 1), the medium shows its importance to the final effect of the works. Vanni creates light and shade in the baroque tradition, and his chiaroscuro (kee-AHR-oh-SKOO-roh) depends on the capacity of the medium to blend smoothly among color areas. Van Gogh, in contrast, requires a medium that will stand up to form obvious brush strokes. Vanni demands the paint to be flesh and cloth. Van Gogh demands the paint to be paint and to be stars and sky, but also to call attention to itself.

Watercolor

Watercolor is a broad category that includes any color medium that uses water as a thinner. However, the term has traditionally referred to a transparent paint usually applied to paper. Because watercolors are transparent, artists must be very careful to control them. If one area of color overlaps another, the overlap will show as a third area combining the previous hues. But their transparency gives watercolors a delicacy that cannot be produced in any other medium.

In Figure 2.2 we see the characteristic transparency of the watercolor pigment in Harrison Begay's *Women Picking Corn.* Typical of Native American watercolor of the mid-twentieth century, Begay uses space by keeping the painting on the surface plane and depicts only the important subjects with no background shown. So, only the women and the corn concern the viewer, and Begay adds no spatial environment. He renders the subjects in two dimensions. The only hint of space beyond the frontal plane lies in the diminutive size of the woman on the left. Begay leaves the horizon line (the viewer's eye level) at the bottom of the painting.

Gouache

Gouache (gwash), also a watercolor medium, adds gum to ground opaque colors mixed with water. Transparent watercolors can be made into gouache by adding Chinese white, a special white, opaque, water-soluble paint that, in contrast to watercolor, creates an opaque paint.

Tempera

Tempera, an opaque watercolor medium, spans recorded history. Employed by the ancient Egyptians, it still finds use today. Tempera comprises ground pigments and

FIGURE 2.2 *Harrison Begay, Women Picking Corn, mid-twentieth century. Watercolor, 15 × 11 ½ ins (38.1 × 29.2 cm).*
Source: Courtesy of National Museum of the American Indian, Smithsonian Institution.

their color binders such as gum or glue, but is best known as egg tempera. A fast-drying medium, it virtually eliminates brush strokes and gives extremely sharp and precise detail. Colors in tempera paintings appear almost gemlike in their clarity and brilliance.

Acrylics

Acrylics, in contrast with tempera, constitute modern synthetic products. Most acrylics are water soluble (they dissolve in water), and use an acrylic polymer as a binding agent. Acrylics offer artists a wide range of possibilities in both color and technique. Either opaque or transparent, depending on dilution, acrylics dry fast, thin, and resistant to cracking under temperature and humidity extremes. Perhaps less permanent than some other media, acrylics adhere to a wider variety of surfaces and will not darken or yellow with age, as will oil.

With acrylic paint showing some of its characteristics of opacity and transparency, Cuban painter and installation artist Jose Bedia (BAY-dee-ah; b. 1959) draws the viewer into *Si se quiere, se puede* (*If you want to, you can;* Fig. 2.3). The painting evokes ideas about leaving Cuba, and the image of a man on a boat shaped like an anvil, coupled with the title and the restricted palette (overall color scheme—see page 56), raises questions

FIGURE 2.3 *Jose Bedia, Si se quiere, se puede (If you want to, you can), 1993. Acrylic on canvas, 5 ft × 7 ft 6 ins (1.52 × 2.29 m).*
Source: Collection of Robertson, Stephens, Inc., San Francisco. Courtesy PanAmerican ArtProjects.

to which the viewer wants to respond. The flat starkness and black against blue colors create a confrontational and engaging image leaving us to ponder larger issues.

Fresco

Fresco, a wall painting *technique*, uses pigments suspended in water and applied to fresh wet plaster. Michelangelo's Sistine Chapel frescoes are the best known examples of this technique. Because the end result becomes part of the plaster wall rather than being painted on it, fresco provides a long-lasting work.

However, once the artist applies the pigments, no changes can be made without replastering the entire section of the wall. Diego Rivera (ree-VAY-rah; 1886–1957) revived the fresco mural as an art form in Mexico in the 1920s. His large-scale public murals such as Figure 2.5 depict contemporary subjects in a style that blends European and native traditions.

Mixed Media

Of course, artists may choose to use a single medium such as those just noted, or they may choose to combine various media

Postimpressionism

postimpressionism (pohst-ihm-PREHSH-uh-nihz-uhm). In visual art, a diverse style dating to the late nineteenth century that rejects the objective naturalism of impressionism and uses form and color in more personal ways. It reflects an "art for art's sake" philosophy. Postimpressionism comprises a number of disparate styles. In subject matters, its paintings appear similar to impressionist paintings—landscapes, familiar portraits, groups, and café and nightclub scenes—but the postimpressionists gave their subject matter a complex and profoundly personal significance. As we can see from van Gogh's *The Starry Night* (Fig. 2.4), a sense of form and structure prevails as well as an interest in the painting as a flat surface carefully composed of shapes, lines, and colors, an idea shared by his fellow postimpressionists, which became the foundation for most of the art movements that followed.

FIGURE 2.4 *Vincent van Gogh, (1853-1890) "The Starry Night" 1889. . Oil on Canvas, 29" × 36¼" (73.7 × 92.1 cm).*
Source: The Museum of Modern Art/Licensed by Scala—Art Resource, NY. Acquired through the Lillie P. Bliss Bequest.(472.1941). Photograph © 2001 The Museum of Modern Art, New York. U.S.A. Digital Image © The Museum of Modern Art/Licensed by SCALA/Art Resource, NY.

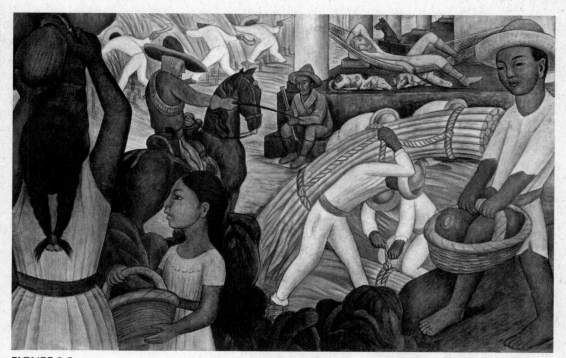

FIGURE 2.5 *Diego Rivera, Mexican, 1886–1957, Sugar Cane, 1930. Fresco, 57 1/8" x 94 1/8" (145.1 x 239.1 cm) Source:* Philadelphia Museum of Art Philadelphia, PA. USA. Photo credit: The Philadelphia Museum of Art /Art Resource NY. © Banco de Mexico Diego Rivera Museum Trust.

in order to create works that allow the artist to transcend the limits of a single medium, as Betye Saar (b. 1926) has done with *The Liberation of Aunt Jemima* (Fig. 2.6). Aunt Jemima was a marketing symbol of surrogate motherhood applied to pancake flour and syrup. In the immediate years after World War II, Aunt Jemima—an African American woman dressed as "Aunt Jemima," demonstrating making pancakes with her brand of mix—was a staple at county fairs and public festivals around the country and as recognizable a corporate icon as Ronald McDonald. The work represents the feminist movement, a social, political, and cultural movement seeking equal rights and status for women in all spheres of life. More radically, it pursues a new order in which men no longer constitute the standard against which equality and

normality are measured. Feminism consists of a diverse ideology of wide-ranging perspectives on the origin and constitution of gender and sexuality, the historical and structural foundations of male power and women's subjugation, and the proper means of achieving women's emancipation.

Prints

Prints generally fall into three main categories based essentially on the nature of the printing surface. The first category is relief printing such as woodcut, wood engraving, collograph, and linoleum cut. The second category consists of intaglio, which includes etching and aquatint. The third category comprises the planographic process, which includes lithography and

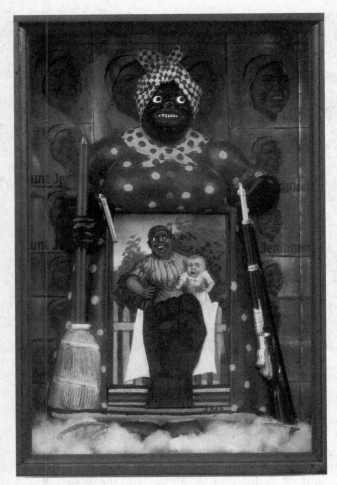

FIGURE 2.6 *Betye Saar, "The Liberation of Aunt Jemima." 1972 Mixed Media. 11³/₄" × 8" × 2³/₄".*
Source: Purchased with the aid of funds from the National Endowment for the Arts (selected by The Committee for the Acquisition of Afro-American Art. Photo: Benjamin Blackwell. University of California/Berkeley Art Museum.

serigraphy (silkscreen) and other forms of stenciling. In addition, printmakers also use other combinations and processes.

Artists choose to produce an original work of art as a print for two main reasons. The first reason, to obtain a number of identical copies, finds its motivation in a desire to create pictures as multiple images or to reinterpret an original drawing or painting in print form. Prints sell less expensively than unique objects and are, thus, more accessible to individuals who may not normally

invest in art. The second reason to choose to produce a print lies in the fact that each printmaking process produces characteristic visual qualities that are distinctly different from painting and drawing.

Every print has a number called an issue number. On some prints the number may appear as a fraction—for example, 36/100. The denominator indicates how many prints were produced from the plate or block. The numerator indicates where in the series the individual print was produced. If only a single

number appears such as 500 (also called an issue number), it simply indicates the total number of prints in the series. Printmakers are beginning to eliminate the former kind of numbering because of the misconception that the relationship of the numerator to the issue total has a bearing on a print's value, monetarily or qualitatively. The issue number does have some value in comparing, for example, an issue of 25 with one of 500, and usually affects the price of a print. However, the edition number is not the sole factor in determining the value of a print. The quality of the print and the reputation of the artist are more important considerations.

Relief Printing

In relief printing (Fig. 2.8), the image transfers to the paper by elimination of non-image areas and inking the remaining surface. Therefore, the image protrudes, in relief, from the block or plate and produces a picture reversed from the image carved by the artist. This reversal characterizes all printmaking media. *Woodcuts* and *wood engravings* are two popular techniques. A woodcut, one of the oldest techniques, utilizes the plank of the

FIGURE 2.7 *Wood plank and butt.*

grain; a wood engraving cuts into the butt of the grain (Fig. 2.7). Figure 2.9 illustrates the linear essence of the woodcut and shows the precision and delicacy possible in this medium. On the other hand, wood block printing can also produce flat color areas such as in Hiroshige's (hee-roh-SHEE-gee) *Maple Leaves at Mama...* (see color insert Plate 5). This strongly colored Japanese woodcut from the mid-nineteenth century shows deep space in a novel fashion, using the foreground to "frame" the distance. Hiroshige uses neither linear nor atmospheric perspective (both of

FIGURE 2.8 *Relief printing techniques.*

FIGURE 2.9 *Albrecht Dürer, German, 1471–1528. Lamentation, c. 1498–99, Woodcut, 15½″ × 11¼″, (39.3 × 28.5 cm).*

Source: Palmer Museum of Art, of the The Pennsylvania State University, Gifts of the Friends of the Palmer Museum of Art, 75.5.

which we discuss momentarily) to achieve the illusion of deep space, and yet the portrayal appears rational. He uses a clever manipulation of the aspects of color to keep interest and control, holding our vision stable in the center of the work. The *collograph* printmaking process glues assorted objects to a board or plate. A collograph represents relief printing when the raised surfaces are inked and printed. When the recessed areas are inked and printed, the collograph becomes an intaglio work.

Intaglio

The intaglio (in-TAHG-lee-oh) process (Fig. 2.10), the opposite of relief printing, transfers ink to the paper not from raised

FIGURE 2.10 *Intaglio processes.*

areas but rather from grooves cut into a metal plate. *Line engraving, etching, drypoint,* and *aquatint* comprise some of the methods of intaglio.

Line Engraving. Line engraving involves cutting grooves into the metal plate with special sharp tools. It requires great muscular control because the pressure must be continuous and constant for the grooves to produce the desired image. The line-engraving process produces very sharp and precise images. This form of intaglio, the most difficult and demanding, can be seen in Albrecht Dürer's (DYOO-ruhr) *Angel with the Key to the Bottomless Pit* at http://sunsite.auc.dk/cgfa/durer/pdurer.htm.

Etchings. Etchings are less demanding. In this process the artist removes the surface of the plate by exposing it to an acid bath. First the artist covers the plate with a thin waxlike substance called a *ground.* Then the artist scratches away the ground to produce the desired lines. She then immerses the plate in the acid, which burns away the exposed areas of the plate. The longer a plate remains in the acid, the deeper the resulting etches; the deeper the etch, the darker the final image. Artists wishing to produce lines or areas of differing darkness must cover those lines that they do not desire to be more deeply cut before further immersions in the acid. They can accomplish this task easily. Repetition of the process yields a plate producing a print with the desired differences in light and dark lines. All the details of Figure 2.11 consist of individual lines, either single or in combination. The lighter lines required less time in the acid than the darker ones. Because of the precision and clarity of the lines, it would

FIGURE 2.11 *Daniel Hopfer, German, 1493–1536.* Ceiling Ornaments. *Etching, 10″ × 8¾″.*
Source: Palmer Museum of Art, The Pennsylvania State University, 76.9.

be difficult to determine, without knowing in advance, whether this print is an etching or an engraving. Drypoint, in contrast, produces lines with less sharp edges.

Drypoint. The drypoint technique requires scratching the surface of the metal plate with a needle. Unlike line engraving, which results in a clean, sharp line, drypoint technique leaves a ridge, called a burr, on either side of the groove, resulting in a somewhat fuzzy line.

Aquatint. The aquatint process enables an artist to create areas of solid tone on an etching plate as well as gradations of tone from white through a range of grays to black. The aquatint process is usually combined with line etching to create an image of greater weight and modeling, but it can be used as a primary technique as well. The intaglio methods noted thus far consist of various means of cutting lines into a metal plate. However, effects—such as solid tones and shading—cannot be produced effectively with lines. Therefore, the artist dusts the plate with a resin substance and then heats the plate, which affixes the resin. The artist then puts the plate into the acid bath. The result yields a plate with a rough surface

texture, like sandpaper, and a print whose tonal areas reflect that texture.

Once the plate is prepared, whether by line engraving, etching, aquatint, drypoint, or a combination of methods, the artist can begin the printing process. He places the plate in a press, laying a special dampened paper over it. Padding is placed on the paper, and then a roller is passed over, forcing the plate and the paper together with great pressure. The ink, which has been carefully applied to the plate and left only in the grooves, transfers as the paper is forced into the grooves by the roller of the press. Even if no ink had been applied to the plate, the paper would still receive an image. This *embossing* effect marks an intaglio process with a very obvious three-dimensional *platemark.*

Planographic Processes

In a planographic process (Fig. 2.12), the artist prints from a plane surface (neither relief not intaglio). *Lithography* (lith-AHG-rah-fee, the term's literal meaning is "stone writing") rests on the principle that water and grease do not mix. To create a lithograph, artists begin with a stone, usually limestone, and grind one side until absolutely smooth. They then draw an image on the stone with a greasy substance. Artists can vary the darkness of the final image by the amount of grease they use: The more grease applied, the darker the image. After artists have drawn the image, they treat the stone with gum arabic and nitric acid and then rinse it with water. This bath fixes the greasy areas to the surface of the stone. When the artist rinses the stone and fans it dry, the surface appears clean. However, the water, gum, and acid have impressed the grease on the stone, and when wetted, the stone absorbs water (limestone being porous) only in those areas previously ungreased. Finally, a grease-based ink is applied to the stone. It, in turn, will not adhere to the water-soaked areas. As a result the stone, with ink adhering only to the areas on which the artist has drawn, can be placed in a press and the image transferred to the waiting paper. In Figure 2.13, we can see the characteristic most attributable to the medium of lithography—a crayon-drawing appearance. Because the lithographer usually draws with a crayonlike material on the stone, the final print has exactly that quality.

FIGURE 2.12 *Planographic process.*

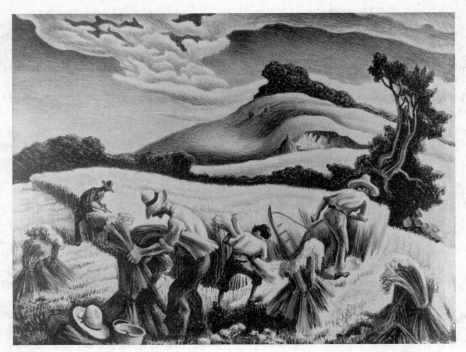

FIGURE 2.13 *Thomas Hart Benton, American, 1889–1974,* Cradling Wheat, *1938. Lithograph, 9½″ × 12″. Source:* Palmer Museum of Art of The Pennsylvania State University. Gift of Carolyn Wose Hull, 73.1. Art ©T.H. Benton and R.P. Benton Testamentary Trusts/UMB Bank Trustee/Licensed by VAGA, New York, NY.

The *serigraphic* process (serigraphy, sair-IHG-ruh-fee) or silk-screening, the most common of the stenciling processes, uses a wooden frame covered with a finely meshed silk fabric. The nonimage areas are blocked out with a glue mixture painted directly on the silk fabric or blocked out by a cut paper stencil. The stencil is placed in the frame and ink applied. By means of a rubber instrument called a squeegee, the artist forces ink through the openings of the stencil, through the screen, and onto the paper below. This technique allows the printmaker to achieve large, flat, uniform color areas. We can see this smooth uniformity of color areas in Figure 2.14. Here the artist, through successive applications of ink, has built up a complex composition with highly verisimilar (lifelike) detail.

A *monotype* or *monoprint*, as its name implies, creates a unique impression by applying printing ink to a flat surface and transferring it to paper. The method, however, excludes one of the usual main purposes of printmaking—obtaining multiple copies of a single image—because a monoprint creates a one-time image only. On the other hand, the marks and textures of the monotype differ characteristically from those drawn or painted on paper. Monoprint appeals to many artists because it requires no presses or studio equipment.

Looking over the figures in this section, we see how the images of the various prints reflect recognizable differences in technique. Some prints reflect a combination of techniques. However, in seeking the

FIGURE 2.14 *Nancy McIntyre, American, b. 1950,* Barbershop Mirror *(1976). Serigraph, 26½″ × 19″ (67.3 × 48.3 cm).*
Source: Palmer Museum of Art, The Pennsylvania State University. Office of Gifts and Endowments, 76.124.

method of execution, we add another layer of potential response to a work.

Photography

Photographic images (and images of photography's subsequent developments—motion pictures and video) provide us, primarily, with information. Cameras (Fig. 2.15) record the world; but, in addition, through editing, a photographer can take the camera's image and change the reality of life as we see it to a reality of the imagination. In one small sense, photography constitutes a simplification of reality that substitutes two-dimensional images for the three-dimensional images of life. It also can amplify reality when a photographer takes a snapshot of one moment in time and transforms it by altering the photographic image and/or artificially emphasizing one of its parts.

Photography and Art

Photographer Ansel Adams (1902–1984) viewed the photographer as an interpretive artist; he likened a photographic negative to a musical score, and the print to a

pentaprism corrects image

mirror moves up when shutter is released

mirror returns instantly to viewing position after exposure

film

FIGURE 2.15 *The single-lens reflex (SLR) camera.*

performance. Thus, despite all the choices an artist may make in committing an image to film, these comprise only the beginning of the artistic process. A photographer still has the choice of size, texture, and value contrast or tonality. A photo of the grain of a piece of wood, for example, can have an enormous range of aesthetic possibilities, depending on how a photographer employs and combines these three elements.

After World War I, as photography entered its second century, significant aesthetic changes occurred. Early explorations of photography as an art form tended to employ darkroom techniques, tricks, and manipulation that created works that seemed staged and imitative of sentimental, moralistic paintings. The followers of such an aesthetic believed that for photography to be art, it must look like art.

During the early years of the twentieth century, however, a new generation of photographers arose who determined to take photography away from the previous pictorial style and its soft focus and toward a more direct, unmanipulated, and sharply focused approach. Called straight photography, it expressed its adherents' belief in photography's unique vision. The principal American force behind the recognition of photography as a fine art, Alfred Stieglitz (STEEGH-lihts; 1864–1946), gained recognition for his clarity of image and reality shots, especially of clouds and New York City architecture. In 1902, he formed the Photo-Secessionist group and opened a gallery referred to as 291 because of its address at 291 Fifth Avenue in New York City. In addition to showcasing photography, Stieglitz's efforts promoted many visual artists, including the woman who would become his wife, Georgia O'Keefe (Plate 17). He also promoted photography as a fine art in the pages of his illustrated quarterly, *Camera Work* (see Alfred Stieglitz's *The Terminal* at http://www.artsmia.org/get-the-picture/stieglitz/frame04.html).

Plate 1 Giovanni Battista Vanni, Italian, 1599-1660, *Holy Family with Saint John*, 1630-1660. Oil on canvas, 70" x 58", Palmer Museum of Art, The Pennsylvania State University, 73.118. Photo by Giovanni Battista.

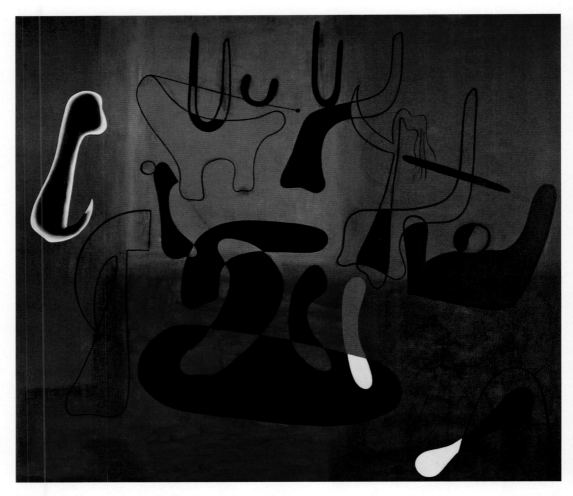

Plate 2 Joan Miro, 1893-1983, *Painting*, 1933. Oil on canvas, 68 1/2" x 65 1/4" (174 x 196.2 cm). Loula D. Lasker Bequest (by exchange). (229.1937). The Museum of Modern Art, New York, NY, U.S.A. Digital Image © The Museum of Modern Art/ SCALA/ Art Resource, NY. ©2004 Successio Miro/ Artists Rights Society (ARS), New York/ADAGP, Paris.

yellow
yellow-orange
yellow-green
orange
green
red-orange
blue-green
red
blue
red-violet
blue-violet
violet

Plate 3 Conventional color wheel from *The Formal Elements*. Pearson Education/PH College.

Plate 4 Pablo Picasso 1881-1973, *Girl Before A Mirror*. Oil on canvas, 64 x 51 1/4" (162.3 x 130.2 cm). Gift of Mrs. Simon Guggenheim. (2.1938). The Museum of Modern Art, New York, NY, U.S.A. Digital Image © The Museum of Modern Art/ SCALA/ Art Resource, NY. ©2004 Estate of Pablo Picasso/Artists Rights Society (ARS), New York.

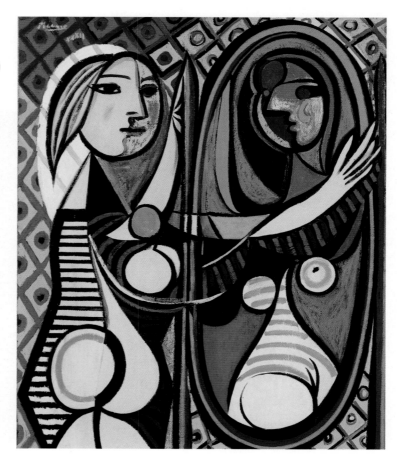

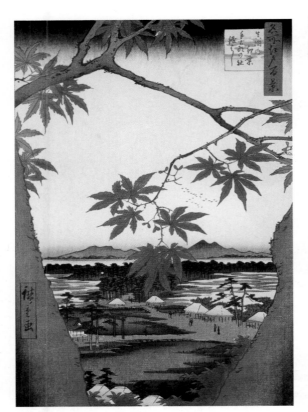

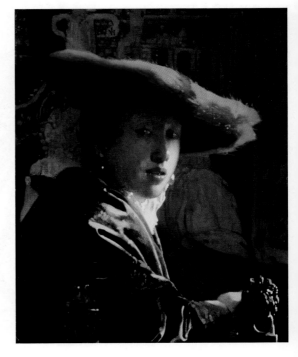

Plate 5 Ando Hiroshige, *Maple Leaves at Mama*, Tekona Shrine and Mama Bridge. © CORBIS All Rights Reserved.

Plate 6 Johannes Vermeer (Dutch, 1632-1675), *Girl with the Red Hat*. Oil on panel, unframed: unframed (painted surface); .228 x .180 cm (9 x 7 1/16"); framed: .445 x .394 x .083 cm (17 1/2 x 15 1/2 x 3 1/4"). National Gallery of Art, Washington, D.C. Andrew W. Mellon Collection. Photo by Richard Carafelli.

The adherents of straight photography found in their ranks perhaps America's most famous photographer, Ansel Adams (1902–1984), who became a recognized leader of modern photography through his sharp, poetic landscape photographs of the American West—for example, his photograph *Moon and Half Dome* (Fig. 2.16). A well-known technician and pioneer in the movement to preserve the wilderness, he did much to elevate photography to the level of art. His work emphasized sharp focus and subtle variety in light and texture, with rich detail and brilliant tonal differences. In 1941, he began making photomurals for the United States Department of the Interior, a project that forced him to master techniques for photographing the light and space of immense landscapes. He developed what he called the zone system, a means for determining the final tone of each part of the landscape.

That tradition and aesthetic continue today. Using an 1898 field camera and shooting only one image of each location, Thomas Joshua Cooper, a member of the Cherokee nation, composes his images, such as *The Mid North Atlantic Ocean* (Fig. 2.17), so that the scale of the composition does not appear immediately apparent. The printing of the pieces further enhances the intensely emotive nature of his work. Renowned for his technical mastery of the photographic medium, Cooper uses subtly "underpainted" images with selenium and gold, resulting in blue and maroon tones in the photographic printing process. His painterly process

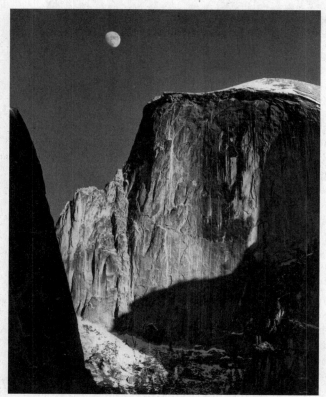

FIGURE 2.16 *Ansel Adams,* Moon and Half Dome, *Yosemite National Park, California (1960).*
Source: © The Ansel Adams Publishing Rights Trust.

FIGURE 2.17 *Thomas Joshua Cooper,* The Mid North Atlantic Ocean, Punta del la Calera; This Isle of La Gomera (The West-most Point of the Island)*, 2002. The Canary Islands, Spain. (*very probable the last Old World Land site seen by Columbus and crew on their first trans Atlantic voyage out in search of the New World) 2002.
Source: Copyright and Photography: Thomas Joshua Cooper. Courtesy of Sean Kelly Gallery, New York.

ensures the uniqueness of each individual print. Cooper presents an image that comforts the viewer, in this case composing the picture with a stable triangle at the base of the image that counters the roiling sea.

We might think of art photography as something fairly lifelike in its presentations, and in the examples just seen, it appears just so. Photography however, can also present the abstract—even the nonobjective—and in the *photograms* of Man Ray (1890–1976), we see the process not of taking pictures, but of making them. In a photogram, the artist places objects directly onto photographic paper and exposes them to light. Although not the first to make photograms, Man Ray has come to represent the process through

his "Rayographs." In Figure 2.18, he creates an image by placing a piece of string, a pin, a magnifying glass, and a gyroscope on a photographic plate, pushing them around, and then exposing them. The resulting image reveals a spontaneous and witty side to the artist and to the styles of Dada and surrealism, which the work also represents.

Postmodern (see Glossary) photography sought to replace painting as a relevant revealer of the world as we experience it. Postmodern photographers believe that photographs can better capture the immediacy of a lifelike image than can paintings. Robert Kawka's *Portrait of a Shell Magnified by Magnifying Glass* (Fig. 2.19) takes recognizable but dissimilar images and juxtaposes

FIGURE 2.18 *Man Ray (1890–1976). Rayograph (gyroscope, magnifying glass, pin). Paris, 1922. Gelatin silver print (photogram), $9^3/_8'' \times 6^{15}/_{16}''$.*
Source: Gift of James Thrall Soby (112.1941). The Museum of Modern Art/Licensed by Scala—Art Resource, NY. © ARS, NY.

them to create a tantalizing display of composition, texture, line, value, and color that piques our curiosity and appears to suggest that familiar objects merit closer examination to reveal new and fascinating contexts and aspects.

James Casebere (case-beer; b. 1953) builds tabletop models and photographs them. For Figure 2.20 he researched the Ottoman architecture of Sinan (1489–1588),

the greatest architect of the time. Casebere then constructed a complex model that he then photographed. His construction pares the architecture down to essential forms and sheds extraneous detail. Casebere wants his artworks viewed as models, but the photographs distort the model—both its reality and its unreality. The photographs deceive our eyes, but they do more than that. They also present us with a strong sense of social

FIGURE 2.19 *Robert Kwaka,* Portrait of a Shell Magnified by Magnifying Glass, 2006.
Source: Digital Photograph © Robert Kawka.

history and a focus on institutional spaces. Further, they show relationships between social control and social structure, delving into sophisticated levels of interpretation.

Documentary Photography

Since the late nineteenth century, photographers have used photography to document social problems. During the Great Depression, a large-scale program in documentary photography began in the United States. Among the photographers using this approach, Dorothea Lange (1895–1965) helped develop an unsurpassed portrait of the nation. Noted for her ability to make strangers seem like familiar acquaintances, her work for the Farm Security Administration, including *Migrant Mother, Nipomo, California* (Fig. 2.21), graphically detailed the erosion of the land and the people of rural America during the Great Depression. Her work brought the plight of the poor to national attention. Her photographs of California's migrant workers, captioned with their own words, were so effective that the state established migrant worker camps to alleviate the suffering. In this photograph, Florence Thompson, a thirty-two-year-old widow with several children, looks past the viewer with a preoccupied, worried

FIGURE 2.20 *James Casebere, Mosque (After Sinan) #2, 2006, digital chromogenic print mounted to Plexiglas, Ill. 75 × 142 inches, Edition of 3; 72 × 91.75 inches.* Source: © James Casebere. Courtesy of the artist and Sean Kelly Gallery, New York.

expression. With her furrowed brow and prematurely aged face, she captures the fears of an entire population of disenfranchised people. Two of her children lean on her for support, their faces buried disconsolately in their mother's shoulders. Lange consciously avoided including all of Thompson's children in the photograph because she did not wish to contribute to the widespread resentment among wealthier people in American regarding overpopulation among the poor. Visit Dorothea Lange's works at ·http://www.artcyclopedia. com/artists/lange_dorothea.html.

Photographic Techniques

The word *camera* means "room" in Latin; in the sixteenth century, artists used a darkened room, called a *camera obscura*, to copy nature accurately. Remarkably, the camera obscura utilized the same device used by today's cameras. Specifically, a small hole on one side of the light-free room admitted a ray of light that projected the scene outside onto a semitransparent scrim cloth. The camera obscura illustrated in Figure 2.22 actually has holes in two walls. The early camera obscuras were also portable, which allowed artists to set them up to project any subject matter. Of course, the camera obscura could not preserve the image it projected, and photography could not emerge until someone solved that technological problem.

The technology of photography began in England in 1839 with the invention of William Henry Fox Talbot, who achieved a process for fixing negative images on a paper coated with light-sensitive chemicals. His process, called a *photogenic drawing*, appeared at about the same time as two French inventors, Louis Jacques Mandé Daguerre (dah-GHAIR) and Joseph Nicéphore Niépce (nee-APE-suh), produced a process in which a positive image could be affixed to a metal plate. Niépce died in 1833, and Daguerre perfected the process, which now bears his name: *daguerreotype* (dah-GHAIR-oh-type).

Unfortunately, the image on the daguerreotype could not be reproduced, whereas the photogenic image, on paper,

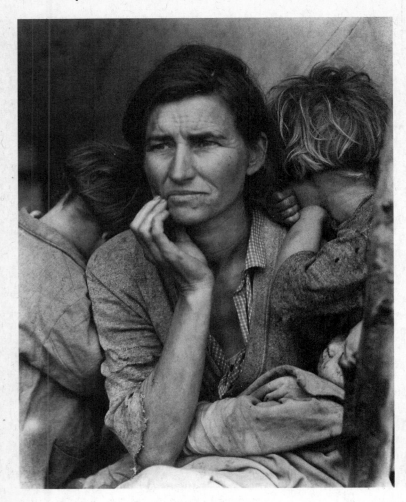

FIGURE 2.21 *Dorothea Lange,* Migrant Mother, Nipomo, California *(1936).*
Source: Courtesy of the Library of Congress, Washington, D.C./ CORBIS.

could. Fox Talbot realized that the negative image of the photogenic drawing could be reversed by covering it with sensitized paper and exposing the two papers to sunlight. Then the latent image on the second paper was developed by dipping the paper in gallic acid, a process called *calotype.*

The early technical developments of Fox Talbot were followed in 1850 by another Englishman, Frederick Archer, who, in a darkened room, poured a viscous chemical solution, liquid collodion, over a glass plate bathed in silver nitrate. Although the process required preparing, exposing, and developing the plate within a span of fifteen minutes, the results were universally accepted within the next five years, and the wet-plate *collodion* photographic process became standard.

In the 1950s and 60s, a new technology, color photography emerged. The availability and inexpensive nature of color processing made color photography very popular. The

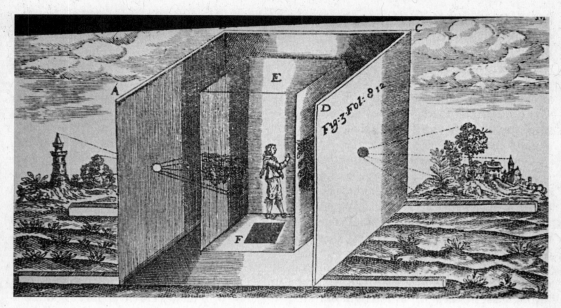

FIGURE 2.22 *Camera obscura. Engraving.*
Source: © Bettmann/CORBIS.

invention of the Polaroid camera only enhanced the situation. By the early years of the twenty-first century, however, another new technology, digital, has for the most part rendered film obsolete and changed photography into a tremendously plastic (shapeable) medium. With digital technology, photographers can "print" images in excess of 15 feet wide (5m) and create and control their images to a degree heretofore impossible.

COMPOSITION

In this section, we move to the study of some technical elements of which works of art are *composed*. These characteristics may be found in all works of visual art and architecture, and they constitute the building blocks that artists manipulate. In this inclusive concept called "composition," we will examine five "elements": (1) line; (2) form; (3) color; (4) mass; and (5) texture—and four "principles": (1) repetition; (2) balance; (3) unity; and (4) focal area.

Elements

Line

The basic building block of a visual design is line. To most of us, a line is a thin mark: _____. In two-dimensional art, line is defined by its three physical characteristics: (1) a linear form in which length dominates over width, (2) a color edge, and (3) an implication of continued direction. Line as a linear form in which length dominates over width can be seen in several places in *Girl Before a Mirror* (Plate 4) by Pablo Picasso—for example, in defining the diamond shapes in the background, along the back of the girl's head, and down her

back. In *Composition* (Plate 2) by Joan Miró (hoh-ahn mee-ROH), the figures defined by the thin outlines also represent this characteristic. Second, as an edge, line defines the place where one object or plane stops and another begins. Again in Plate 2, the edges where the white, black, and red color areas stop and the gray and gold backgrounds begin constitute lines.

The third characteristic, implication, appears in Figure 2.23. The three rectangles create a horizontal line that extends across the design. No physical line connects the tops of the forms, but their spatial arrangement creates one by implication. A similar use of line occurs in van Gogh's *The Starry Night* (Fig. 2.4), where we can see a definite linear movement from the upper left border through a series of swirls to the right border. Although composed not of a form edge or outline but of a carefully developed relationship of numerous color areas, the implied line emerges quite clearly. This characteristic of line also appears in Jackson Pollock's *One (Number 31, 1950)* (Fig. 2.24), although in a much more subtle and sophisticated way.

Artists use line to control our vision, to create unity and emotional value, and ultimately to develop meaning. In pursuing

those ends, and by employing the three aforementioned characteristics, artists find that line has one of two simple characteristics: curvedness or straightness. Whether expressed as a length-dominant, linear form, a color edge, or by implication, and whether simple or in combination, a line comprises a derivative of straightness or curvedness.

Some people speculate whether line can also be thick or thin. Certainly that quality helps to describe some works of art. Those who deny that quality, however, have a point difficult to refute in asking. If line can be thick or thin, at what point does it cease to be a line and become a form?

Form

Form relates closely to line in both definition and effect. Form comprises the *shape* of an object within the composition, and *shape* often is used as a synonym for form. Literally, form defines space described by line. A building is a form. So is a tree. We perceive them as buildings or trees, and we also perceive their individual details because of the line that composes them; form cannot be separated from line in two-dimensional design.

Color

Color constitutes an additional and very important aspect of the composition of an art work. We can approach color in many ways. We could begin with color as electromagnetic energy; we could discuss the psychology of color perception; and/or we could approach color in terms of how artists use it. The first two provide extremely interesting possibilities, and the physics and psychology of color provide many potential crossovers between art and science and life. Nonetheless, we will limit our discussion to

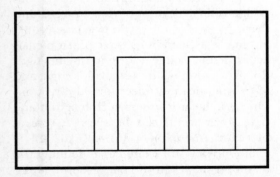

FIGURE 2.23 *Outline and implied line.*

A Question of Style

Abstract Expressionism

abstract expressionism (ab-STRAKT-ehk-SPREH-shuhn-ihz-uhm). A mid-twentieth-century visual art movement characterized by nontraditional brushwork, nonrepresentational subject matter, and expressionist emotional values. The style originated in New York, and it spread rapidly throughout the world on the wings of modern mass communication. Its characteristics, as just noted, freed the artist to reflect inner life and led to the creation of works with high emotional intensity. Absolute individuality of expression and the freedom to pursue irrationality underlie this style. Jackson Pollock (PAH-luhk; 1912–1956; Fig. 2.24) came upon his characteristic approach to painting only ten years before his death. Although he insisted that he had absolute control, his compositions consist of what appear to be simple dripping and spilling of paint onto huge canvases, which he placed on the floor in order to work on them. His work, often called "action painting," conveys a sense of tremendous energy. The viewer seems to feel the painter's motions as he applied the paint.

FIGURE 2.24 *Jackson Pollock, (1219-1956).*One (Number 31, 1950) *1950. Oil and enamel on unprimed canvas, 8'10" × 17'5⁵⁄₈" (269.5 × 530.8 cm).*

Source: Sidney and Harriet Janis Collection Fund (by exchange). (7.1968) Digital Image © The Museum of Modern Art/ Licensed by Scala—Art Resource, NY. © 2004 Pollock-Krasner Foundation/Artists Rights Society (ARS), New York.

A Question to Ask

In what ways does the artist utilize line in this work?

the last of these—use. The discussion that follows focuses on three color components; hue, value, and intensity.

Hue. Hue is a specific color with a measurable wavelength. The visible range of the color spectrum or range of colors we can actually distinguish extends from violet on one end to red on the other (Fig. 2.25). The traditional color spectrum consists of seven basic hues (red, orange, yellow, green, blue, indigo, and violet). These are *primary* hues (red, blue, and yellow) and *secondary* hues that are direct derivatives of the primaries. In all (depending on which theory one follows) from ten to twenty-four perceivably different hues exist, including these seven.

Assuming, for the sake of clarity and illustration, twelve basic hues, we can arrange them in a series (Fig. 2.26) or turn them into a "color wheel" (Fig. 2.27, Plate 3). With this visualization, artists' choices with regard to color become clearer. First,

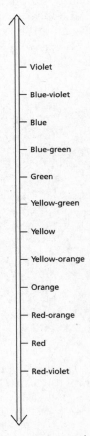

FIGURE 2.26 *Color spectrum of the twelve basic hues.*

FIGURE 2.25 *Basic color spectrum.*

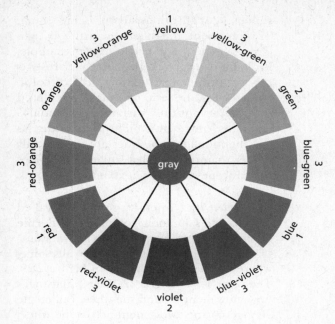

FIGURE 2.27 *Color wheel. (See also color insert Plate 3.) 1-primary hues; 2-secondary hues; 3-tertiery hues.*

an artist can mix the primary hues of the spectrum two at a time in varying proportions, which creates the other hues of the spectrum. For example, red and yellow in equal proportions make orange, a *secondary* hue. Varying the proportions—adding more red or more yellow—makes yellow-orange or red-orange, which are *tertiary* (TUHR-shee-air-ee) hues. Yellow and blue make green, and also blue-green and yellow-green. Red and blue make violet, blue-violet, and red-violet. Hues directly opposite each other on the color wheel constitute complementary colors. When mixed together in equal proportions, they produce gray.

Value. Value, sometimes called key, is the relationship of blacks to whites and grays. The range of possibilities from black to white forms the value scale (Fig. 2.28), which has black at one end, white at the other, and medium gray in the middle. The perceivable tones between black and white are designated light or dark: The lighter, or whiter, a color, the higher its value. Likewise, the darker a color, the lower its value. For example, light pink has high value while dark red has low value, even though they both have as their base the same primary red. Adding white to a hue (like primary red) creates a tint of that hue. Adding black creates a shade.

Some hues appear intrinsically brighter than others, a factor we will discuss momentarily, but the possibility of a brightness difference in the same color also exists. The brightness may involve a change in value, as just discussed—that is, a pink versus a grayed or dull red. Brightness may also involve surface reflectance, a factor of considerable importance to all visual artists. A highly reflective surface creates a brighter color (and therefore a different response from the viewer) than does a surface of lesser

White

High light

Light

Medium light

Medium (gray)

High dark

Dark

Low Dark

Black

FIGURE 2.28 *Value scale.*

reflectance, all other factors being equal. This represents the difference between high-gloss, semigloss, and flat paints, for example. Probably surface reflectance represents more a property of texture than of color. Nonetheless, the term *brilliance* is often used to describe not only surface gloss but also characteristics synonymous with value. As just mentioned, some hues are intrinsically darker than others. That situation describes the concept we discuss next: intensity.

Intensity. Intensity, sometimes called chroma and saturation, comprises the degree of purity of a hue. Every hue has its own value; that is, in its pure state, each hue falls somewhere on the value scale, as in Figure 2.29. The color wheel (Fig. 2.27, Plate 3) illustrates how movement around the wheel can create change in hue. Movement across the wheel also alters intensity, for example, by adding green to red. When, as in this case, hues reside directly opposite each other on the color wheel, mixing them grays the original hue. Therefore, because graying a hue constitutes a value change, the terms *intensity* and *value* are occasionally used interchangeably. Some sources use the terms independently but state that changing a hue's value automatically changes its intensity. Graying a hue by using its complement differs from graying a hue by adding black (or gray derived from black and white). Gray derived from complementaries, because it has hue, creates a far livelier color than a gray derived from black and white, which does not have hue. The composite, or overall, use of color by an artist

A Question to Ask

Has the artist used a broad or limited palette? How has that affected the composition of the work and my response?

W

HL Yellow

Yellow-green L Yellow-orange

Green ML Orange

Blue-green M Red-orange

Blue MD Red

Blue-violet D Red-violet

Violet LD

B

FIGURE 2.29 *Color-value equivalents.*

constitutes *palette.* An artist's palette can be broad, restricted, or somewhere in between, depending on whether the artist has utilized the full range of the color spectrum and/or whether he or she explores the full range of *tonalities*—brights and dulls, lights and darks.

Mass (space)

Only three-dimensional objects have mass, that is, take up space and have density. However, two-dimensional objects give the illusion of mass, *relative* only to the other objects in the picture.

Texture

The texture of a picture is its apparent roughness or smoothness. Texture ranges from the smoothness of a glossy photo to the three-dimensionality of *impasto,* a painting technique with pigment applied thickly with a palette knife to raise areas from the canvas. The texture of a picture resides

anywhere within these two extremes. Texture may be illusory in that the surface of a picture may be absolutely flat but the image gives the impression of three-dimensionality. So we can apply the term to the pictorial arts either literally or figuratively.

Principles

Repetition

Probably the essence of any design is repetition: how the basic elements in the picture repeat or alternate. In discussing repetition, let's consider three terms: *rhythm*, *harmony*, and *variation*.

Rhythm. Rhythm is the ordered recurrence of elements in a composition. Recurrence may be regular or irregular. If the work employs equally related elements, we describe its rhythm as regular (Fig. 2.23). If not, the rhythm is irregular. However, we must examine the composition as a whole to discern if patterns of relationships exist and whether or not the *patterns* are regular, as they are in Figure 2.30.

Harmony. Harmony is the logic of the repetition. Harmonious relationships employ components that appear to join naturally and

comfortably as in Figure 2.1. If an artist employs forms, colors, or other elements that appear incongruous, illogical, or out of sync, then we would use a musical term and say the resulting picture has dissonance; its constituents simply do not go together in the way our cultural conditioning would describe as natural. We do need to understand here, nevertheless, that ideas and ideals relative to harmonious relationships in color or other elements often reflect cultural conditioning or arbitrary understandings (conventions).

Variation. Variation is the relationship of repeated items to each other, like theme and variation in music. How does an artist take a basic element in the composition and use it again with slight or major changes? In color insert Plate 4, Pablo Picasso has taken two geometric forms, the diamond and the oval, and created a complex painting via repetition. The diamond with a circle at its center repeats over and over to form the background. Variation occurs in the color given to these shapes. Similarly, the oval of the mirror repeats with variations in the composition of the girl. The circular motif also repeats throughout the painting, with variations in color and size—similar to the repetition and variation in the design of the Volkswagen noted in Figure 1.1.

Balance

The concept of balance employs certain innate judgments. Looking at a composition, we almost intuitively understand if it does or does not appear balanced. Most individuals have this sense. Determining *how* artists achieve balance in their pictures forms an important aspect of our own response to pictures.

FIGURE 2.30 *Repetition of patterns.*

Symmetry. The most mechanical method of achieving balance employs *symmetry*, or specifically bilateral symmetry, the balancing of like forms, mass, and colors on opposite sides of the vertical axis of a picture. Symmetry has measurable precision. Pictures employing absolute symmetry tend to be stable, stolid, and without much sense of motion. Many works approach symmetry, but retreat from placing mirror images on opposite sides of the centerline, as do Figures 2.23, 2.31, and 2.32, all of which are symmetrical.

FIGURE 2.31 *Closed composition (composition kept within the frame).*

FIGURE 2.32 *Open composition (composition allowed to escape the frame).*

Asymmetry. *Asymmetrical balance,* sometimes referred to as psychological balance, results from careful placement of unlike items (Fig. 2.33). Every painting illustrated in this chapter uses asymmetry. Often color balances line and form. Because some hues, such as yellow, have great eye attraction, they can balance tremendous mass and activity on one side of a painting, by being placed on the other side.

Unity

With a few exceptions, we can say that artists strive for a sense of self-contained completeness in their artworks. Thus, an important characteristic in a work of art constitutes the means by which *unity* is achieved. All the elements of composition work together toward meaning. Often artists juxtapose compositional elements in unusual or uncustomary fashion to achieve a particular effect. Nonetheless, that effect usually comprises a conscious attempt at maintaining or completing a unified statement, that is, a total picture. Critical analysis of the elements of a painting should lead us to a judgment about whether the total statement comprises a unified one.

With regard to unity, we also must consider whether or not the artist allows the composition to *escape the frame.* People occasionally speak of *closed composition,* or composition in which use of line and form always directs the eye into the painting (Fig. 2.31), as unified, and *open composition,* in which the eye is led or allowed to wander off the canvas, or *escape the frame* (Fig. 2.32), as disunified. Such is not the case. Keeping the artwork within the frame is a stylistic device that has an important bearing on the artwork's meaning. For example, painting in the classical style stays within the frame. This illustrates a concern for the self-containment of the artwork and for precise structuring. Anticlassical design, in contrast,

profile

Beverly Buchanan

Contemporary Voice

Beverly Buchanan's (b. 1940) work explores the medium of pastel oilsticks, and central to her work are the makeshift shacks that dot the Southern landscape near her home in Athens, Georgia. "Beginning in the early 1980s, Buchanan started photographing these shacks, an enterprise she has carried on ever since. 'At some point,' she says, 'I had to realize that for me the structure was related to the people who built it. I would look at shacks, and the ones that attracted me always had something a little different or odd about them. This evolved into my having to deal with [the fact that] I'm making portraits of a family or person.'

"Buchanan soon began to make drawings and sculptural models of the shacks. Each of these models tells a story . . . for instance . . .

> Some of Richard's friends had already moved north, to freedom, when he got on the bus to New York. Richard had been 'free' for fifteen years and homeless now for seven. . . . After eight years as a foreman, he was 'let go.' He never imagined it would be so hard and cruel to look for something else. Selling his blood barely fed him. At night, dreams took him back to a childhood of good food, hard work, and his Grandmother's yard of flowers and pinestraw and wood. Late one night, his cardboard house collapsed during a heaving rain. Looking down at a soggy heap, he heard a voice, like thunder, roar this message through his brains, RICHARD GO HOME!

"Buchanan's sculpture does not represent the collapsed cardboard house in the North, but Richard's new home in the South. It is not just a ramshackle symbol of poverty. Rather, in its improvisational design, in its builder's determination to use whatever materials are available, to make something of nothing, as it were, the shack is a testament to the energy and spirit of its creator. More than just testifying to Richard's will to survive, his shack underscores his creative and aesthetic genius.

"Buchanan's oilstick drawings such as *Monroe County House with Yellow Datura* (Fig. 2.34) are embodiments of this same energy and spirit. In their use of expressive line and color, they are almost abstract, especially in the fields of color that surround the shacks. Their distinctive scribble-like marks are based on the handwriting of Walter Buchanan, Beverly Buchanan's great-uncle and the man who raised her. Late in his life he suffered a series of strokes, and before he died he started writing letters to family members that he considered very important. 'Some of the words were legible,' Buchanan explains, 'and some were in this kind of script that I later tried to imitate. . . . What I thought about in his scribbling was an interior image. It took me a long time to absorb that. . . . And I can also see the relation of his markings to sea grasses, the tall grasses, the marsh grasses that I paint.' The pastel oilstick is the perfect tool for this line, the seemingly untutored rawness of its application mirroring the haphazard construction of the shacks. And it results in images of great beauty, as beautiful as the shacks themselves."

Henry M. Sayre, *A World of Art*, 2nd edition (Upper Saddle River, NJ: Prentice Hall, Inc., 1997), pp. 184–185.

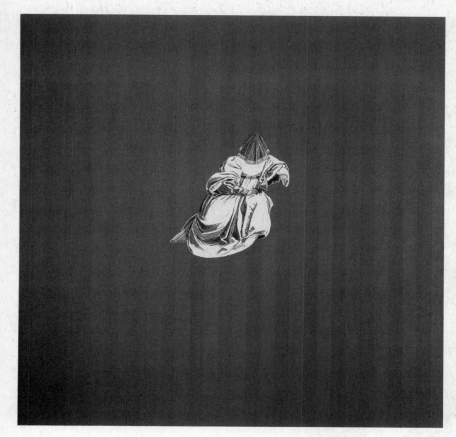

FIGURE 2.33 *Julie Roberts, "Catholic/ The Protane and Sacred Love", 1996. Oil and acrylic on canvas, unframed dimensions: 60 x 60" 5 ft × 5 ft (1.5 m × 1.5 m). Source:* Sean Kelly Gallery, New York.

often forces the eye to escape the frame, suggesting perhaps a universe outside or the individual's place within an overwhelming cosmos. So unity can be achieved by keeping the composition closed, but it is not necessarily lacking when the opposite state exists.

Focal Area

When we look at a picture for the first time, our eye moves around it, pausing briefly at those areas that seem of greatest visual appeal. These are *focal areas.* A painting may have a single focal area, which draws our eye immediately and from which it will stray only with conscious effort. Or it may have an infinite number of focal points. We describe a picture of the latter type as "busy": the eye bounces at will from one point to another on the picture, without much attraction at all.

Artists achieve focal areas in a number of ways—through confluence of line, by encirclement (Fig. 2.35) or by color, to name just a few. To draw attention to a particular point in the picture the artist may make all lines lead to that point. He or she may place the focal object or area in the center of a ring of objects, or may give the object a color that demands our attention

FIGURE 2.34 *Beverly Buchanan,* Monroe County House with Yellow Datura, *1994. Oil pastel on paper, 60" × 79".*

Source: Photo by Adam Reich. Collection of Bernice and Harold Steinbaum. Courtesy of Bernice Steinbaum Gallery, Miami, Florida.

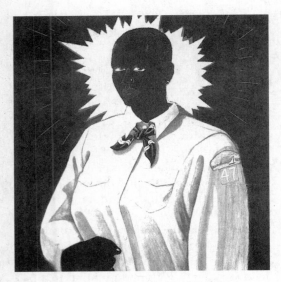

FIGURE 2.35 *Kerry James Marshall,* Den Mother, *1996. Acrylic on paper mounted on wood, 41 × 40 ins (104.1 × 101.5 cm).*

Source: Collection of General Mills Corporation, Minneapolis, Minnesota. The Jack Shainman Gallery, New York.

more than the other colors in the picture. Again, for example, bright yellows attract our eye more readily than dark blues. Artists use focal areas, of whatever number or variety, as controls over what we see and when we see it when we look at a picture.

OTHER FACTORS

Perspective

Artists use perspective as a tool to indicate spatial relationships of objects in a picture. Based on the perceptual phenomenon that causes objects farther away from us to appear smaller, perspective indicates the spatial relationship between the objects in the foreground and objects in the background. We also can discern the rationality of the relationship—that is, whether or not the relationships of the objects appear as we see them in life. For example, paintings executed prior to the Italian Renaissance (when mechanical procedures for rendering perspective were

developed) look rather strange because although background objects appear smaller than foreground objects, the positioning does not appear rational. So their composition strikes us as being rather primitive. There are a number of types of perspective (see Glossary) that artists use to create the sense of "deep space"—that is, the illusion of depth in a work. We will illustrate three. These are linear, atmospheric, and shifting perspective.

Linear Perspective

Linear perspective employs the phenomenon we perceive when standing on railroad tracks and watching the two rails apparently come together at the horizon (see Figure 2.36). It uses *line* to achieve the sense of distance. In Corot's landscape (Fig. 1.7), the road recedes from foreground to background and becomes narrower as it does

so. We perceive that recession, which denotes distance, through the artist's use of line.

Atmospheric Perspective

Atmospheric perspective indicates distance through the use of light and atmosphere. For example, mountains in the background of a picture appear distant by being painted in less detail; they are hazy. In the upper left of Plate 1 a castle appears at a great distance. We know so because of its smallness and, more importantly, its haziness.

Shifting Perspective

Shifting perspective appears especially in Chinese landscapes and results from additional factors of culture and convention. The painting *Buddhist Retreat by Stream and Mountains*, attributed to the Chinese artist

FIGURE 2.36 *Linear perspective.*

Juran (zhoo-RAHN; Fig. 2.37), divides the picture into two basic units—foreground and background. The foreground of the painting consists of details reaching back toward the middle ground. At that point a division occurs, so that the background and the foreground stay separate because of an openness in what might have been a deep middle ground. The foreground represents the nearby, and its rich detail causes us to pause and ponder on numerous elements, including the artist's use of brushstroke in creating foliage, rocks, and water. Then, a break appears, and the background looms up, suspended—almost as if a separate entity. Although the foreground gives us a sense of dimension—of space receding from the front plane of the painting—the background appears flat, a factor that serves to enhance further the sense of height in the mountains. The apparent shift in perspective, however, results from the concept that truth to natural appearance should not occur at the expense of a pictorial examination of how nature works. The painting invites the viewer to enter its spaces and examine them, but not to take a panoramic view from a single position. Rather, the artist reveals each part as though the viewer were walking through the landscape. Shifting perspective allows for a personal journey and for a strong personal, spiritual impact.

Content Arguably, all works of art pursue verisimilitude (vair-ih-sih-MIHL-ih-tood), and they do so with a variety of treatments of content. We can regard treatment of content as ranging from naturalism to stylization. Included are such concepts as abstract, representational, and nonobjective (see Glossary). The word *versimilitude* comes from the Latin, *verisimilitudo*, and it means plausibility. Aristotle, in his *Poetics*, insisted that art should reflect nature—for example,

FIGURE 2.37 Buddhist Retreat by Stream and Mountains. *Hanging scroll, ink on silk, height 185.4 cm. Attributed to Juran, Chinese, active* c. A.D., *960–80, northern Song dynasty.*
Source: © The Cleveland Museum of Art. Gift of Katherine Holden Thayer, 1959.348.

even highly idealized representations should possess recognizable qualities and that what is probable should take precedence over what is merely possible. This has come to mean in art that the search for a portrayal of truth can sometimes mean a distortion of what we observe around us in favor of an image that, while perhaps not lifelike, better speaks to the underlying truth of human existence than mere lifelikeness does. So, the verisimilar, whether lifelike or not, constitutes the acceptable or convincing according to the respondent's own experience or knowledge. In some cases, this means enticing the respondent into suspending disbelief and accepting improbability within the framework of the work of art.

Chiaroscuro

Chiaroscuro (sometimes called *modeling*, in Italian "light and shade") is the device used by artists to make their forms appear *plastic* or three dimensional. The problem of making two-dimensional objects appear three dimensional rests heavily on an artist's ability to render highlight and shadow effectively. Without them all forms are two dimensional in appearance.

Use of chiaroscuro gives a picture much of its character. For example, the dynamic and dramatic treatment of light and shade in color insert Plate 6 gives this painting a quality quite different from what would have resulted had the artist chosen to give full, flat, front light to the face. The highlights, falling as they do, create not only a dramatic effect but also a compositional triangle extending from shoulder to cheek, down to the hand, and then across the sleeve and back to the shoulder. Consider the substantial change in character of Plate 1 had highlight and shadow been executed in a different manner. Finally, the treatment of chiaroscuro in a highly lifelike fashion in color insert Plate 15 helps give that painting its strangely real yet dreamlike appearance.

In contrast, works that do not employ chiaroscuro have a two-dimensional quality. This can be seen to a large extent in Figure 2.2 and also in Plate 4 and Figure 2.38.

FIGURE 2.38 *Pablo Picasso.* Guernica *(mural) 1937. Oil on canvas, 11′6″ × 25′8″.*
Source: Museo Nacional Centro de Arte Reina Sophia, Madrid. © 2004 Estate of Pablo Picasso/Artists Rights Society (ARS), New York.

HOW DOES IT STIMULATE THE SENSES?

We do not touch pictures, and so we cannot feel their roughness or their smoothness, their coolness or their warmth. We cannot hear pictures, and we cannot smell them. So, when we conclude that a picture affects our senses in a particular way, we are responding in terms of visual stimuli transposed into mental images of touch, taste, sound, and so forth.

CONTRASTS

We refer to the colors of an artist's palette as warm or cool depending on which end of the color spectrum they fall. Reds, oranges, and yellows comprise warm colors: the colors of the sun, which call to mind our primary source of heat. So they carry strong implications of warmth. Colors falling on the opposite end of the spectrum—blues and greens—are cool colors because they imply shade, or lack of light and warmth. As we will notice frequently, this constitutes a mental stimulation that has a physical basis. Tonality and color contrast also affect our senses. The stark value contrasts of Figure 2.38 contribute significantly to the harsh and dynamic qualities of the work. The colorlessness of this monochromatic black, white, and gray work completes its horrifying comment on the tragic bombing of the Spanish city of Guernica. In the opposite vein, the soft, yet dramatic, tonal contrasts of Plate 6 and the strong warmth and soft texture of the red hat bring us a completely different set of stimuli.

Many of the sense-affecting stimuli work in concert. We already have noted some of the effects of chiaroscuro, but one more will serve well. One of the most interesting effects to observe in a picture is the treatment of flesh. Some flesh appears cold and harsh like stone. Other flesh appears soft and true to life. We respond tactilely to whatever treatment has been given—we want to touch, or we believe we know what we would feel if we touched. Chiaroscuro affects essentially how an artist achieves those effects. Harsh shadows and strong contrasts create one set of responses; diffused shadows and subdued contrasts create another. Rubens's *The Assumption of the Virgin* (color insert Plate 16) presents us with softly modeled flesh whose warmth and softness come from color and chiaroscuro. Highlight and shadow function to create softness, and predominantly red hues warm the composition; our sensual response is heightened dramatically.

DYNAMICS

Although pictures do not contain motion, they can effectively stimulate a sense of movement and activity. They also can create a sense of stable solidity. An artist stimulates these sensations by using certain conventional devices. Principally vertical composition can express, for example, a sense of dignity and grandeur (See color insert Plate 17 and Figure 2.39). A horizontal picture can elicit a

A Question to Ask

What degree of chiaroscuro or three-dimensionality has the artist used to create form, and what effect does that have on my response?

sense of stability and placidity (Fig. 2.40). The triangle constitutes a most interesting form in engineering because of its structural qualities. It has artistic interest because of its psychological qualities. If we place a triangle so its base forms the bottom of a picture, we create a definite sense of solidarity and immovability (Fig. 2.41). If that triangle were a pyramid

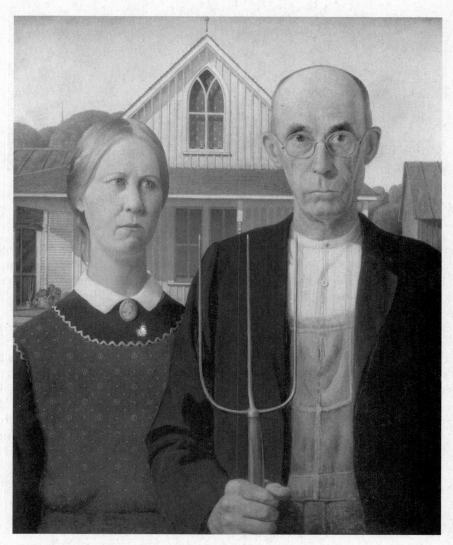

FIGURE 2.39 *Grant Wood, American (1891–1942), American Gothic (1930). Oil on beaver board, 30$^{11}/_{16}$ × 25$^{11}/_{16}$ in. (78 × 65.3 cm) unframed.*
Source: Friends of American Art Collection, 1930.934. Reproduction, The Art Institute of Chicago. Photography © The Art Institute of Chicago.

FIGURE 2.40 *Masaccio,* Tribute Money *(c. 1427). Santa Maria del Carmine, Florence.*
Source: Courtesy of Heaton-Sessions, Stone Ridge, New York. Scala/Art Resource.

sitting on a level plane, it would take a great deal of effort to tip it over. If we invert the triangle so it balances on its apex, a sensation of extreme instability results (Fig. 2.42). Although we can feel clearly the sensations stimulated by these rather simple geometric forms, we should not conclude that geometric forms used as compositional positional devices are either explicit or limited in communication. Nonverbal communication in

the arts is not that simple. Nonetheless, the basic compositional devices do influence our response and impact on our perceptions.

The use of line also affects sense response. Figure 2.43 illustrates how this use of curved line can elicit a sense of relaxation. The broken line in Figure 2.44, in contrast, creates a more dynamic and violent sensation. We can also feel that the upright triangle in Figure 2.41, although solid and stable, creates greater dynamic activity than the horizontals of Figure 2.40 because it uses stronger diagonal line, which tends to stimulate a sense of movement. Precision of linear execution also can create sharply defined forms or soft, fuzzy images.

TROMPE L'OEIL

Trompe l'oeil (trawmp LYUH), or "trick the eye," gives the artist a varied set of stimuli by which to affect our sensory response. It represents a form of illusionist painting that

FIGURE 2.41 *Upright-triangular composition.*

FIGURE 2.42 *Inverted-triangular composition.*

FIGURE 2.43 *Curved line.*

FIGURE 2.44 *Broken line.*

attempts to show an object as existing in three dimensions at the surface of a painting, accounting also for the point of view of the observer, for example, Masaccio's *Holy Trinity with the Virgin, Saint John the Evangelist, and Donors* (http://sunsite.cgfadk/masaccio/p-masacciol.htm).

JUXTAPOSITION

We can also receive sense stimuli from the results of juxtaposing curved and straight lines, which results in linear dissonance or consonance. Figure 2.45 illustrates the juxtaposing of inharmonious forms, which creates instability. Careful use of this device can stimulate some very interesting and specific sense responses, as the artist has done in Plate 4.

OBJECTIVITY

Content, which involves any or all of the characteristics we have discussed, gives an artist a powerful device for effecting both sensory responses and more intense, subjective responses. Lifelikeness or nonobjectivity can stimulate individual response. It would seem logical for individuals to respond intellectually to nonobjective pictures because the subject matter should be neutral, with no inherent expressive stimuli. However, the opposite tends to occur. When asked

FIGURE 2.45 *Juxtaposition.*

whether they feel more comfortable with the treatment of subject matter in Plate 1 or that in Figure 2.24, most individuals choose the former.

Does an explicit appeal cause a more profound response? Or does the stimulation provided by the unfamiliar cause us to think more deeply and respond more fully because our imagination is left free to wander? The answers to these questions are worth considering as we perceive artworks, many of whose keys to response are not immediately obvious.

Sample Outline and Critical Analysis

The following very brief example illustrates how we can use some of the terms explained in the chapter to form an outline and then develop a critical analysis of a work of art. Here is how that might work regarding Peter Paul Rubens's painting *The Assumption of the Virgin* (color insert Plate 16).

Outline	Critical Analysis
Subject matter and medium	Rubens's painting of the Assumption of the Virgin depicts a Christian religious event in which the Virgin Mary is taken directly to heaven without dying. The painting is done in oil painted on a wooden panel. This is a contrast to oil painting done on canvas. The artist's treatment of his subject matter reflects a high degree of lifelikeness. The people look like real people, flesh looks like real flesh, the fabrics drape like real fabrics, and the lighting that creates highlight and shadow appears to come from a single source and creates a sense of reality in the work.
Composition Line	The painting is composed so that it seems to have two distinct parts separated by a strong, implied line running on the diagonal from lower left to upper right. The line created by color edges, while shaded naturally, seems to predominate in strongly contrasted transitions from one color area to the next. In addition, the artist has created intense activity in the painting by using curved line that
Shape	makes shapes within shapes appear to swirl around. Therefore, the shapes in the painting all seem rounded.
Color	Rubens's use of color stays predominantly on the warm end of the spectrum, with flesh tones, reds, and golds in the majority and contrasting with whites. A few neutral grays and a very limited amount of cool hues make the figures stand out.
Focal areas	The primary focal point of the painting is the Virgin Mary in the top center of the composition. The eye is drawn to her mostly because of the use of encirclement and directional line. Her clothing is far richer and more detailed than the other figures, and that helps give her focus and stature.

Outline	Critical Analysis
Balance Deep space and perspective	Rubens uses asymmetrical balance, and although there is linear perspective in the steps, the painting seems to stay on the surface plane, with little concern for deep space.

Additional Study and Cyber Sources

PAINTING

Prehistory–c. 500 B.C.E.

Paleolithic and neolithic cave paintings: www.
culture.fr/culture/arcnat/lascaux/en
Ancient Greece Vase painting: www.
perseus.tufts.edu/cgi-bin/image?
lookup=1992.06.0078&type=vase

c. 500 B.C.E.–c. 1500 C.E.

Rome: Roman wall paintings—http://www.
metmuseum.org/collections/view1.asp?dep=
13&full=0&item=03%2E14%2E13a%2Dg
The Middle Ages (Cimabue, Giotto, Lorenzetti):
http://www.artcyclopedia.com/index.html
Italy (early Renaissance—Fra Angelico, Fra Lippo
Lippi, Botticelli, Ghirlandaio, Masaccio,
Mantegna, Perugino): www.artcyclopedia.
com/history/early-renaissance.html
Northern Renaissance (Schongauer, Dürer,
Baldung Grien): www.artcyclopedia.com/
history/northern-renaissance.html

c. 1480–c. 1700

High Renaissance (Leonardo da Vinci,
Michelangelo, Raphael, Bellini, Giorgione,
Titian): www.artcyclopedia.com/history/
high-renaissance.html
Mannerism (Bronzino, Parmigianino,
Tintoretto, Breughel the Elder): www.
artcyclopedia.com/history/mannerism.html
Baroque (Bomenichino, Caravaggio, Velásquez,
Rubens, Poussin, Rembrandt, van Ruysdael,
Vermeer): www.artcyclopedia.com/history/
baroque.html

c. 1700–c. 1905

Rococo (Watteau, Boucher, Chardin, Canaletto,
Fragonard, Gainsboro): www.artcyclopedia.
com/history/rococo.html
Neoclassicism (David, Ingres): www.artcyclopedia.
com/history/neoclassicism.html
Romanticism (Goya, Gros, Géricault, Delacroix,
Constable, Turner): www.artcyclopedia.
com/history/romanticism.html
Realism (Courbet, Manet, Daumier): www.
artcyclopedia.com/history/realism.html
Impressionism (Manet, Monet, Renoir, Degas):
www.artcyclopedia.com/history/
impressionism.html
Postimpressionism (Seurat, van Gogh, Cézanne,
Gauguin): www.artcyclopedia.com/history/
post-impressionism.html

c. 1900–

Fauvism (Matisse, Rouault). www.artcyclopedia.
com/history/fauvism.html
Expressionism (Beckman, Kandinsky, Klee):
www.artcyclopedia.com/history/
expressionism.html
Cubism (Picasso, Braque): www.artcyclopedia.
com/history/cubism.html
Futurism (Balla, Carrà): www.artcyclopedia.
com/history/futurism.html
Abstract Expressionism (de Kooning, Pollock,
Frankenthaler, Rothko): www.artcyclopedia.
com/history/abstract-expressionism.html
Dada (Arp, Duchamp): www.artcyclopedia.
com/history/dada.html
Surrealism (Dali, de Chirico): www.artcyclopedia.
com/history/surrealism.html

Precisionism (Demuth, Sheeler): www.
artcyclopedia.com/history/precisionism.
html

Pop Art (Lichtenstein, Indiana, Warhol): www.
artcyclopedia.com/history/pop.html

Op Art (Vasarely): www.artcyclopedia.com/
history/optical.html

Photorealism (Hanson, Close): www.
artcyclopedia.com/history/phtorealism.html

Minimalism (Kelly, Stella): www.artcyclopedia.
com/history/minimalism.html

PRINTMAKING

1700–1900

Ando Hiroshige: www.artcyclopedia.com/
artists/hiroshige_ando.html

Toulouse-Lautrec: www.artcyclopedia.com/
artists/toulouse-lautrec_henri_de.html

1900–

Peter Max: www.artcyclopedia.com/artists/
max_peter.html

Robert Longo: www.artcyclopedia.com/artists/
longo_robert.html

PHOTOGRAPHY

Alfred Stieglitz: www.artcyclopeida.com/
artists/stieglitz_alfred.html

Edward Steichen: www.artcyclopedia.com/
artists/steichen_edward_j.html

Edward Weston: www.artcyclopedia.com/
artists/weston_edward.html

Man Ray: www.artcyclopedia.com/artists/
man_ray.html

Dorothea Lange: www.artcyclopedia.com/
artists/lange_dorothea.html

Sculpture

Sculpture, in contrast to pictures, seems less personal and more public. In fact, we are likely to find works of sculpture mostly in public spaces. Outside city halls and in parks and corporate office buildings we find statues of local dignitaries and constructions of wood, stone, and metal that appear to represent nothing at all. We might even wonder why our tax dollars were spent to buy them. Today, as throughout history, sculpture (and other forms of art) often nurture public pride and controversy. Because of its permanence, sculpture often represents the only artifact of entire civilizations. In this chapter, we'll not only see how

artists make sculpture and how sculpture works, but also ideas of artists from ancient history, contemporary times, and many cultures.

WHAT IS IT?

Sculpture is a three-dimensional art. It may take the form of whatever it seeks to represent, from pure, or nonobjective form, to lifelike depiction of people or any other entity. Sometimes sculpture, because of its three-dimensionality, comes very close to reality in its depiction. Duane Hanson and

John DeAndrea, for example, use plastics to render the human form so realistically that the viewer must approach the artwork and examine it closely to determine its reality.

HOW IS IT PUT TOGETHER?

DIMENSIONALITY

Sculpture comprises *full round, relief,* or *linear*. Full round works stand free in full three-dimensionality (Fig. 3.1). A work that projects from a background constitutes *relief* sculpture (Fig. 3.2). A work utilizing narrow, elongated materials is called *linear* (Fig. 3.15). A sculptor's choice of full round, relief, or linearity as a mode of expression dictates to a large extent what he or she can and cannot do, both aesthetically and practically.

Full Round

Sculptural works that explore full three-dimensionality and intend viewing from any angle are called *full round*. Some subjects and styles pose certain constraints in this regard, however. Painters, printmakers, and photographers have virtually unlimited choice of subject matter and compositional arrangements. Full round sculptures dealing with such subjects as clouds, oceans, and panoramic landscapes pose problems for sculptors. In addition, because full round sculpture stands free and three dimensional, sculptors must concern themselves with the practicalities of engineering and gravity. For example, they cannot create a work with great mass at the top unless they can find a way (within the bounds of acceptable composition) to keep the statue from falling over. In numerous full round works, sculptors use small animals, branches, tree stumps, rocks, and other devices as additional support to give practical stability to a work.

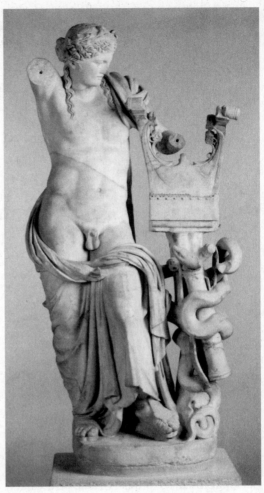

FIGURE 3.1 *Apollo playing the lyre (Roman copy of a Greek statue), from the Temple of Apollo at Cyrene (first century A.D.). Marble, over life size.*
Source: © The Trustee of the British Museum/Art Resource, NY.

Relief

Sculptors who create works in relief do not have quite so many restrictions because their work attaches to a background. Clouds, seas, and perspective landscapes lie

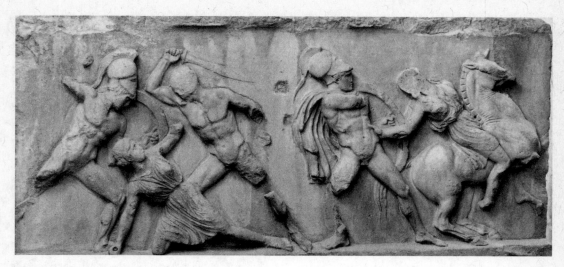

FIGURE 3.2 *East Frieze,* Halicarnassus.
Source: © The Trustees of the British Museum/Art Resource, NY.

within relief sculptors' reach because their work needs only to be viewed from one side. Relief sculpture, then, is three dimensional. However, because it protrudes from a background, it maintains a two-dimensional quality, as compared to full round sculpture. We call relief sculptures that project only a small distance from their base, such as the Halicarnassus frieze, *low relief* or *bas* (bah) *relief.* Sculptures such as those from Chartres Cathedral that project by at least half their depth go by the name *high relief* or *haut* (oh) *relief.*

Linear

The third category of sculpture, *linear sculpture*, emphasizes construction with thin, elongated items such as wire or neon tubing. Mobiles fall into this category (Fig. 3.15; http://www.nga.gov/cgi-bin/pinfo? Object=55433+O+none). Artworks using linear materials and occupying three-dimensional space will occasionally puzzle

us as we consider or try to decide whether they constitute linear or full round sculpture.

METHODS OF EXECUTION

In general, sculptors execute their work using subtractive, construction, substitute, or manipulative techniques, or any combination of these.

Subtraction

We call carved works *subtractive.* The sculptor begins with a large block, usually wood or stone, and cuts away (subtracts) the unwanted material. In previous eras, and to some extent today, sculptors have had to work with materials at hand. Wood carvings emanated from forested regions, soapstone carvings came from the Eskimos, and great works of marble came from the regions surrounding the quarries of the Mediterranean. Anything that can yield to the carver's tools can be formed into a work of sculpture.

However, stone, with its promise of immortality, has proven to be the most popular material.

Three types of rock hold potential for the carver. *Igneous* rock, for example, granite, a hard and potentially long-lasting stone, proves difficult to carve and therefore not popular. *Sedimentary* rock like limestone, a relatively long-lasting, easy-to-carve, polishable stone, yields beautifully smooth and lustrous surfaces. *Metamorphic* rock, including marble, provides the sculptor's ideal: long lasting, a pleasure to carve, and existing in a broad range of colors, for example *Venus of the Doves,* http://www.nga.gov/cgi-bin/pinfo?Object=41443+0+none. Whatever the artist's choice, one requirement must be met: The material to be carved, whether wood, stone, or a bar of soap, must be free of flaws.

A sculptor who sets about to carve a work does not begin simply by imagining a *Samson Slaying a Philistine* (Fig. 3.3) and then attacking the stone. He or she first creates a model, usually smaller than the intended sculpture. The model, made of clay, plaster, wax, or some other material, shows precise detail—a miniature of the final product.

Once the likeness of the model has been enlarged and transferred, the artist begins to rough out the actual image ("knocking away the waste material," as Michelangelo put it). In this step of the sculpting process, the artist carves to within 2 or 3 inches of what is to be the finished area, using specific tools designed for the purpose. Then, using a different set of carving tools, she carefully takes the material down to the precise detail. Finishing work and polishing follow.

Construction

In contrast with carving from a large block of material, the sculptor using construction starts with raw material and *adds* element to element until finishing work.

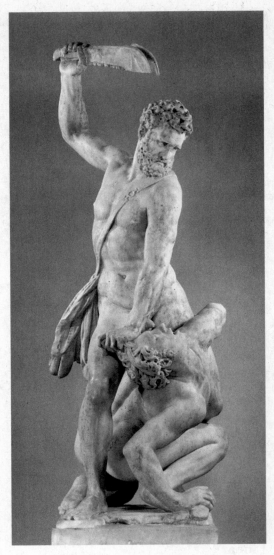

FIGURE 3.3 *Giambologna, Italian, (1529–1608).* Samson Slaying a Philistine, *1567.*
Source: Marble Courtesy of The Board of Trustees of the Victoria & Albert Museum. V&A Picture Library.

The term *built sculpture* often describes works executed with a construction method. The materials employed in this process can be plastics, metals such as aluminum or steel,

terracottas (clay), epoxy resins, or wood. Many times materials are combined (Fig. 3.4 and http://www.bluffton.edu/~sullivanm/ baltimore/smith1.jpg.). Sculptors also combine constructional methods as well. For example, built sections of metal or plastic may combine with carved sections of stone.

Substitution

Any material transformable from a plastic, molten, or fluid state into a solid state can be molded or *cast* into a work of sculpture. The creation of a piece of cast sculpture always involves the use of a mold.

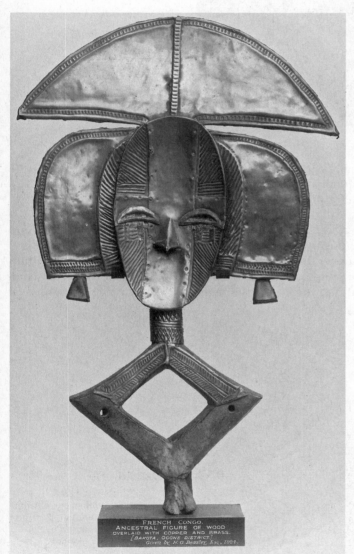

FIGURE 3.4 *Bakota ancestor figure from Gabon, late 19th century. French Congo. Ancestral figure of wood. Overlaid with copper and brass.*
Source: Given by H. G. Beasley, Esq., 1924. The Trustees of the British Museum/ Art Resource. NY

FIGURE 3.5 *Ronald James Bennett, (American, b. 1941). Landscape #3, 1969. Cast bronze, 8" high × 10" wide × 7" deep.*
Source: Palmer Museum of Art, The Pennsylvania State University. Gift of the Class of 1975 (76.60).

First, the artist creates an identically sized model of the intended sculpture (called a *positive*). He or she then covers the positive with a material, such as plaster of paris, that when hardened and removed will retain the surface configurations of the positive. This form, called a *negative*, becomes the mold for the actual sculpture. The sculptor pours the molten or fluid material into the negative and allows it to solidify. When he removes the mold, the work of sculpture emerges. Surface polishing, if desired, brings the work to its final form. Figures 3.5 and 3.6 show the degrees of complexity and variety achievable through casting.

The lost-wax technique, sometimes known by the French term *cire-perdue*, comprises a method of casting sculpture in

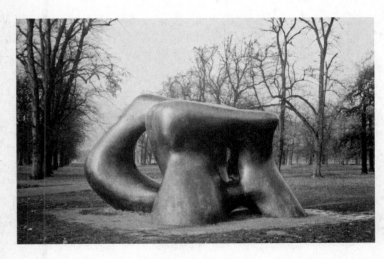

FIGURE 3.6 *Henry Moore, Two Large Forms (1969).*
Source: The Serpentine, Hyde Park, London. The work illustrated on this page has been reproduced by permission of the Henry Moore Foundation.

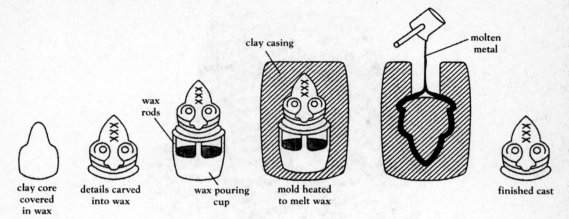

clay casing

molten metal

wax rods

clay core covered in wax

details carved into wax

wax pouring cup

mold heated to melt wax

finished cast

FIGURE 3.7 *Lost wax casting.*
Source: From Dennis J. Sporre, *The Creative Impulse*, 5th edition (Upper Saddle River, NJ: Prentice Hall, 2000), p. 23.

which the basic mold uses a wax model, which is then melted to leave the desired spaces in the mold. The technique probably began in Egypt, and by 200 B.C.E. the technique was used in China and ancient Mesopotamia (Fig. 3.7). The artist covers a heat-resistant "core" of clay—approximately the shape of the sculpture—with a layer of wax about the thickness of the final work. The sculptor carves the details in the wax, attaches rods and a pouring cup made of wax to the model, and then covers the model, rods, and cup with thick layers of clay. When the clay dries, the artist heats the mold to melt the wax. She then pours molten metals into the mold. When the molten metal dries and the clay mold is broken and removed, the sculpture cannot be duplicated.

Very often artists cast sculpture so it is hollow. This method, of course, is less expensive because it requires less material. It also results in a work less prone to crack since it is less susceptible to expansion and contraction resulting from changes in temperature. Finally, hollow sculpture is, naturally, lighter and thus more easily shipped and handled.

Manipulation

In this technique, also called modeling, artists shape materials such as clay by skilled use of the hands. We see the difference, between this technique and construction when we watch an artist take a single lump of clay and skillfully transform it, as it turns on a potter's wheel, into a final shape.

Pottery, the greatest of the prehistoric arts, continues today almost completely as an aesthetic activity. Early pottery vessels designed for everyday use sublimated technique to practical concerns—potters sacrificed time taken for exquisite finishing techniques to getting the object into use. Clay bowls such as those made by Lucy Lewis (Fig. 3.8) reflect the time-honored traditions of southwest Native American art, but they rise by the quality of finish and design to the status of high art, thus sustaining the culture.

FIGURE 3.8 *Lucy Lewis, ceramic bowl, from the Pueblo area, Acoma, New Mexico, 1969.*
Source: National Museum of the American Indian, Smithsonian Institution, Washington, D.C.

COMPOSITION

Composition in sculpture comprises the same elements and principles as composition in the pictorial arts: mass, line, form, balance, repetition, color, proportion, and unity. Sculptors' uses of these elements differ significantly, however, because they work in three dimensions.

Elements

Mass (Space)

Unlike a picture, a sculpture has literal mass. It takes up three-dimensional *space*, and its materials have *density*. Mass in pictures is *relative* mass: The mass of forms in a picture has application principally in *relation* to other forms within the same picture.

A Question to Ask

What method of execution has the artist used, and how does the method affect the appearance of the work?

In sculpture, however, mass consists of actual volume and density. So the mass of a sculpture 20 feet high, 8 feet wide, and 6 feet deep and made of balsa wood would seem less than a sculpture 10 feet high, 4 feet wide, and 3 feet deep and made of lead. Space and density must both be considered. Later in the chapter we'll discuss what happens when an artist disguises the material of a work to look and feel like a different material.

Line and Form

We can separate line and form (with some difficulty) when we discuss pictures because in two dimensions an artist uses line to define form. In painting, artists use line as a construction tool. Without using line, artists cannot reveal their forms, and when we analyze a painting, line arguably, becomes more important to us than the actual form it reveals. Notwithstanding, in sculpture the case nearly reverses. The form draws our interest, and when we discuss line in sculpture, we do so in terms of its revelation in form.

When we view a sculpture, its elements direct our eye from one point to another, just as focal points do, via line and color, in a picture. Some works direct the eye through the piece and then off into space. Such sculptures have an *open* form. Figure 3.12 directs the eye outward from the work in the same fashion as composition that escapes the frame in painting. If, however, the eye is directed continually back into the form, we call the form *closed*. If we allow our eye to follow the linear detail of Figure 3.9, we find we are continually led back into the work in the same fashion as composition kept within the frame in painting and closed forms in music, which we discuss in Chapter 5. Often we encounter difficulty fiting a work precisely into one or the other of these categories. For example, Figure 3.3 exhibits elements of closed composition

and, as indicated by the fabric flying to the left, open composition as well.

Obviously, not all sculptures are completely solid; they may have openings. We call any such holes in a sculpture *negative space*, and we can discuss this characteristic in terms of its role in the overall composition. In some works negative space is inconsequential; in others it is quite significant. It is up to us to decide which, and to determine how negative space contributes to the overall piece. In Figure 3.6 negative space plays a significant role. It might be argued that negative space is as instrumental to the overall concept of the work as is the metal form. In Figure 3.1, in contrast, negative space is clearly incidental.

Color

Perhaps color does not seem particularly important when we relate it to sculpture. We tend to see ancient sculpture as white and modern sculpture as natural wood or rusty iron. Nevertheless, color acts as importantly to the sculptor as to the painter. In some cases the material itself may be chosen because of its color; in others, the sculpture may be painted. The lifelike sculptures of Duane Hanson depend on color for their effect. They are so lifelike that we easily could confuse them with real people. Finally, still other materials may be chosen or treated so that nature will provide the final color through oxidation or weathering.

Texture

Texture, the roughness or smoothness of a surface, constitutes a tangible characteristic of sculpture. We can touch sculpture to perceive its texture. Even when we cannot touch a work of sculpture, we can perceive and respond to texture, which can be

profile

Michelangelo

Michelangelo (1475–1564), a sculptor, painter, and architect and perhaps the greatest artist in a time of greatness, lived during the Italian Renaissance, a period known for its creative activity, and his contemporaries included Leonardo da Vinci and Raphael. In art, the age's great achievement, Michelangelo led all others. Michelangelo had a remarkable ability to concentrate his thoughts and energy. Often while working, he would eat only a little bread, would sleep on the floor or on a cot beside his unfinished painting or statue, and continue to wear the same clothes until his work was finished.

His birthplace, Caprese, Italy, was a tiny village that belonged to the nearby city-state of Florence. He attended school in Florence, but his mind was on art, not on his studies. Even as a young child he was fascinated by painters and sculptors at work.

Without his father's knowledge or permission, Michelangelo went to work under Bertoldo, a talented sculptor working for Lorenzo di Medici (Lorenzo the Magnificent). One day Lorenzo himself saw the boy carving a marble faun's head. Lorenzo liked it so much that he took Michelangelo to live with him in his palace and treated the boy like a son.

Lorenzo died in 1492, and Florence changed almost overnight. Fra Girolao Savonarola, a Dominican monk, rose to power and held all the people under the spell of his sermons. Michelangelo feared Savonarola's influence and decided to leave Florence.

In 1496, Michelangelo lived in Rome for the first time. There he was commissioned to carve a Pietà (pee-ay-TAH), a marble group showing the Virgin Mary supporting the dead Christ on her knees. This superb sculpture, known as the *Madonna della Pietà*, won him wide fame. One of the few works signed by Michelangelo, it now stands in St. Peter's Basilica in Rome.

When he was 26, Michelangelo returned to Florence. He was given a nearly ruined 18-foot (5.5-meter) marble block that another sculptor had already started to carve. Michelangelo worked on it for more than two years. Out of its huge mass, and in spite of the difficulties caused by the first sculptor's work, he carved his youthful, courageous *David* (Fig. 3.9).

Between 1508 and 1512 Michelangelo painted the vaulted ceiling of the Sistine Chapel in Rome with hundreds of giant figures that made up his vision of the world's creation. Painting and sculpture, however, did not absorb all Michelangelo's genius. When Florence was in danger of attack, he superintended its fortification. He also wrote many sonnets. In his last years he designed the dome of St. Peter's Basilica in Rome, which has been called the finest architectural achievement of the Italian Renaissance. Michelangelo worked with many of the leaders of his time: the popes and the rulers of the Italian city-states. He knew and competed with Leonardo da Vinci and Raphael. He died on Feb. 18, 1564, at the age of 89, and was buried in the church of Santa Croce in Florence.

High Renaissance

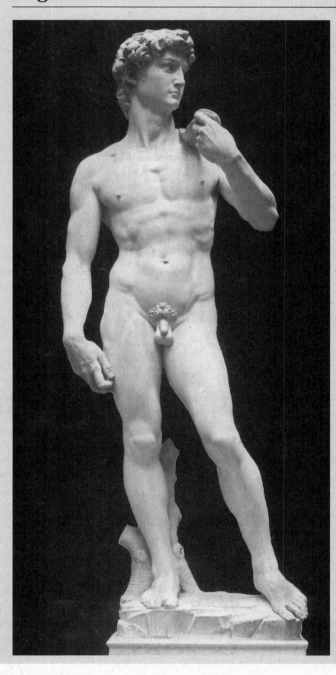

FIGURE 3.9 *Michelangelo,* David *(1501–1504) Marble, 13'5".*
Source: Academy, Florence. Alinari-Art Reference Bureau/Art Resource.

(Continued)

A Question of Style (continued)

High Renaissance (hy REHN-eh-sahns). A movement dating to the late fifteenth to early sixteenth centuries that followed classical ideals and sought a universal ideal through impressive themes and styles. In visual art, figures became types rather than individuals. We call this time the High Renaissance because the term "high" when applied to artistic styles or movements signifies an advancement toward an acme or fullest extent, specifically a late, fully developed, or most creative stage or period. One of the great artists of the High Renaissance, Michelangelo, broke with earlier Renaissance artists in his insistence that measurement subordinate to judgment. In the earlier, Renaissance period, a great deal of attention was paid to precisely replicating the proportions of Roman classicism. Michelangelo believed that measurement and proportion should be kept "in the eyes." This rationale for genius to do what it would, free from any preestablished "rules" enabled him to produce works such as *David* (Fig. 3.9), a colossal figure and the earliest monumental sculpture of the High Renaissance.

both physical and suggested. Sculptors go to great lengths to achieve the texture they desire for their works. In fact, much of a sculptor's technical mastery manifests itself in that final ability to impart a surface to the work. The glossy smoothness of African American sculptor Elizabeth Catlett's (b. 1915) *Singing Head* (Fig. 3.10) turns the surface texture of this black Mexican marble work into a complex experience of reflectivity as light plays off the black color and offset planes. The overall effect is tempered by the soft curves of the work's line. We examine texture more fully in our discussion of sense responses.

Principles

Proportion

Proportion is the relative relationship of shapes to one another. Just as we have a seemingly innate sense of balance, so we have a feeling of proportion. That feeling tells us that each form in the sculpture has a proper relationship to the others. However, as any student of art history will tell us, proportion—or the ideal of relationships—has varied from one civilization or culture to another. For example, such a seemingly obviously proportioned entity as the human body has varied greatly in its proportions as sculptors over the centuries have depicted it. Study the differences in proportion in the human body among Michelangelo's *David* (Fig. 3.9), the Chartres *Saints* (Fig. 3.16), an ancient Greek *Kouros* figure (Fig. 3.11), and Giacometti's *Man Pointing* (Fig. 3.12). Each depicts the human form, but with differing proportions. This difference in proportion helps transmit the message the artist wishes to communicate about his or her subject matter.

Repetition

Rhythm, harmony, and variation constitute repetition in sculpture, as they did in the pictorial arts. In sculpture, though, we must look more carefully and closely to determine

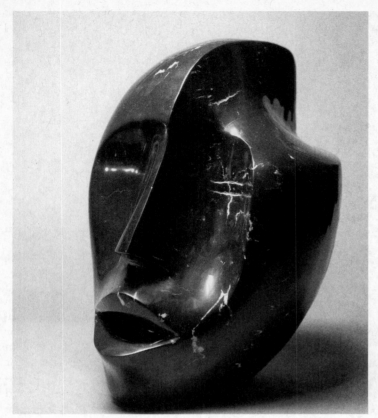

FIGURE 3.10 *Elizabeth Catlett, (1919–). "Singing Head." 1980. Sculpture, black Mexican marble. 16″ × 9½″ × 12″ (40.7 × 24.2 × 30.5 cm).* © *COPYRIGHT RESTRICTED.*

Source: Smithsonian American Art Museum, Washington DC/Art, Resource, NY. Art © Elizabeth Catlett/ licensed by VAGA, ©2004 New York, NY.

how the artist has employed these elements because these characteristics occur more subtly. If we reduce a sculpture to its components of line and form, we begin to see how (as in music) rhythmic patterns—regular and irregular—occur. Figure 3.2, for example, establishes a regular rhythmic pattern in space as the eye moves from figure to figure and from leg to leg of the figures. We also can see whether the components contain consonance or dissonance. For instance, in Figure 3.2, a sense of dynamics or action or movement results

from the dissonance created by juxtaposing the strong triangles of the stances and groupings with the *biomorphic* lines of the human body. Unity of the curves in Figure 3.13, in contrast, provides us with a consonant series of relationships. Finally, we can see how line and form are used in theme and variation. We noted the repetition of triangles in Figure 3.2. In contrast, the sculptor of Figure 3.13 varies his motif, the oval, as the eye moves from the child's face to the upper arm, the hand, and finally the cat's face.

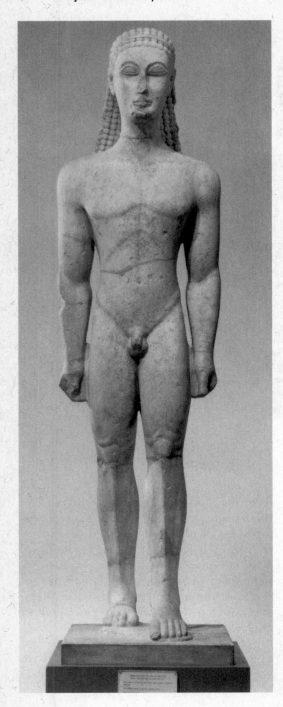

FIGURE 3.11 *"Statute of Kouros (youth)".*
Island marble. Greek, 6th century, B.C., ca.
590-580 B.C.E. Marble. Naxian; H. without plinth 76
5/8 (194.6 cm); H. of head 1/2 in. (30.5 cm); lenght of
face 8 7/8 in. (22.6 cm); shoulder width 20 5/16 in.
(51.6 cm) Fletcher Fund, 1932. (32.11.1). The
Metropolitan Museum of Art, New York, NY USA.
Image copyright © The Metropolitan Museum of Art/Art
Resouce NY.

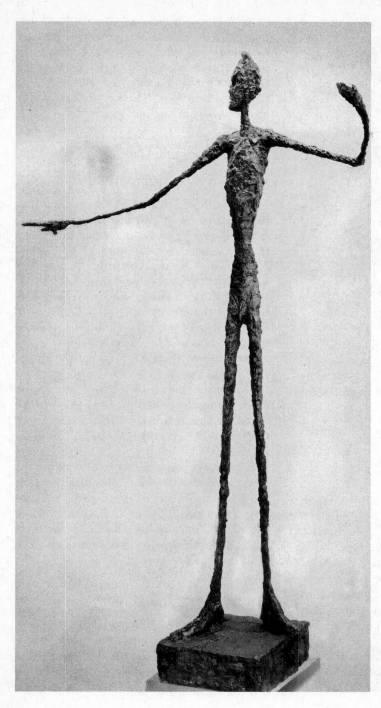

FIGURE 3.12 *Alberto Giacometti,(1901-1966), "Man Pointing" (1947). Bronze, 70 1/2 x 40 3/4 x 16 3/8" ,at base 12 x 13 x1/4.* Source: Gift of Mrs. John D. Rockefeller 3rd. (678.1954) The Museum of Modern Art, New York, USA. Digital Image © The Museum of Modern Art/Licensed by SCALA/Art Resource, NY. © 2006 Artists Rights Society (ARS), New York/ADAGP, Paris.

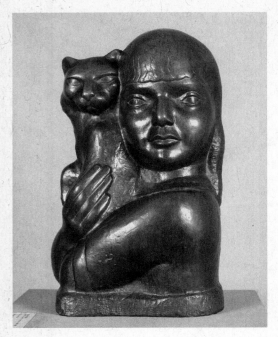

FIGURE 3.13 *William Zorach, American, 1887–1966,* Child with Cat, *1926, Bronze, 17½″ × 10″ × 7½″.*
Source: Palmer Museum of Art, The Pennsylvania State University, 77.16.

OTHER FACTORS

Articulation

In viewing sculpture we should also note the manner by which we move from one element to the next. That manner of movement, called *articulation*, applies to sculpture, painting, photography, and all the other arts. As an example, let us step outside the arts to consider human speech. Sentences, phrases, and individual words comprise nothing more than sound syllables (vowels) articulated (joined together) by consonants. We understand what someone says because that individual articulates as he or she speaks. Let us put the five vowel sounds side by side: Eh–EE–Ah–O–OO.

As yet we do not have a sentence. Articulate those vowels with consonants, and we have meaning: "Say, she must go too." The nature of an artwork depends on how the artist has repeated, varied, harmonized, and related its parts and how he or she has articulated the movement from one part to another—that is, how the sculptor indicates where one part stops and the other begins.

Focal Area (Emphasis)

Sculptors, like painters or any other visual artists, must concern themselves with drawing our eye to those areas of their work that are central to what they wish to communicate. They also must provide the means by which our eye can move around the work. Dealing in three dimensions with little control over the direction from which we will first perceive the piece complicates the sculptor's taste; the entire 360-degree view contributes to the total message communicated by the work.

Converging lines, encirclement, and color all work for sculptors as they do for painters. The encircling line of the tree and body parts in Figure 3.14 causes us, however we proceed to scan the work, to focus ultimately on the torso of this fertility figure.

Sculptors also have the option of placing moving objects in their work. Such an object immediately becomes a focal point of the sculpture. A mobile (Fig. 3.15) presents many ephemeral patterns of focus as it turns at the whim of the breezes.

Found

Often natural objects, whether shaped by human hands or otherwise, take on characteristics that stimulate aesthetic responses. They become *objets d'art* not because an artist put them together (although an artist

On February 12, 2005, Christo (b. 1939) and Jeanne-Claude (b. 1939) revealed their installation, *The Gates, Central Park, New York, 1979–2005* (color insert Plate 18). The event brought to fruition the artists' vision for the temporary work of art. The work consisted of 7,503 gates, sixteen feet tall and varying in width from 5 feet 6 inches to 18 feet, depending on the width of the twenty-five different walkways on which the gates appeared. From the horizontal top pieces of the gates, the artists suspended free-hanging saffron-colored fabric panels. Each panel hung to approximately seven feet above the ground, and the gates were spaced at twelve-foot intervals. After sixteen days, the gates were disassembled and all the materials recycled. As with all their previous projects, the artists financed the project entirely themselves through their C.V.J. Corporation with sales of preparatory studies, collages, and scale models, earlier works of the 1950s and 1960s, and original lithographs on other subjects. The artists do not accept sponsorships or donations.

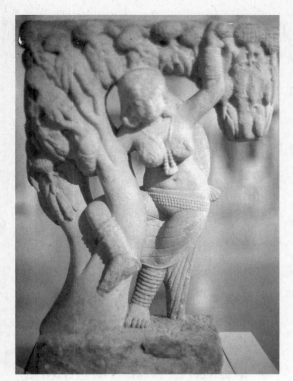

FIGURE 3.14 Tree Spirit (Bracket Figure), *central India (1st Century A.D.).*
Source: © The Trustees of the British Museum/Art Resource, NY.

may combine found objects to create a work), but because an artist chose to take them from their original surroundings and hold them up to the rest of us as vehicles for aesthetic communication. In other words, an artist decided that such an object said something aesthetically and *chose* to present it in that vein.

Ephemeral

Ephemeral art has many different expressions. Designed to be transitory, ephemeral art makes its statement and then, eventually, ceases to exist.

Interactivity

A contemporary approach, media art or "new"-media (also referred to as digital media), essentially encompasses works that involve various kinds of electronic media, often, collaborative efforts, and typically some kind of interactivity with the viewer. Problematical to define, exhibit, sell, or—for our purposes—illustrate, this approach can go beyond technology to a degree that reshapes conventional concepts of "artwork," and could be studied as visual art, music, performance art, film, or a multitude of forms. New-media tends to focus on contemporary society's increasing involvement with technology. The adherents of new-media art come from widely divergent backgrounds,

FIGURE 3.15 *Alexander Calder, American, 1898–1976.* Spring Blossoms, *1965, Painted metal and heavy wire, extends 52" × 102 x 72".*
Source: Palmer Museum of Art, The Pennsylvania State University. Gift of the Class of 1965. 65.1. © 2005 Estate of Alexander Calder/Artists Rights Society (ARS), New York.

from visual art, music, animation, and graphic design to architecture, engineering, and computer science, and they see themselves perhaps not as artists, but as some kind of mixture floating between research and artistry, utilizing nontraditional materials. Some of these "artists" try to create art that neither looks nor acts like art. Most want viewers to participate bodily in the work. They also see electronic media as a potential for collaborations among, for example, artists, architects, engineers, and scientists. We get a feel for new-media from descriptions of the works of two practitioners, Julian Bleecker and Simon Penny.

Julian Bleecker's *WiFi Bedouin* looks like a high-tech backpack and functions as a mobile server and transmitter, allowing the wearer to create an "island internet" accessible to those in proximity, allowing them access to the wearer's self-contained network. Bleecker's work focuses on rethinking how people use technology and invites innovative and active responses to things that occasionally feel fixed or overwhelming.

As best a still photograph can capture media art, we see an early example in Australian artist Simon Penny's (b. 1955) "Big Father" machine interactive installation 1992–93 (Fig. 3.17). Here five robotic sensory stations vaguely resemble the human form and allow viewer interaction.

HOW DOES IT STIMULATE THE SENSES?

TOUCH

We can touch sculpture and feel its roughness or its smoothness, its coolness or perhaps its warmth. Even if museum regulations prohibits

Gothic

Gothic (gothic) (GHAHTH-ihk). In architecture, painting, and sculpture, a medieval style based on a pointed-arch structure and characterized by simplicity, verticality, elegance, and lightness. Gothic sculpture portrays serenity, idealism, and simple lifelikeness. Gothic sculpture reflects a human quality suggesting that life has value, and

FIGURE 3.16 *Jamb Statues, West Portal, Chartres Cathedral (begun 1145).*
Source: Lauros-Giraudon/Art Resource, New York.

(Continued)

A Question of Style (continued)

portrayals of Christ, for example, depict a benevolent teacher, with God awesome in his beauty as opposed to his vengeance. Visual images carry over a distance with distinctness and have order, symmetry, and clarity. The figures of Gothic sculpture step out of their material and stand away from their backgrounds. The content of Gothic sculpture, like most church art, was didactic (designed to teach) with straightforward lessons.

The sculptures of the cathedral of Notre Dame, Chartres (shahrt), France, bracket nearly a century from 1145 to 1220, and Figure 3.16 shows figures from the middle of the twelfth century. They display a relaxed serenity, idealism, and simple lifelikeness and form an integral part of the portal columns, but they also emerge from the columns, each figure in its own space. Each figure has a particular human dignity despite the idealization. Cloth drapes easily over the bodies. Detail remains somewhat formal and shallow, but we see the human figure beneath the fabric, in contrast to works that use fabric merely as a surface decoration such as the Indian bracket figure shown in Figure 3.14.

The term *gothic* also applies to literature and a particular style of late eighteenth- and early nineteenth-century fiction characterized by the use of medieval settings, murky atmosphere, horror, and mysterious and violent incidents: for example, Horace Walpole's *Castle of Otranto* and Ann Radcliffe's *The Italian*. Much of early science fiction owed its roots to this style. In the mid-twentieth century, the term *Southern Gothic* described a style portraying visions of the South, again, with grotesque, macabre, or fantastic incidents, specifically writers like Flannery O'Connor, Tennessee Williams, Truman Capote, William Faulkner, and Carson McCullers.

us from touching a sculpture, we can see the surface texture and translate the image into an imaginary tactile sensation. Any work of sculpture cries out to be touched.

TEMPERATURE AND AGE

Color in sculpture stimulates our response by utilizing the same universal symbols as it does in paintings, photographs, and prints.

Reds, oranges, and yellows stimulate sensations of warmth; blues and greens, sensations of coolness. In sculpture, color can result from the conscious choice of the artist, either in the selection of material or in the selection of the pigment with which the material is painted. Or, as we indicated earlier, color may result from the artist's choice to let nature color the work through wind, water, sun, and so forth.

A Question to Ask

Where does one part of the work stop and another begin? How does the way the artist has articulated the parts affect the way I perceive and respond to the work?

FIGURE 3.17 *Simon Penny, 1955–, "Big Father "/Machine Media Interactive Installation 1992-1993: steel, concrete, electromechanicals, medical hardware, ultrasonic sensors, audio, and video; 5 units, each 7 high, plus attendant hardware.* Source: Simon Penny.

This weathering effect, of course, creates very interesting patterns, but in addition it gives the sculpture the attribute not only of space but also of time, because the work obviously will change as nature works her wonders. A copper sculpture early in its existence will be a different work, a different set of stimuli, than it will be in five, ten, or twenty years. This is not accidental; artists choose copper, knowing what weathering will do to it. They obviously cannot predict the exact nature of the weathering or the exact hues of the sculpture at any given time in the future, but such predictability remains largely irrelevant. Our response to a work of art may in fact be shaped by the effects of age. Ancient objects possess a great deal of charm and character.

DYNAMICS

Line, form, and juxtaposition create dynamics in works of sculpture. The activity of a sculpture tends to be heightened because of its three-dimensionality. In addition, we experience a certain sense of dynamics as we move around the work. Although we move and not the sculpture, we perceive and respond to what seems to be movement in the work itself.

Nonetheless, sculptures can create their own dynamism, as the Japanese sculpture shown in Figure 3.18 illustrates. Peace statue in the Nagasaki Peace Park commemorates the dropping of an atomic bomb in 1945 on Nagasaki, Japan. Its open composition achieves action through the tension of a muscular man sitting with one leg folded under and one arm extended, pointing to the sky.

FIGURE 3.18 *Seibou Kitamura, The Peace Statue (1955), Height: 33ft. Nagasaki, Japan, Asia.*
Source: Robert Harding World Images.

SIZE

Because sculpture has mass, (takes up space and has density) our senses respond to the weight and/or scale of a work. Easter Island sculpture, solid, stable, and oversized (see Fig. 3.19), has mass and proportion as well as line and form that make it appear heavier than other works of basically the same size and material, such as in Figure 3.3. Moreover, the very same treatment of texture, verisimilitude, and subject would elicit a completely different sense response if the work were 3 feet tall than if it were 30 feet tall.

Early in the chapter we mentioned the possibility of artists' *disguising the material* from which they make a work. Marble polished to appear like skin or wood polished to look like fabric can change the appearance of the mass of a sculpture and significantly affect our response to it.

We also must consider the purpose of disguising material. Examine the cloth represented in Figures 3.1 and 3.14. In both cases the sculptor has disguised the material by making stone appear to be cloth. In Figure 3.1 the cloth is detailed to reflect reality. It drapes as real cloth would drape, and as a result its effect in the composition depends on the subtlety of line characteristic of draped cloth. However, in Figure 3.14 the sculptor has depicted cloth in such a way

FIGURE 3.19 *Chile, Easter Island (Rapa Nui), Moai Statues on hillside.*
Source: Getty Images, Inc.—Stone Allstock.

A Question to Ask

Does the detailing of the sculpture reflect a concern for greater lifelikeness?

that its effect in the design depends not on how cloth drapes, but rather on the decorative function of line as the sculptor wishes to use it. Real cloth cannot drape as the sculptor has depicted it. Nor, probably, did the sculptor care. His main concern here was for decoration, for using line (that looks like cloth) to emphasize the rhythm of the work. When sculpture de-emphasizes lifelikeness in order to draw attention to the substance of its material, we call it *glyptic*. Glyptic sculpture emphasizes the material of the work and usually retains the fundamental geometric qualities of that material.

LIGHTING AND ENVIRONMENT

One final factor significantly influences our sense response to a sculpture, a factor we very often do not consider and which remains outside the control of the artist unless he or she personally supervises every exhibition of the work: *lighting* and *environment*. As we note in the chapter on theatre, light plays a fundamental role in our perception of and thereby our response to three-dimensional objects. The direction and number of sources of light striking a three-dimensional work can change the entire composition of that work. Whether the work is displayed outdoors or indoors, the method of lighting affects the overall presentation of the work. Diffuse room lighting allows us to see all aspects of a sculpture without external influence. However, placing the work in a darkened room and illuminating it from particular directions by spotlights, makes it much more dramatic.

Where and how a work is exhibited also contributes to our response. A sculpture can create a far different response if placed in a carefully designed environment that screens our vision from distracting or competing visual stimuli than if exhibited among other works amid the bustle of a public park, for instance.

At least for some Americans, Maya Lin's *Vietnam Memorial* in Washington, D.C. (Fig. 3.20) evokes tremendous emotional and sense response. This V-shaped wall of names sits outside in a public space and merges with the landscape of its context. Starting at ground level and sinking to its deepest point at the apex of the V, the work seems to suggest the gradual decline of the United States into the Vietnam War, and then as it ascends back to the surface along its second side, suggesting the slow healing process that the subsequent years have produced. Provocative in its form, this anti-memorial memorial, consists of shiny, polished black granite and contains nothing but straight lines and sharp angles. The only relief to the hardness of the image comes from the lettering of the 58,000 names of the men and women who died during that conflict. Standing before the black wall looking at the names, the viewers find their own images reflected back at them, which stimulates an implicit sense of involvement with not only the sculpture but the acts of dying by those memorialized.

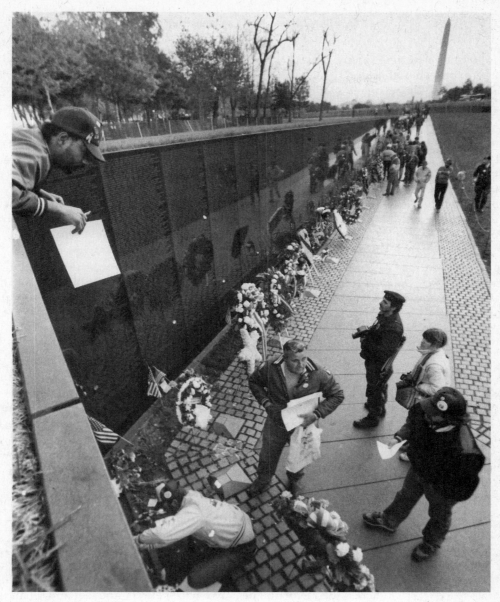

FIGURE 3.20 *May Lin, Vietnam Memorial, 1982. Black granite, length. 493½'. The Mall, Washington, DC.*
Source: AP Wide World Photos.

Sample Outline and Critical Analysis

The following very brief example illustrates how we can use some of the terms explained in the chapter to form an outline and then develop a critical analysis of a work of art. Here is how that might regarding Michelangelo's sculpture, *David* (Fig. 3.9).

Outline	Critical Analysis
Dimensionality full-round	Michelangelo's *David* is a full-round work standing eighteen feet above the floor. Its larger-than-life size contributes to its sense of heroic grandeur. Much of its effect depends on the bulging muscles, exaggerated rib cage, heavy hair, undercut eyes, and frowning brow, all of which seem intended to allow the work's details to be seen from a distance.
Method of execution Substraction Texture	Using a subtractive method, Michelangelo carved the work out of marble, a metamorphic rock that provided a workable basis for the finely polished finish and carefully executed details. As a result, the stone has the smooth texture of skin—of real flesh stretched over taut but pliable musculature. Each detail has a subtlety and smoothness that seem to breathe.
Scale Mass Line	The size (scale) and proportions of the work give it great mass, which in turn creates a sense of awe in the viewer, compared to the same work were it life-size. Michelangelo's use of line provides a complex set of stimuli in which the work seems to be self-contained while at the same time wanting to escape its space. The downward stare of the eyes directs the viewer to the hand containing the sling, which drapes over David's back. Then the viewer's eye travels down the arm and pauses at the elbow, perhaps not sure if it wants to move back into the space occupied by the statue or off into the adjacent space where Goliath awaits. The same can be said of work's line as it moves down the body's left leg to the ground and either off into space or back to the right leg along the rocky ground. The positioning of the right arm with the hand canted in to the thigh, again sets up a circular direction keeping the viewer's attention inside the space of the statue. The line moves across the lower thigh
Negative space	across the incidental negative space between the legs and seems to engage an implied line moving from the extended elbow that takes
Focal point	the viewer's eye upward to the focal point of the work—David's heroic face. The statue appears full of dynamic tension, and yet seems comfortably stable.

Additional Study and Cyber Sources

c. 3000 B.C.E.–c. 700 B.C.E.

Mesopotamian and Egyptian: http://www.mcad.
edu/AICT/html/ancient/aneast.html;
http://www.artchive.com/artchive/ftptoc/
egyptian_ext.html

c. 700 B.C.E.–c. 400 B.C.E.

Archaic and Classical Greece: Kore—
http://harpy.uccs.edu/greek/archaicsculpt.
html;
Kritios Boy: Parthenon sculptures—
http://harpy.uccs.edu/greek/archaicsculpt.
html
Myron: *Discus Thrower:* Polykleitos: *The Scraper*—
http://harpy.uccs.edu/greek/classicalsc.html

c. 200 B.C.E.–c. 1400 C.E.

Hellenistic Greece: *Winged Victory of Samothrace*—
http://www.louvre.fr/img/photos/collec/
ager/grande/ma2369.jpg
Hagesandro: *Laocoon and His Sons*—
http://www.artchive.com/artchive/G/greek/
laocoon.jpg.html
Roman: http://harpy.uccs.edu/roman/html/
romsculp.html
Medieval (Romanesque): http://www.thais.it/
scultura/romanica.htm; (Gothic):http://
gallery.euroweb.hu/html/zgothic/gothic/2/
index.html

c. 1400–c. 1700

Renaissance (Brunelleschi, Ghiberti, Donatello):
http://witcombe.sbc.edu/ARTHLinks2.html#
Italy15

High Renaissance (Michelangelo):
http://www.kfki.hu/~/arthp/html/m/
michelan/1sculptu/index.html
Baroque (Bernini): http://www.artcyclopedia.
com/artists/bernini_gianlorenzo.html

c. 1700–c. 1900

Eclecticism (Rodin): http://www.artcyclopedia.
com/artists/rodin_auguste.html

c. 1900–present

Cubism (Picasso, Lipchitz): http://www.
artcyclopedia.com/history/cubism.html
Futurism (Boccioni): http://www.moma.org/
docs/collection/paintsculpt/c68,.htm
Abstract Expressionism (David Smith):
http://www.artcyclopedia.com/artists/smith_
david.html
Surrealsim (Giacometti): http://www.
artcyclopedia.com/artists/giacometti_alberto.
html
Abstraction (Calder): http://www.artcyclopedia.
com/artists/calder_alexander.html
Primary Structures (Nevelson):
http://www.artcyclopedia.com/artists/
nevelson_louise.html
Video Art (Paik): http://www.artcyclopedia.com/
artists/paik_nam_june.html
Neo-Abstraction (Benglis): http://www.
artcyclopedia.com/artists/benglis_lynda.html
An exhaustive chronological list of sculptors
(with dates and nationalities) is located at
http://www.artcyclopedia.com/media/Sculptor.
html

Architecture

Every street in our towns represents a museum of ideas and engineering. The houses, churches, and commercial buildings we pass every day reflect appearances and techniques that may be as old as the human race itself. We go in and out of these buildings, often without notice, and yet they engage us and frequently dictate actions we can or cannot take.

In approaching architecture as an art, we cannot separate aesthetic properties from practical or functional properties. In other words, architects first have a practical function to achieve in their buildings, which forms their principal concern. The aesthetics of the building remain important, but they must be tailored to overall practical considerations. For example, when architects set about to design a 110-story skyscraper, they are locked into a vertical rather than horizontal aesthetic form. They may attempt to counter verticality with strong horizontal elements, but the physical fact that the building will be taller than wide creates the basis from which the architects must work. Their structural design must take into account all the practical needs implicit in the building's use. Nonetheless,

considerable room for aesthetics remains. Treatment of space, texture, line, and proportion can give us buildings of unique style and character or buildings of unimaginative sameness.

Architecture often is described as the art of sheltering. To consider it as such, we must use the term *sheltering* very broadly. Obviously, types of architecture exist within which people do not dwell and under which they cannot escape the rain. Architecture encompasses more than buildings. So, we can consider architecture as the art of sheltering people both physically and spiritually from the raw elements of the unaltered world.

WHAT IS IT?

As we noted, architecture can be considered the art of sheltering. In another large sense, it comprises the design of three-dimensional space to create practical enclosure. Its basic forms include residences, churches, and commercial buildings. Each of these forms can take innumerable shapes, from single-family residences to the ornate palaces of kings to high-rise condominiums and apartments. We also could expand our categorization of architectural forms to include bridges, walls, monuments, and so forth.

HOW IS IT PUT TOGETHER?

In examining how a work of architecture is put together, we limit ourselves to ten fundamental elements: structure, materials, line, repetition, balance, scale, proportion, context, space, and climate.

STRUCTURE

Many systems of construction or systems of structural support exist. We deal with only a few of the more prominent. *Post-and-lintel,*

arch, and *cantilever* systems can be viewed, essentially, as historical systems. Contemporary architecture, however, can better be described by two additional terms, which to some extent overlap the others. These contemporary systems are *bearing-wall* and *skeleton frame.*

Post-and-Lintel

Post-and-lintel structure (Figs. 4.1–4.4) consists of horizontal beams (lintels) laid across the open spaces between vertical supports (posts). In this architectural system, the traditional material is stone. Post-and-lintel structure is similar to *post-and-beam* structure, in which series of vertical posts join horizontal members, traditionally of wood. The wooden members of post-and-beam structure are held together by nails, pegs, or lap joints.

Lack of tensile strength in its fundamental material, stone, limits post-and-lintel structure in its ability to define space. *Tensile strength* is the ability of a material to withstand bending. If we lay a slab of stone across an open space and support it only at each end, we can span only a narrow space before it cracks in the middle and falls to the ground. However, stone has great *compressive strength*—the ability to withstand compression or crushing.

A primitive example of post-and-lintel structure is Stonehenge, that ancient and mysterious religious configuration of giant stones in Great Britain (Fig. 4.1). The ancient Greeks refined this system to high elegance; the most familiar of their post-and-lintel creations is the Parthenon (Fig. 4.4). A more detailed view of this style and structure can be seen in Figures 4.2 and 4.3.

The Greek refinement of post-and-lintel structure forms a *prototype* for buildings

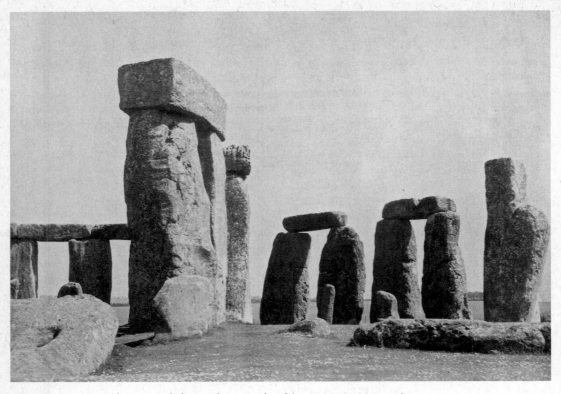

FIGURE 4.1 *Stonehenge, Salisbury Plain, England (c. 1800–1400 B.C.E.).*
Source: British Information Services photo.

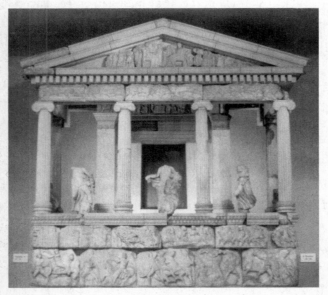

FIGURE 4.2 *The Nereid Monument, c. 400 B.C.*
Source: © The Trustees of the British Museum/Art Resource NY.

FIGURE 4.3 *The Nereid Monument, c. 400 B.C. (roof detail).*
Source: © The Trustees of the British Museum/Art Resouce, NY.

throughout the world and across the centuries. So it makes sense to pause to examine the Greek style in more detail. One of the more interesting aspects of the style consists of its treatment of columns and *capitals*. Figure 4.5 shows the three basic Greek orders: Ionic, Doric, and Corinthian. These, of course, represent only some of the styles of post-and-lintel structure. Column capitals can vary as much as the imagination of the architect who designed them. They function primarily as a transition for the eye as it moves from post to lintel. Columns also may express a variety of detail—for example, Figures 4.6 and 4.7. A final element, present in some columns, is *fluting*—vertical ridges cut into the column (Fig. 4.3).

Arch

The arch represents a second type of architectural structure. As we indicated earlier, post-and-lintel structure has limitations in the amount of unencumbered space it can achieve. The arch, in contrast, can define large spaces because its stresses transfer outward from its center (the *keystone*) to its legs. So it does not depend on the tensile strength of its material.

Many different styles of arches exist, as illustrated in Figure 4.8. The characteristics of different arches may have structural as well as decorative functions.

The transfer of stress from the center of an arch outward to its legs dictates the

Classical

classical (KLAS-ih-kuhl). Adhering to traditional standards. May refer to a style in art and architecture dating to the mid-fifth century B.C.E. in Athens, Greece, or ancient Rome, or any art that emphasizes simplicity, harmony, restraint, proportion, and reason. In Greek classical architecture, Doric and Ionic orders appear in temple architecture. In vase painting, geometry remains from the archaic style, but figures have a sense of idealism and lifelikeness.

The prototype of all classical buildings is the Parthenon (Fig. 4.4). The Parthenon exemplifies Greek classical architecture. Balance results from geometric symmetry, and the clean, simple lines represent a perfect balance of forces holding the composition together. In plan, the Parthenon has short sides slightly less than half the length of the long sides. The temple has peripteral form (surrounded by a single row of columns). A specific convention determined the number of columns across the front and along the sides of the temple. The harmony of the design rests in the regular repetition of virtually unvaried forms. All the columns

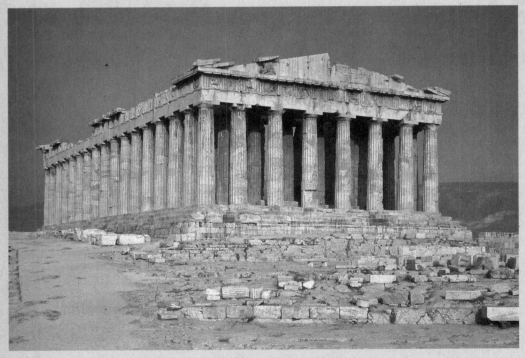

FIGURE 4.4 *The Parthenon, Acropolis, Athens (448–432 B.C.E.)*
Soure: Studio Kontos Photostock.

A Question of Style **(continued)**

appear to be alike and spaced equidistantly. But at the corners the spacing adjusts to give a sense of grace and perfect balance, while preventing the monotony of unvaried repetition. There are, however, some refinements—that is, intentional departures from strict geometric regularity. The slight bulge of the horizontal elements compensates for the eye's tendency to see a downward sagging when all elements are straight and parallel. Each column swells toward the middle by about 7 inches to compensate for the tendency of parallel vertical lines to appear to curve inward. We call this swelling *entasis*. The columns also tilt inward slightly at the top, in order to appear perpendicular. The stylobate, or foundation, rises toward the center so as not to appear to sag under the immense weight of the stone columns and roof.

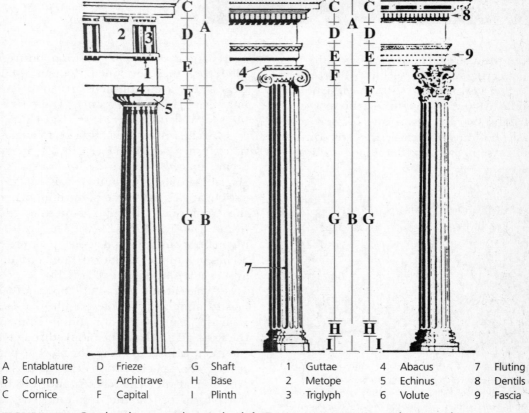

A	Entablature	D	Frieze	G	Shaft	1	Guttae	4	Abacus	7	Fluting
B	Column	E	Architrave	H	Base	2	Metope	5	Echinus	8	Dentils
C	Cornice	F	Capital	I	Plinth	3	Triglyph	6	Volute	9	Fascia

FIGURE 4.5 *Greek columns and capitals: (left) Doric, (center) Ionic, (right) Corinthian.*
Source: Laurence King Publishing Ltd.

FIGURE 4.6 *Column capital, Central portal, Westminster Cathedral, London.*

need for a strong support to keep the legs from caving outward. Such a reinforcement is called a *buttress* (Fig. 4.9). The designers of Gothic cathedrals sought to achieve a sense of lightness. Because stone formed their basic building material, they recognized some system had to be developed that would

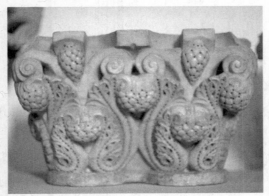

FIGURE 4.7 *Capital.* Made of Limestone. Boldly cut foilage and volutes on twin columns below. Production: Date 12thC (1100 - 1199). Period/Culture: IslamicAssociation F (Found/Acquired). Place Haram al-Sharif(Asia, MIddle East, Levant, Jerusalem, Haram al-Sharif) ©The Trustees of the British Museum

overcome the bulk of a stone buttress. Therefore, they developed a system of buttresses that accomplished structural ends but were light in appearance. These structures are called *flying buttresses* (Fig. 4.10).

Arches placed back to back to enclose space form a *tunnel vault* (Fig. 4.12). Several arches placed side by side form an *arcade* (Fig. 4.11). When two tunnel vaults intersect at right angles, as they do in the floor plan of the traditional Christian cathedral, they form a *groin vault* (Fig. 4.13). The protruding masonry indicating diagonal juncture of arches in a tunnel vault or the juncture of a groin vault is *rib vaulting* (Fig. 4.14).

When arches join at the top with their legs forming a circle, they result in a *dome* such as St. Paul's Cathedral and the Dome of the Rock (Fig. 4.15). The dome, through its intersecting arches, allows for more expansive, freer space within the structure. However, if the structures supporting the dome form a circle, they result in a circular building such as the Pantheon (color insert, Plate 11). To permit squared space beneath

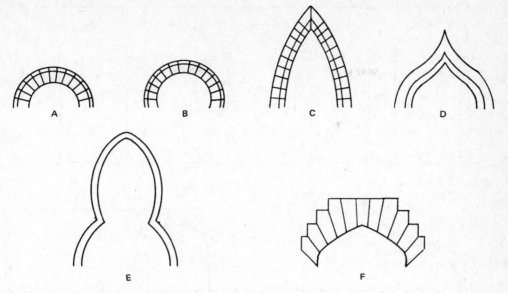

FIGURE 4.8 *The Arch.* **A**. *Round (Roman) arch.* **B**. *Horseshoe (Moorish) arch.* **C**. *Lancet (pointed, Gothic) arch.* **D**. *Ogee arch.* **E**. *Trefoil arch.* **F**. *Tudor arch.*

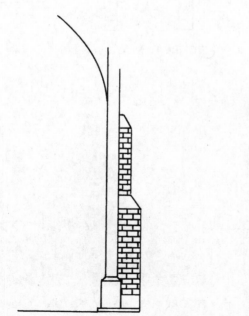

FIGURE 4.9 *Buttress.*

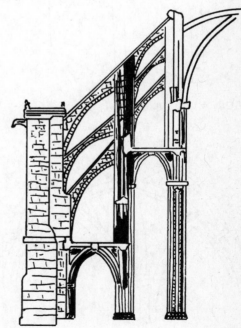

FIGURE 4.10 *Flying buttresses.*

FIGURE 4.11 *Arcade.*

FIGURE 4.12 *Tunnel vault.*

FIGURE 4.13 *Groin vault.*

FIGURE 4.14 *Ribbed vault.*

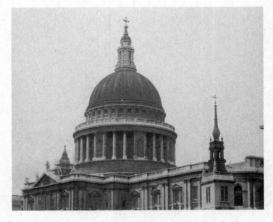

FIGURE 4.15 *Dome, St. Paul's Cathedral, London (1675–1710).*
Source: British Tourist Authority.

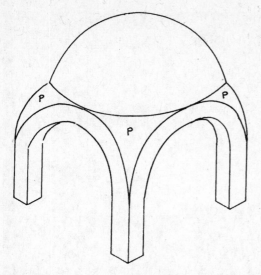

FIGURE 4.16 *Dome with pendentives (P).*

a dome, the architect can transfer weight and stress through the use of *pendentives* (Fig. 4.16).

Cantilever

A *cantilever* comprises an overhanging beam or floor supported only at one end (Fig. 4.17). Although not a twentieth-century innovation—many nineteenth-century barns in the central and eastern parts of the United States employed it—the most dramatic uses of cantilever have emerged with the introduction of modern materials such as steel beams and prestressed concrete (Fig. 4.18).

Bearing-Wall

In the bearing-wall system, the wall supports itself, the floors, and the roof. Log cabins examplify bearing-wall construction; so do solid masonry buildings, in which the walls are the structure. In variations of bearing-wall construction, such as in Figure 4.30, the wall material is continuous, that is, not jointed or pieced together. We call this variation *monolithic* construction.

Skeleton Frame

In a skeleton frame, a framework supports the building; the walls attach to the frame forming an exterior skin. When skeleton framing utilizes wood, as in house construction, we call the technique *balloon construction*. When metal forms the frame, as in skyscrapers, we call the technique *steel cage construction*.

BUILDING MATERIALS

Historic and contemporary architectural practices and traditions often center on specific materials, and to understand architecture further, we need to note a few.

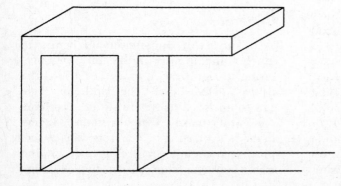

FIGURE 4.17 *Cantilever.*

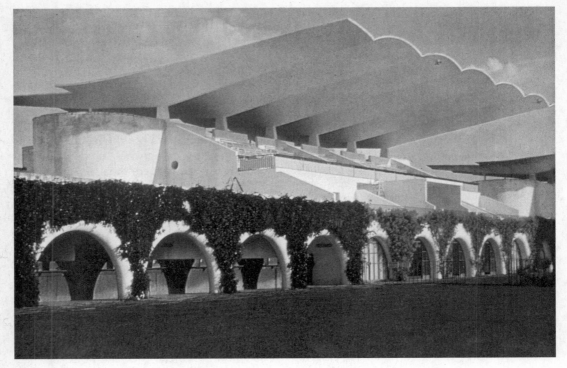

FIGURE 4.18 *Grandstand, Zarzuela Race Track, Madrid (1935). Architect: Eduardo Torroja.*

Stone

The use of stone as a material turns us back to post-and-lintel systems and Figures 4.1 through 4.4. When stone combines with mortar, for example, in arch construction, that combination results in *masonry* construction. The most obvious example of masonry, however, remains the brick wall, and masonry construction is based on that principle. Stones, bricks, or blocks are joined together with mortar, one on top of the other, to provide basic, structural, weight-bearing walls of a building, a bridge, and so forth (Fig. 4.19). Masonry has limits because of the pressures that play on the joints between blocks and mortar and the foundation on which they rest. However, when one considers that tall office buildings such as Chicago's Monadnock Building (Fig. 4.20) have walls that consist completely of masonry (there are no hidden steel reinforcements in the walls), it becomes obvious that great possibilities exist with this elemental combination of stone and mortar.

Concrete

The use of concrete remains central to much contemporary architectural practice, owing its significance to as far back in the past as ancient Rome. The Pantheon (Plate 11) comprises a masterful structure of concrete with a massive concrete dome, 142 feet in diameter, resting on concrete walls 20 feet thick. In contemporary architecture, we find *precast* concrete (concrete cast in place using

What system forms the structure of this building? Is that structure expressed outwardly or hidden?

FIGURE 4.19 *Masonry wall.*

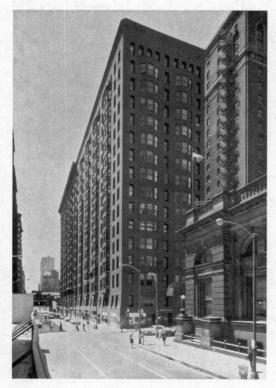

FIGURE 4.20 *Monadnock Building, Chicago, Illinois (1891). Architects: Burnam and Root.*

wooden forms around a steel framework). We also find *ferro-concrete* or *reinforced concrete,* which utilizes metal reinforcing embedded in the concrete. Such a technique combines the tensile strength of the metal with the compressive strength of the concrete. *Prestressed* and *posttensioned* concrete use metal rods and wires under stress or tension to cause structural forces to flow in predetermined directions. Both comprise extremely versatile building materials.

Wood

Whether in balloon framing or in laminated beaming, wood has played a pivotal role, especially in the United States. As new technologies emerge in making engineered beams from what once was scrap wood, wood's continuation as a viable building product will probably remain—with less negative impact on the environment.

Steel

The use of steel comprises nearly endless variation and almost limitless possibilities for construction. Its introduction into the nineteenth-century industrial age forever changed style and scale in architecture. We noted *steel cage* construction and cantilever construction earlier. *Suspension* construction in bridges, superdomes, aerial walkways, and so on, has carried architects to the limits of space spansion. The *geodesic dome* (Fig. 4.21) is a unique use of materials invented by an American architect, R. Buckminster Fuller (1895–1983). Consisting

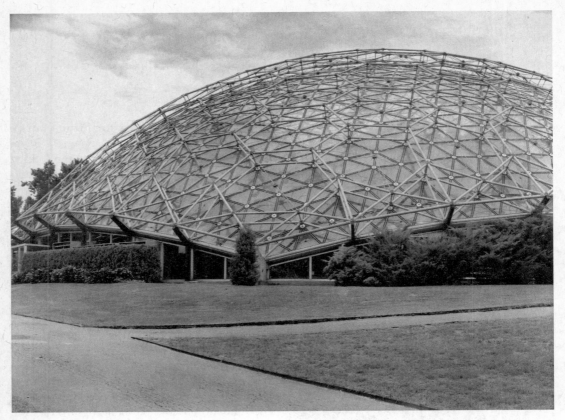

FIGURE 4.21 *Geodesic dome. Climatron, St. Louis, Missouri (1959). Architect: R. Buckminster Fuller.*
Source: Wayne Andrews/Esto Photographics, Inc.

of a network of metal rods and hexagonal plates, the dome is a light, inexpensive, yet strong and easily assembled building. Although it has no apparent size limit (Fuller claimed he could roof New York City, given the funds), its potential for variation and aesthetic expressiveness seems somewhat limited.

LINE, REPETITION, AND BALANCE

Line and repetition perform the same compositional functions in architecture as in painting and sculpture. In his Marin County Courthouse (Fig. 4.22), Frank Lloyd Wright takes a single motif, the arc, varies only its size, and repeats it almost endlessly. The result, rather than being monotonous, is dynamic and fascinating.

Let's look at three other buildings. The main gate of Hampton Court Palace (Fig. 4.23), built in the English Tudor style around 1515 by Thomas Wolsey, achieves bilateral symmetry—that is, the architect balanced identical items on each side of the centerline. In addition, line and form give

profile

Frank Lloyd Wright

Frank Lloyd Wright (1867–1959) pioneered ideas in architecture far ahead of his time and became probably the most influential architect of the twentieth century. Born in Richland Center, Wisconsin, Wright grew up under strong influences of his clergyman father's love of Bach and Beethoven. He entered the University of Wisconsin at age 15, forced to study engineering because the school had no program in architecture.

In 1887, Wright took a job as a draughtsman in Chicago and, the next year, joined the firm of Adler and Sullivan. In short order, Wright became Louis Sullivan's chief assistant. As Sullivan's assistant, Wright handled most of the firm's designing of houses. Deep in debt, Wright moonlighted by designing for private clients on his own. When Sullivan objected, Wright left the firm to set up his own private practice.

As an independent architect, Wright led the way in a style of architecture called the Prairie school. Houses designed in this style have low-pitched roofs and strong horizontal lines reflecting the flat landscape of the American prairie. These houses also reflect Wright's philosophy that interior and exterior spaces blend together.

In 1904, Wright designed the strong, functional Larkin Building in Buffalo, New York, and in 1906, the Unity Temple in Oak Park, Illinois. Traveling to Japan and Europe, he returned in 1911 to build a house on his grandfather's farm, Taliesin, which is Welsh for "shining brow." In 1916, Wright designed the Imperial Hotel in Tokyo, floating the structure on an underlying sea of mud. As a consequence, when the catastrophic earthquake of 1923 occurred, the hotel suffered very little damage.

The Great Depression of the 1930s greatly curtailed new building projects, and Wright spent his time writing and lecturing. In 1932, he established the Taliesin (ta-lee-AY-zihn) Fellowship, a school in which students learned by working with building materials and problems of design and construction. In winter, the school moved from Wisconsin to Taliesin West, a desert camp near Phoenix, Arizona.

The mid-1930s represented a period of intense creative output for Frank Lloyd Wright, and some of his most famous designs occurred during those years. Perhaps his most dramatic project, the Kaufmann House—Falling Water—in Bear Run, Pennsylvania (Fig. 4.28) emerged in 1936–1937 during this period. Another famous project was the S. C. Johnson and Son Administration Building in Racine, Wisconsin.

Two other significant buildings, among many, came later. The Solomon R. Guggenheim Museum (Fig. 4.33) began in 1942 with completion in 1957, and the Marin County Courthouse (Fig. 4.22), California, followed over the period during 1957–1963.

Wright's work was always controversial, and he lived a flamboyant life full of personal tragedy and financial difficulty. Married three times, he had seven children and died in Phoenix, Arizona, on April 9, 1959.

A Question of Style

Modernism

modernism (MAH-duhr-nihz-uhm). In the arts, modernism developed as a wide-ranging reaction to Romanticism and realism. It rejected conventional narrative content and conventional modes of expression to depict a world seen as althogether new and constantly in flux. In architecture, it refers to a twentieth-century style characterized by the glass and steel rectangular skyscraper (also called International Style) but with a variety of explorations of space and line including curvilinear treatments and highly symbolic exploration of form. In visual art, it includes a variety of approaches following the introduction of cubism and other "modernist" works at the International Exhibition of Modern Art (called the Armory Show) in 1913. In dance, it characterizes the nonballet tradition emphasizing angularity and asymmetry. We often associate modernism in architecture with the rectangular glass and steel box skyscraper. Modernism, however, also embraced the simple clean lines of the horizontal as well, and we can see this in Frank Lloyd Wright's Marin County Courthouse (Fig. 4.22). Seeming to emerge as one piece with its environment (context), the organic feeling of the building reflects Wright's belief that buildings should relate to their setting. Wright's courthouse, as, indeed, all his buildings, seem to grow out of, and never violate, their environment.

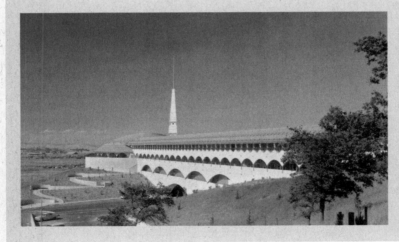

FIGURE 4.22 *Marin County Courthouse, California (1957–1963). Architect: Frank Lloyd Wright.*
Source: Ezra Stoller/Esto Photographics, Inc.

Hampton Court Palace the appearance of a substantial palace.

Figure 4.24 is the same Hampton Court Palace. Figure 4.23 reflects the style and taste of England during the reign of Henry VIII (who appropriated the palace from its original owner, Cardinal Wolsey). Later monarchs found the cumbersome and primitive appearance unsuited to their tastes, and Christopher Wren was commissioned to plan a new palace. So, in 1689, in the reign of William and Mary, renovation of the palace proper began.

FIGURE 4.23 *Hampton Court Palace, England. Tudor entry (c. 1515).*

FIGURE 4.24 *Hampton Court Palace, England. Wren façade (1689)*

The result was a new and classically oriented facade in the style of the English baroque.

As we can see in Figure 4.24, Wren designed a sophisticated and overlapping system of repetition and balance. Note first that the facade is symmetrical. The outward wing at the far left of the photograph duplicates at the right (not shown in the photo). In the center of the building reside four attached columns surrounding three windows. The middle window forms the exact center of the design, with mirror-image repetition on each side. Now note that above the main windows is a series of relief sculptures, pediments (triangular casings), and circular windows. Now return to the main row of windows at the left border of the photo and count toward the center. The outer wing contains four windows; then seven windows; then the central three; then seven; and finally the four of the unseen outer wing. Patterns of threes and sevens are very popular in architecture and carry religious and mythological symbolism. Wren established a pattern of four in the outer wing, three in the center, and then repeated it within each of the seven-window groups to create yet three additional patterns of three! How can he create four patterns of three with only seven windows? First, locate the center window of the seven. It has a pediment and a relief sculpture above it. On each side of this window are three windows (a total of six) without pediments. So, we have *two* groupings of three windows each. Above each of the outside four windows is a circular window. The window on each side of the center window does not have a circular window above it. Rather, it has a relief sculpture, the presence of which joins these two windows with the center window to give us our third grouping of three. Line, repetition, and balance in this facade form a marvelous perceptual exercise and experience.

Buckingham Palace (Fig. 4.25) and the Palace of Versailles (Fig. 4.26) illustrate different treatments of line and repetition. Buckingham Palace uses straight line almost exclusively, with repetition of rectilinear and triangular form. Like Hampton Court Palace, it exhibits *fenestration* groupings of threes and sevens, and the building itself is symmetrically balanced and divided by three pedimented, porticolike protrusions. Notice how the predominantly horizontal line of the building is broken by the three major pediments and given interest and contrast across its full length by the window pediments and the verticality of the attached columns.

Contrast Buckingham Palace with the Palace of Versailles, in which repetition occurs in groupings of threes and fives. Contrast is provided by juxtaposition and repetition of curvilinear line in the arched windows and baroque statuary. Notice how the horizontal line of the building, despite three porticoes, remains virtually undisturbed, in contrast with Buckingham Palace.

SCALE AND PROPORTION

Scale in architecture refers to a building's size and the relationship of the building and its decorative elements to the human form. Proportion, or the relationship of individual elements to each other, also plays an important role in a building's visual effect. Scale may range from an intimate bungalow, for example, to the towering power of a skyscraper (Fig. 4.36). Proportion and scale are tools with which the architect can create relationships that may be straightforward or deceptive. We must decide how these elements are used and to what effect. In addition, proportion in many buildings is mathematical: The relationships of one part to another often form ratios of three to two, one to two, one to three, and so on. Discovering such relationships in a building challenges us whenever we encounter a work of architecture.

FIGURE 4.25 *Buckingham Palace, London.*
Source: British Tourist Authority.

FIGURE 4.26 *Palace of Versailles, France (1669–1685). Architects: Louis LeVau and Jules Hardouin-Mansart.*
Source: Pan American Airways, Corp.

Context

An architectural design must take into account its context, or environment. In many cases, context is essential to the statement made by the design. For example, the cathedral of Notre Dame, Chartres (Fig. 4.27) sits at the center of and on the highest point in the village of Chartres, France. Its placement at that particular location had a purpose for the medieval artisans and clerics responsible for its design. The centrality of the cathedral to the community made an essential statement of the centrality of the Church to the

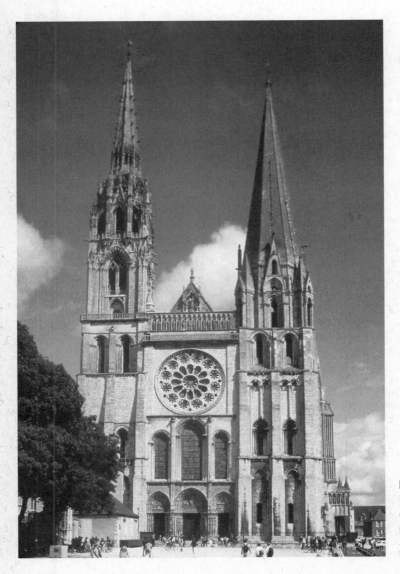

FIGURE 4.27 *Herve Champollion/Caisse National des Monuments Historique et des Sites, Paris, France*
Source: Photo Lauros/Giraudon, Art Resource, N.Y.

life of the medieval community. Context also has a psychological bearing on scale. A skyscraper in the midst of skyscrapers has great mass but does not appear as massive in scale when overshadowed by another, taller skyscraper. A cathedral, when compared with a skyscraper, appears relatively small in scale. However, when standing at the center of a community of small houses, it seems quite the opposite.

Two additional aspects of context concern the design of line, form, and texture relative to the physical environment of the building. On one hand, the environment can be shaped according to the compositional qualities of the building. Perhaps the best illustration of that principle is Louis XIV's palace at Versailles (Fig. 4.26), whose formal symmetry is reflected in the design of thousands of acres around it.

In contrast, a building may be designed to reflect the natural characteristics of its environment. Frank Lloyd Wright's "Falling Water" (Fig. 4.28) illustrates this principle.

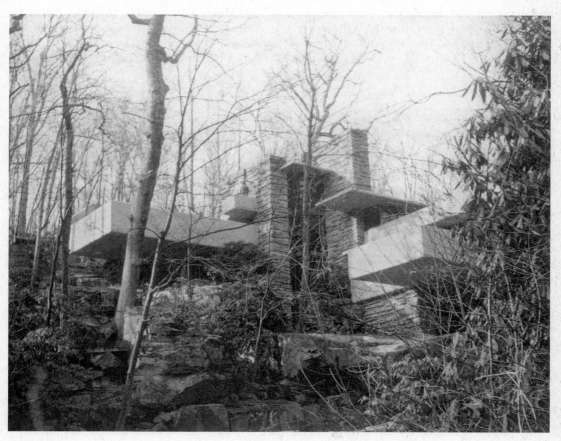

FIGURE 4.28 *Frank Lloyd Wright (1867–1959), Kaufmann House, "Falling Water," Bear Run, Pennsylvania, 1936–37. Courtesy of Donald Girouard.*

Such an idea has been advanced by many architects and can be seen especially in residences in which large expanses of glass allow us to feel a part of the outside while we are inside. The interior decoration of such houses often takes as its theme the colors, textures, lines, and forms of the environment surrounding the home. Natural fibers, earth tones, delicate wooden furniture, pictures that reflect the surroundings, large open spaces—together they form the core of the design, selection, and placement of nearly every item in the home, from walls to furniture to silverware. Sometimes a building seems at odds with its context. Situated in the middle of historic Paris near the old marketplace, Les Halles, the Pompidou Centre (color inserts, Plates 12 and 13), an art museum whose brightly painted infrastructure appears on the outside of the building, seems out of place beside its more ancient neighbors.

SPACE

It seems almost absurdly logical to state that architecture must concern space—for what else, by definition, is architecture? However, the world teems with examples of architectural design that have not met that need. Design of space essentially means the design and flow of contiguous *spaces* relative to function. Take, for example, a sports arena. Of primary concern is the space necessary for the sports intended to occupy the building. Will it play host to basketball, hockey, track,

A Question of Style

Postmodern

postmodern (pohst-MAHD-uhrn). In visual art, architecture, dance, and literature, a diverse, highly individualistic style that rejects modernism and its principles. It is distinguished by eclecticism and anachronism, in which works may reflect and comment on a wide range of stylistic expressions and cultural–historical viewpoints, including breaking down the distinctions between "high art" and popular culture. Self-reference is often at the center of creation and presentation. One common theme appears to be a basic concern for how art functions in society. In architecture, it seeks social identity, cultural continuity, and sense of place. We see the tenets of postmodernism and its repudiation of the glass-and-steel box of the modern, International, style in the design of the Pompidou (pohm-pee-DOO) Center in Paris (color inserts, Plates 12 and 13). The building literally turns inside out, with its network of ducts, pipes, and elevators color-coded and externalized, and its internal structure hidden. The interior spaces have no fixed walls, but temporary dividers allow any configuration wanted. The bright primary colors on the exterior combine with the serpentine, Plexiglas-covered escalators to give a whimsical, lively appearance to a functional building. The Pompidou Center has become a tourist attraction in Paris rivaling the Eiffel Tower, and, while controversial, it has gained wide popular acceptance.

A Question to Ask

In what ways does the building reflect or compete with its context?

football, or baseball? Each of these sports places a design restriction on the architect, and curious results occur when functions not intended by the design force themselves into its parameters. When the Brooklyn Dodgers moved to Los Angeles, they played for a time in the Los Angeles Coliseum, a facility designed for the Olympic games and track and field and reasonably suited for the addition of football. However, the imposition of baseball created ridiculous effects; the left-field fence was only slightly over 200 feet from home plate.

In addition to the requirements of the game, a sports arena must also accommodate the requirements of the spectators. Pillars that obstruct the spectator's view do not create goodwill and the purchase of tickets. Likewise, attempting to put more seats in a confined space than ought to be there can create great discomfort. Determining where to draw the line between more seats and fan comfort is not easy. The old Montreal Forum, in which anyone over the height of 5 feet 2 inches had to sit with the knees under the chin, did not prove deleterious to ticket sales for the Montreal Canadiens hockey team. However, such a design of space might be disastrous for a franchise in a less hockey-oriented city.

Finally, the design of space must concern the relationship of various needs peripheral to the primary functions of the building. Again, in a sports arena the sport and its access to the spectator are primary. However, the relationship of access to spaces such as restrooms and concession stands must also be considered. I once had season basketball tickets in an arena seating 14,000 people in which access to the *two* concession stands required standing in a line that, because of spatial design, intersected the line to the restrooms. If the effect was not chaotic, it certainly was confusing, especially at half time of an exciting game.

CLIMATE

Climate always has been a factor in architectural design in zones of severe temperature, either hot or cold. As the world's energy supplies diminish, this factor will grow in importance. In the temperate climate of much of the United States, solar systems and designs that make use of the moderating influence of the earth are common. These are *passive* systems—that is, their design accommodates natural phenomena rather than adding technological devices such as solar collectors. For example, in the colder

A Question to Ask

How does the building either assist or inhibit a smooth traffic flow through its spaces?

sections of the United States a building can be made energy efficient by being designed with no glass, or minimal glass, on its north-facing side. Windows facing south can be covered or uncovered to catch existing sunlight, which even in midwinter provides considerable warmth. Also, because temperatures at the shallow depth of 3 feet below the earth's surface rarely exceed or go below 50 degrees regardless of season, the earth presents a gold mine of potential for design. Houses built into the sides of hills or recessed below the earth's surface require much less heating or cooling than those standing fully exposed—regardless of climate extremes. Even in zones of uniform and moderate temperature, climate is a design factor. The "California lifestyle," as it often is known, has created design that accommodates easy access to the out-of-doors, and large, open spaces with free-flowing traffic patterns.

HOW DOES IT STIMULATE THE SENSES?

As should be clear at this point, our sensual response to a form of aesthetic design consists of a composite experience. To be sure, the individual characteristics we have discussed previously stimulate our response. Lately, color has become an important tool to the postmodern architect in stimulating our sense responses. The effects of color in the Plaza d'Italia (color insert, Plate 14) turn architecture into an exotic sensual experience.

CONTROLLED VISION AND SYMBOLISM

The Gothic cathedral has been described as the perfect synthesis of intellect, spirituality, and engineering. The upward, striving line of the Gothic arch makes a simple yet powerful statement of medieval people's striving to understand their earthly relation to the spiritual unknown. Even today the simplicity and grace of that design have an effect on most who view a Gothic cathedral. Chartres' cathedral of Notre Dame (Figs. 4.27 and 4.29), unlike the symmetry of other gothic churches, has an asymmetrical design, arising from the replacement of one of its steeples because of fire. The new steeple reflects a later and more complex Gothic style, and as a result impedes the eye as it progresses upward. Only after some pause does the eye reach the tip of the spire, the point of which symbolizes the individual's escape from the earthly known to the unknown.

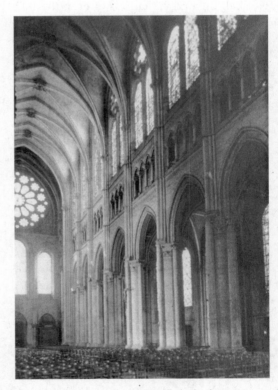

FIGURE 4.29 *Interior, Cathedral of Notre Dame, Chartres, France.*

Included in this grandeur of simple vertical line is an ethereal lightness that defies the material from which the cathedral is constructed. The medieval architect has created in stone not the heavy yet elegant composition of the early Greeks, which focused on treatment of stone, but rather a treatment of stone that focuses on space—the ultimate mystery. Inside the cathedral the design of stained glass kept high above the worshipers' heads controls the light entering the cathedral to effect an overwhelming sense of mystery. Line, form, scale, color, structure, balance, proportion, context, and space all combine to form a unified composition that has stood for nearly eight hundred years as a prototype and symbol of the Christian experience.

STYLE

The Christian experience forms the denominator of the design of the Holy Family Church (Fig. 4.30). However, despite the clarity of line and the upward striving power of its composition, this church suggests modern sophistication through its style, perhaps speaking more of our own conception of space, which to us seems less unknowable and more conquerable, than it seemed to our medieval predecessors. The juxtaposing of rectilinear and curvilinear line creates an

FIGURE 4.30 *The Church of the Holy Family, Parma, Ohio (1965). Architects: Conrad and Fleishman.*

active and dynamic response, one that prompts in us abruptness rather than mystery. The composition evolves coolness, and its material calls attention to itself—to its starkness and to its lack of decoration.

Each part of the church emerges distinctly and does not quite subordinate to the totality of the design. This building perhaps represents a philosophy intermediate between the philosophy underlying the Cathedral of Notre Dame, whose entire

design can be reduced to a single motif—the Gothic arch—and the philosophy such as the baroque style, as seen in the Hall of Mirrors of the Palace of Versailles (Fig. 4.31). No single part of the design of this hall epitomizes the whole, yet each part is subordinate to the whole. Our response to the hall is shaped by its ornate complexity, which calls for detachment and investigation and intends to overwhelm us with its opulence. Here, as in most art, the expression and the stimuli reflect the

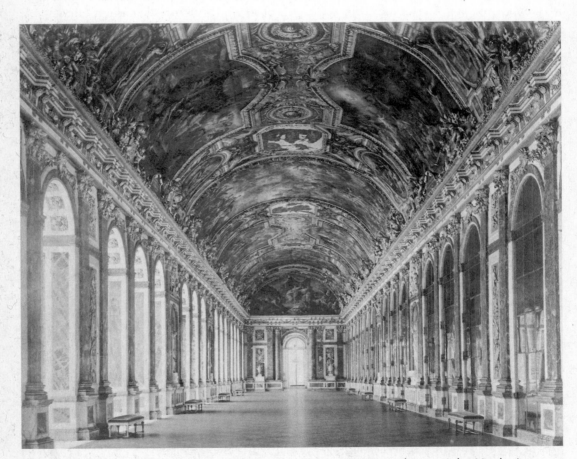

FIGURE 4.31 *Hall of Mirrors, Palace of Versailles, France (1680). Architects: Jules Hardouin-Mansart and Charles LeBrun.*
Source: French Government Tourist Office.

patron. The Cathedral of Notre Dame reflects the medieval church, the Church of the Holy Family, the contemporary church, and Versailles, King Louis XIV. Versailles is complex, highly active, and yet warm. The richness of its textures, the warmth of its colors, and its curvilinear softness create a certain kind of comfort despite its scale and formality.

In the U.S. Capitol, a neoclassic house of government (Fig. 4.32), formality creates a foursquare, solid response. The symmetry of its design, the weight of its material, and its coldness give us a sense of impersonal power, which is heightened by the crushing weight of the dome. Rather than the upward-striving spiritual release of the Gothic arch, or even the powerful elegance

of the Greek post-and-lintel, the Capitol building, based on Michelangelo's design for St. Peter's Basilica, Rome, elicits a sense of struggle. This is achieved through upward columnar thrust (heightened by the context provided by Capitol Hill) and downward thrust (of the dome) focused toward the interior of the building.

APPARENT FUNCTION

The architect Louis Sullivan, of whom Frank Lloyd Wright was a pupil, is credited with the concept that form follows function. To a degree, we have seen that concept in the previous examples, even though, with the exception of the Church of the Holy

FIGURE 4.32 *United States Capitol Building (1792–1856). Washington, D.C.*
Source: Convention and Visitors Association Photo.

Family, they all precede Sullivan in time. A worthy question concerning the Guggenheim Museum (Fig. 4.33) might be how well Wright followed his teacher's philosophy. There is a story that Wright hated New York City because of unpleasant experiences he had had with the city fathers during previous projects. As a result, the Guggenheim, done late in his life, became his final gesture of derision to the city. This center of contemporary culture and art, with its single, circular ramp from street level to roof, was built (so the story goes) from the plans for a parking garage. Be that as it may, the line and form of this building create a simple, smoothly flowing, leisurely, upward movement juxtaposed against a stark and dynamic rectilinear form. The building's line and color and the feeling they produce are contemporary statements appropriate to the contemporary art the museum houses. The modern design of the Guggenheim contrasts with the classical proportions of the Metropolitan Museum of Art, just down the street, which houses great works of ancient and modern art. The interior design is outwardly expressed in the ramp, and one can speculate that the slowly curving, unbroken line of the ramp is highly appropriate to the leisurely pace that one should follow when going through a museum.

DYNAMICS

Leisurely progress through the Guggenheim diametrically opposes the sensation stimulated by the cantilevered roof of the grandstand at Zarzuela Race Track in Spain (Fig. 4.18). Speed, power, and flight are its preeminent concerns. The sense of dynamic instability inherent in the structural form—that is, cantilever, and this particular application of that form—mirror the dynamic instability and forward power of the race horse at full speed. However, despite the form and the strong diagonals of this design, it is not out of control; the architect has unified the design through repetition of the track-level arcade in the arched line of the cantilevered roof. The design is dynamic and yet humanized in the softness of its curves and the control of its scale.

Dynamics also defines Canadian-born architect, Frank Gehry's (GHAIR-ee; b. 1929) Disney Hall in Los Angeles, California (Fig. 4.34). His architectural theory creates functional works of sculpture

FIGURE 4.33 *The Solomon R. Guggenheim Museum, New York City (1942–1959). Architect: Frank Lloyd Wright.*
Source: Photograph by David Heald/The Solomon R. Guggenheim Museum Photo. © The Solomon R. Guggenheim Foundation, New York.

rather than buildings in the traditional sense. His early works witnessed an architectural language of plywood and corrugated metal. Later, these evolved into distorted but lucid concrete and metal. They reflect an aesthetic that appears somewhat disjointed, as if attempting to belong to social context likewise disjointed. Disney Hall in Los Angeles, California, suggests to some the sails of a ship. It also can suggest the turmoil of our times in its "visual chaos." This building, along with Gehry's Guggenheim Museum building in Bilbao, Spain, attempts to change the language of architecture. Both stand like immense works of sculpture against the background of the city and continue a curvaceous, freeform style that has become the architect's signature. He utilized similar abstract, freeform components in other works such as the Gehry House and the Fishdance Restaurant, which employ a similarly sleek curvaceous cladding. The forms of the building take on sculptured dimensions so complex that they required an advanced aerospace computer program to allow the contractor to build the building in a reasonable way.

FIGURE 4.34 *Frank Gehry, Walt Disney Concert Hall, Los Angeles, California (opened 2003). Photograph by Lara Swimmer. Esto Photographics, Inc.*

A Question to Ask

In what ways do the dynamics of the building stimulate an emotional or intellectual response in me? Why is this so?

Elizabeth Diller (b. 1955) and Ricardo Scofidio (b. 1942) together form Diller & Scofidio, a collaborative interdisciplinary studio involved in architecture, the visual arts, and the performing arts. Their Blur Building, a media building for Swiss EXPO 2002, turns architecture into performance art. Blur Building (Fig. 4.35) constitutes a cloud measuring 300 feet wide by 200 feet deep hovering over Lake Nuechâtel in Yverdon-les-Bains, Switzerland, and floating at a height of 75 feet above the water. The cloud consists of filtered lake water shot as a fine mist through a dense array of high-pressure fog nozzles. The artificial cloud creates a dynamic form that constantly changes shape in response to actual weather: A built-in weather station electronically adjusts the water pressure and temperature in thirteen zones according to shifting humidity, wind direction, and speed.

The public can approach the cloud from shore via pedestrian ramp. Upon entering, the visitor finds visual and acoustical references slowly erased, leaving only an optical "white-out" and the "white noise" of pulsing

FIGURE 4.35 *Diller Scofidio + Renfro, Blur Building, Yverdon-les-Bains, Switzerland 2002.*

FIGURE 4.36 *C. Y. Lee and Partners, Taipei 101, Tapei, Taiwan, 2004.*
Source: ©Robert Holmes/DanitaDelimont Photography

fog nozzles. Sensory deprivation stimulates a sensory heightening: The density of air inhaled with every breath, the lowered temperature, the soft sound of water spray, and the scent of atomized water begin to overwhelm the senses. The public can circulate through the cloud, enter an interactive media space at its center, discover small media events distributed just outside in the fog, then proceed up and emerge, in the words of the architects, "like an airplane piercing a cloud layer" to the Angel Bar at the summit.

SCALE

Nothing suggests the technological achievement of modern humans more than the overwhelming scale of the skyscraper. Also, nothing symbolizes the subordination of humans to their technology like the scale of Taipei 101 (Fig. 4.36). On July 20, 2007, the Burj Dubai became the tallest building in the world when it officially surpassed 509 metres (1,671 feet), the height of Taiwan's Taipei 101. When finished in the summer of 2009, Burj Dubai will hold the record in all four categories as recognized by the Council on Tall Buildings and Urban Habitat, have the highest publicly accessible observation deck, and the world's fastest lift, which will shoot along at 65 km/hour (40 mph). Designed by the architects Skidmore, Owings, and Merrill, the Burj Dubai, in Dubai, United Arab Emirates, will have 200 floors and cost $800 million. As a point of departure, its appeal to our senses raises the question of what comes next, the conquest of space or a return to respect for its natural mysteries?

Sample Outline and Critical Analysis

The following very brief example illustrates how we can use our own personal response as a starting point along with some of the terms explained in the chapter to form an outline and then develop a critical analysis of a work of art. Here is how that might work regarding Baghdad-born and London-based architect Zaha Hadid's Lois and Richard Rosenthal Center for Contemporary Art in Cincinnati, Ohio (Fig. 4.37).

Outline	Critical Analysis
Personal reaction	An inventory of initial personal reactions to the museum includes sensations like dynamism, warmth, friendliness, and these play off other sensations like awkwardness, cramping, and edginess. Fundamentally, I like looking at the building. It has a terrific sense of movement caused by its almost inverted pyramidal design; that is, the top is wider than the bottom. That, however, is where the awkwardness comes in. It feels like the building defies gravity and might tip over at any minute. All the jutting angles and pure rectilinear forms seem edgy and sharp without much sense of softness, but at the same time, the building seems warm, open, people friendly, and human in scale.
Structure Materials	The specific structure of the building remains hidden, but the openness of the first, third, and fourth floors suggest steel cage. Knowing that the edifice is an art museum suggests the need for large, open areas, meaning that the

FIGURE 4.37 *Zaha Hadid, Lois and Richard Rosenthal Center for Contemporary Art, Cincinnati, Ohio, opened 2003.*
Source: Zaha Hadid Architects. Photo by Roland Halbe

Outline	Critical Analysis
	walls probably are curtain walls hanging from the skeleton. She has effectively employed cantilever, which gives the building most of its dynamism. The architect has used a variety of materials: glass, steel, concrete, and perhaps other materials in the decorative rectangles appended to the front and side of the building.
Context	The building seems squeezed into its context, sandwiched among larger buildings that tower over it in the rear, and similar-sized buildings that partner it along the street to its left. Ms. Hadid has made maximum use of the

Outline	Critical Analysis
	site, however, letting the building rise vertically, and yet at street level she has set the tower back from the perimeter of the site, the open space around the building creates its own envelope of environment.
Space	The extensive use of glass opens the building to view, and we see open public areas and some of the galleries, which appear to allow the free flow of movement required for viewing art in a museum context.

Additional Study and Cyber Sources

The following two sources offer hundreds of architectural examples indexed by architect. The first site adds dates and nation. The second site lists the architect and building and offers a cross-index of date and period: http://www.artcyclopedia.com/media/Architect.html
http://www.greatbuildings.com

c. 4000 B.C.E.–c. 300 C.E.

Egyptian Pyramids
Ancient Greece
 Ictinos and Callicrates: The Parthenon
 Temple of Athena
Rome
 Colosseum; Parthenon; Aqueduct, Segovia, Spain

c. 300–c. 1570

Byzantium
 Hagia Sophia
Romanesque Europe
 St. Trophime, Arles; St. Sernin, Toulouse
Gothic
 Notre Dame de Paris; Amiens Cathedral, France; Exeter Cathedral, England
Renaissance Europe
 Brunelleschi: Pazzi Chapel, Florence
 Alberti: Palazzo Rucellai, Florence
High Renaissance
 Bramante: Tempietto, Rome
 Michelangelo: apse, St. Peter's Rome

Mannerism
 Lescot: Lescot Wing of the Louvre, Paris

c. 1570–1800

Baroque
 Le Vau, Hardoin-Mansart: Versailles Palace
Neoclassicism
 Jefferson: Monticello
Rococo
 Poppelmann: Zwinger Palace, Dresden, Germany
 Zimmermann: Church at Die Veis, Bavaria

c. 1800–Present

Romanticism
 Berry: Houses of Parliament, London
 Gilbert: Woolworth Building, New York
Art Nouveau
 Gaudi: Casa Battlo, Barcelona
Modern
 Skidmore, Owings, and Merrill: Lever House, New York City
 Sullivan: Prudential Building, Buffalo, New York
 Le Corbusier: Savoye House, Poissy-sur-Seine, France
Prairie Style
 Wright: Robie House, Chicago
Postmodern
 Graves: Portland Public Office Building, Portland, Oregon

Music

We all have favorite forms of music. They might be tejano, reggae, rock, rhythm and blues, rap, gospel, or classical. Occasionally our favorite tune or musical form had a previous life: a rock tune once an operatic aria, or an ethnic style that combines styles from other ethnic traditions. Whatever the case, music comprises rhythms and melodies differing only in their method of composition. In this chapter, we'll concentrate first on some classical forms, but after that we'll discuss qualities that apply to all music.

Music often has been described as the purest of the art forms because of its freedom from the physical restrictions of space that apply to the other arts. However, the freedom enjoyed by the composer becomes a constraint for us listeners because music places significant responsibility on us, especially in trying to learn and apply musical terminology. We have only a fleeting moment to capture many of the characteristics of music. A painting or a sculpture stands still for us; it does not change or disappear, despite the length of time it takes us to find or apply some new characteristic.

We live in a society in which aural perceptions usually do not require any kind of

active listening. For example, we hear satellite service music in many stores, restaurants, office buildings, and on telephone "hold," intended solely as a soothing background designed not to attract attention. We hear music constantly on the radio, the television, and in the movies, but nearly always in a peripheral role. Therefore, we hardly ever undertake the kind of practice we need to attend to music and to perceive it in detail. However, like any skill, the ability to hear perceptively grows through repetition and training. If we have had limited experience in responding to music, we will find challenge in the concert hall hearing what there is to hear in a piece of music that passes in just a few seconds.

WHAT IS IT?

At a formal level, our experience of a musical work begins with its type or form, a term that has many different connotations. In addition to the forms we identify momentarily, we can also identify broader "forms" of music, including classical, and jazz, such as pop/rock, and so on. The term *classical* also refers to a specific style of music, mostly associated with the seventeenth century, within this broad "classical" form (see next column).

The basic form of a music composition shapes our initial encounter by providing us with some specific parameters for understanding. Unlike our experience with the theatre, for example, we usually find an identification of the musical composition, by type, in the concert program. Thus, if we know the definitions of the form, we can understand more fully how the piece works and what it might mean. The remainder of this section on What Is It? contains descriptions of two broadforms, classical and jazz

and some of their subforms. Because many musical forms grew out of a specific stylistic tradition, some of the descriptions include brief historical references.

CLASSICAL FORMS

Art Song

An art song is a setting of a poem for solo voice and piano. Typically, it adapts the poem's mood and imagery into music. Art song grew out of the Romantic style of the nineteenth century, and thus it has an emotional tendency, and its themes often encompass lost love, nature, legend, and the far away and long ago. In this type of composition, the accompaniment plays an important role in the composer's interpretation and acts as an equal partner with the voice. In this form, important words use stressed tones or melodic climaxes.

Franz Schubert's (SHOO-bairt; 1797–1828) "The Erlking" provides an excellent example. The song consists of a musical setting of a poem by Goethe (GHUHR-tuh) about the supernatural. Schubert uses a through-composed setting—he writes new music for each stanza—in order to capture the poem's mounting excitement. The piano plays the role of an important partner in transmitting the mood of the piece, creating tension with rapid octaves and menacing bass motif. Imaginative variety in the music allows Schubert's vocal soloist to sound like several characters in the dramatic development.

Cantata

A cantata, usually a choral work with one or more soloists and an instrumental ensemble, has several movements. Typified by the church cantata of the Lutheran church of the baroque period (1600–1750),

it often includes chorales and organ accompaniment. The word *cantata* originally meant a piece that was sung—in contrast to a sonata, which was played. The Lutheran church cantata (exemplified by those of Johann Sebastian Bach) uses a religious text either original or drawn from the Bible or familiar hymns (chorales). In essence, it serves as a sermon in music, drawn from the lectionary (prescribed Bible readings for the day and on which the sermon is based). A typical cantata might last twenty-five minutes and include several different movements—choruses, recitatives, arias, and duets.

Mass

The mass, a sacres choral composition, consists of five sections: Kyrie, Gloria, Credo, Sanctus, and Agnus Dei. These also form the parts of the mass ordinary (the Roman Catholic church texts that remain the same from day to day throughout most of the year). The Kyrie text implores, "Lord, have mercy upon us. Christ, have mercy upon us. Lord, have mercy upon us." The Gloria text begins, "Glory be to God on high, and on earth peace, good will towards men." The Credo states the creed: "We believe in one God, the Father, the Almighty, maker of heaven and earth," and so on. Sanctus confirms, "Holy, holy, holy, holy, Lord God of Hosts. Heaven and earth are full of thy glory. Glory be to thee, O Lord Most High." The Agnus Dei (Lamb of God) implores, "O Lamb of God, that takest away the sins of the world, have mercy upon us. O Lamb of God, that takest away the sins of the world, have mercy upon us. O Lamb of God, that takest away the sins of the world, grant us thy peace." The *requiem mass*, which often comprises a musical program, is a special mass for the dead.

Oratorio

An oratorio, a large-scale composition, uses a chorus, vocal soloists, and orchestra. Normally an oratorio sets a narrative text (usually biblical), but does not employ acting, scenery, or costumes. The oratorio was a major achievement of the baroque period. This type of musical composition unfolds through a series of choruses, arias, duets, recitatives, and orchestral interludes. The chorus of an oratorio, an important part, can comment on or participate in the dramatic exposition. Another feature of the oratorio, the narrator, uses recitatives (vocal lines imitating the rhythms and inflections of normal speech) to tell the story and connect the various parts. Like operas, oratorios can last more than two hours.

A familiar example is George Frederick Handel's (HAHN-duhl; 1685–1759) *Hallelujah Chorus* from the oratorio *Messiah*. The *Hallelujah Chorus* forms the climax of the second part of the work. The text proclaims a victorious Lord, whose host is an army with banners. Handel creates infinite variety by sudden changes of texture (see page 149) among monophony, polyphony, and homophony. Words and phrases repeat over and over again. In unison, the voices and instruments proclaim, "For the Lord God Omnipotent reigneth." Polyphony marks the repeated exclamations of "Hallelujah" and yields to homophony in the hymnlike *The kingdom of this world.*

Concerto

The *solo* concerto, an extended composition for an instrumental soloist and orchestra, reached its zenith during the classical period of the eighteenth century. It typically contains three movements, in which the first is fast, the second slow, and the

profile

Mozart

Wolfgang Amadeus Mozart (1756–1791), often considered the greatest musical genius of all time, produced—especially in view of his short life—an enormous amount of music including 16 operas, 41 symphonies, 27 piano and five violin concerti, 25 string quartets, 19 masses, and other works in every form popular in his time. Perhaps his greatest single achievement was the characterization of his operatic figures.

Mozart was born on January 27, 1756, in Salzburg, Austria. His father, Leopold Mozart, held the position of composer to the archbishop and was a well-known violinist and author of a celebrated theoretical treatise. When Wolfgang was only six years old, his father took him and his older sister, Maria Anna (called Nannerl) on tours throughout Europe during which they performed as harpsichordists and pianists, both separately and together. They gave public concerts, played at the various courts, and met the leading musicians of the day. In Paris in 1764, Mozart wrote his first published works, four violin sonatas. In London he came under the influence of Johann Christian Bach. In 1768, young Mozart became honorary concertmaster for the archbishop.

In 1772, however, a new archbishop came to power, and the cordial relationship Mozart enjoyed with the previous archbishop came to an end. By 1777, the situation became so strained that the young composer asked to be relieved of his duties, and the archbishop grudgingly agreed.

In 1777, Mozart traveled with his mother to Munich and Mannheim, Germany, and to Paris, where she died. On this trip alone, Mozart composed seven violin sonatas, seven piano sonatas, a ballet, and three symphonic works, including the *Paris Symphony*.

The final break between Mozart and the archbishop occurred in 1781, although prior to that time Mozart had unsuccessfully sought another position. Six years later, in 1787, Emperor Joseph II finally engaged him as chamber composer—at a salary considerably smaller than that of his predecessor. Mozart's financial situation worsened steadily, and he incurred significant debts that hounded him until his death.

Meanwhile, his opera *The Abduction from the Seraglio* (sih-RAHL-yo) enjoyed great success in 1782; in the same year, he married Constanze Weber (vay-bair), the daughter of friends. He composed his great *Mass in C Minor* for her, and she sang the soprano solos at its premiere.

During the last ten years of his life, Mozart produced most of his great piano concerti; four horn concerti; the *Haffner, Prague, Linz,* and *Jupiter* symphonies; the six string quartets dedicated to Haydn; five string quintets; and the major operas—*The Marriage of Figaro, Don Giovanni, Cosí Fan Tutte, La Clemenza di Tito,* and *The Magic Flute*. Mozart could not complete his final work, a Requiem, because of illness. He died in Vienna on December 5, 1791, and was buried in a multiple grave. Although the exact nature of his illness is unknown, there is no evidence that Mozart's death was deliberately caused (as the popular movie *Amadeus* implies).

A Question of Style

Classicism in Music

classicism (KLAS-uh-sihz-uhm). The principles, historical traditions, aesthetic attitudes, or style of the arts of ancient Greece and Rome, including works created in those times or later inspired by those times. Or, classical scholarship. Or, adherence to or practice of the virtues thought to be characteristic of classicism or to be universally and enduringly valid—that is, formal elegance and correctness, simplicity, dignity, restraint, order, and proportion. Musical classicism (eighteenth century) pursued classical goals through careful attention to form. It exhibits five basic characteristics: (1) variety and contrast in mood, (2) flexibility of rhythm, (3) a predominantly homophonic texture, (4) memorable melody, and (5) gradual changes in dynamics.

The classical symphony takes its name from the Latin *symphonia* (based in turn on a Greek word), meaning "a sounding together." Seen as the typical classical symphony, Mozart's Symphony No. 40 in G minor has a clear order and restraint, and yet it exhibits tremendous emotional urgency. The first of its four movements is written in sonata form (see page 151) and begins *allegro molto*. The violins state the first theme above a soft chordal accompaniment, which establishes the tonic key of G minor. Three short motifs repeat throughout the piece. The liveliness of the lower strings accentuates the restlessness of the rhythm. The second theme in the woodwinds and strings provides a relaxing contrast. In a contrasting key, the relative major, B flat, it flows smoothly, each phrase beginning with a gliding movement down a chromatic scale. A codetta echoes the basic motif on various instruments and finishes with a cadence in B flat major. In most performances, the entire exposition section repeats, giving the movement an AABA form.

The development section concentrates on the basic three-note motif and explores the possibilities of the opening theme. This somewhat brief section has lots of drama. The recapitulation restates the first theme in the home key, and then the second theme, also in G minor rather than in the original major. This gives the ending a more mournful character than the equivalent section in the exposition. A coda in the original key ends the movement.

third fast. Concertos join a soloist's virtuosity and interpretive skills with the wide-ranging dynamics and tonal colors of an orchestra. The concerto provides, thus, a dramatic contrast of musical ideas and sound in which the soloist is the star. Typically, concertos present great challenge to the soloist and great reward to the listener, who can delight in the soloist's meeting of the technical and interpretive challenges of the work. Nonetheless, the concerto retains a balance in which the orchestra and soloist act as partners. The interplay between orchestra and soloist provides the listener with fertile ground for involvement and discernment. Concertos can last from 20 to 45 minutes. Typically, during the first movement, and sometimes the third, of a classical concerto,

the soloist has an unaccompanied show-piece called a cadenza.

Common to the late baroque period, the *concerto grosso*, a composition for several instrumental soloists and small orchestra, contrasts between loud and soft sounds and between large and small groups of perform-ers. In a concerto grosso, a small group of soloists (two to four) contrasts a larger group called the *tutti*, which consists of eight to twenty players. Most often a concerto grosso contains three movements with contrasts in tempo and character. The first movement is fast; the second, slow; and the third, fast. The opening movement, usually bold, explores the contrasts between tutti and soloists. The slow movement is more lyrical, quiet, and intimate. The final movement is lively, light-hearted, and sometimes dancelike.

Symphony

An orchestral composition, usually in four movements, a symphony typically lasts between twenty and forty-five minutes. In this large work, the composer explores the full dynamic and tonal range of the orches-tral ensemble. The symphony came from the classical period of the eighteenth cen-tury and evokes a wide range of carefully structured emotions through contrasts of tempo and mood. The sequence of move-ments usually begins with an active fast movement, changes to a lyrical slow move-ment, moves to a dancelike movement, and closes with a bold fast movement. The opening movement is almost always in sonata form. Most classical symphonies have self-contained movements, each with its own set of themes. Unity in a symphony occurs partly from the use of the same key in three of the movements and also from careful emotional and musical complement among the movements. As an example, Ludwig van Beethoven's (1770– 1827) Symphony No. 5 has no break between the third and fourth movements. In some of his four-movement works, he changed the traditional third move-ment minuet and trio to a scherzo and trio of significantly livelier character. Beethoven's symphonies draw heavily on imagery, for example the image of heroic action in Symphony No. 3 and pastoral settings in Symphony No. 6. The famous Symphony No. 5 in C minor, for example, begins with a motif that Beethoven described as "fate knocking at the door."

Fugue

The fugue (fyoog), a polyphonic (two or more melodic lines of relatively equal importance performed at the same time) composition based on one main theme or subject, can be written for a group of instru-ments or voices or for a single instrument like an organ or harpsichord. Throughout the composition, different melodic lines, called "voices," imitate the subject. The top melodic line is the soprano and the bottom line, the bass. A fugue usually includes three, four, or five voices. The composer's explo-ration of the subject typically passes through different keys and combines with different melodic and rhythmic ideas. An extremely flexible form, the fugue has as its only con-stant feature the beginning in which a single unaccompanied voice states the theme or subject. The listener must, then, remember that subject and follow it through the various manipulations that follow.

Jazz Forms

Jazz probably began toward the end of the nineteenth century, but we do not know for sure because for many years it existed solely

A Question of Style

Baroque

baroque (buh-ROHK). A diverse artistic style from the late sixteenth to early eighteenth centuries, marked typically by complexity, elaborate form, and appeal to the emotions. In literature it witnessed bizarre, calculatedly ingenious, and sometimes intentionally ambiguous imagery.

Baroque music, like its visual cousins, in many cases reflected the needs of churches, which used its emotional and theatrical qualities to make worship more attractive and appealing. The new scientific approaches of Galileo and Newton, for example, and the rationalism, sensuality, materialism, and spirituality of the times also found themselves manifested in art and music. The term *baroque* refers to music written during the period extending approximately from 1600 to 1750. The term itself originally referred to a large, irregularly shaped pearl of the kind often used in the extremely fanciful jewelry of the post-Renaissance period, and music of this style was a luscious, ornate, and emotionally appealing as its siblings of painting, sculpture, and architecture (see Plates 1 and 16, and Fig 4.31). Exemplary of the style were the works of Johann Sebastian Bach (1685–1750). His *Brandenburg* Concerto No. 2 has three movements (fast-slow-fast), which contrast the solo and the *ripieno* (full ensemble). Bach treats the solo group in various combinations. The solo group contains recorder, oboe, horn, and violin, and Bach exhibits their timbre characteristics among solos, duets, trios, and quartets. This piece is often played with *flute* and trumpet (an early manuscript allows for horn as an alternative), but the word flute usually meant recorder in Bach's time. The piece has three sections, with an "episode" between the second and third. Bach uses thematic material very ingeniously, combining, recombining, and moving from instrument to instrument with deft handling of harmonies and textures.

in performance rather than being written down. Almost no jazz pieces found their way to recordings before 1923, and none at all before 1917 when the Original Dixieland Jazz Band made a recording. Jazz blended elements from diverse musical cultures, including West Africa, America, and Europe. Several important characteristics developed from the West African traditions. These included emphasis on improvisation, percussion, rhythmic complexity, and a characteristic called "call and response." African drumming, like jazz, is often extremely complex, producing a dense, interlocking texture of multiple, simultaneous rhythms and notes. Call and response also lies at the core of West African tribal music and consists of a soloist who sings a phrase to which a chorus responds. Jazz uses this when a voice or instrument is answered by an instrument or group of instruments.

Blues

Developing out of a variety of venues—street, bars, brothels, and dance halls—in New Orleans and played mostly by African American musicians, jazz employs

improvisation, syncopation, a steady beat, unique tone colors, and specialized performance techniques such as "blues," which became a national craze in the 1920s. Probably the most popular blues song ever written is W. C. Handy's (1873–1958) "St. Louis Blues." The melody contains the Afro-Spanish habanera rhythms that Handy heard when he toured Cuba with his minstrel show at the turn of the twentieth century. He borrowed the final strain in the song from "Jogo Blues," an instrumental piece he had written the year before, whose melody came from Handy's preacher. Another type of blues, vocal blues, is intensely personal and often has references to sexuality, the pain of desertion, and unrequited love, with a very specific metrical and poetic form consisting of two rhythmic lines and a repeat of the first line. Performers like Bessie Smith (1894–1937) gave the blues an emotional quality, which the accompanying instruments tried to imitate.

New Orleans Style

Jazz also found its materials in spirituals, work songs, and gospel hymns. Out of this deep well came jazz as we know it in its wide variety of substyles, including New Orleans style (Dixieland), swing, bebop, cool jazz, and free jazz. In the New Orleans style, the front line or melodic instruments improvise several contrasting melodic lines at once, supported by a rhythm section clearly marking the beat and providing a background of chords. New Orleans style typically has a march or church melody, ragtime piece, or popular song as its base. Swing developed in the 1920s and flourished from 1935 to 1945. This is a "big band" style, ideal for dancing, and it worked its way into the forefront of American popular music.

Ragtime

Ragtime is a type of piano music (occasionally played on other instruments) dating to the 1890s. Mostly growing out of the saloons and dancehalls of the South and Midwest, and largely played by African American pianists like Scott Joplin (1868–1917), "ragging" involves taking a classical or popular tune and playing it with syncopation. It later developed a style and compositions of its own, such as Joplin's *Maple Leaf Rag*. Typically in duple meter, ragtime takes a steady, regular beat in the left hand and juxtaposes it against a lively, syncopated melody in the right hand.

Free Jazz

By the end of the 1950s, jazz moved away from fixed chord progressions, and by the 1960s and 70s had produced a new style called "free jazz." Free jazz depends on two qualities, creative improvisation and original compositions. Abstract, dense, and difficult to follow, this style often does away with regular rhythmic patterns and melodic lines, and utilizes energetic drumming and melodic improvisation with extremely high notes, squawks, and squeals. Raucous and chaotic, it lacks the appeal of other forms of jazz.

Fusion

In the 1970s and 80s, jazz combined with elements of rock music to produce an extremely popular style called fusion. The primary elements of fusion are use of electronic instruments (synthesizers, electric pianos, and electric bass guitar), large percussion sections, and simplicity of form and harmony. Often based on simple chord progressions and repetitive rhythmic patterns, it layers above these foundations a wide variety of different sounds.

Plate 7 Shakespeare's *Richard II,* Act II, scene 2: Entrance into St. Stephen's Chapel. Producer: Charles Kean, London (1857). Courtesy of The Victoria and Albert Museum, London. Colored sketching of this scene with man and three women in picture. V & A Images.

Plate 8 Scene design (probably an alternate design) for Charles Fechter's revival of Shakespeare's *Hamlet*, Lyceum Theatre, London (1864). Designer: William Telbin. Courtesy of The Victoria and Albert Museum, London. V & A Images.

Plate 9 Dancers create a pyramidal form. National Dance Theater Company. Photo by Denis Anthony Valentine. © Denis Anthony Valentine/CORBIS All Rights Reserved.

Plate 10 The Dome of the Rock mosque, known in Arabic as Al Quds (The Holy), with its golden dome under a deep blue sky, on the noble Rock, Jerusalem, Israel. Photo by David Paterson. Creative Eye/MIRA.com.

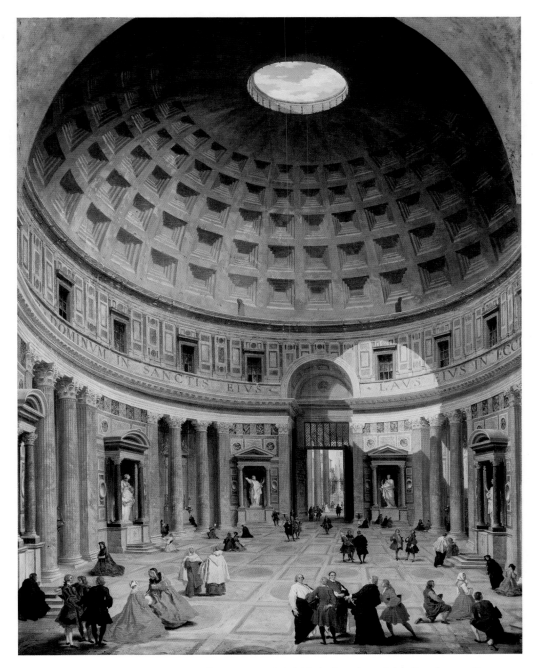

Plate 11 Giovanni Paolo Panini (Roman, 1691-1765), *Interior of the Pantheon, Rome*, c. 1734. Oil on canvas, 1.280 x .990 (50 1/2 x 39); framed, 1.441 x 1.143 (56 3/4 x 45). Samuel H. Kress Collection. Photograph © 2001 Board of Trustees, National Gallery of Art, Washington, D.C. 1939.1.24.(135)/PA. Photo by Richard Carafelli.

Plate 12 View Centre Beaubourg, Paris. Front view of large modern building, with tubal covered stairs across front. Distant view of people in front court of building. The Centre Pompidou first opened in 1977. Photo by Charles Kennard. Stock Boston.

Plate 13 Pompidou Centre-Paris. Upward view of people riding on/in a glass enclosed escalator. View of both up and down escalators. The Centre Beaubourg was first opened in 1977. Photo by David Simpson. Stock Boston.

Plate 14 Piazza d'Italia, New Orleans, Louisiana. Charles Moore designed the Piazza d'Italia, built in 1977-8. This community center is used for Italian-American celebrations and festivals. Photo by Richard Pasley. Stock Boston.

Groove

Moving from the 1990s into the twenty-first century, jazz has seen another revival of popularity with the reappearance of many of the old styles: Dixieland, big-band, and be-bop, for example, with Wynton Marsalis among the featured names. In the twenty-first century, jazz has become its own international language with large followings in Japan, Europe, and North and South America, and it continues to evolve, blending with popular dance rhythms and emerging new styles such as "groove" music, or "funk," which suggests the blues in a highly complex, repetitive, and rhythmic approach.

HOW IS IT PUT TOGETHER?

Understanding vocabulary and being able to identify its application in a musical work help us comprehend communication using the musical language, and thereby understand the creative communicative intent of the composer and the musicians who bring the composition to life. The ways in which musical artists shape the characteristics that follow bring us experiences that can challenge our intellects and excite our emotions. As in all communication, meaning depends on each of the parties involved; communicators and respondents must assume responsibility for facility in the language utilized.

Among the basic elements by which music is put together, we will identify and discuss seven: (1) Sound, (2) Rhythm, (3) Melody, (4) Harmony, (5) Tonality, (6) Texture, and (7) Musical Form.

SOUND

Music designs sound and silence. In the broadest sense, sound is anything that excites the auditory nerve: sirens, speech, crying babies, jet engines, falling trees, and so on. We might even call such sources noise. Musical composition, although it can even employ "noise," usually depends on controlled and shaped sound consistent in quality. We distinguish music from other sounds by recognizing four basic properties: (1) pitch, (2) dynamics, (3) tone color, and (4) duration.

Pitch

Pitch, the relative highness or lowness we hear in sound represents a physical phenomenon measurable in vibrations per second. So, when we describe differences in pitch, we describe recognizable and measurable differences in sound waves. A pitch has a steady, constant frequency. A faster frequency produces a higher pitch; a slower frequency, a lower pitch. If we shorten a sounding body—a vibrating string, for example—it vibrates more rapidly. Musical instruments designed to produce high pitches, such as the piccolo, therefore tend to be small. Instruments designed to produce low pitches tend to be large—for instance, bass viols and tubas. In music, we call a sound that has a definite pitch a tone.

In Chapter 2, we discussed color. Color comprises a range of light waves within a visible spectrum. Sound also comprises a spectrum, one whose audible pitches range from 16 to 38,000 vibrations per second. We can perceive 11,000 different pitches; obviously more than practical for musical composition. Therefore, *by convention*, musicians divide the sound spectrum into roughly ninety equally spaced frequencies comprising seven and a half *octaves*. The piano keyboard, consisting of eighty-eight keys (seven octaves plus two additional tones) representing the same number of

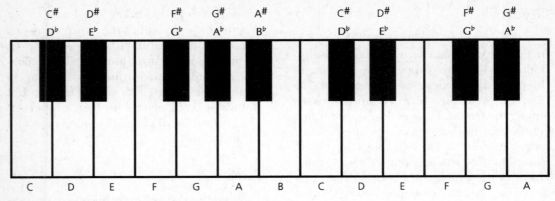

FIGURE 5.1 *Part of the piano keyboard and its pitches*

equally spaced pitches, serves as an illustration (Fig. 5.1).

A scale, an arrangement of pitches or tones played in ascending or descending order, represents a conventional organization of the frequencies of the sound spectrum (Fig. 5.2). Not all music conforms to this convention. Music of Western civilization prior to approximately C.E. 1600 does not, nor does Eastern music, which makes great use of quarter tones. In addition, some contemporary Western music departs from the conventions of tonality of the major or minor scale. Islamic calls to prayer exhibit this quality. These examples represent cultures whose music does not conform to the Western conventions of pitch and scale, or tonality. Other characteristics, however, make this music sound different from the music of Bach, for example.

Dynamics

We call degrees of loudness or softness in music dynamics. Any tone can be loud, soft, or anywhere in between. Dynamics is the *decibel* level of tones and depends on the physical phenomenon of *amplitude* of vibration. Greater force employed in the production of a tone results in wider sound waves and causes greater stimulation of the auditory nerves. The *size* of the sound wave, not its number of vibrations per second, changes.

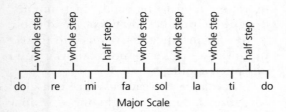

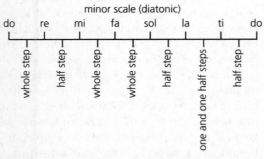

FIGURE 5.2 *The major and minor scales.*

A Question to Ask

Does this music sound like music typical of my culture? What musical characteristics make this so?

Composers indicate *dynamic levels* with a series of specific notations:

pp	pianissimo (pee-yah-NEES—ee-moh)	very soft
p	piano	soft
mp	mezzo (MEHT-zoh) piano	moderately soft
mf	mezzo forte	moderately loud
f	forte (FOR-tay)	loud
ff	fortissimo (for-TEE-see-moh)	very loud

The notations of dynamics that apply to an individual tone, such as *p*, *mp*, and *f*, also may apply to a section of music. Changes in dynamics may be abrupt, gradual, wide, or small. A series of symbols also governs this aspect of music.

⊂	Crescendo (kreh-SHENN-doh)	becoming louder
⊃	Decrescendo	becoming softer
>∧*sfz*	Sforzando (sfohrt-ZAHN-doh)	"with force"; a strong accent immediately followed by *p*

As we listen to and compare musical compositions, we can consider the use and breadth of dynamics in the same sense that we consider the use and breadth of palette in painting.

Tone Color

Tone color, or *timbre* (TAM-buhr), signifies the characteristic of tone that allows us to distinguish a pitch played on a violin, for example, from the same pitch played on a piano. In addition to identifying characteristic differences among sound-producing sources, tone color characterizes differences in quality of tones produced by the same source. Here the analogy of tone color is particularly appropriate. We call a tone produced with an excess of air—for example, by the human voice—"white." Figure 5.3 illustrates some of the various sources that produce musical tone and account for its variety of tone colors. The following table also lists these and other sources that produce musical tone and account for its timbres.

Voice		*Electronic*
Soprano	⎫	Synthesizer
Mezzo-soprano	⎬ Women's	
Contralto	⎭	
Tenor	⎫	
Baritone	⎬ Men's	
Bass	⎭	

Strings	*Woodwinds*	*Brasses*
Violin	Flute	Trumpet
Viola	Piccolo	Horn
Cello	Oboe	Trombone
(violoncello)	English horn	Tuba
Bass	Clarinet	
Harp	Bassoon	

Percussion		
Snare drum	Piano	Harpsichord
Bass drum		
Timpani		
Triangle		
Cymbal		

The piano could be considered either a stringed or a percussion instrument because it produces its sound by vibrating strings *struck* by hammers. The harpsichord's strings are set in motion by plucking.

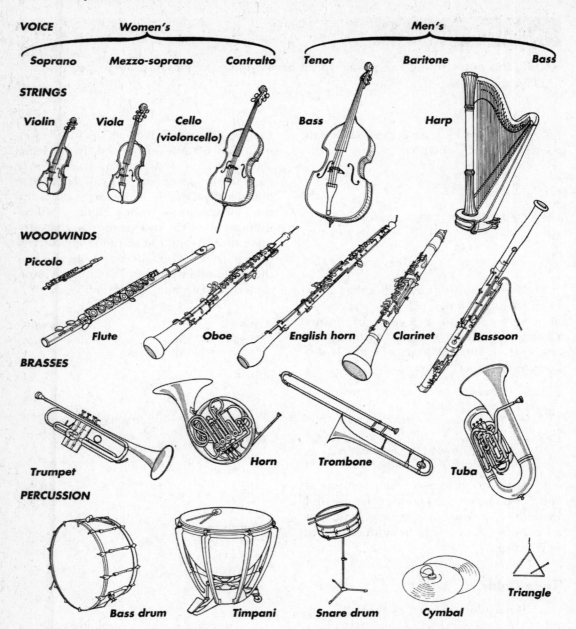

VOICE

Women's — Soprano Mezzo-soprano Contralto

Men's — Tenor Baritone Bass

STRINGS

Violin Viola Cello (violoncello) Bass Harp

WOODWINDS

Piccolo Flute Oboe English horn Clarinet Bassoon

BRASSES

Trumpet Horn Trombone Tuba

PERCUSSION

Bass drum Timpani Snare drum Cymbal Triangle

FIGURE 5.3 *The key sources of musical tone in an orchestra (instruments not to scale).*
Source: Laurence King Publishing Ltd., London, England.

Electronically produced music, available since the development of the RCA synthesizer at the Columbia-Princeton Electronics Music Center, has become a standard source in assisting contemporary composers (Fig. 5.4). Originally electronic music fell into two categories: (1) the electronic altering of acoustically produced sounds, which came to be labeled as *musique concrète* (see Glossary), and (2) electronically generated sounds. However, advances in technology have blurred those differences over the years.

Synthesizing technology took an important step forward with the development of MIDI (pronounced mihd-dee; for musical instrument digital interface), a standard adopted by manufacturers for interfacing synthesizer equipment. MIDI allowed the device played on to be separated from tone production, for example keyboards that look, feel, and play like a piano and string controllers that play like a violin. In addition, control signals can be fed to and from a MIDI instrument into and out of a

FIGURE 5.4 *Musician at an electronic control panel. Randy Matusow/Monkmeyer Press. Source:* Dan Nelken/Dan Nelken Studio Inc.

personal computer so users can edit and store music and convert to and from musical notation. Computers now can act both as controllers to drive MIDI equipment and for direct digital synthesis.

Duration

Duration, another characteristic of sound, constitutes the length of time in which vibration is maintained without interruption. Duration in musical composition uses a set of conventions called musical notation (Fig. 5.5). This system consists of a series of symbols (notes) by which the composer indicates the relative duration of each tone. The system is progressive—that is, each note is either double or half the duration of an adjacent note. Musical notation also includes a series of symbols that denote the duration of *silences* in a composition. These symbols, called *rests*, have the same durational values as the symbols for duration of tone.

RHYTHM

Rhythm comprises recurring pulses and accents that create identifiable patterns. Without rhythm we have only an aimless rising and falling of tones. Earlier we noted that each tone and silence has duration. Composing music means placing each tone

into a time or rhythmical relationship with every other tone. As with the dots and dashes of the Morse code we can "play" the rhythm of a musical composition without reference to its tones. Each symbol (or note) of the musical notation system denotes a duration relative to every other symbol in the system. Rhythm consists of: (1) beat, (2) meter, and (3) tempo.

Beat

The individual pulses we hear are called beats. Beats may be grouped into rhythmic patterns by placing accents every few beats. Beats represent basic units of time and form the background against which the composer places notes of various lengths.

Meter

Normal musical practice groups clusters of beats into units called *measures*. When these groupings are regular and reasonably equal they comprise *simple* meters. When the number of beats in a measure equals three or two it constitutes *triple* or *duple* (DOO-puhl) meter. As listeners, we can distinguish between duple and triple meters because of their different *accent* patterns. In triple meter we hear an accent every third beat—ONE two three, ONE two three—and in duple meter the accent is every other beat—ONE two, ONE two. If there are four beats in a measure, the second accent is weaker than the first—ONE two THREE four, ONE two THREE four. When accent occurs on normally unaccented beats, we have *syncopation*.

Tempo

Tempo is the rate of speed of the composition. A composer may notate tempo in two ways. The first involves a *metronome marking*,

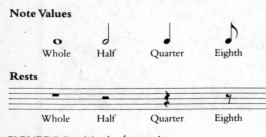

Note Values

Whole Half Quarter Eighth

Rests

Whole Half Quarter Eighth

FIGURE 5.5 *Musical notation.*

such as ♩ = 60. This means playing or singing the piece at the rate of sixty quarter notes (♩) per minute. The other method, although less precise, involves more descriptive terminology in Italian.

The tempo may be quickened or slowed, and the composer indicates this by the words *accelerando* (accelerate) and *ritardando* (retard, slow down). A performer who takes liberties with the tempo uses *rubato* (roo-BAH-toh).

Largo (broad) Grave (grahv) (grave, solemn)	Very slow
Lento (slow) Adagio (ah-DAHZH-ee-oh) (leisurely)	Slow
Andante (at a walking pace) Andantino (somewhat faster than andante) Moderato (moderate)	Moderate
Allegretto (briskly) Allegro (cheerful, faster than allegretto)	Fast
Vivace (vih-VAH-chay) (vivacious) Presto (very quick) Prestissimo (as fast as possible)	Very fast

MELODY

Melody is a succession of sounds with rhythmic and tonal organization. We can visualize melody as linear and essentially horizontal. Thus, any organization of musical tones occurring *one after another* constitutes a melody. Two other terms, *tune* and *theme*, relate to melody as parts to a whole. For example, the *tune* in Figure 5.6 is a melody—that is, a succession of tones. However, a melody is not always a tune. In general, the term *tune* implies singability, and many melodies cannot be sung. A *theme* is also a melody. However, in musical composition, it specifically means a central musical idea, which may be restated and varied throughout a piece. Thus a melody is not necessarily a theme.

Related to theme and melody, the *motif* (moh-TEEF), or *motive*, constitutes a short melodic or rhythmic idea around which a composer may design a composition. For example, in Beethoven's Symphony No. 5 in C minor, the first movement develops around a motif of four notes.

In listening for how a composer develops melody, theme, and motive, we can use two terms to describe what we hear: *conjunct* and *disjunct*. Conjunct melodies comprise notes close together, stepwise, on the musical scale. For example, the interval between the opening notes of the soprano line of J. S. Bach's chorale "Jesu Joy of Man's Desiring" from his Cantata 147 (Fig. 5.7) never occupy more than a whole step. Such melodic development is highly conjunct. Disjunct melodies contain intervals of a third or more. However, no formula determines disjunct or conjunct characteristics; no line exists at which a melody ceases to be disjunct and becomes conjunct. These constitute relative and comparative terms that assist us in description. For example, we would say that the opening melody of "The Star Spangled Banner" (Fig. 5.6) is more disjunct than the opening melody of "Jesu Joy of Man's Desiring"—or that the latter is more conjunct than the former.

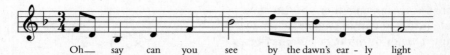

FIGURE 5.6 *"The Star Spangled Banner" (excerpt).*

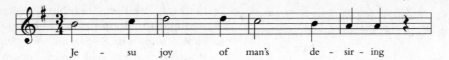

Je - su joy of man's de - sir - ing

FIGURE 5.7 *"Jesu Joy of Man's Desiring" (excerpt).*

HARMONY

When two or more tones sound at the same time, we have harmony. Harmony is essentially a vertical arrangement, in contrast with the horizontal arrangement of melody.

However, as we shall see, harmony also has a horizontal property—movement forward in time. In listening for harmony, we are interested in how simultaneous tones *sound together.*

Two tones played simultaneously are an *interval*; three or more form a *chord.* When we hear an interval or a chord, we first respond to its *consonance* or *dissonance.* Consonant harmonies sound stable in their arrangement. Dissonant harmonies sound tense and unstable. Consonance and dissonance, however, are not absolute properties. Essentially they are conventional and, to a large extent, cultural. What sounds dissonant to our ears may not to someone else's. In musical response, we must determine *how* the composer utilizes these two properties. Most Western music is primarily consonant. Dissonance, on the other hand, can be used for contrast, to draw attention to itself, or as a normal part of *harmonic progression.*

As its name implies, harmonic progression involves the movement forward in time of harmonies. In discussing pitch, we noted the convention of the major and minor scales—that is, the arrangement of the chromatic scale into a system of *tonality*. When we play or sing a major or minor scale, we note a particular phenomenon: Our movement from *do* to *re* to *mi* to *fa* to *sol* to *la* seems

smoothly natural. But when we reach the seventh tone of the scale, *ti*, something strange happens. It seems as though we must continue back to *do*, the *tonic* of the scale. Sing a major scale and stop at *ti*. You feel uncomfortable. Your mind tells you to *resolve* that discomfort by returning to *do*. That same sense of tonality—that sense of the tonic—applies to harmony. Within any scale, a series of chords may be developed on the basis of the individual tones of the scale. Each of the chords has a subtle relationship to each of the other chords and to the tonic—that is, the *do* of the scale. That relationship creates a sense of progression that leads back to the chord based on the tonic.

We call the harmonic movement toward, and either resolving or not resolving to, the tonic, *cadence* (Figure 5.8.). Composers use cadence as one way of articulating sections of a composition or of surprising us by upsetting our expectations. A composer using a full cadence uses a harmonic progression that resolves just as our ear tells us it should. We have a sense of ending, of completeness. However, when a composer uses a half cadence or a deceptive

FIGURE 5.8 *Full cadence.*

cadence, she upsets the expected progression, and the musical development moves in an unexpected direction.

As we listen to music of various historical periods, we may note that in some compositions tonal centers are blurred because composers frequently *modulate*—that is, change from one key (see Glossary) to another. In the twentieth century, many composers (see Serialism, p. 150) some of them using purely mathematical formulas to utilize equally all tones of the chromatic scale, have removed tonality as an arranging factor and have developed *atonal* music, or music without tonality. A convention of harmonic progression is disturbed when tonality is removed. Nonetheless, we still have harmonic progression, and we still have harmony—dissonant or consonant.

TONALITY

Utilization of tonality, or key, has taken composers in various directions over the centuries. Conventional tonality, employing the major and minor scales and keys we discussed previously relative to pitch, forms the basis for most sixteenth- to twentieth-century music, as well as traditionally oriented music of the twentieth century. In the early twentieth century, traditional tonality was abandoned by some composers, and a new *atonal* harmonic expression occurred. Atonal compositions seek the freedom to use any combination of tones without the necessity of having to resolve chordal progressions.

TEXTURE

The term *texture* has various spatial connotations. Texture in painting and sculpture denotes surface quality: roughness or smoothness. Texture in weaving denotes the interrelationship of the warp and the woof (the horizontal and vertical threads in fabric). In music, texture has three characteristics: monophony, polyphony, and homophony.

Monophony

When we have a single musical line without accompaniment, we have a texture called monophonic. Many voices or instruments may be playing at the same time, but as long as they sing the same notes at the same time—in unison—the texture remains monophonic. Handel's "Hallelujah" Chorus has instances in which men and women sing the same notes in different octaves. This still represents monophony.

Polyphony

Polyphony or counterpoint means "many-sounding," and it occurs when two or more melodic lines of relatively equal interest are performed at the same time. We can hear it in a very simple statement in Josquin Desprez's (day-PRAY) "Ave Maria . . . Virgo Serena." Palestrina's "Kyrie" from the *Pope Marcellus Mass* has more complexity. When the counterpoint uses an immediate restatement of the musical idea, then the composer employs *imitation*.

Homophony

When chords accompany one main melody, we have homophonic texture. Here the composer focuses attention on the melody by supporting it with subordinate sounds.

Of course, composers may change textures within a piece, as Handel does in the "Hallelujah" Chorus. This creates an even richer fabric of sound for our response.

A Question of Style

Serialism

serialism (SIHR-ee-uh-lihz-uhm). In music, a mid-twentieth-century type of composition based on the twelve-tone system. In serialism, the techniques of the twelve-tone system are used to organize musical dimensions other than pitch, for example, rhythm, dynamics, and tone color. At the root of the movement was Arnold Schoenberg (SHURN-bairk; 1874–1951). Between 1905 and 1912 Schoenberg moved away from the gigantic post-Romantic works he had been composing and began to adopt a more contained style, writing works for smaller ensembles, and treating instruments in a more individual manner. Although the word *atonality*, meaning without tonality, describes Schoenberg's works, he preferred the term *pantonality*—inclusive of all tonalities. In his compositions, Schoenberg used any combination of tones without having to resolve chord progressions, a concept he called "the emancipation of dissonance." He broke down the musical texture, alternating timbres swiftly and fragmenting rhythm and melody. In 1911, Schoenberg wrote *Six Little Piano Pieces, op. 19*. In these, he made some advances in his new style and eliminated some of the traditional procedures, for example, repetition or recall of earlier musical statements. These short pieces contain only nine to eighteen measures. Nonetheless, each, like "Etwas rasch" (rather quick), constitutes a tiny but free-standing presentation of expression.

MUSICAL FORM

Tones and rhythms that proceed without purpose or stop arbitrarily make little sense to the listener. Therefore, just as the painter, sculptor, or any other artist must try to develop design that has focus and meaning, the musician must attempt to create a coherent composition of sounds and silences. The principal means by which artists create coherence is repetition. As we noted in Chapter 1, the Volkswagen (Fig. 1.1) achieved unity through strong geometric repetition that varied only in size. Music achieves coherence, or unity, through repetition in a similar fashion. However, because music deals with time as opposed to space, repetition in music usually involves recognizable themes.

Thus, we can define form as organization through repetition to create unity.

A Question to Ask

What kind or kinds of texture appear in this composition?

Binary form, as the name implies, consists of two parts: the opening section of the composition and a second part that often acts as an answer to the first: AB. Each section is then repeated.

Ternary form is a three-part development in which the opening section repeats after the development of a different second section: ABA.

Ritornello (rih-tor-NEHL-loh), which developed in the baroque period, and *rondo*, which developed in the classical period, employ a continuous development that returns to modified versions of the opening theme after separate treatments of additional themes. Ritornello alternates orchestral or *ripieno* passages with solo passages. Rondo alternates a main theme in the tonic key with subordinate themes in contrasting keys.

Sonata form, or *sonata–allegro form* takes its name from the conventional treatment of the first movement of the sonata. It also serves as the form of development of the first movement of many symphonies: ABA or AABA. The first A section, known as the *exposition*, states two or three main and subordinate themes. To cement the perception of section A, the composer may repeat it: AA. The B section, the *development*, takes the original themes and develops them with several fragmentations and modulations. The movement then returns to the A section: This final section, called the *recapitulation*, usually does not exactly repeat the opening section; in fact, it may be difficult to recognize in some pieces. In Mozart's Symphony No. 40, the opening movement (allegro) employs sonata–allegro form. However, we recognize the recapitulation section only by a very brief restatement of the first theme, as heard in the exposition, and not as a repetition of the opening section. Then, after a lengthy *bridge*, the second theme from the exposition appears. Mozart closes the movement with a brief *coda*, or closing section, in the original key, based on the first phrase of the first theme.

The *fugue*, which we introduced earlier, is a polyphonic development of one, two, or sometimes three short themes. Fugal form, which takes its name from the Latin *fuga* ("flight"), has a traditional, although not a necessary, scheme of development with two common characteristics: (1) counterpoint and (2) a clear dominant-tonic relationship—that is, imitation of the theme at the fifth above or below the tonic. Each voice in a fugue (as many as five or more) develops the basic subject independent from the other voices, and passes through as many of the basic elements as the composer deems necessary. Unification results not by a return to an opening section, as in closed form, but by the varying recurrences of the subject throughout.

The *canon*, a contrapuntal form based on note-for-note imitation of one voice by another, separates the voices by a brief time interval—for example (the use of letters here does not indicate sectional development):

Voice 1: a b c d e f g
Voice 2: a b c d e f g
Voice 3: a b c d e f g

The interval of separation can vary among the voices. The canon differs from the *round*, for example "Row, row, row your boat." A round is also an exact melodic repeat, but The canon develops new material indefinitely: The round repeats the same phrases over and over. The interval of separation in the round stays constant—a phrase apart.

Variation form modifies an initial theme through melodic, rhythmic, and harmonic treatments, each more elaborate than the last. Each section usually ends with a strong

cadence, and the piece ends, literally, when the composer decides he or she has done enough.

HOW DOES IT STIMULATE THE SENSES?

OUR PRIMAL RESPONSES

We can find no better means of illustrating the sensual effect of music than to contrast two totally different musical pieces. Debussy's *Claire de Lune* (see p. 155) provides us with an example of how musical elements can combine to give us a relaxing and soothing experience. Here, the tone color of the piano added to the elements of a constant beat in triple meter, consonant harmonies, subtle dynamic contrasts, and extended duration of the tones combine in a richly subdued experience that engages us but lulls us at the same time. In contrast, listen to Stravinsky's "Auguries of Spring: Dances of the Youths and Maidens" from *The Rite of Spring*. Here the driving rhythms, strong syncopation, dissonant harmonies, wildly contrasting dynamics, and the broad tonal palette of the orchestra rivet us and ratchet up our excitement level. It is virtually impossible to listen to this piece without experiencing a rise in pulse rate. In both cases, our senses have responded at an extremely basic rate over which we have, it would seem, little control.

Music contains a sensual attraction difficult to deny. At every turn music causes us to tap our toes, drum our fingers, or bounce in our seats in a purely physical response. This involuntary motor response creates perhaps the most primitive of our sensual involvement—as primitive as the images in Stravinsky's *Rite of Spring*. If the rhythm is irregular and the beat divided or syncopated,

as in *Rite of Spring*, we may find one part of our body doing one thing and another part doing something else. Having compared the Debussy and Stravinsky pieces, do we have any doubt that a composer's choices have the power to manipulate us sensually?

From time to time throughout this chapter, we have referred to certain historical conventions that permeate the world of music. Some of these have a potential effect on our sense response. Some notational patterns represent a kind of musical shorthand, or perhaps mime, that conveys certain kinds of emotion to the listener. Of course, they have little meaning for us unless we take the time and effort to study music history. Some of Mozart's string quarters indulge in exactly this kind of communication: yet another illustration of how expanded knowledge can increase the depth and value of the aesthetic experience.

THE MUSICAL PERFORMANCE

A certain part of our sense response to music occurs as a result of the nature of the performance itself. As we suggested earlier in the chapter, the scale of a symphony orchestra gives a composer a tremendously variable canvas on which to paint. Let's pause, momentarily, to familiarize ourselves with this fundamental aspect of the musical equation. As we face the stage in an orchestral concert, we note perhaps as many as one hundred instrumentalists facing back at us. Their arrangement from one concert to another remains fairly standard, as illustrated in Figure 5.9.

A large symphony orchestra can overwhelm us with diverse timbres and volumes; a string quartet cannot. Our expectations and our focus may change as we perceive the performance of one or the other. For example, because we know our perceptual

A Question of Style

Romanticism

Romanticism (roh-MAN-tuh-sihz-uhm). A philosophy as well as a style in all the arts and literature, dating to the late eighteenth through nineteenth centuries. In architecture, it borrowed styles from previous eras while experimenting with modern materials. It also sought an escape to the past. In painting, the style turned to emotionalism, the picturesque, and nature. It fragmented images and dramatized with personal subjectivity. In theatre, the style resulted in dazzling scenery. In literature, music, and ballet, it sought the subjective and the colorful, reflecting great diversity.

In an era of Romantic subjectivity, music provided the medium in which many found an unrivaled opportunity to express emotion. In trying to express human emotion, Romantic music made stylistic changes to classical music, and although Romanticism amounted to a rebellion in many of the arts, in music it involved a more gradual and natural expression of classical principles. Music put its primary emphasis in this era on beautiful, lyrical, and expressive melody.

One of the style's exemplars was Frédérick Chopin (sho-PAN; 1810–1849), who wrote almost exclusively for the piano. Each of his études, or studies, explored a single technical problem, usually set around a single motif. More than simple exercises, these works explored the possibilities of the instrument and became short tone poems in their own right. Chopin's "Revolutionary" *Etude in C Minor, Op. 10* has a blazing and furious quality perhaps inspired by the Russian takeover of Warsaw in Chopin's home country of Poland. As an *étude*, the "Revolutionary Étude" tackles the problem of developing speed and strength in the pianist's left hand: The piece requires the performer to play rapid passages throughout. The work begins with a dramatic explosion. High, dissonant chords couple with rushing downward passages culminating in the main melody played in octaves by the right hand. The melody's rhythms and stormy accompaniment give the work a mounting tension. Near the end, after a climax, tension subsides briefly only to be followed by a fiery passage sweeping down the keyboard and coming to rest in strong closing chords.

experience with a string quartet will not involve the broad possibilities of an orchestra, we tune ourselves to seek the qualities that challenge the composer and performer within the particular medium. The difference between listening to an orchestra and listening to a quartet is similar to the difference between viewing a museum painting of monumental scale and viewing the exquisite technique of a miniature.

Textual suggestion can have much to do with sensual response to a musical work. For example, Debussy's *Prelude à l'après midi d'un faune* elicits images of Pan frolicking through the woodlands and cavorting with the nymphs on a sunny afternoon. Of course, much of what we imagine has been stimulated by the title of the composition. Our perception is heightened further if we are familiar with the poem by Mallarmé on

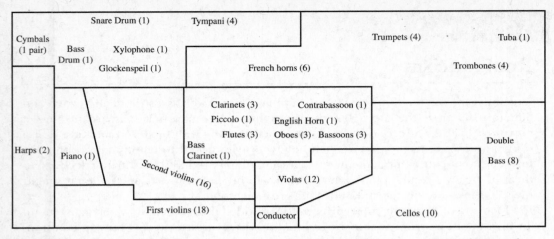

FIGURE 5.9 *Typical seating plan for a large orchestra (about 100 instrumentalists), showing the placement of instrumental sections.*

which the symphonic poem is based. Titles and especially text in musical compositions may be the strongest devices a composer has for communicating directly with us. Images are triggered by words, and a text or title can stimulate our imaginations and senses to wander freely and fully through the musical development. Johannes Brahms called a movement in his *German Requiem* "All Mortal Flesh Is as the Grass"; we certainly receive a philosophical and religious communication from that title. Moreover, when the chorus ceases to sing and the orchestra plays alone, the instrumental melodies and harmonies stimulate images of fields of grass blowing in the wind.

Harmony and tonality both stimulate our senses considerably. Just as paintings and sculpture stimulate sensations of rest and comfort or action and discomfort, so harmonies create a feeling of repose and stability, if consonant, and a sensation of restlessness and instability if dissonant. Harmonic progression that leads to a full cadential resolution leaves us feeling fulfilled; unresolved cadences puzzle and

perhaps irritate us. Major or minor tonalities have significantly differing effects: major sounds positive; minor, sad or mysterious. The former seems close to home, and the latter, exotic. Atonal music sets us adrift to find the unifying thread of the composition.

Melody, rhythm, and tempo relate closely to the use of line in painting, and the term *melodic contour* could be seen as a musical analogue to this element of painting. When the tones of a melody undulate slowly and smoothly (conjunct), they trace a pattern having the same sensual effect as their linear visual counterpart—soft, comfortable, and placid.

When music employs melodic disjunct contours and rapid tempos, the pattern and response change:

In conclusion, it remains for us as we respond to music to analyze how each of the elements available to the composer has in

A Question of Style:

Impressionism

impressionism (ihm-PREHSH-uh-nihz-uhm). A mid- to late-nineteenth-century style originating in France. In painting it sought spontaneity, harmonious colors, subjects from everyday life, and faithfulness to observed lighting and atmospheric effects by seeking to capture the psychological perception of reality in color and motion. It emphasized the presence of color within shadows and the result of color and light making an "impression" on the retina. In music, it freely challenged traditional tonality with new tone colors, oriental influence, and harmonies away from the traditional. Gliding chords—that is, repetition of a chord up and down the scale—was a hallmark.

Impressionist music can best be found in the work of its primary champion, the Frenchman Claude Debussy (deh-BYOO-see; 1862–1918), although he did not like to be called an "impressionist"—the label, after all, had been coined by a critic of the painters and was meant to be derogatory. He created fleeting moods and gauzy atmospheres. Debussy maintained that he represented "an old Romantic who has thrown the worries of success out the window," and he sought no association with the painters. We can, however, draw similarities. His use of tone color has been described as "wedges of color," much like those the painters provided with individual brushstrokes. Debussy reduced melodic development to limited short motifs. He considered a chord strictly on the merits of its expressive capabilities, apart from any idea of tonal progression within a key. On a nicely subdued scale, we find Debussy's tonal colorings and gliding chords evident and combined with a simple visual image in the easily accessible piece *Claire de Lune* ("Moonlight").

fact become a part of the channel of communication, and how the composer, consciously or unconsciously, has put together a work that elicits sensory responses from us.

OPERA

The composer Pietro Mascagni reportedly said, "In my operas, do not look for melody or beauty . . . look only for blood." Mascagni represented a style of late-nineteenth-century opera called *verismo* (vay-REEZ-moh), a word with the same root as verisimilitude, meaning true to life. Verismo opera

treated themes, characters, and events from life in a down-to-earth fashion. In Mascagni's operas and operas of other composers of the verismo style, we find plenty of blood, but we also find fine drama and music. The combination of drama and music into a single artistic form constitutes opera. In basic terms, opera comprises drama sung to orchestral accompaniment. In opera, music comprises the predominant element, but the addition of a story line, scenery, costumes, and staging make opera significantly different from other forms of music.

In one sense, we could describe opera as the purest integration of all the arts. It

contains music, drama, poetry, and visual arts. It even includes architecture because an opera house constitutes a particular architectural entity with very specific requirements for orchestra, audience, and stage space, as well as stage machinery. In its wide variety of applications, opera ranges from tragedies of spectacular proportions involving several hundred people, to intimate music dramas and comedies with two or three characters (Figures 5.10, 5.11, 5.12).

Unlike theatre, an opera production reveals character and plot through song rather than speech. This convention removes opera from the lifelikeness we might expect in the theatre and asks us to suspend our disbelief so we can enjoy magnificent music and the heightening of dramatic experience that music's contribution to mood, character, and dramatic action affords us. Central to

an opera are performers who can sing and act simultaneously. These include major characters played by star performers as well as secondary solo singers and chorus members plus *supernumeraries*—"supers" or "extras"— who do not sing but merely flesh out crowd scenes.

TYPES OF OPERA

In Italian, the word *opera* means "work." In Florence, Italy, in the late sixteenth century, artists, writers, and architects eagerly revived the culture of ancient Greece and Rome. Opera represented an attempt by a group known as the *camerata* (cah-may-RAHT-ah; Italian for "fellowship" or "society") to re-create the effect of ancient Greek drama, in which, scholars believed, words were chanted or sung as well as spoken. Through

FIGURE 5.10 *Giacomo Puccini,* Manon Lescaut. *Opera Company of Philadelphia. Photo by Trudy Cohen.*

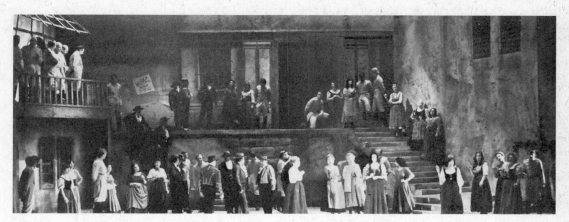

FIGURE 5.11 *Georges Bizet,* Carmen. *Opera Company of Philadelphia. Composite photo by Trudy Cohen.*

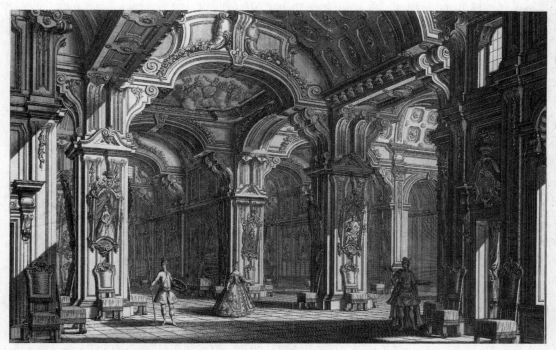

FIGURE 5.12 *Giuseppi Galli de Bibiena (1696–1757), "Scene Design for an Opera," 1719. engraving late 17th-early 19th century.* Source: The Metropolitan Museum of Art, New York. The Elisha Whittelsey Collection, The Elisha Whittelsey Fund, 1951. (51.501.2731).The Metropolitan Museum of Art, New York, NY, U.S.A. Image © The Metropolitan Museum of Art.

profile

Richard Danielpour

Contemporary Voice

Richard Danielpour (b. 1956) studied at the New England Conservatory and the Juilliard School and also trained as a pianist. Currently he is a member of the composition faculty at the Curtis Institute and the Manhattan School of Music. Speaking of his recent rise in the ranks of recognized composers, Danielpour reflected, "From the beginning, it was agonizing. It was like waiting for a Polaroid to develop, but the Polaroid took 10 years instead of 30 seconds." Indicative of his standing in the music world is his collaboration with Nobel Prize-winning writer Toni Morrison on a piece titled "Sweet Talk," premiered by Jessye Norman at Carnegie Hall.

In the early 1980s, Mr. Danielpour moved away from the complexities of modernism toward a more accessible style. As a result, his music's large and romantic gestures, brilliant orchestrations and vibrant rhythms appeal to a wide cross-section of the public. In this regard, some critics have compared him to Leonard Bernstein, Aaron Copland, Igor Stravinsky, Dmitri Shostakovich, and other twentieth-century masters.

"As I got older, I was aware of a number of different strands coming together in my music, rather than seeing myself on a mission with one particular axe to grind," he said. He calls himself an assimilator rather than an innovator. By utilizing familiar and unthreatening styles as a basis for his compositions, he has been able to win over even conservative audiences.

In the process of finding the means to express his message, Danielpour draws from many resources. "For me style is not the issue," he said. "It's how well a piece is written on a purely technical level. If other composers see themselves as superior just because their music may be more 'original,' that's O.K. That's not what I'm about." His "American-sounding rhythmic swagger," easy lyricism, and keen understanding of instrumental color create an appealing formula.

Although reluctant to discuss his music's spiritual component, he tends to label supposedly abstract instrumental works with intriguing, metaphysical titles. The movements of his Piano Quintet, for example, are "Annunciation," "Atonement," and "Apotheosis." Such titles, he admits, can be distracting. "Maybe it would be better not to have any at all," he said. When he does discuss spirituality in music, he doesn't hesitate to place himself in good company. "Some of my favorite composers," he said, "are also philosopher–composers who find themselves addressing questions about life and death in the very music they write: Mahler, Shostakovich, Bernstein."

He speaks of the creative process in spiritual and perhaps eccentric terms. "Where is the music received from?" he asks. "Where do your dreams come from? Composing is like being in a waking dream. To me the where is not important. It's intuition that has to lead the way and thinking that has to follow it. To speak of the mind first is worthless."

Perhaps typical of all professionals in today's music world, he has a sense of the business side of music. He knows about contracts and commissions and how to be in the right place at the right time. Nonetheless, Mr. Danielpour insists that he is no more active in self-promotion than his colleagues.[*]

[*]*The New York Times*, January 13, 1998, section, p. 41.

succeeding centuries, various applications of the fundamental concept of opera have arisen, and among these applications we find three basic types of opera: (1) grand opera; (2) opera buffa; and (3) operetta.

Grand Opera

Grand opera, used synonymously with *opera*, refers to serious or tragic opera, usually in five acts. Another name for this type of opera is *opera seria* ("serious opera"), which usually treats heroic subjects—for example, the gods and heroes of ancient times—in a highly stylized manner.

Opera Buffa

Opera buffa is comic opera, which usually does not have spoken dialogue. Opera buffa usually uses satire to treat a serious topic with humor—for example, Mozart's *Marriage of Figaro*.

Operetta

The third variety, *operetta*, also has spoken dialogue, but it has come to refer to a light style of opera characterized by popular themes, a romantic mood, and often a humorous tone. It is frequently considered more theatrical than musical, and its story line is usually frivolous and sentimental.

THE OPERA PRODUCTION

Like theatre, opera, a collaborative art, joins the efforts of a composer, a dramatist, a stage director, and a musical director. At its beginnings, an opera emerges when a composer sets to music a text, called a *libretto* (and written by a *librettist*). As we suggested earlier, the range of subjects and characters in opera may be extremely broad, from mythological to everyday. All characters come to life through performers who combine singing and acting. Opera includes the basic voice ranges we noted earlier (soprano, alto, tenor, bass), but divides them more precisely, as indicated in the following list.

Coloratura soprano	Very high range; capable of executing rapid scales and trills
Lyric soprano	Fairly light voice; cast in roles requiring grace and charm
Dramatic soprano	Full, powerful voice, capable of passionate intensity
Lyric tenor	Relatively light, bright voice
Dramatic tenor	Powerful voice, capable of heroic expression
Basso buffo	Cast in comic roles; can sing very rapidly
Basso profundo	Extremely low range, capable of power; cast in roles requiring great dignity.

Because the large majority of operas in the contemporary repertoire are not of American origin, the American respondent usually has to overcome the language barrier to understand the dialogue and thereby the plot. Performing operas in their original language makes it possible for the best singers to be heard around the world. Think of the complications that would arise if Pavarotti, for example, had to learn a single opera in the language of every country in which he performed it. In addition, opera loses much of its musical character in translation. We spoke of tone color, or timbre, earlier in this chapter. Timbre characteristics implicit, for example, in the Russian, German, and Italian languages, get lost when translated into English.

Experienced operagoers may study the score before attending a performance. However, every concert program contains a plot synopsis (even when the production is in English), so that even the neophyte can

follow what is happening. Opera plots, unlike mysteries, have few surprise endings, and knowing the plot ahead of time does not diminish the experience of responding to the opera. To assist the audience, opera companies often project translated lyrics on a screen above the stage (super titles), much like subtitles in a foreign film.

The overture marks the opening element in an opera. This orchestral introduction may have two characteristics. First, it may set the mood or tone of the opera. Here the composer works directly with our sense responses, putting us in the proper frame of mind for what is to follow. In his overture to *I Pagliacci* (ee pahl-YAH-chee), for example, Ruggiero Leoncavallo creates a tonal story that tells us that we will experience comedy, tragedy, action, and romance. If we listen to this overture, we will identify these elements and, in doing so, understand how relatively unimportant the work's being in English is to comprehension. Add to the "musical language" the language of body and mime, and we can understand even complex ideas and character relationships—*without* words. In addition to this type of introduction, an overture may provide melodic introductions—passages introducing the arias and recitatives that will follow.

The plot unfolds musically through *recitative* (reh-sih-tah-TEEV or ray-chee-tah-TEEV), or sung dialogue. The composer uses recitative to move the plot along from one section to another; recitative has little emotional content to speak of, and the words are more important than the music. *Recitativo secco* (SEH-ko) has very little musical accompaniment for the singer or none at all. Any accompaniment usually takes the form of light chording under the voice. The second type, *recitativo stromento*, gives the singer full musical accompaniment.

The real emotion and poetry of an opera lie in its *arias*. Musically and poetically, an aria reflects high dramatic feeling. The great, familiar opera songs are arias, such as "Dido's Lament" by Henry Purcell.

Every opera contains duets, trios, quartets, and other small ensemble pieces, as well as chorus sections in which everyone gets into the act. In addition, ballet or dance interludes are not uncommon. These may have nothing to do with the development of the plot, but add more life and interest to the dramatic production and, in some cases, provide a *segue* from one scene into another.

Bel canto, as its name implies, means a style of singing emphasizing the beauty of sound. Its most successful composer, Gioacchino Rossini, had a great sense of melody and sought to develop the *art song* to its highest level. In bel canto singing, the melody provides the focus.

Richard Wagner gave opera and theatre a prototype that continues to influence theatrical production—*organic unity*. He integrated and shaped every element of his productions to create a work of total unity. Wagner was also famous for the use of *leitmotif* (LYT-moh-TEEF), a common element in contemporary film. A leitmotif is a musical theme associated with a particular person or idea. Each time that person appears or comes to mind, or each time the idea surfaces, the leitmotif occurs.

Sample Outline and Critical Analysis

The following very brief example illustrates how we can use some of the terms explained in the chapter to form an outline and then develop a critical analysis of a musical work. Here is how that might work regarding Haydn's Symphony No. 94 in G major.

Outline	Critical Analysis
Classical form Symphony Theme	Haydn's Symphony No. 94 in G major contains four movements, of which I will concentrate on the first, although the second movement contains the simple theme and dramatic musical surprise that gives the Symphony its popular name—the "Surprise Symphony." The orchestra begins with a soft statement of the theme. After presenting the theme a second time, even more quietly, a very loud chord appears—the surprise.
Sonata Form Triple meter Tempo Exposition	In the opening movement Haydn uses sonata form preceded by a pastoral introduction in a slow, singing style, in triple meter. The introductory material alternates between the strings and the woodwinds. The tempo switches to very fast, and the strings quietly introduce the first theme in G major (the exposition).
	The last note of the theme is very loud (forte), and at this point the full orchestra joins the violins in a lively section, Just before a pause, the orchestra plays a short phrase that recurs throughout the movement.
Scale Motif	The first theme then reappears with a slightly altered rhythmic pattern. A quick series of scales in the violins and flutes leads to the introduction of a second theme, a lyrical theme with trills and a falling motif. The exposition section closes with a short scale figure and repeated notes, and then the entire exposition is repeated.
Development Key Dynamics Recapitulation	The development section opens with a variation of the first theme and then goes through a series of keys and dynamic changes.
	The recapitulation starts with a return to the first theme in the original key. A passage based on motifs from the first theme, a repeat and brief development of the first theme, a pause, and finally, another repeat of the first theme follow. Then the second theme appears again, now in the home key, and the movement closes with a short scale passage and a strong cadence.

Additional Study and Cyber Sources

c. 600–1400

Medieval (Gregorian Chant; Hildegard of
 Bingen)

c. 1400–c. 1825

Renaissance (Desprez, Dufay, Palestrina):
 http://www.prs.net/early.html#p
Baroque (J. S. Bach, Handel, Vivaldi):
 http://www.prs.net/bach.html;
 http://www.prs.net/handel.html;
 http://www.prs.net/midi-t-z.html#v
Classical (Haydn, Mozart, Beethoven):
 http://www.prs.net/haydn.html;
 http://www.prs.net/mozart.html;
 http://www.prs.net/beethovn.html

c. 1825–c. 1900

Romanticism (Berlioz, Brahms, Chopin, Liszt,
 Mendelssohn, Tchaikovsky):
 http://www.prs.net/midi-a-e.html#b;

http://www.prs.net/brahms.html;
http://www.prs.net/chopin.html;
http://www.prs.net/liszt.html;
http://www.prs.net/mendel.html;
http://www.prs.net/tchai.html

c. 1900–present

Bartok: http://www.prs.net/midi-a-e.html#b
Debussy: http://www.prs.net/debussy.html
Ives: http://www.prs.net/midi-f-m.html#i
Satie: http://www.prs.net/midi-n-s.html#s
Copland: *Appalachian Spring*
Ives: *The Unanswered Question*
Shoenberg: *Variations for Orchestra, Op. 31*
Danielpour: *Sweet Talk*

Literature

Read any good books lately? Ever tried to write poetry? From the earliest of times, cultures have been defined by their literature, whose medium comprises language. Today, before a movie or soap opera comes to the screen, we must have a story and, usually, a script. Such things constitute literature, whose greatest characteristic is the arousal of the imagination and the emotions by means of speech and writing.

WHAT IS IT?

Traditionally, literature falls into two categories: utilitarian and creative. Creative literature has a different approach than utilitarian literature. The approach determines the category—creative or utilitarian—in the same sense that one picture (composed of line, form, and color) can be termed "art," whereas another picture composed of those same elements, but which seeks only to present a visual copy, can be termed "illustration." This text focuses on creative literature—literature pursuing excellence of form or expression and presenting ideas of permanent or universal interest.

People read creative literature because they expect it to hold their interest and provide pleasure—for the same reasons they watch athletic contests or go to movies. Common experience maintains that reading creative literature is good for us, but, in all

honesty, we read for the immediate reward of the pleasure it provides. Some rewards of reading may lie in the future, but immediate rewards come from the experience of participating. Creative literature takes us out of ourselves while we engage in it.

This chapter, like the preceding ones, focuses on fundamentals. History comes later. It helps to know the categories of literature and how literature is put together in order to get the most out of reading and to share experiences with others using the proper descriptive terminology. As do artists in all the arts, writers utilize the formal and technical details discussed here to shape their material in order to effect responses in their readers. They choose their words very carefully to provide maximum impact. Our initial response (What is it?) to works of literature, made up of those carefully chosen words and devices, begins, as it does in the other arts, with formal divisions, or genres. The formal divisions of creative literature are fiction, poetry, nonfiction, and drama.

FICTION

Fiction emanates from the author's imagination rather than from fact. Normally it takes one of two approaches to its subject matter: realistic—the appearance of observable, true-to-life details; or nonrealistic—fantasy. Fictional elements can appear in narrative poetry, drama, and even biography and epic poetry. Traditionally, however, we divide fiction into two categories, novels and short stories.

Novels

The novel, a fictional prose narrative of considerable length, has a plot that unfolds from the actions, speech, and thoughts of the characters. Normally novels treat events within the range of ordinary experience and draw upon original subject matter rather than traditional or mythic subjects. Novels typically have numerous characters and employ normal, daily speech. Their subject matter falls into two general categories: sociological–panoramic, covering a wide-ranging story of many years and various setting; and dramatic–intimate, covering a restricted time and setting.

Often novels fall into classification by subject matter, including the following:

Epistolary Told through the medium of letters written by one or more of the characters, for example, Samuel Richardson, *Pamela* (1740).

Gothic Pseudomedieval fiction with a prevailing atmosphere of mystery and terror, for example, Ann Radcliffe, *The Mysteries of Udolpho* (1794).

Historical Set in a period of history and attempting to portray the spirit, manners, and social conditions of the time with realistic detail and faithfulness to historical fact, for example, Robert Graves, *I, Claudius* (1934).

Manners Finely detailed observations of the customs, values, and mores of a highly developed and complex society, for example, Jane Austen, *Pride and Prejudice* (1813).

Picaresque The adventures of a rogue or lowborn adventurer, for example, Thomas Nash, *The Unfortunate Traveller* (1594).

Psychological Depicting the thoughts, feelings, and motivations of the characters as equal to or greater than the external action of the

narrative. The internal states of the characters are influenced by and in turn trigger external events, for example, Leo Tolstoy, *War and Peace* (1864–1869).

Sentimental Exploiting the reader's capacity for tenderness, compassion, or sympathy to a disproportionate degree by presenting an unrealistic view of its subject, for example, once again, Samuel Richardson, *Pamela* (1740).

As we noted in other chapters about categories of art, often we find that we can fit a work into more than one category. For example, we might place contemporary novelist Toni Morrison's (see Profile box p. 166) novel *Love* (2003) in both historical and psychological categories. The work typifies Morrison's style with its scope and complexity. On a large scale, it explores the consequences of desegregation: Is assimilation good or bad? Should black people have kept what they had? Where does racial uplift end and nationalism begin? Nonetheless, the novel also has a small and intimate level focusing on love: parental love, unbridled love, lust, celibacy, and the deepest of friendships. In Morrison's universe, even hate constitutes a form of love. All these themes wrap around a story about Bill Cosey, a charismatic black entrepreneur who ran a chic seaside resort for wealthy African Americans during segregation. When segregation ended and black people could spend their money in wider circles, the business faltered and ultimately failed. At the beginning of the novel, two feuding women now reside at the long-closed resort: Cosey's widow and his granddaughter. They set the current action in motion.

Short Stories

As the name implies, short stories are short prose fictional works focusing on unity of characterization, theme, and effect, as differentiated from more expansive narrative forms such as the novel. Short stories typically concern only a single effect portrayed in a single, significant episode or scene and utilizing a limited number of characters. In short stories, we find very concise narration and character that lacks full development. Although, as a specific literary form, the short story did not develop until the nineteenth century, it has an historical precedent, and we can consider as part of the short story genre, the *fables* of ancient times: narratives designed to enforce a useful truth, particularly in which animals or inanimate objects speak and act like human beings. A fable differs from a folktale in that it has a moral woven into the story, for example, Aesop's fables. Perhaps the best known poet of ancient Greece, Aesop's (EE-sahp; sixth century B.C.E.?) existence, however, probably consists only in legend. Various citations and traditions surround him, and attempts occurred even in ancient Greece to establish him as an actual person. Editors ascribe approximately 200 fables to him: fables such as the turtle and the hare and the fox and the grapes. Aesop marks the onset of the Western fable tradition. Fables like the fox and the grapes provide us with examples of *accismus* (ak-SIHZ-muhs), a form of irony in which a person feigns indifference to or pretends to refuse something he or she really desires, for example, the fox's dismissal of the grapes.

One hot summer's day a Fox was strolling through an orchard till he came to a bunch of Grapes just ripening on a vine, which had been trained over a lofty branch. "Just the things to quench my thirst," quoth he. Drawing back a few paces, he took a run

profile

Toni Morrison

Toni Morrison (b. 1931) was born in Lorain, Ohio, as Chloe Anthony Wofford. She was the second of four children of George Wofford, a shipyard welder, and Ramah Willis Wofford. Her parents moved from the South to escape racism and to find better opportunities in the North. At home, Chloe heard many songs and tales of Southern black folklore. The Woffords were proud of their heritage. Lorain was a small industrial town populated with immigrant Europeans, Mexicans, and Southern blacks who lived next to each other. Chloe attended an integrated school. In her first grade, she was the only black student in her class and the only one who could read. She was friends with many of her white schoolmates and did not encounter discrimination until she started dating. While attending Howard University in Washington, D.C., she majored in English, and because many people couldn't pronounce her first name correctly, she changed it to Toni, a shortened version of her middle name.

Later she taught at Howard where she joined a small writer's group as refuge from an unhappy marriage to a Jamaican architect, Harold Morrison. Today Ms. Morrison is one of America's most celebrated authors. Her six major novels, *The Bluest Eye* (1969), *Sula* (1973), *Song of Solomon* (1977), *Tar Baby* (1981), *Beloved* (1987), and *Jazz* (1992), have received extensive national acclaim. She received the National Book Critics Award in 1977 for *Song of Solomon* and the 1988 Pulitzer Prize for *Beloved*. In 1993, Ms. Morrison was awarded the Nobel prize for literature. She is an editor at Random House and a visiting lecturer at Yale University.

She is noted for her spare but poetic language, emotional intensity, and sensitive observation of African American life. Her novel, *Jazz*, is meant to follow *Beloved* as the second volume of a projected trilogy, although *Jazz* doesn't extend the story told in *Beloved* in a conventional way. The characters are new, and so is the location. Even the narrative approach is different. In terms of chronology, however, *Jazz* begins roughly where *Beloved* ended and continues the greater story Morrison wishes to tell of her people passing through their American experience, from the days of slavery to the present. The individuals struggle to establish and sustain a personal identity without abandoning their own history, while individual and community interests clash. *Jazz* reads like a blues ballad from the musical age it suggests.

and a jump, and just missed the bunch. Turning around again with a One, Two, Three, he jumped up, but with no greater success. Again and again he tried after the tempting morsel, but at last had to give it up, and walked away with his nose in the air, saying, "I am sure they are sour."

"It is easy to despise what you cannot get."

In the short story "The Blood-feud of Toad-Water: A West-country Epic," the Scottish writer H. H. Munro (1870–1916), who wrote under the pseudonym of Saki, describes a scene of Edwardian England. He uses flippancy, wit, and invention to satirize social pretension, unkindness, and stupidity.

The Blood-feud of Toad-Water: a West-country Epic

Saki (H. H. Munro)

1870–1916

The Cricks lived at Toad-Water, and in the same lonely upland spot Fate had pitched the home of the Saunderses, and for miles around these two dwellings there was never a neighbour or a chimney or even a burying-ground to bring a sense of cheerful communion or social intercourse. Nothing but fields and spinneys and barns, lanes and wastelands. Such was Toad-Water; and, even so, Toad-Water had its history. Thrust away in the benighted hinterland of a scattered market district, it might have been supposed that these two detached items of the Great Human Family would have leaned towards one another in a fellowship begotten of kindred circumstances and a common isolation from the outer world. And perhaps it had been so once, but the way of things had brought it otherwise. Indeed, otherwise. Fate, which had linked the two families in such unavoidable association of habitat, had ordained that the Crick household should nourish and maintain among its earthly possessions sundry head of domestic fowls, while to the Saunderses was given a disposition towards the cultivation of garden crops. Herein lay the material, ready to hand, for the coming of feud and ill-blood. For the grudge between the man of herbs and the man of live stock is no new thing; you will find traces of it in the fourth chapter of Genesis. And one sunny afternoon in late springtime the feud came—came, as such things mostly do come, with seeming aimlessness and triviality. One of the Crick hens, in obedience to the nomadic instincts of her kind, wearied of her legitimate scratching-ground, and flew over the low wall that divided the holdings of the neighbours. And there, on the yonder side, with a hurried consciousness that her time and opportunities might be limited, the misguided bird scratched and scraped and beaked and delved in the soft yielding bed that had been prepared for the solace and well-being of a colony of seedling onions. Little showers of earth-mould and root-fibres went spraying before the hen and behind her, and every minute the area of her operations widened. The onions suffered considerably. Mrs. Saunders, sauntering at this luckless moment down the garden path, in order to fill her soul with reproaches at the iniquity of the weeds, which grew faster than she or her good man cared to remove them, stopped in mute discomfiture before the presence of a more magnificent grievance. And then, in the hour of her calamity, she turned instinctively to the Great Mother, and gathered in her capacious hands large clods of the hard brown soil that lay at her feet. With a terrible sincerity of purpose, though with a contemptible inadequacy of aim, she rained her earth bolts at the marauder, and the bursting pellets called forth a flood of cackling protest and panic from the hastily departing fowl. Calmness under misfortune is not an attribute of either hen-folk or womenkind, and while Mrs. Saunders declaimed over her onion bed such portions of the slang dictionary as are permitted by the Nonconformist conscience to be said or sung, the Vasco da Gama fowl was waking the echoes of Toad-Water with crescendo bursts of throat music which compelled attention to her griefs. Mrs. Crick had a long family, and was therefore licensed, in the eyes of her world, to have a short temper, and when some of her ubiquitous offspring had informed her, with the authority of eye-witnesses, that her neighbour had so far forgotten herself as to heave stones at her hen—her best hen, the best layer in the countryside—her thoughts clothed themselves in language "unbecoming to a Christian woman"— so at least said Mrs. Saunders, to whom most of the language was applied. Nor was she, on her part, surprised at Mrs. Crick's conduct in letting her hens stray into other body's gardens, and then abusing of them, seeing as how she remembered things against Mrs. Crick—and the latter simultaneously had recollections of lurking episodes in the past of Susan Saunders that were nothing to her credit. "Fond memory, when all things fade we fly to thee," and in the paling light of an April afternoon the two women confronted each other from their respective sides of the party

wall, recalling with shuddering breath the blots and blemishes of their neighbour's family record. There was that aunt of Mrs. Crick's who had died a pauper in Exeter workhouse—every one knew that Mrs. Saunders' uncle on her mother's side drank himself to death—then there was that Bristol cousin of Mrs. Crick's! From the shrill triumph with which his name was dragged in, his crime must have been pilfering from a cathedral at least, but as both remembrancers were speaking at once it was difficult to distinguish his infamy from the scandal which beclouded the memory of Mrs. Saunders' brother's wife's mother—who may have been a regicide, and was certainly not a nice person as Mrs. Crick painted her. And then, with an air of accumulating and irresistible conviction, each belligerent informed the other that she was no lady—after which they withdrew in a great silence, feeling that nothing further remained to be said. The chaffinches clinked in the apple trees and the bees droned round the berberis bushes, and the waning sunlight slanted pleasantly across the garden plots, but between the neighbour households had sprung up a barrier of hate, permeating and permanent. The male heads of the families were necessarily drawn into the quarrel, and the children on either side were forbidden to have anything to do with the unhallowed offspring of the other party. As they had to travel a good three miles along the same road to school every day, this was awkward, but such things have to be. Thus all communication between the households was sundered. Except the cats. Much as Mrs. Saunders might deplore it, rumour persistently pointed to the Crick he-cat as the presumable father of sundry kittens of which the Saunders she-cat was indisputably the mother. Mrs. Saunders drowned the kittens, but the disgrace remained. Summer succeeded spring, and winter summer, but the feud outlasted the waning seasons. Once, indeed, it seemed as though the healing influences of religion might restore to Toad-Water its erstwhile peace; the hostile families found themselves side by side in the soul-kindling atmosphere of a Revival Tea, where hymns were blended with a beverage that came of tea-leaves and hot water and look after the latter parent, and where

ghostly counsel was tempered by garnishings of solidly fashioned buns—and here, wrought up by the environment of festive piety, Mrs. Saunders so far unbent as to remark guardedly to Mrs. Crick that the evening had been a fine one. Mrs. Crick, under the influence of her ninth cup of tea and her fourth hymn, ventured on the hope that it might continue fine, but a maladroit allusion on the part of the Saunders good man to the backwardness of garden crops brought the Feud stalking forth from its corner with all its old bitterness. Mrs. Saunders joined heartily in the singing of the final hymn, which told of peace and joy and archangels and golden glories; but her thoughts were dwelling on the pauper aunt of Exeter. Year, have rolled away, and some of the actors in this wayside drama have passed into the Unknown; other onions have arisen, have flourished, have gone their way, and the offending hen has long since expiated her misdeeds and lain with trussed feet and a look of ineffable peace under the arched roof of Barnstaple market. But the Blood-feud of Toad-Water survives to this day.

POETRY

Poetry seeks to convey a vivid and imaginative sense of experience. It uses condensed language selected for its sound, suggestive power, and meaning, and employs specific technical devices such as meter, rhyme, and metaphor. We divide poetry into three major types: narrative, dramatic, and lyric.

Narrative

Narrative poetry tells a story. Epic poetry is narrative poetry of substantial length and elevated style. It uses strong symbolism, and has a central figure of heroic proportions. A ballad is a sung or recited narrative, and a metrical romance is a long narrative, romantic tale in verse. Chaucer's *The Canterbury Tales* illustrates narrative poetry.

The Canterbury Tales

Geoffrey Chaucer

c. 1340–1400

THE COOK'S PROLOGUE

The cook from London, while the reeve yet
spoke,
Patted his back with pleasure at the joke.
"Ha, ha!" laughed he, "by Christ's great
suffering.
This miller had a mighty sharp ending
Upon his argument of harbourage!
For well says Solomon, in his language,
'Bring thou not every man into thine house'.
For harbouring by night is dangerous.
Well ought a man to know the man that he
Has brought into his own security.
I pray God give me sorrow and much
care
If ever, since I have been Hodge of Ware,
Heard I of miller better brought to mark.
A wicked jest was played him in the dark.
But God forbid that we should leave off
here;
And therefore, if you'll lend me now an ear,
From what I know, who am but a poor man,
I will relate, as well as ever I can,
A little trick was played in our city."
 Our host replied: "I grant it readily.
Now tell on, Roger; see that it be good;
For many a pasty have you robbed of blood,
And many a Jack of Dover have you sold
That has been heated twice and twice grown
cold.
From many a pilgrim have you had Christ's
curse,
For of your parsley they yet fare the worse,
Which they have eaten with your stubble
goose;
For in your shop full many a fly is loose.
Now tell on, gentle Roger, by your name.
But yet, I pray, don't mind if I make game,
A man may tell the truth when it's in play."
"You say the truth," quoth Roger, "by my fay!
But 'true jest, bad jest' as the Fleming saith.

And therefore, Harry Bailey, on your
faith, Be you not angry ere we finish here,
If my tale should concern an inn-keeper.
Nevertheless, I'll tell not that one yet.
But ere we part your jokes will I upset."
 And thereon did he laugh, in great
good cheer,
And told his tale, as you shall straightway
hear.

THUS ENDS THE PROLOGUE OF THE COOK'S TALE

There lived a,' prentice, once, in our city,
And of the craft of victuallers was he;
Happy he was as goldfinch in the glade,
Brown as a berry, short, and thickly made,
With black hair that he combed right prettily.
He could dance well, and that so jollily,
That he was nicknamed Perkin Reveller.
He was as full of love, I may aver,
As is a beehive full of honey sweet;
Well for the wench that with him chanced to
meet.
At every bridal would he sing and hop,
Loving the tavern better than the shop.
 When there was any festival in Cheap,
Out of the shop and thither would he leap,
And, till the whole procession he had seen,
And danced his fill, he'd not return again.
He gathered many fellows of his sort
To dance and sing and make all kinds of sport.
And they would have appointments for to
meet
And play at dice in such, or such, a street.
For in the whole town was no apprentice
Who better knew the way to throw the dice
Than Perkin; and therefore he was right free
With money, when in chosen company.
His master found this out in business there;
For often-times he found the till was bare.
For certainly a revelling bond-boy
Who loves dice, wine, dancing, and girls of
joy—
His master, in his shop, shall feel the effect,
Though no part have he in this said respect;
For theft and riot always comrades are.
And each alike he played on gay guitar.

Revels and truth, in one of low degree,
Do battle always, as all men may see.
This' prentice shared his master's fair abode
Till he was nigh out of his' prenticehood,
Though he was checked and scolded early
and late
And sometimes led, for drinking, to Newgate;
But at the last his master did take thought,
Upon a day, when he his ledger sought,
On an old proverb wherein is found this
word:
"Better take rotten apple from the hoard
Than let it lie to spoil the good ones there."
So with a drunken servant should it fare;
It is less ill to let him go, apace,
Than ruin all the others in the place.
Therefore he freed and cast him loose to go
His own road unto future care and woe;
And thus this jolly' prentice had his leave.
Now let him riot all night long, or thieve.
　　But since there's never thief without a
buck
To help him waste his money and to suck
All he can steal or borrow by the way,
Anon he sent his bed and his array
To one he knew, a fellow of his sort,
Who loved the dice and revels and all sport,
And had a wife that kept, for countenance,
A shop, and whored to gain her sustenance.

OF THIS COOK'S TALE CHAUCER
MADE NO MORE.

Dramatic

Dramatic poetry utilizes dramatic form or technique. Typically, it involves a portrayal of life or character or the telling of a story usually involving conflicts and emotions through action and dialogue (drama can also utilize prose). The major form of dramatic poetry, the dramatic monologue, takes the form of a poem written as a speech of an individual character to an imaginary audience. It develops a narrative sense of the speaker's history and psychological insights into his or her character in a single vivid scene, for example, Robert Browning's "My Last Duchess."

Lyric

Lyric poetry, originally intended to be sung and accompanied by a lyre, comprises a brief, subjective work employing strong imagination, melody, and feeling to create a single, unified, and intense impression of the personal emotion of the poet. The sonnet represents the most finished form of lyric poetry. It has two types: Petrarchan (Italian) and Shakespearean (English). Petrarch (PEE-trahrk or PEH-trahrk; 1304–1374) developed the sonnet form to its highest expression, to the degree that we now call this form the Petrarchan (sometimes, Italian) sonnet. A fixed verse form, it contains fourteen lines. Typically sonnets treat a variety of moods and subjects, but particularly the poet's intense psychological reactions to his beloved. The fourteen lines divide into eight lines rhymed *abbaabba* and six lines with a variable rhyme scheme. Usually the first eight lines present the theme or problem in the poem, and the final six present a change in thought or resolution of the problem.

The sonnet form developed in Italy in the thirteenth century, and reached its highest form of expression in Petrarch. Imported into England, it adapted to create the form now called a Shakespearean sonnet. Shakespearean sonnet adapts the Petrarchan sonnet and has fourteen lines grouped into three quatrains (four lines) and a couplet, with a rhyme scheme of *abab cdcd efef gg* as Sonnet XIX illustrates. Here Shakespeare uses intriguing imagery to address the effects of aging: blunting the lion's paws; making the earth devour her own sweet brood; plucking keen teeth from

the fierce tiger's jaws, and burning the phoenix in her blood (the Phoenix was an Egyptian mythological creature that consumed itself by fire after 500 years, and rose renewed from its ashes); creating age lines with an antique pen. He solves the dilemma by countering time with the ageless nature of literature.

SONNET XIX

WILLIAM SHAKESPEARE

Devouring Time, blunt thou the lion's
paws,
And make the earth devour her own
sweet brood;
Pluck the keen teeth from the fierce
tiger's jaws,
And burn the long-lived phoenix in her
blood.

Make glad and sorry seasons as thou
fleets,
And do whate'er thou wilt, swift-footed
Time,
To the wide world and all her fading
sweets;
But I forbid thee one most heinous
crime:
O, carve not with thy hours my love's
fair brow,
Nor draw no lines there with thine
antique pen;
Him in thy course untainted do allow
For beauty's pattern to succeeding men.

Yet, do thy worst, old Time: despite thy
wrong,
My love shall in my verse ever live young.

NONFICTION

Nonfiction consists of literary works based mainly on fact rather than on the imagination, although nonfictional works may contain fictional elements. Biography, essays, speeches, and sacred scriptures comprise the major forms of nonfiction. Over the centuries, biography, a written account of a person's life, has taken many forms, including literary narratives, simple catalogues of achievement, and psychological portraits, and biographies of saints and other religious figures. Traditionally, the essay consists of a short literary composition on a single subject, usually presenting the personal views of the author. Essays include many subforms and a variety of styles, but they uniformly present a personal point of view with a conscious attempt to achieve grace of expression. Characteristically, the best essays show clarity, good humor, wit, urbanity, and tolerance. Speeches such as Abraham Lincoln's "Gettysburg Address" and Martin Luther King's "I Have a Dream" mark an important category of nonfiction, as do historical articles and texts such as political legislation and newspaper articles.

Biography

A biography undertakes a written account of a person's life. Over the centuries, it has taken many forms and witnessed many techniques and inventions, including literary narratives, catalogues of achievement, and psychological portraits. We call accounts of the lives of saints and

other religious figures hagiographies (ha-ghee-AHGH-ruh-fee or hay-jee-AHGH-ruh-fee). John Wesley (1703–1791), the Anglican clergyman who founded the Methodist Church, provides a sample of the elements of biography in *God Brought Me Safe.*

God Brought Me Safe

John Wesley 1703–1791

[Oct. 1743.]

Thur. 20—After preaching to a small, attentive congregation, I rode to Wednesbury. At twelve I preached in a ground near the middle of the town to a far larger congregation than was expected, on "Jesus Christ, the same yesterday, and to-day, and for ever." I believe every one present felt the power of God; and no creature offered to molest us, either going or coming; but the Lord fought for us, and we held our peace.

I was writing at Francis Ward's in the afternoon when the cry arose that the mob had beset the house. We prayed that God would disperse them, and it was so. One went this way, and another that; so that, in half an hour, not a man was left. I told our brethren, "Now is the time for us to go"; but they pressed me exceedingly to stay; so, that I might not offend them, I sat down, though I foresaw what would follow. Before five the mob surrounded the house again in greater numbers than ever. The cry of one and all was, "Bring out the minister; we will have the minister." I desired one to take their captain by the hand and bring him into the house. After a few sentences interchanged between us the lion became a lamb. I desired him to go and bring one or two more of the most angry of his companions. He brought in two, who were ready to swallow the ground with rage; but in two minutes they were as calm as he. I then bade them make way, that I might go out among the people. As soon as I was in the midst of them I called for a chair, and, standing up, asked, "What do any of you want with me?" Some said, "We want you to go with us to the

Justice." I replied, "That I will, with all my heart." I then spoke a few words, which God applied; so that they cried out with might and main. "The gentlemen is an honest gentleman, and we will spill our blood in his defence." I asked, "Shall, we go to the Justice tonight, or in the morning?" Most of them cried, "To-night, to-night"; on which I went before, and two or three hundred followed, the rest returned whence they came.

The night came on before we had walked a mile, together with heavy rain. However, on we went to Bentley Hall, two miles from Wednesbury. One or two ran before to tell Mr. Lane they had brought Mr. Wesley before his Worship. Mr. Lane replied, "What have I to do with Mr. Wesley? Go and carry him back again." By this time the main body came up, and began knocking at the door. A servant told them Mr. Lane was in bed. His son followed, and asked what was the matter. One replied, "Why an't please you, they sing psalms all day; nay, and make folks rise at five in the morning. And what would your Worship advise us to do?" "To go home," said Mr. Lane, "and be quiet."

Here they were at a full stop,' till one advised to go to Justice Persehouse at Walsall. All agreed to this; so we hastened on, and about seven came to his house. But Mr. P. likewise sent word that he was in bed. Now they were at a stand again: but at last they all thought it the wisest course to make the best of their way home. About fifty of them undertook to convoy me. But we had not gone a hundred yards when the mob of Walsall came, pouring in like a flood, and bore down all before them. The Darlaston mob made what defense they could; but they were weary, as well as outnumbered; so that in a short time, many being knocked down, the rest ran away, and left me in their hands.

To attempt speaking was vain, for the noise on every side was like the roaring of the sea. So they dragged me along till we came to the town, where, seeing the door of a large house open, I attempted to go in; but a man, catching me by the hair, pulled me back into the middle of the mob. They made no more stop till they had carried me through the main street, from one end of the town to the other. I continued speaking all the time to those within hearing, feeling no pain

or weariness. At the west end of the town, seeing a door half open, I made toward it, and would have gone in, but a gentleman in the shop would not suffer me, saying they would pull the house down to the ground. However, I stood at the door and asked, "Are you willing to hear me speak?" Many cried out, "No, no! knock his brains out; down with him; kill him at once." Others said, "Nay, but we will hear him first." I began asking, "What evil have I done? Which of you all have I wronged in word or deed?" and continued speaking for above a quarter of an hour, till my voice suddenly failed. Then the floods began to lift up their voice again, many crying out, "Bring him away! Bring him away!"

In the meantime my strength and my voice returned, and I broke out aloud into prayer. And now the man who had just before headed the mob turned and said, "Sir, I will spend my life for you: follow me, and not one soul here shall touch a hair of your head." Two or three of his fellows confirmed his words, and got close to me immediately. At the same time, the gentleman in the shop cried out, "For shame, for shame! Let him go." An honest butcher, who was a little farther off, said it was a shame they should do thus; and pulled back four or five, one after another, who were running on the most fiercely. The people then, as if it had been by common consent, fell to the right and left; while those three or four men took me between them, and carried me through them all. But on the bridge the mob rallied again: we therefore went on one side over the milldam, and thence through the meadows, till, a little before ten, God brought me safe to Wednesbury, having lost only one flap of my waistcoat and a little skin from one of my hands.

Essay

The essay, a nonfictional literary composition on a single subject, usually presents the personal views of the author. The word *essay* comes from the French, meaning "to try" and the vulgar Latin, meaning "to weigh." Essays include many subforms and a variety of styles, but they characteristically imply clarity, grace, good humor, wit, urbanity, and tolerance. For the most part essays are brief, but occasionally they find the form of much longer works, such as *The Federalist Papers* by Alexander Hamilton, John Jay, and James Madison (1787). Traditionally, essays fall into two categories: informal or formal.

Informal

Informal essays tend to be brief, conversational in tone, and loose in structure. We categorize them as familiar (or personal) and character. The personal essay presents an aspect of the author's personality as he or she reacts to an event. Character essays describe individuals, isolating their dominant traits, for example.

Formal

Formal essays, longer and more tightly structured than informal ones, tend to focus on impersonal subjects and place less emphasis on the personality of the author. Oliver Goldsmith provides an example.

The Benefits of Luxury, In Making a People More Wise and Happy
Oliver Goldsmith
1730?–1774

From such a picture of nature in primeval simplicity, tell me, my much respected friend, are you in love with fatigue and solitude? Do you sigh for the severe frugality of the wandering Tartar, or regret being born amidst the luxury and dissimulation of the polite? Rather tell me, has not every kind of life vices peculiarly its own? Is it not a truth, that

refined countries have more vices, but those not so terrible; barbarous nations few, and they of the most hideous complexion? Perfidy and fraud are the vices of civilized nations, credulity and violence those of the inhabitants of the desert. Does the luxury of the one produce half the evils of the inhumanity of the other? Certainly those philosophers who declaim against luxury have but little understood its benefits; they seem insensible, that to luxury we owe not only the greatest part of our knowledge, but even of our virtues.

It may sound fine in the mouth of a declaimer, when he talks of subduing our appetites, of teaching every sense to be content with a bare sufficiency, and of supplying only the wants of nature; but is there not more satisfaction in indulging those appetites, if with innocence and safety, than in restraining them? Am not I better pleased in enjoyment than in the sullen satisfaction of thinking that I can live without enjoyment? The more various our artificial necessities, the wider is our circle of pleasure; for all pleasure consists in obviating necessities as they rise: luxury, therefore as it increases our wants, increases our capacity for happiness.

Examine the history of any country remarkable for opulence and wisdom, you will find they would never have been wise had they not been first luxurious; you will find poets, philosophers, and even patriots, marching in luxury's train. The reason is obvious: we then only are curious after knowledge, when we find it connected with sensual happiness. The senses ever point out the way, and reflection comments upon the discovery. Inform a native of the desert of Kobi, of the exact measure of the parallax of the moon, he finds no satisfaction at all in the information; he wonders how any could take such pains, and lay out such treasures, in order to solve so useless a difficulty: but connect it with his happiness, by showing that it improves navigation, that by such an investigation he may have a warmer coat, a better gun, or a finer knife, and he is instantly in raptures at so great an improvement. In short, we only desire to know what we desire to possess; and whatever we may talk against it, luxury adds the spur to curiosity, and gives us a desire to becoming more wise.

But not our knowledge only, but our virtues are improved by luxury. Observe the brown savage of Thibet, to whom the fruits of the spreading pomegranate supply food, and its branches are habitation. Such a character has few vices, I grant, but those he has are of the most hideous nature: rapine and cruelty are scarcely crimes in his eye; neither pity nor tenderness, which ennoble every virtue, have any place in his heart; he hates his enemies, and kills those he subdues. On the other hand, the polite Chinese and civilized European seem even to love their enemies. I have just now seen an instance where the English have succoured those enemies, whom their own countrymen actually refused to relieve.

The greater the luxuries of every country, the more closely, politically speaking, is that country united. Luxury is the child of society alone; the luxurious man stands in need of a thousand different artists to furnish out his happiness; it is more likely, therefore, that he should be a good citizen who is connected by motives of self-interest with so many, than the abstemious man who is united to none.

In whatsoever light, therefore, we consider luxury, whether as employing a number of hands naturally too feeble for more laborious employment; as finding a variety of occupation for others who might be totally idle; or as furnishing our new inlets to happiness, without encroaching on mutual property; in whatever light we regard it, we shall have reason to stand up in its defence, and the sentiment of Confucius still remains unshaken: *that we should enjoy as many of the luxuries of life as are consistent with our own safety, and the prosperity of others; and that he who finds out a new pleasure is one of the most useful members of society.*

SACRED SCRIPTURES

The Qur'an (Arabic, "the Recital") is the sacred scripture of Islam, and Muslims regard it as the infallible Word of God: a flawless record of an eternal tablet preserved in Heaven, revealed over a period of

twenty years to the Prophet Muhammad. For the Muslim community, the Qur'an forms the ultimate source of knowledge and continuing inspiration for life.

Consisting of 114 *surahs* or chapters of unequal length, the entire Qur'an has a length somewhat shorter than the Christian New Testament. The earliest surahs are the shortest chapters and exhibit a dynamic rhymed prose. Later surahs are longer and more prosaic. In the current version of the Qur'an, the arrangement falls according to length, with the shortest surahs placed last. The early surahs issue a call to moral and religious obedience in view of the coming Day of Judgment. The later surahs give directions for the establishment of a social order agreeable to the moral life called for by God. The Qur'an presents a forceful vision of a single, all-powerful, and merciful God. Muslims believe it to be God's final revelation, which is given in a vivid language capable of being fully understood only in the original Arabic. Translations have traditionally been forbidden, and any translations are viewed as paraphrases to assist in understanding the actual scripture. *Surah 4* ("Women") addresses issues pertinent to Arabic society at the time of Muhammad: that of a code of conduct protecting the legal rights of women and assuring care for the poor and unfortunate.

Surah 4, 1–5

"The Women"

In the name of Allah, the Beneficent, the Merciful.

4.1: O people! Be careful of (your duty to) your Lord, Who created you from a single being and created its mate of the same (kind) and spread from these two, many men and women; and be careful of (your duty to) Allah, by Whom you demand one of another (your rights), and (to) the ties of relationship; surely Allah ever watches over you.

4.2: And give to the orphans their property, and do not substitute worthless (things) for (their) good (ones), and do not devour their property (as an addition) to your own property; this is surely a great crime.

4.3: And if you fear that you cannot act equitably towards orphans, then marry such women as seem good to you, two and three and four; but if you fear that you will not do justice (between them), then (marry) only one or what your right hands possess; this is more proper, that you may not deviate from the right course.

4.4: And give women their dowries as a free gift, but if they of themselves be pleased to give up to you a portion of it, then eat it with enjoyment and with wholesome result.

4.5: And do not give away your property which Allah has made for you a (means of) support to the weak of understanding, and maintain them out of (the profits of) it, and clothe them and speak to them words of honest advice.

DRAMA

Drama consists of a composition in prose or poetry intended to portray life or character or to tell a story usually involving conflicts and emotions through action and dialogue. Typically, dramas are intended for theatrical production, and, as such, we treat them in this text within the category of theatre. However, we can classify many dramas in literature as "closest dramas"—dramas written for reading (not acted or performed on a stage).

HOW IS IT PUT TOGETHER?

FICTION

Point of View

In simplest terms, point of view represents the perspective from which an author tells a story to the reader. Point of view has

A Question to Ask

What general type of literature does the work represent, and how does it express the characteristics of that genre?

three main types: first person, third person singular, and third person omniscient. When an author uses first person singular, she tells the story using a narrative from the "I" point of view. For example, in Charlotte Brontë's (BRAHN-tee or BRAHN-tay; 1816–1855) *Jane Eyre* we see the story through the eyes and narration of one of the characters. Third person gives us a story told by a narrator, not one of the characters in the story. It has two forms: singular and omniscient. In the first case—first person singular—the narrator writes from the viewpoint of a single character, describing or seeing only what that character sees, hears, and knows, but not in the voice of that character. In the latter form—third person omniscient—the narrator may take the viewpoint of any or all characters, or stand outside the characters, thus capable of commenting on any aspect of the story. Authors may vary or combine these forms of point of view to suit their own purposes. Thus, point of view serves as one means by which fiction is put together, allowing authors to communicate meaning.

Appearance and Reality

Fiction claims to be true to actuality, but it builds on invented sequences of events. It refers back on itself, layering the fictional and the factual.

Tone

Tone, or the atmosphere of the story, represents, essentially, the author's attitude toward the story's literal facts. In reading, much like listening to conversation, the words carry meaning, but the way in which the speaker or author says or presents them—their tone—shapes meaning much more than we realize. In addition, the atmosphere of the story sometimes includes the setting or the physical environment. In many stories, atmosphere holds psychological as well as physical characteristics, and when all of these characteristics of tone merge, they provide subtle and powerful suggestions leading to fuller understanding of the work.

Character

Literature appeals through its people, but not just people alone. It draws our interest because we see a human character struggling with some important problem. Authors write to that potential interest and usually strive to focus our attention, and to achieve unity, by drawing a central character with whose actions, decisions, growth, and development we can identify, and in whom we can find an indication of some broader aspect of the human condition. As we note in Chapter 7, the term *character* goes beyond the mere identification of a "person." *Character* means the psychological spine of individuals, the driving force that makes them respond the way they do when faced with a given set of circumstances. Character interests us: Given a set of troubling or challenging circumstances, what does the character of the individual lead him or her to do?

A Question of Style

Neoclassicism

neoclassicism (nee-oh-KLA-sih-siz-uhm). Adherence to or the practice of the qualities thought to characterize classical art, literature, and eighteenth-century music. These qualities include formal elegance and correctness, simplicity, dignity, restraint, order, and proportion. Adherents of classicism believe these qualities are universal and eternally valid. Neoclassicism, thus, refers to art inspired by classical antiquity but produced in later times (see Fig. 4.32). One who followed classical examples in literature, the American poet Phillis Wheatley (c. 1753–1784) probably came from in or near the current African nation of Senegal. She came to America, captive, on the slaver *Phillis*. At the age of seven, she was sold to John Wheatley, a Boston merchant. Recognizing her talent, the Wheatleys taught her to read and write not only in English but also in Latin. She read poetry, and at the age of fourteen, began to write. Her elegy on the death of George Whitefield (1770) brought her acclaim. With the 1772 publication of her *Poems on Various Subjects* in England, Phillis Wheatley's fame spread in Europe as well as America. Freed from slavery in 1773, she remained with the Wheatley family as a servant and died in poverty. Her poetry follows neoclassical style, has African influences, and reflects Christian concerns for morality and piety. In the short poem "On Virtue," her language invokes imagery, figures, and allegory to make the moral quality of virtue a "bright jewel" and imbue it with personal characteristics. The unrhymed lines of the poem flow freely in iambic pentameter.

ON VIRTUE

PHILLIS WHEATLEY

O Thou bright jewel in my aim I strive
To comprehend thee. Thine own words declare
Wisdom is higher than a fool can reach.
I cease to wonder, and no more attempt
Thine height t'explore, or fathom thy profound.
But, O my soul, sink not into despair,
Virtue is near thee, and with gentle hand
Would now embrace thee, hovers o'er thine head.
Fain would the heav'n-born soul with her converse,
Then seek, then court her for her promis'd bliss.
Auspicious queen, thin heav'nly pinions spread,

(Continued)

A Question of Style (continued)

And lead celestial *Chastity* along;
Lo! Now her sacred retinue descends,
Array'd in glory from the orbs above.
Attend me, *Virtue*, thro' my youthful years!
O leave me not to the false joys of time!
But guide my steps to endless life and bliss.
Greatness, or *Goodness*, say what I shall call thee,
To give an higher appellation still,
Teach me a better strain, a nobler lay,
O thou, enthron'd with Cherubs in the realms of day!

In developing character, an author has numerous choices, depending, again, on purpose. Character may be fully three-dimensional and highly individual—as complex as the restrictions of the medium allow. Novels, because of their length and the fact that the reader can go back to double-check a fact or description, allow much more complex character development or individuality than do plays, whose important points must be found by the audience almost at the moment they are presented. Also, a change of narrative viewpoint, appropriate to a novel but not to a play (unless the play uses a narrator, as in *Our Town*, or a chorus, as in Greek classical tragedy), can give the reader aspects of character in a more efficient manner than can revelation through action or dialogue.

On the other hand, the author's purpose may be served by presenting character not as a fully developed individual but as a type. Whatever the author's choice, the nature of character development tells much about the meaning of the work.

Plot

Plot, the structure of the work, embodies more than the story line or the facts of the piece. In literature, as in the theatre, we find our interest dependent upon action. The action of a literary work dramatizes a fully realized theme, situation, or character. Plot brings that action into coherency. It creates unity in the work and thereby helps us to find meaning. Plot forms the skeleton that determines the ultimate shape of the piece, once the elements of flesh have been added to it.

Plot may be the major or subordinate focus in a work, and it can be open or closed. Closed plots rely on the Aristotelian model of pyramidal action with an exposition, complication, and dénouement. An open plot has little or no resolution. We merely leave the characters at a convenient point and imagine them continuing as their personalities dictate.

Theme

Most good stories have an overriding idea or theme that shapes the other elements. Quality in works of art rest at least

A Question of Style

Romanticism

romanticism (roh-MAN-tuh-sihz-uhm). A philosophy as well as a style in all the arts and literature, dating to the late eighteenth through nineteenth centuries. In architecture, it borrowed styles from previous eras while experimenting with modern materials. It also sought an escape to the past. In painting, the style turned to emotionalism, the picturesque, and nature. It fragmented images and dramatized with personal subjectivity. In theatre, the style resulted in dazzling scenery. In literature, music, and ballet, it sought the subjective and the colorful, reflecting great diversity.

Romanticism as a fully developed style had related developments in the late eighteenth century, called pre-Romanticism. In English literature, Romanticism proper began in the late 1790s with the publication of William Wordsworth and Samuel Coleridge's *Lyrical Ballads.* In Wordsworth's "Preface" to the second edition (1800), he described poetry as "the spontaneous overflow of powerful feelings." This sentiment underscored the English Romantic movement in poetry. The Romantic novel can be exemplified by Charlotte Brontë (BRAHN-tee or -tay; 1816–1855), particularly the novel *Jane Eyre,* a powerful story of a woman in conflict with her basic desires and social condition. The title character, a willful orphan, survives a number of years at a charity school and then becomes governess to the ward of a mysterious Mr. Rochester, with whom she falls in love. Before the marriage, however, Jane learns that Mr. Rochester is already married and that his wife is insane and confined to the attic of the estate. Learning this, Jane leaves, but later, after Rochester's wife dies, she reunites with him.

partly on artists' ability to utilize the tools of their medium, as well as on whether they have something worthwhile to say. Some critics argue that the quality of a theme has less importance than what the author does with it. Yet the conclusion seems inescapable: The best artworks are those in which the author has taken a meaningful theme and developed it exceptionally. The theme or idea of a work consists, then, of what the author has to say. *Theme* may mean a definite intellectual concept, or it may indicate a highly complex situation. Clues to understanding the idea can come as early as our exposure to the title. Beyond that, the author usually reveals the theme in small pieces as the work moves from beginning to conclusion.

Symbols

As we discussed in Chapter 1, symbols stand for or suggest something else by reason of relationship, association, convention, or accidental resemblance. They often comprise a visible manifestation of something invisible (for example, the lion as a symbol for courage and the cross as a symbol of Christianity). In this sense, all words function as symbols. The symbols used in literature are often private or personal in that their significance only emerges in the context of the work in which they appear. For example, the optician's trade sign of a huge pair of spectacles in F. Scott Fitzgerald's *The Great Gatsby* (1925) functions as a piece of scenic detail, but we can also

A Question of Style

Magic Realism

magic realism. A Latin American literary movement incorporating fantastic or mythic elements into otherwise realistic fiction. Perhaps the master of this form is Gabriel García Marquez (gahr-SEE-ah MAHR-kays; b. 1928), a Columbian-born author and journalist who won the 1982 Nobel Prize for Literature. His best-known work, *One Hundred Years of Solitude* (1967), tells the story of Macondo and its founders, the Buendía family. An epic tale of seven generations, it spans the years of Latin American history from the 1820s to the 1920s during which patriarch Arcadio Buendía built the utopian city of Macondo in the middle of a swamp. As time elapses, the city and the family slip into depravity. Finally, a hurricane totally obliterates the city. Complex fantasy combined with realism mark this book, making it a superb example of the magic realist genre.

understand it as a symbol of divine nearsightedness. A symbol can have more than one meaning. It can be hidden, profound, or simple. Symbols function in literature, as in all art, as devices that expand the content of a work beyond specifics to universals. In literature, symbols give a work its richness and much of its appeal. When we realize that a character in a story, for example, represents a symbol, regardless of how much of an individual the writer may have portrayed, the story takes on new meaning because the character symbolizes us—some aspect of our complex and often contradictory natures.

POETRY

Language

In discussing the language of poetry, we focus on five factors: rhythm, imagery, figures, metaphor, and symbols.

Rhythm in poetry consists of the flow of sound through accents and syllables. For example, in Robert Frost's "Stopping by Woods on a Snowy Evening" (see following), each line contains eight syllables with an accent on every other syllable. We call

rhythms like Frost's, which depend on a fixed number of syllables per line, accentual-syllabic. Contrast that with the freely flowing rhythm of Shakespeare's "The Seven Ages of Man," from Act II of *As You Like It*, in which rhythmic flow uses naturally occurring stresses in the words. This use of stress to create rhythm we call accentual.

STOPPING BY WOODS ON A SNOWY EVENING

ROBERT FROST

1874–1963

Whose woods these are I think I know.
His house is in the village though;
He will not see me stopping here
To watch his woods fill up with snow.

My little horse must think it queer 5
To stop without a farmhouse near

Between the woods and frozen lake
The darkest evening of the year.

He gives his harness bells a shake
To ask if there is some mistake. 10

 The only other sound's the sweep

 Of easy wind and downy flake.

The woods are lovely, dark and deep.
But I have promises to keep,
And miles to go before I sleep, 15
And miles to go before I sleep.

Source: Robert Frost, "Stopping by Woods on a Snowy Evening" from *The Poetry of Robert Frost*, edited by Edward Connery Lathem. Copyright 1923 © 1969 by Henry Holt and Co., Inc. Reprinted by permission of Henry Holt and Co., Inc.

THE SEVEN AGES OF MAN

WILLIAM SHAKESPEARE

1564–1616

All the world's stage,
And all the men and women merely players.
They have their exits and their entrances,
And one man in his time plays many parts,
His acts being seven ages. At first the infant, 5
Mewling[1] and puking in the nurse's arms.
Then the whining schoolboy, with his satchel

And shining morning face, creeping like snail
Unwillingly to school. And then the lover,
Sighing like furnace, with a woeful ballad[2] 10
Made to his mistress' eyebrow. Then a soldier,
Full of strange oaths and bearded like the pard,[3]
Jealous in honor,[4] sudden and quick in quarrel,
Seeking the bubble reputation[5]
Even in the cannon's mouth. And then the justice. 15
In fair round belly with good capon lined,[6]
With eyes severe and beard of formal cut,
Full of wise saws[7] and modern instances;[8]
And so he plays his part. The sixth age shifts
Into the lean and slippered Pantaloon,[9] 20
With spectacles on hose and pouch on side;
His youthful hose, well saved, a world too wide

[1]Whimpering.
[2]Poem.
[3]Leopard.
[4]Sensitive about honor.
[5]As quickly burst as a bubble.
[6]Magistrate bribed with a chicken.
[7]Sayings.
[8]Commonplace illustrations.
[9]The foolish old man of Italian comedy.

For his shrunk shank, and his big
manly voice,
Turning again toward childish treble,
pipe
And whistles in his sound. Last scene of
all, 25
That ends this strange eventful history,
Is second childishness and mere oblivion,
Sans[10] teeth, sans eyes, sans taste, sans
everything.

Source: As You Like It, Il. vii. 139–1661.

Imagery, a verbal representation of objects, feelings, or ideas, can be literal or figurative. The former involves no change or extension in meaning; for example, "green eyes" means eyes that are green in color. The latter, figurative, involves a change in literal meaning; for example, green eyes might become "green orbs."

Figures, like images, take words beyond their literal meaning. Much of poetic meaning comes from comparing objects in ways that go beyond the literal. For example, in Robert Frost's "Stopping by Woods on a Snowy Evening," the poet describes snowflakes as "downy," which endows them with the figurative quality of soft, fluffy feathers on a young bird. In the same sense, Frost uses "sweep" and "easy" to describe the wind.

Metaphors constitute figures of speech by which words receive new implications. Thus, the expression "the twilight of life" applies the word *twilight* to the concept of life to create an entirely new image and meaning. Metaphors use implication but not explicit comparisons.

[10]Without.

Symbols are also often associated with figures of speech, but not all figures are symbols, and not all symbols are figures. Poetry depends on symbolism because poetry relies on compressed language to express, and carry us into, its meanings. In poetry, parts and the whole interact with complexity. Specifically, the parts find their meaning from the whole, and the whole depends for its meaning on the parts.

The *allegory* constitutes a work in which related symbols work together, with characters, events, or settings that represent ideas or moral qualities. Often the characters of an allegory personify abstractions such as Fellowship and Good Deeds in the fifteenth-century English morality play *Everyman*. In the following poem, *Uphill* (1858), Christina Rossetti (1830–1894) uses the road, the hill, the inn, the darkness at end of day, the traveler, and the other wayfarers as parts of the poet's allegorical vision of our spiritual journey to our ultimate destination.

UPHILL

CHRISTINA ROSSETTI

Does the road wind uphill all the way?
 Yes, to the very end.
Will the day's journey take the whole
long day?
 From morn to night, my friend.

But is there for the night a resting place?
 A roof for when the slow dark hours
begin.
May not the darkness hide it from my
face?
 You cannot miss that inn.

Shall I meet other wayfarers at night?
 Those who have gone before.
Then must I knock, or call when just in
sight?
 They will not keep you standing at
that door.

Shall I find comfort, travel-sore and weak?
 Of labor you shall find the sum.
Will there be beds for me and all who
seek?
 Yea, beds for all who come.

Structure

Form or structure in poetry derives
from fitting together lines of similar struc-
ture and length tied to other lines by end
rhyme. For example, the sonnet, as we dis-
cussed earlier, has fourteen lines of iambic
pentameter rhymed 1–3, 2–4, 5–7, 6–8,
9–11, 10–12, 13–14 (see "Meter" on p. 184).
In contrast to the highly structured sonnet,
examine the loose rhyme scheme used by
Langston Hughes in "Theme for English B."

THEME FOR ENGLISH B

LANGSTON HUGHES

1902–1967

The instructor said,
Go home and write
a page tonight.
And let that page come out of you—

Then it will be true.
I wonder if it's that simple?

I am twenty-two, colored, born in
Winston-Salem.
I went to school there, then Durham,
then here
to this college on the hill above Harlem.
I am the only colored student in my class.
The steps from the hill lead down into
Harlem
through a park, then I cross St. Nicholas.
Eighth Avenue. Seventh, and I come to
the Y,
the Harlem Branch Y, where I take the
elevator
up to my room, sit down, and write this
page:
It's not easy to know what is true for you
or me
at twenty-two, my age. But I guess I'm
what
I feel and see and hear, Harlem, I hear
you:
hear you, here me-we two-you, me, talk
on this page.
(I hear New York, too) Me—who?

Well, I like to eat, sleep, drink, and be
in love.
I like to work, read, learn, and under-
stand life.
I like a pipe for a Christmas present,
or records—Bessie, bop, or Bach.
I guess being colored doesn't make me
not like

the same things other folks like who
are other races.
So will my page be colored that I write?
Being me, it will not be white.
But it will be
a part of you, instructor.
You are white—
Yet a part of me, as I am a part of you.
that's American.
Sometimes perhaps you don't want to
be a part of me.
Nor do I often want to be a part of you.
But we are, that's true!
As I learn from you
I guess you learn from me—
although you're older—and white—
and somewhat more free.

This is my page for English B.

Source: Langston Hughes, "Theme for English B" from
Collected Poems. Copyright © 1994 by the estate of
Langston Hughes. Reprinted by permission of Alfred A.
Knopf. Inc.

Sound Structures

Sound structures give poetry its ear.
We note four of them: rhyme, alliteration,
assonance, and consonance.

Rhyme—the coupling of words that
sound alike—constitutes the most common
sound structure in poetry. It ties the sense
together with the sound. Rhyme can be mas-
culine, feminine, or triple. Masculine rhyme
uses single-syllable vowels such as "hate" and
"mate." Feminine rhyme uses sounds forming
accented and unaccented syllables, for exam-
ple, "hating" and "mating." Triple rhyme has a
correspondence over three syllables, such as
"despondent" and "respondent."

Alliteration, a second type of sound
structure, repeats an initial sound for effect:
for example "fancy free."

Assonance uses a similarity among vow-
els but not consonants, for example, "quite
like."

Consonance repeats or involves recur-
rence of identical or similar consonants, as
in Shakespeare's song "The ousel co*ck* so
bla*ck* of hue." Poets often combine conso-
nance with assonance and alliteration.

Meter

Meter refers to the type and number of
rhythmic units in a line. We call rhythmic
units feet. Four common kinds of feet are
iambic, trochaic, anapestic, and dactylic.
Iambic meter alternates one unstressed and
one stressed syllable; trochaic alternates
one stressed and one unstressed syllable;
anapestic alternates two unstressed and one
stressed syllable; and dactylic alternates one
stressed and two unstressed syllables.

Line, also called verse, determines the
basic rhythmic pattern of the poem. Lines
take their names from the number of feet
they contain: one foot—monometer; two—
dimeter; three—trimeter; four—tetrameter;
five—pentameter; six—hexameter; seven—
heptameter; and eight—octameter.

NONFICTION
Biography

Writers use any number of elements to
compose biographies, including the basic
matters of facts and anecdotes.

A Question to Ask

What sound structures has the poet used, and how does the use of sound structures give clarity, appeal, and meaning to the work?

Facts

Facts, the verifiable details around which writers shape biographies, often have a way of becoming elusive when they go beyond the simple matters of birth, death, marriage, and other date-related occurrences. Facts can turn out to be observations filtered through the personality of the observer. Incontrovertible facts may comprise a chronological or skeletal framework for a biography, but they may well not create much interest. Frequently they do not provide much of a skeleton either. In truth, many individuals of interest to us may have few facts recorded about them.

On the other hand, the lives of other important individuals have been chronicled in such great detail that almost too many facts exist. Artistry entails selection and composition, and many facts require omission from the narrative in order to maintain the reader's interest. Another issue concerns what the author should actually do with the facts. If they constitute injurious material, should the author use them? In what context? Whatever the situation, facts alone prove highly insufficient for an artistic or interesting biography.

Anecdotes

Anecdotes, stories or observations about moments in a biography take the basic facts and expand them for illustrative purposes, thereby creating interest. Either true or untrue, anecdotes serve the purpose of creating a memorable generalization. They sometimes also generate debate or controversy.

Quotations form part of anecdotal experience. Authors use quotations to create interest by changing the presentational format to that of dialogue. In the sense that dialogue creates the impression that we are part of the scene, as opposed to being third parties listening to someone else describe a situation, dialogue brings us closer to the subjects of the biography.

HOW DOES IT STIMULATE THE SENSES?

Literature, like all the arts, appeals to our senses by the way in which the writer uses the tools of the medium. Specifically, literature uses words. What we see and hear in literature results from the skill of the writer in turning words into sense-stimulating images.

PICTURES

Skillful wordplay opens many sensual vistas, and any of the excerpts in this chapter can bring us to those vistas. The very words of the title of Saki's short story—Toad-water—conjure pictures. Perhaps the image of this place depends on our having had some

A Question to Ask

What devices has the writer used to stimulate my senses of sounds and emotions? Why do I react as I do to the writer's words?

experience of toads, so for those who have not, toad-water brings to mind a soggy primeval place hovering somewhere around the level of squalor. Toads, with their warts and other unlovely features, constitute denizens of dank, unlovely places. Likewise, William Shakespeare's "Seven Ages of Man" conjures vivid pictures of an infant mewling and puking in its mother's arms, or an old person "sans teeth, sans eyes, sans taste, sans everything."

SOUNDS

We hear real sounds stimulated by words. Shakespeare again creates sounds through words as he describes a "big manly voice,/ Turning again toward childish treble, pipe/ And whistles in his sound," and we hear the sibilance of a toothless octogenarian and picture puckered lips caving inward over exposed gums. Even John Wesley's straightforward description of anger, brought to life by quotations, evokes the raucous belligerency of the mob, brought to life by images of rioting mobs of our day crashing into our rooms via television news. A writer's choice of words causes sounds to well up in our heads, often as real as if we were there ourselves.

EMOTIONS

The mood evoked by a piece of literature can turn us in on ourselves, stimulating sensations traveling from pleasure to pain. We may not understand why we react as we do, but we understand vividly the power of words to invade our personal world and move us. When Langston Hughes writes "Nor do I often want to be a part of you./But we are, that's true," this poem, written many years ago, cannot help but raise an emotion. The emotion may differ depending on whether we are black, white, yellow, or some combination, liberal or conservative, but the emotion strikes home in one way or another nonetheless. Visceral reactions, arguably, form the top layer of the onion comprising our response to literary stimuli. When we peel the top layer away and delve into those layers beneath, real pleasure and sense of accomplishment result. Examining the whats of artistic stimulation provides significant challenge. Determining the whys multiplies the reward exponentially.

Sample Outline and Critical Analysis

The following very brief example illustrates how we can use some of the terms explained in the chapter to form an outline and then develop a critical analysis of a work of literature. Here is how that might work regarding Phillis Wheatley's poem *On Virtue* (page 177).

Outline	**Critical Analysis**
Genre Poetry	This is a poem, and as a poem it means that the poet's words are very important: Poetry is about words and the choices made by the poet to convey something larger than the surface of literal meaning. The title chosen, and the subject of the entire poem, is Virtue. This is a word we don't hear much in the twenty-first century, perhaps because the word itself has become obsolete, or worse, because the qualitites that it connotes have become obsolete. Perhaps I fear the latter, which is
Reaction	why I like the poem. It speaks to my need to have something and someone out there (even if it is a poet who has been dead nearly two hundred and twenty-five years) who contemplates and seeks to understand— "in my aim I strive to comprehend thee"—the qualities Virtue means: goodness, valor, moral excellence. In other words, someone who at least in the poem seeks something ennobling, uplifting, higher than the status quo. I think pursuit of virtue is important if humankind is to escape sliding into a banal, and ultimately, feral existence where nothing counts except unbridled selfishness and the worst we are capable of being. So, to repeat, the poem strikes a chord.
Meter Sound structures Rhyme	With regard to the poem itself, its meter is iambic pentameter: Five rhythmic units (feet) per line with an unstressed and stressed syllable making up each foot. However, the meter is not slavish; it does not plod along duh-dah duh-dah, and so on. Rather, it moves according to the nature of speech. The meter is there, but not distracting. The sound structure of rhyme is unrhymed. None of the ending words of the lines rhyme.
Language Symbols—allegory	The most obvious characteristic in the poet's use of language is her use of symbols in the form of allegory. She represents the abstract ideas of Virtue—Chastity, Goodness—and Virtue itself as characters by capitalizing them and thereby raises them to a higher plane of existence than a mere behavioral quality.

Additional Study and Cyber Sources

Prehistory–c. 1800 C.E.

Mesopotamia (Gilgamesh Epic):
 http://www.hist.unt.edu/ane-09.htm
Ancient Greece (Homer. *The Iliad*):
 http://srd.yahoo.com/srst/4102/lliad/
 1/9/*
 http://darkwing.uoregon.edu/~joelja/iliad.
 html

(Sappho): http://www.earthlight.co.nz/users/
 spock/sappho.html
Rome (Virgil. *The Aeneid*):
 http://srd.yahoo.com/srst/5644/Aeneid/
 1/3/*
 http://darkwing.uoregon.edu/~joelja/
 aeneid.html
Middle Ages (Beowulf): http://www
 .lone-star.net/literature/beowulf/index.html

(Dante. *Divine Comedy*):
 http://www.divinecomedy.org/divine_
 comedy.html
Renaissance (Boccaccio. *Decameron*):
 http://srd.yahoo.com/srst/5696126/Decame
 ron%2c+Boccaccio/4/4/
 *http://www.brown.edu/Departments/
 Italian_Studies/dweb/
 dweb.shtml
Baroque (Cervantes. *Don Quixote*):
 http://www.donquixote.com/paronechap12.
 html

c. 1800–Present

Romanticism (Goethe. *Faust*):
 http://www.bb.com/looptestlive.cfm?
 BOOKID=593&StartRow=15

(Dostoevsky. *Brothers Karamazov*):
 http://eserver.org/fiction/brothers-
 karamazov.txt
Byron: *Don Juan*
T. S. Eliot. *The Wasteland:*
 http://www.bartleby.com/201/1.html
O'Connor: *Revelation*
Jones: *Corregidora*
Walker: *The Color Purple*
Morrison: *Jazz*
Kawabata: *Snow Country*
Solzhenitsyn: *One Day in the Life of Ivan Denisovich*
Gao Xingjian: *Soul Mountain*

Theatre

Like all the arts, theatre tries to personalize the love, rejection, disappointment, betrayal, joy, elation, and suffering that we experience in our daily lives. In this case, it does so using live people acting out situations that very often look and sound like real life. Theatre once functioned in society like television and movies do today. Many of the qualities of all three forms are identical. We'll find in this chapter the ways that theatre, which frequently relies on *drama* (a written script), takes lifelike circumstances and compresses them into organized episodes. The result, although looking like reality, goes far beyond reality in order to make us find in its characters pieces of ourselves. At the same time, we engage in willing suspension of disbelief. That is, we disregard what we know is improbable and accept the reality of what we see and hear portrayed for us on the stage (or in the film). We know we sit in a theatre with other people around us, and we know that when the curtain opens or the stage lights go up, we will witness an enactment. That enactment is not real—even if the play depicts historical

events. Nonetheless, we are able to shed the disbelief of the fictional moment and accept and enter into the emotions and understandings of what the play portrays. This allows us to empathize: We will cry if we see sadness; we will wince in pain if we see a slap in the face, and so on. Otherwise, we would simply say to ourselves, "That's not actually happening; it's all fake."

The word *theatre* comes from the Greek *theatron*—the part of the Greek theatre where the audience sat. Its literal meaning is "a place for seeing," but for the Greeks this implied more than the sense experience of vision (which, indeed, forms an important part of the theatrical production). To the ancient Greeks, "to see" also may include comprehension and understanding. Thus, witnessing—seeing and hearing—a theatrical production was felt with the emotions and mediated by the intelligence of the mind, leading to an understanding of the importance of the play. Further, for the ancient Greek, *theatron*, while a physical part of the theatre building, implied a nonphysical place—a special state of being of those who together watched the lives of the persons of the drama.

Like the other performing arts, theatre is an interpretive discipline. Between the playwright and the audience stand the director, the designers, and the actors. Although each functions as an individual artist, each also serves to communicate the playwright's vision to the audience. Sometimes the play becomes subordinate to the expressive work of its interpreters, and sometimes the concept of director as master artist places the playwright in a subordinate position. Nonetheless, a theatrical production always requires the interpretation of a concept through spectacle and sound by theatre artists.

WHAT IS IT?

Theatre represents an attempt to reveal a vision of human life through time, sound, and space. It gives us flesh-and-blood human beings involved in human action (color insert Plate 19)—we must occasionally remind ourselves that the dramatic experience is not reality but, rather, an imitation of reality, acting as a symbol to communicate something about the human condition. Theatre is make-believe: Through gesture and movement, language, character, ideas, and spectacle, it imitates action. However, if this were all theatre consisted of, we would not find it as captivating as we do, and as we have for more than 2,500 years.

At the formal level, theatre comprises *genre*—or type of play—from which the production evolves. *Some* of the genres of theatre include *tragedy, comedy, tragicomedy,* and *melodrama.* Some came from specific periods of history, and illustrate trends that no longer exist; others remain developmental and as yet lack definite form. Our response to genre differs from our formal response or identification in music, for example, because we seldom find generic identification in the theatre program. Some plays are well-known examples of a specific genre, for example, the tragedy *Oedipus* (EH-dih-puhs) *the King* by Sophocles (SAH-fuh-kleez). In these cases, as with a symphony, we can see how the production develops the conventions of genre. Other plays, however, are not well known or may be open to interpretation. As a result, we can draw our conclusions only after the performance has finished.

Tragedy

We commonly describe tragedy as a play with an unhappy ending. The playwright Arthur Miller describes tragedy as "the

consequences of a man's total compulsion to evaluate himself justly, his destruction in the attempt posits a wrong or an evil in his environment." In the centuries since its inception, tragedy has undergone many variations as a means by which the playwright makes a statement about human frailty and failing.

Typically, tragic heroes make free choices that bring about suffering, defeat, and sometimes, triumph as a result of defeat. The protagonist often undergoes a struggle that ends disastrously. In Greek classical tragedy of the fifth century B.C.E., the hero generally was a larger-than-life figure who gained a moral victory amid physical defeat. The classical hero usually suffers from a tragic flaw—some defect that causes the hero to participate in his or her own downfall. In the typical structure of classical tragedies, the climax of the play occurs as the hero or heroine recognizes his or her role, and accepts destiny (example: Sophocles, *Oedipus the King*). In the years from Ancient Greece to the present, however, writers of tragedy have employed many different approaches. Playwright Arthur Miller argues the case for tragic heroes of "common stuff," suggesting tragedy is a condition of life in which human personality flowers and realizes itself.

COMEDY

In many respects, comedy is much more complex than tragedy and even harder to define. Comedy embraces a wide range of theatrical approaches, ranging from the intellectual and dialogue-centered high comedy of the seventeenth century (called Comedy of Manners) to the slapstick, action-centered low comedy found in a variety of plays from nearly every historical period. Low comedy may include *farce*, typically a wildly active and hilarious comedy of situation, usually involving a trivial theme. We might say that the difference between comedy and farce consists of more than a matter of degree and includes a different point of view. We usually like comic characters and find sympathy with them. Characters in farce are often ridiculous and, occasionally, contemptible. We associate this kind of comedy with actions such as pies in the face, mistaken identities, and pratfalls. Whatever happens in a farce carries little serious consequence. It perhaps provides an opportunity for the viewer to express unconscious and socially unacceptable desires without having to take responsibility for them.

Between the extremes just noted exist a variety of comic forms including the popular domestic comedy, in which family situations focus our attention, and in which members of a family and their neighbors find themselves in various complicated and amusing situations, for example, Neil Simon's plays *Brighton Beach Memoirs* and *Broadway Bound*.

Defined in its broadest terms, comedy may not involve laughter. Many employ stinging *satire*, although we probably can say with some accuracy that humor forms the root of all comedy. In many circumstances, comedy treats a serious theme, but remains basically lighthearted in spirit: Characters may be in jeopardy, but not *too* seriously so. Comedy deals with the world as we find it, focusing on everyday people through an examination of the incongruous aspects of behavior and relationships. The idea that comedy ends happily probably results from expectations that in happy endings everyone remains more or less free to do what they please. However, happy endings often imply different sets of circumstances in different plays. Comedy appears to defy any such thumbnail definitions.

A Question of Style

Greek Classicism

classicism (KLAS-uh-sihz-uhm). The principles, historical traditions, aesthetic attitudes, or style of the arts of ancient Greece and Rome (see Fig. 4.4), including works created in those times or later inspired by those times. Or, **classical** scholarship. Or, adherence to or practice of the virtues thought to be characteristic of classicism or to be universally and enduringly valid—that is, formal elegance and correctness, simplicity, dignity, restraint, order, and proportion.

The ancient Greek tragedian Sophocles' *Oedipus the King* treats one of the great legends of Western culture. At the beginning of the play, Oedipus (EHD-ih-puhs) is the beloved ruler of the city of Thebes, whose citizens have been stricken by a plague. Consulting the Delphic oracle, Oedipus learns that the plague will cease only when the murderer of Queen Jocasta's (joh-CAS-tuh) first husband, King Laius (LAY-uhs), has been found and punished for his deed. Oedipus resolves to find Laius's killer, only to discover that the old man he himself killed when he first approached Thebes as a youth, was none other than Laius. Finally, Oedipus learns the truth about himself and his past. Laius was Oedipus's father, and Jocasta, now Oedipus's wife and mother of his children, is, in fact, his mother. At the end, Jocasta hangs herself, and guilt-stricken Oedipus blinds himself with Jocasta's brooch pin.

In the play, Sophocles explores the reality of the dual nature we all share. He poses the eternal question—can we control our destinies or are we the pawns of fate? In exploring this question, he vividly portrays the circumstances in which one's strengths become one's weaknesses. Oedipus's hamartia (huh-MAHR-shuh), or tragic flaw, is the excessive pride, or hubris (HYOO-brihs), which drives him to pursue the truth, as a king—or man—should, only to find the awful answer in himself.

Although a tragedy, the play has a message of uplift and positive resolution. When Oedipus recognizes his own helplessness in the face of the full horror of his past, he performs an act of contrition: He blinds himself, and then exiles himself. As grotesque as this may seem, it nevertheless releases Oedipus onto a higher plane of understanding. The chorus chants, "I was blind," while seeing with normal eyes, and Oedipus moans, "I now have nothing beautiful left to see in this world." Yet, being blind, Oedipus is now able to "see" the nobler, truer reality of his self-knowledge.

TRAGICOMEDY

As the name suggests, tragicomedy is a mixed form of theatre, which, like the other types, has been defined in different terms in different periods. Until the nineteenth century, the ending determined the necessary criterion for this form. Traditionally, characters reflect diverse social standings—kings (like tragedy) and common folk (like comedy), and reversals went from bad to good and good to bad. It also included language appropriate to both tragedy and

profile

William Shakespeare

William Shakespeare (1564–1616), one of the world's greatest literary geniuses, worked mostly in the theatre, but he left a remarkable sequence of sonnets (see p. 171) in which he pushed the resources of the English language to breathtaking extremes. In his works for the theatre, Shakespeare represents the Elizabethan love of drama, and the theatres of London were patronized by lords and commoners alike. They sought and found, usually in the same play, action, spectacle, comedy, character, and intellectual stimulation deeply reflective of the human condition. Thus it was with Shakespeare, the preeminent Elizabethan playwright. His appreciation of the Italian Renaissance— which he shared with his audience—can be seen in the settings of many of his plays. With true Renaissance breadth, Shakespeare went back into history, both British and classical, and far beyond, to the fantasy world of *The Tempest*. Like most playwrights of his age, Shakespeare wrote for a specific professional company of which he became a partial owner. The need for new plays to keep the company alive from season to season provided much of the impetus for his prolific output.

Although we know only a little of his life, the principal facts are well established. Playwrights were not highly esteemed in England in the sixteenth century, and there was virtually no reason to write about them. We do, however, know more about Shakespeare than we do most of his contemporaries. Baptized in the parish church of Stratford-upon-Avon on April 26, 1564, he probably attended the local grammar school. We next learn of him in his marriage to Ann Hathaway in 1582, when a special action was necessary to allow the marriage without delay. The reason is clear—five months later, Ann gave birth to their first daughter, Susanna. The next public mention comes in 1592, when his reputation as a playwright warranted a malicious comment from another playwright, Robert Greene. From then on, many sources record his activities as dramatist, actor, and businessman. In addition to his steady output of plays, he also published a narrative poem entitled *Venus and Adonis*, which was popular enough to have nine printings in the next few years. His standing as a lyric poet grew with the publication of 154 Sonnets in 1609.

In 1594 he helped found a theatrical company called the Lord Chamberlain's Company, in which he functioned as shareholder, actor, and playwright. In 1599, the company built its own theatre, the Globe, which came directly under the patronage of James I (and called the King's Men) when he assumed the throne in 1603. (A complete reproduction of Shakespeare's Globe Theatre was completed in London in 1998.) Shakespeare died in 1616 shortly after executing a detailed will. Shakespeare's will, still in existence, bequeathed most of his property to Susanna and her daughter. He left small mementoes to friends. He mentioned his wife only once, leaving her his "second best bed" with its furnishings.

comedy. Tragicomedies comprised serious plays that ended, if not happily, then at least by avoiding catastrophe. In the last century and a half, the term has been used to describe plays in which the mood may shift from light to heavy, or plays in which endings are neither exclusively tragic or comic.

MELODRAMA

Melodrama represents another mixed form. It takes its name from the terms *melo*, Greek for music, and "drama." Melodrama first appeared in the late eighteenth century, when dialogue took place against a musical background. In the nineteenth century, the term described serious plays without music. Melodrama uses stereotypical characters involved in serious situations arousing suspense, pathos, terror, and occasionally hate. Melodrama portrays the forces of good and evil battling in exaggerated circumstances. As a rule, the issues involved remain either black or white—simplified and uncomplicated: Good is good and evil is evil; no ambiguities exist.

Geared largely for a popular audience, the form concerns itself primarily with situation and plot. Conventional in its morality, melodrama tends toward optimism—good always triumphs in the end. Typically, the hero or heroine finds him- or herself in life-threatening situations resulting from the acts of an evil villain and creating multiple climaxes. Rescue occurs at the last instant. The forces against which the characters struggle are external ones—caused by an unfriendly world rather than by inner conflicts. Probably because melodrama took root in the nineteenth century at a time when scenic spectacularism was the vogue, many melodramas depend on sensation scenes for much of their effect. This penchant can be seen in the popular nineteenth-century adaptation of Harriet Beecher Stowe's novel *Uncle Tom's Cabin*, as Eliza and the baby, Little Eva, escape from the plantation and are pursued across a raging ice-filled river. These effects taxed the technical capacities of contemporary theatres to their maximum, but gave the audience what it desired—spectacle. Not all melodramas use such extreme scenic devices, but such use occurred so frequently that it has become identified with the type. If we include motion pictures and television as dramatic structures, we could say that melodrama was the most popular dramatic form of the twentieth century.

PERFORMANCE ART

The late twentieth century produced a form of theatrical presentation called *Performance Art*. Performance art pushes the traditional theatre envelope in a variety of directions, some of which deny traditional concepts of theatrical production itself. A type of performance that combines elements from fields in the humanities and arts, from urban anthropology to folklore, and dance to feminism, performance art pieces called "Happenings" grew out of the Pop-Art movement of the 1960s. Designed as critiques of consumer culture, their central focus often included the idea that art and life should be connected.

Because of its hybrid and diverse nature, no "typical" performance artist or work stands out as an illustration. We can, however, note two brief examples, which, if they do not typify, at least illumine this movement. The Hittite Empire, an all-male

A Question to Ask

What genre does this play represent, and how do its characteristics exemplify that genre?

performance art group, performs *The Undersiege Stories,* which focuses on nonverbal communication and dance and includes confrontational scenarios. Performance artist Kathy Rose blends dance and film animation in unique ways. In one performance in New York, she creatively combined exotic dances with a wide variety of styles and science fiction. In the 1990s, performance art saw some difficult times because many people viewed it as rebellious and controversial for its own sake.

HOW IS IT PUT TOGETHER?

Theatre consists of a complex combination of elements that form a single entity called a performance, or a production. Understanding the theatre production as a work of art can be enhanced if we have some tools for approaching it, which come to us from the distant past.

Writing 2,500 years ago in the *Poetics,* Aristotle argued that tragedy consisted of plot, character, diction, music, thought, and spectacle. We can use and expand on Aristotle's terminology to describe the basic parts of a production and to use them as a set of tools for understanding theatrical productions as these six parts—and their descriptive terminology—still cover the entire theatrical product.

In the paragraphs that follow, we reshape Aristotle's terms into language more familiar to us, explain what the terms mean, and learn how we can use them to know how a theatrical production is put together—things to look and listen for in a production. We examine first the script, and include in that discussion Aristotle's concept of diction, or *language.* Next, we examine plot, thought—themes and ideas—character, and spectacle, which we call the visual elements. That is followed by a brief discussion of what Aristotle called music but which, to avoid confusion, we call aural elements.

THE SCRIPT

A playwright creates a written document called a *script,* which contains the dialogue used by the actors. Aristotle called the words written by the playwright *diction;* however, we refer to this part of a production as its *language.* The playwright's language tells us at least part of what we can expect from the play. For example, if he has used everyday speech, we generally expect the action to resemble everyday truth or reality. In the play *Fences,* playwright August Wilson uses everyday language to bring the characters to life in the context of the period, 1957:

> (Act I, scene iii. Troy is talking to his son.)

> Like you? I go out of here every morning . . . bust my butt . . . putting up with them crackers everyday . . . cause I like you? You about the biggest fool I ever saw.

> (Pause)

> It's my job. It's my responsibility! You understand that? A man got to take care of his family. You live in my house . . . sleep you behind on my bedclothes . . . fill you belly up with my food . . . cause you my son.

Poetic language, in contrast, usually indicates less realism and perhaps stronger symbolism. Compare the language of *Fences* with the poetry used by Jean Racine, seventeenth-century dramatist, in *Le Cid*

(luh seed) to create a mythical hero who is larger than life:

(Act III, scene iv)

Rodrigue: I'll do your bidding, yet still do I desire
To end my wretched life, at your dear hand.
But this you must not ask, that I renounce

My worthy act in cowardly repentance.
The fatal outcome of too swift an anger
Disgraced my father, covered me with
 shame.

Playwrights also use monologues (soliloquies) as a language device to communicate characters' inner thoughts to us in the only way possible in the live theatre. That is, the characters talk out loud. We can hear

A Question of Style

Realism

realism (REE-uhl-ihz-uhm). In visual art and theatre, a mid-nineteenth-century style seeking to present an objective and unprejudiced record of the customs, ideas, and appearances of contemporary society through spontaneity, harmonious colors, and subjects from everyday life with a focus on human motive and experience.

The son of a white father and an African American mother, August Wilson (b. 1945) writes with an ear tuned to the rhythms and patterns of the blues and the speech of the black neighborhoods. Wilson believes that the American black has the most dramatic story of all humankind to tell. His concern lies with the stripping away of important African traditions and religious rituals from blacks by whites. He realistically portrays the complexity of African American attitudes toward themselves and their past. The conflicts between black and white cultures and attitudes form the central core of Wilson's work and can be seen in plays such as *Fences* (1986).

Fences treats the lives of black tenement-dwellers in Pittsburgh in the 1950s. Troy Maxson, a garbage collector, takes great pride in his ability to hold his family together and to take care of them. Frustrated, he believes he has been deprived, because of his race, of the opportunities to get what he deserves—and this becomes a central motif.

Nilo Cruz (b. 1960), a Cuban American playwright, came to America just before his tenth birthday on a Freedom Flight to Miami. Winner of a Pulitzer Prize in 2003, his *Anna in the Tropics* opens in 1929 with a mother and her daughters waiting expectantly for the arrival of a ship from Cuba, which has on board a lector, someone who will read to them and their coworkers at a cigar-rolling factory in Tampa, Florida. Lectors comprise a long Cuban tradition as a way of enhancing manual labor with culture. Influenced by August Wilson, Cruz focuses on his own community, using strongly developed female characters to realistically depict the varieties of Hispanic experience. The central character, Anna, is taken from the Russian writer, Tolstoy's late nineteenth-century realist novel, *Anna Karenina*, which Cruz weaves into the fabric of the play by use of the figure of the lector.

them, but none of the other characters on stage at the time can. Our willing suspension of disbelief allows us to accept such a device without destroying the "reality" of the scene before us.

In both plays, we use language and its tone to help determine the implication of the words. Language helps to reveal the overall tone and style of the play. It also can reveal character, theme, and historical context.

PLOT

Plot is the structure of the play, the skeleton that gives the play shape and on which the other elements hang. The nature of the plot determines how a play works: how it moves from one moment to another, how conflicts are structured, and how ultimately the experience comes to an end. We can examine the workings of plot by seeing the play somewhat as a timeline, beginning as the script or production begins, and ending at the final curtain, or the end of the script. In many plays, plot tends to operate like a climactic pyramid (Fig. 7.1). In order to keep our attention, the dynamics of the play will rise in intensity until they reach the ultimate crisis—the *climax*—after which they will relax through a resolution called the *denouement*, to the end of the play.

Depending on the playwright's purpose, plot may be shaped with or without some of the features described below. Sometimes plot may be so deemphasized that it virtually disappears. However, as we try to evaluate a play critically, the elements of plot give us things to look for—if only to note that they do not exist in the play at hand.

Exposition

Exposition provides necessary background information: Through it the playwright introduces the characters, their personalities, relationships, backgrounds, and their present situation. Exposition frequently comprises a recognizable section at the beginning of a play. It can be presented through dialogue, narration, setting, lighting, costume—or any device the playwright or director chooses. The amount of exposition in a play depends on where the playwright takes up the story, called the *point of attack*. A play told chronologically may need little expositional material; others require a good bit of prior summary.

Complication

Drama is about conflict. Although not every play fits that definition, in order to interest an audience, conflict of some sort serves as a fundamental dramatic device. At some point in the play, something frustrates

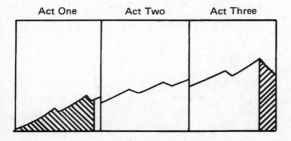

FIGURE 7.1 *Hypothetical dynamic and structural development of a three-act play.*

the normally expected course of events, giving the audience a reason to be interested in what transpires. At a specific moment, an action occurs or a decision is made that upsets the current state of affairs. Sometimes called the *inciting incident*, it opens the middle part of the plot—the complication. The complication contains the meat of the play, and it comprises a series of conflicts and decisions—called *crises* (from the Greek word *krisis*, meaning "to decide")—that rise in intensity until they reach a turning point—the *climax*—that constitutes the end of the complication section.

Denouement

The denouement (deh-noo-MAWN) is the final resolution of the plot: the period of time during which the audience senses an end to the action: a period of adjustment, downward in intensity, from the climax. Ideally, the denouement brings about a clear and ordered resolution.

Exposition, complication, and denouement comprise a time frame in which the remaining parts of the play operate. The neat structural picture of plot that exposition, complication, and denouement describe will not, however, always be so neat. The fact that a play does not conform to this kind of plot structure does not make it a poorly constructed play or one of inferior quality. Nor does it mean that these concepts cannot be used as a means for describing and analyzing how a play is put together.

Foreshadowing

Preparation for subsequent action—foreshadowing—helps to keep the audience clear about where they are at all times. Foreshadowing provides credibility for future action, keeps action logical, and

avoids confusion. It builds tension and suspense. The audience senses that something may happen, but because we do not know exactly what or when, anticipation builds suspense and tension. In the movie *Jaws*, a rhythmic musical theme foreshadows the presence of the shark. Just as the audience becomes comfortable with that device, the shark suddenly appears—without the music. As a result, uncertainty as to the next shark attack heightens immensely. Foreshadowing also moves the play forward by pointing toward events that will occur later.

Discovery

Discovery is the revelation of information about characters, their personalities, relationships, and feelings. Shakespeare's Hamlet discovers from his father's ghost that his father was murdered by Claudius, and is urged to revenge the killing, a discovery without which the play cannot proceed. The skill of the playwright in structuring the revelation of such information in large part determines the overall impact of the play on the audience.

Reversal

Reversal is any turn of fortune; for example, Oedipus falls from power and prosperity to blindness and exile; Shakespeare's King Lear goes from ruler to disaster. In comedy, reversal often changes the roles of social classes, as peasants jump to the upper class, and vice versa.

CHARACTER

Character is the psychological motivation of the persons in the play. In most plays, the audience will focus on why individuals do what they do, how they change, and how

they interact with other individuals as the plot unfolds.

Plays reveal a wide variety of characters—both persons and motivating psychological forces. In every play, we will find characters that fulfill major functions and on which the playwright wishes us to focus. We will also find minor characters—those whose actions may interact with the major characters, and whose actions constitute subordinate plot lines. Much of the interest created by the drama lies in the exploration of how persons with specific character motivations react to circumstances. For example, when Rodrigue in *Le Cid* discovers his father has been humiliated, what in his character makes him decide to avenge the insult, even though it means killing the father of the woman he loves, thereby jeopardizing that love? Such responses or choices, driven by character, move plays forward.

THE PROTAGONIST

Inside the structural pattern of a play some kind of action must take place. We must ask ourselves: How does this play work? How do we get from the beginning to the end? Most of the time, we take that journey via the actions and decisions of the *protagonist*, or central personage. Deciding the protagonist of a play presents challenges, even for directors. However, in order to understand the play, we must understand the protagonist. In Terence Rattigan's *Cause Célèbre* (say-LEHB-ruh), we could have three different responses depending on the director's decision as to protagonist. The problem is this: There are two central feminine roles. A good case could be made for either as the central personage of the play. Or they both could be equal. What we understand the play to be about depends on whom the director chooses to focus as protagonist.

THEMES

Themes or ideas comprise the intellectual content of a play. (Aristotle used the word *thought*). In Lanford Wilson's *Burn This* (1987), for example, a young dancer, Anna, lives in a Manhattan loft with two gay roommates, Larry and Robby. As the play opens, we learn that Robby has been killed in a boating accident; Anna has just returned from the funeral and a set of bizarre encounters with Robby's family. Larry, a sardonic advertising executive, and Burton, Anna's boyfriend, maintain a constant animosity. Into the scene bursts Pale, Robby's brother and a threatening, violent figure. Anna is both afraid and irresistibly attracted to Pale; the conflict of their relationship drives the play forward to its climax.

This brief description summarizes the *plot* of the play. However, what the play is about—its thought—remains for us to discover and develop. Some might say the play is about loneliness, anger, and the way not belonging manifests itself in human behavior. Others might focus on abusive relationships, and others would see a thought content dealing with hetero- and homosexual conflicts and issues. The process of coming to conclusions about meaning involves several layers of interpretation. One involves the playwright's interpretation of the ideas through the characters, language, and plot. A second layer of interpretation lies in the director's decisions about what the playwright has in mind, which will be balanced by what the director wishes to communicate, because, or in spite, of the playwright. Finally, we interpret what we actually see and hear in the production, along with what we may perceive independently from the script.

A Question to Ask

Who is the protagonist of this play, and how do this person's decisions and actions drive the play forward? What, ultimately, is the play about?

VISUAL ELEMENTS

The director takes the playwright's language, plot, and characters and translates them into action by using, among other things, what Aristotle called *spectacle*, or what the French call *mise-en-scène* (meez-awn-sehn), but what we can simply call the *visual elements*. The visual elements of a production include, first of all, the physical relationship established between actors and audience. The actor/audience relationship can take any number of shapes. For example, the audience might sit surrounding or perhaps on only one side of the stage. The visual elements also include stage settings, lighting, costumes, and properties, as well as the actors and their movements. Whatever the audience can see contributes to this part of the theatrical production.

Theatre Types

Part of our response to a production is shaped by the design of the space in which the play is produced. The earliest and most natural arrangement is the theatre-in-the-round, or *arena* theatre (Fig. 7.2), in which the audience surrounds the playing area on all sides. Whether the playing area is circular, square, or rectangular is irrelevant. Some argue that the closeness of the audience to the stage space in an arena theatre provides the most intimate kind of theatrical experience. A second possibility is the *thrust*, or three-quarter, theatre (Fig. 7.3), in which the audience surrounds the playing area on three

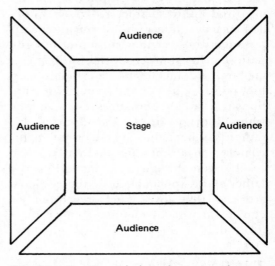

FIGURE 7.2 *Ground plan of an arena theatre.*

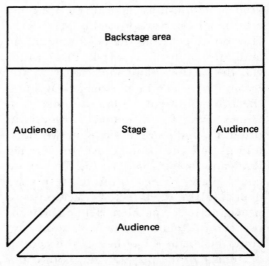

FIGURE 7.3 *Ground plan of a thrust theatre.*

sides. The most familiar illustration of this theatre is what we understand to be the theatre of the Shakespearean period. The third actor/audience relationship, and the one most widely used in the twentieth century, is the *proscenium* theatre, in which the audience sits on only one side and views the action through a frame (Fig. 7.4).

There are also experimental arrangements of audience and stage space. On some occasions, acting areas in the middle of the audience create little island stages. In certain circumstances, these small stages stimulate quite an interesting set of responses and relationships between actors and audience.

Common experience indicates that the physical relationship of the acting area to the audience has a causal effect on the depth of audience involvement. Experience has also indicated that certain kinds of emotional responses require some separation. We call this mental and physical separation *aesthetic distance.* The proper aesthetic

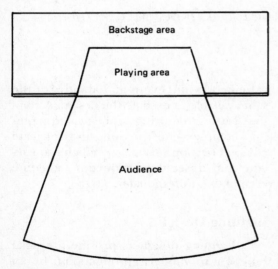

FIGURE 7.4 *Ground plan of a proscenium theatre.*

distance allows us to become involved in what we know is fictitious and even unbelievable.

The visual elements may or may not have independent communication with the audience; this is one of the options of the director and designers. Before the nineteenth century, no coordination of the various elements of a theatre production existed. This, of course, had all kinds of curious, and in some cases catastrophic, consequences. However, for the last century, most theatre productions have adhered to what we call the *organic theory of play production*: Everything, visual and aural, pursues a single purpose. Each production has a specific goal in terms of audience response, and all of the elements in the production attempt to achieve this.

Scene Design

Simply stated, the purpose of scene design in the theatre is to create an environment conducive to the production's ends. The scene designer uses the same tools of composition—line, form, mass, color, repetition, and unity—as the painter. In addition, because a stage design occupies three-dimensional space and must allow for the movement of the actors in, on, through, and around the elements of scenery, the scene designer becomes a sculptor as well. Figures 7.5 and 7.6 illustrate how emphasis on given elements of design highlight different characteristics in the production. C. Ricketts's design for *The Eumenides* (yew-MEHN-ih-deez; Fig. 7.5) stresses formality, symmetricality, and symbolism. Charles Kean's *Richard II* (color insert Plate 17) is formal, but light and spacious. His regular rhythms and repetition of arches create a completely different feeling from the one elicited by Ricketts's design. William Telbin's *Hamlet* (color insert Plate 18), with its strong central

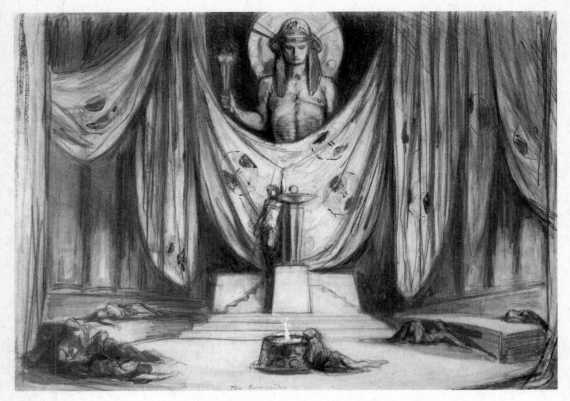

FIGURE 7.5 *Scene design for Aeschylus's* The Eumenides *(c. 1922). Designer: C. Ricketts.*
Source: Courtesy of the Victoria and Albert Museum, London.

triangle and monumental scale, creates an overwhelming weight that, while utilizing diagonal activity in the sides of the triangles, cannot match the action of Robert Burroughs's zigzagging diagonals juxtaposed among verticals in his design for *Peer Gynt* (peer gihnt; Fig. 7.6). Unlike the painter or sculptor, however, the scene designer is limited by the stage space, the concepts of the director, the amount of time and budget available for the execution of the design, and elements of practicality; for example, can the design withstand the wear and tear of the actors? A scene designer also

is limited by the talent and abilities of the staff available to execute the design. A complex setting requiring sophisticated painting, complex construction, and intricate computerization may prove difficult to execute and upset the production schedule even in the professional theatre.

Lighting Design

Lighting designers provide a crucial function in modern productions. In an indoor production without their art, little done by the actors, costume designer,

FIGURE 7.6 *Scene design for Henrik Ibsen's* Peer Gynt, *the University of Arizona Theatre. Director: Peter R. Marroney. Scene designer: Robert C. Burroughs.*

property master, director, or scene designer would reach the audience with maximum artistry. Yet lighting designers work in an ephemeral medium. They must sculpt with light and create shadows that fall where they desire them to fall; they must "paint" over the colors provided by the other designers. In doing so, they use lighting instruments with imperfect optical qualities. Lighting designers, even with the availability of computer assistance, essentially do their work in their minds, unlike scene designers, who can paint a design and then calculate it in feet and inches. Lighting designers must imagine what their light will do to an actor, to a costume, to a set. They must enhance the color of a costume, accent the physique of an actor, and reinforce the plasticity of a setting. They also try to reinforce the dramatic structure and dynamics of the play. They work within the framework of light and shade. Without shadows and highlights, the human face and body become imperceptible: A human face without shadows cannot be seen clearly more than a few feet away. In a theatre, such small movements as the raising of an eyebrow must be seen clearly as much as 100 feet away. The lighting designer makes this possible.

Costume Design

One is tempted to think of the costumes of the theatre merely as clothing that has to be researched to reflect a particular historical period and constructed to fit a particular actor. But costuming goes beyond that. Costume designers work with the entire body of the actor. They design hair styles and clothing and sometimes makeup to suit a specific purpose or occasion, a character, a locale, and so forth (Figs. 7.7 and 7.8).

Stage costuming has a threefold function. First, it *accents*—it shows the audience which personages are the most important in a scene, and it shows the relationship between personages. Second, it *reflects*—a particular era, time of day, climate, season, location, or occasion. The designs in Figure 7.7 reflect a historical period. We recognize different historical periods primarily through silhouette, or outline. Costume designers may merely suggest full detail or may actually provide it, as has been done in

FIGURE 7.7 *Costume designs for Shakespeare's* Twelfth Night, *the Old Globe Theatre, San Diego, California. Director: Craig Noel. Costume designer: Peggy J. Kellner.*

KING LEAR
Act IV Scene VI

FIGURE 7.8 *Costume designs for Shakespeare's* King Lear, *the Old Globe Theatre, San Diego, California. Director: Edward Payson Call. Costume designer: Peggy J. Kellner.*

Figure 7.7. We see here the designer's concern not only for period, but also for character in her choice of details, color, texture, jewelry, and also hairstyle. Notice the length to which the designer goes to indicate detail, providing not only front but also back views of the costume, and also a head study showing the hair without a covering. Third, stage costuming *reveals* the style of the performance, the characters of the personages, and the personages' social position, profession, cleanliness, age, physique, and health. In Figure 7.8, the concern of the designer focuses less on historical period than on production style and character. This costume design reveals the high emotional

content of the particular scene, and we see at first glance the deteriorated health and condition of King Lear as he turns mad on the heath. The contrast provided by the king in such a state heightens the effect of the scene, and details such as the bare feet, the winter furs, and the storm-ravaged cape are precise indicators of the pathos we are expected to find and respond to. Costume designers work, as do scene and lighting designers, with the same general elements as painters and sculptors: the elements of composition. A stage costume is an actor's skin: It allows her to move as she must, and occasionally it restricts her from moving as she should not.

Properties

Properties fall into two general groups: *set props* and *hand props*. Set properties are part of the scene design: furniture, pictures, rugs, fireplace accessories, and so on. Along with the larger elements of the set, they identify the mood of the play and the character of those who inhabit the world they portray. Hand properties used by the actors in stage business also help to portray characters: cigarettes, papers, glasses, and so forth. The use of properties can be significant to our understanding of a play. For example, if at the opening curtain all properties appear to be neat and in order, but as the play develops the actors disrupt the properties, so that at the end of the play the entire scene is in disarray, that simple transition can help illustrate what may have happened in the play.

AURAL ELEMENTS

What we hear also contributes to our understanding and enjoyment of the production. Aristotle's term for the aural elements of a production is *music*, which meant something

quite different from today. The aural elements, whether the actors' voices, the background music, or the clashing of swords, constitute an important part of the theatrical production. How a production sounds—and looks, and feels, and reads—represents a series of conscious choices on the part of all the artists involved: playwright, director, actors, and designers. Just as a composer of a musical piece creates harmonies, dynamics, rhythms, and melodies, the director, working with the actors and sound designer, makes the production develop in an aural sense so the audience has the proper mood, goes in the proper emotional direction, and attends to the proper attention points.

DYNAMICS

Every production has its own dynamic patterns, which we can chart (for example, as in Fig. 7.1). The structural pattern of a play, about which we just spoke, communicates with us through the dynamic patterns the director establishes. These patterns also help to hold the interest of the audience. Scientific studies indicate that attention or interest is not a constant factor; human beings are able to concentrate on specific items only for very brief periods. Therefore, to hold audience attention over the two-hour span of a production, the production must employ devices whereby from time to time interest or attention can peak and then relax. However, the peaks must be carefully controlled. A production should build to a high point of dramatic interest—the climax. However, each scene or act has its own peak of development—again, to maintain interest. So, the rise from the beginning of the play to the high point of dramatic interest maintains not a steady rise, but a series of peaks and valleys. Each successive peak comes closer to the ultimate one. The director controls where

and how high these peaks occur by controlling the dynamics of the actors—volume and intensity, both bodily and vocal.

THE ACTOR

Although we can not always tell which functions in a production belong to the playwright, director, or the actor, the main channel of communication between the playwright and the audience is the actors. Through their movements and speech the audience perceives the play.

We can look for two elements in an actor's portrayal of a role that will enhance our response. The first is speech. Language is the playwright's words. Speech is the manner in which the actor delivers those words. Speech, like language, can range from high lifelikeness to high theatricality. If speech adheres to normal conversational rhythms, durations, and inflections, we respond in one way. If it utilizes extended vowel emphasis, long, sliding inflections, and dramatic pauses, we respond quite differently, even though the playwright's words are identical in both cases.

The second element of an actor's portrayal that aids our understanding constitutes the physical reinforcement he or she gives to the character's basic motivation. Most actors try to identify a single basic motivation for their character. That motivation is called a *spine*, or *superobjective*. Everything that pertains to the decisions the person makes is kept consistent for the audience because those decisions and actions

stem from this basic drive. Actors translate that drive into something physical they can do throughout the play. For example, Blanche, in Tennessee Williams's *A Streetcar Named Desire,* is driven by the desire to clean what she encounters because of the way she regards herself and the world around her. Ideally, the actress playing Blanche will discover that element of Blanche's personality as she reads the play and develops the role. To make that spine clear to us in the audience, the actress will translate it into physical action. Therefore, we see Blanche constantly smoothing her hair, rearranging and straightening her dress, cleaning the furniture, brushing imaginary dust from others' shoulders, and so forth. Nearly every physical move she makes will relate somehow to the act of cleaning. Of course, these movements will be subtle, but if we are attentive, we can find them, thereby understanding the nature of the character we are perceiving.

LIFELIKENESS

In describing the relationship of the visual elements to the play, we have noted the designers' use of compositional elements. The use of these elements relative to life can be placed on a continuum, one end of which is theatricality and the other, lifelikeness. Lifelike items are those with which we deal in everyday life: language, movements, furniture, trees, rocks, and so forth. As we progress on our continuum from lifelike to theatricality, the elements of the production express less and less relationship to everyday

A Question to Ask

What physical devices have the actors used to reinforce our understanding of their character's spine?

A Question of Style

Absurdism

Absurdism (uhb-SUHRD-iz-uhm; uhb-ZUHRD-ihzm). In theatre and prose fiction, a twentieth-century philosophy in conflict with traditional beliefs and values and based on the contention that the universe is irrational and meaningless and that the search for order causes conflict with the universe.

Many artists of the early twentieth century, in which absurdism arose, had lost faith in religion, science, and humanity itself. In their search for meaning, they found only chaos, complexity, grotesque laughter, and perhaps insanity. Albert Camus (kah-MOO; 1913–1960) first applied the term *absurd* to the human condition. This he took to be a state somewhere between humanity's aspirations and the meaninglessness of the universe, which is the condition of life. The playwright from whom sprang the style called absurdism was Luigi Pirandello (peer-an-DEHL-loh; 1867–1936). His plays obsessively ask the question "What is real?" with brilliant variations. In the psychological play, *Six Characters in Search of an Author* (1921), Pirandello sought to fragment reality by destroying conventional dramatic structures and adopting new ones. *Six Characters* employed a play within a play. Pirandello sought to achieve perfect unity between ideas and dramatic structure by transferring the dissociation of reality from the plane of content to that of form. *Right You Are If You Think You Are* (1917) presents a wife living with her husband in a top-floor apartment and not permitted to see her mother. She converses with her daily, the mother in the street and the daughter at a garret window. Soon a neighbor demands an explanation from the husband. He answers, but so does the mother, who has an equally plausible but different answer. Finally, someone approaches the wife, the only one who can clear up the mystery. Her response, as the curtain falls: hysterical laughter. Pirandello expressed his dismay at an incomprehensible world in mocking laughter directed at those who thought they knew the answers.

life. They become distorted, exaggerated, and perhaps even nonobjective. Poetry is high in theatricality; everyday speech is lifelike. The position of the various elements of a production on this continuum suggests the style of the play in the same sense that brushstroke, line, and palette indicate style in painting.

Figures 7.6, 7.9, and 7.10 illustrate the range between lifelikeness and theatricality. Figure 7.9, a proscenium setting high in lifelikeness, includes a full ceiling over the setting. The setting in Figure 7.10 moves further toward theatricality, and indicates clearly through exaggerated detail and two-dimensionality the whimsical and fun nature of the production. The designs in Figure 7.6 create a purely formal and theatrical environment. It depicts no specific locale.

In most arts, the artist has unique style, a recognizable mark on his or her artwork. Some artists change their style, but they do so by their own choice. Interpretive artists such as costume, scene, and lighting designers,

FIGURE 7.9 *A proscenium setting for Jean Kerr's* Mary Mary, *the University of Arizona Theatre. Director: H. Wynn Pearce. Scene and lighting designer: Dennis J. Sporre.*

FIGURE 7.10 *Scene design for Jerry Devine and Bruce Montgomery's* The Amorous Flea *(musical), the University of Iowa Theatre. Director: David Knauf. Scene and lighting designer: Dennis J. Sporre.*

and to a degree conductors as well, must submerge their personal style to that of the work with which they are involved. The playwright or the director sets the style, and the scene designer adapts to it and makes his or her design reflect that style.

HOW DOES IT STIMULATE THE SENSES?

Each of the elements just discussed stimulates our senses in a particular manner. We respond to the play's structure and how it works; we respond to dynamics. We react to the theatricality or lifelikeness of the language of the playwright and the movements and speech of the actors. We find our response shaped by the relationship of the stage space to the audience, and by the sets, lights, properties, and costumes. All of these elements bombard us simultaneously with complex visual and aural stimuli. How we respond, and how much we can respond, determines our ultimate reaction to a production.

The theatre is unique in its ability to stimulate our senses because only in the theatre do we have a direct appeal to our emotions through the live portrayal of other individuals involved directly in the human condition. Being in the presence of live actors gives us more of life in two hours than we could experience outside the theatre in that same time span. That phenomenon is difficult to equal. The term we use to describe our reaction to and involvement with what we experience in a theatrical production is *empathy*. Empathy causes us to cry when individuals we know are only actors become involved in tragic or emotional situations. Empathy makes us wince when an actor slaps the face of another actor or when two football players collide at full speed.

Empathy is our mental and physical involvement in situations in which we are not direct participants.

Now let us examine a few of the more obvious ways a production can appeal to our senses. In plays that deal in conventions, language may act as virtually the entire stimulant of our senses. Through language, the playwright sets the time, place, atmosphere, and even small details of decoration. We become our own scene, lighting, and even costume designer, imagining what the playwright tells us ought to be there. In the opening scene of *Hamlet*, we find Bernardo and Francisco, two guards. The hour is midnight; it is bitter cold; a ghost appears, in "warlike form." How do we know all of this? In a modern production, we might see it all through the work of the costume and set designers. But this need not be the case because the playwright gives us all of this information in the dialogue. Shakespeare wrote for a theatre that had no lighting save for the sun. His theatre (such as we know of it) probably used no scenery. The costumes were the street clothes of the day. The theatrical environment was the same whether the company was playing *Hamlet, Richard III*, or *The Tempest*. So what needed to be seen needed to be imagined. The language provided the stimuli for the audience.

We also respond to what we see. A sword fight performed with flashing action, swift movements, and great intensity sets us on the edge of our chair. Although we know the action is staged and the incident fictitious, we are caught in the excitement of the moment. We also can be gripped and manipulated by events of a quite different dynamic quality. In many plays, we witness character assassination, as one life after another is laid bare before us. The intense but subtle movements of the actors—both bodily and vocal—can pull us here and

A Question to Ask

What kinds of stimuli has this production utilized and how have I reacted to them?

push us there emotionally, and perhaps cause us to leave the theatre feeling emotionally and physically drained. Part of our response results from subject matter, part from language—but much comes from careful manipulation of dynamics.

Mood plays an important role in theatrical communication and, hence, sense response. Before the curtain goes up, our senses are tickled by stimuli designed to put us in the mood for what follows. The houselights in the theatre dim, and we may see a cool or warm light on the front curtain. Music fills the theatre. We may recognize the raucous tones of a 1930s jazz piece or a melancholy ballad. Whatever the stimuli, they are all carefully designed to cause us to begin to react the way the director wishes us to react. Once the curtain rises, the assault on our senses continues. The palette utilized by the scene, lighting, and costume designers helps communicate the mood of the play and other messages about it. The rhythm and variation in the visual elements capture our interest and reinforce the rhythmic structure of the play. In Figure 7.6, the use of line and form as well as color provides a formal and infinite atmosphere reflecting the epic grandeur of Ibsen's *Peer Gynt*.

According to Aristotle, one of the attributes of tragedy is that it produces catharsis, or the purging of the emotions of pity and fear. So we may say of drama that part of the sense stimulation we receive can cause us to cleanse ourselves of some emotional liabilities: For example, fright releases us from fearfulness, and witnessing other types of behavior in fictional characters,

including laughing at their foibles, can bring us release from anxieties and tensions.

The degree of plasticity or three-dimensionality created by the lighting designer's illumination of the actors and the set causes us to respond in many ways. If the lighting designer has placed the primary lighting instruments directly in front of the stage, plasticity will be diminished and the actors will appear washed out or two dimensional. We respond quite differently to that visual stimulant than to the maximum plasticity and shadow resulting from lighting coming nearly from the side.

We also react to the mass of a setting. Scenery that towers over the actors and appears massive in weight is different in effect from scenery that seems minuscule in scale relative to the human form. The settings in Figures 7.9 and color insert Plates 17 and 18 are different from one another in scale, and each places the actors in a different relationship with their surroundings. In Figure 7.9, the personages are at the center of their environment; in color insert Plate 18, they are clearly subservient to it.

Finally, focus and line act on our senses. Careful composition can create movement, outlines, and shadows that are crisp and sharp. Or it can create images that are soft, fuzzy, or blurred. Each of these devices stimulates us; each has the potential to elicit a relatively predictable response. Perhaps in no other art are such devices so available and full of potential for the artist. We, as respondents, benefit through nearly total involvement in the life situation that comes to us over the footlights.

Sample Outline and Critical Analysis

The following very brief example illustrates how we can use a few of the terms explained in the chapter to form an outline and then develop a critical analysis of a work of art. Here is how that might work regarding Molière's play *Tartuffe.* See Figure 1.13 for a picture of a setting for a production of *Tartuffe* and note the discussion of the play's story in the Chapter 1 section on criticism.

Outline	Critical Analysis
Genre Comedy	Molière's play, *Tartuffe,* is a comedy, but its comedy lies in ironic humor rather than lightheartedness. The subject the playwright treats is a very serious one—religious hypocrisy—and it is clear from the dialogue that the playwright regards the subject as important. Although skillful dialogue and carefully constructed scenes yield plenty of laughter at the situation and the clear foibles of M. Orgon, at no time do we find this treatment frivolous.
Character Protagonist	The play's action moves forward logically based on the actions and decisions of the characters (personages) and those actions and decisions are logical expressions of the character of each person as developed by the playwright. The chief character, the protagonist, is M. Orgon, although a good case might be made also for the little character, Tartuffe. The case for Orgon rests on the fact that, ultimately, his decisions and actions provide the principal incidents to which the other characters react and which drive the play forward.
Plot Exposition Complication Crises Climax Denouement	The plot moves on the decisions of Orgon. The exposition consists of the opening segment of the play wherein the play wright introduces the members of M. Orgon's household, the condition in which Tartuffe has been admitted into the household, and the reactions of the other characters to that admission—particularly Mme. Pernelle, Orgon's mother, who will hear no ill spoken of Tartuffe. A particular crisis arises when Orgon announces that he has agreed to let Tartuffe marry Orgon's daughter Marianne—to the horror of all, particularly Marianne. Another significant crisis arises when Tartuffe attempts to seduce Elmire, Orgon's wife. The play rises to a climax when Orgon finally realizes Tartuffe's hypocrisy and orders him from the house only to be blackmailed by Tartuffe in return. The situation resolves through intervention of the king.

Additional Study and Cyber Sources

c. 600 B.C.E.–c. 1875

Greek Tragedy (Sophocles. *Oedipus the King*):
http://www.hti.umich.edu/cgi/p/pd-modeng/pd-modeng-idx?type=HTML&rgn=DIVO&byte=58284777

Medieval (*Everyman*):
http://darkwing.uoregon.edu/~rbear/everyman.html

Renaissance (Shakespeare. *King Lear*):
http://www.bibliomania.com/Shakespeare/Tragedy/KingLear/scene1.1.html

French Neoclassicism (Molière. *Tartuffe*):
http://www.bibliomania.com/Drama/Moliere/Plays/ch2act01.html

English Restoration (Sheridan. *The School for Scandal*):
ftp://metalab.unc.edu/pub/docs/books/gutenberg/etext99/scndl10.txt

Romanticism (Goethe. *Faust*):
http://eserver.org/drama/faust.txt

c. 1875–Present

Realism (Ibsen. *A Doll's House*):
http://www.triton.cc.il.us/undergrad_ctr/files/dollshse.html#act1

(Shaw. *Man and Superman*):
http://www.bartleby.com/157/1.html

Eugene O'Neill. *The Hairy Ape*:
http://www.eoneill.com/texts/ha/contents.htm

Arthur Miller: *After the Fall*

Tennessee Williams: *The Glass Menagerie*

Bertholdt Brecht: *The Good Woman of Setzuan*

Harold Pinter: *The Homecoming*

Peter Shaffer: *The Royal Hunt of the Sun*

Edward Albee: *Who's Afraid of Virginia Woolf?*

David Mamet: *The Cryptogram*

Tony Kushner: *Angels in America*

Cinema

Like theatre, but without the spontaneity of "live" performers, cinema can confront us with life very nearly as we find it on our streets. On the other hand, through the magic of sophisticated *special effects*, it can take us to new worlds open to no other form of art.

The most familiar and the most easily accessible art form, cinema usually finds acceptance almost without conscious thought, at least in terms of the story line or the star image presented or the basic entertainment value of the product. Yet all these elements come carefully crafted out of editing techniques, camera usage, juxtaposition of image, and structural rhythms, among others. These details of cinematic construction can enhance our film viewing and can raise a film from mere entertainment into the realm of serious art. Bernard Shaw once observed that "details are important; they make comments." Our perception of the details of a film presents challenges because at the same time we search them out, the entertainment elements of the film draw our attention away from the search.

WHAT IS IT?

Cinema is aesthetic communication through the design of time and three-dimensional space compressed into a two-dimensional image. Once the principles of photography had evolved and the mechanics of recording and projecting cinematic images were understood, society was ready for the production of pictures that could move, be presented in color, and eventually talk.

If we examine a strip of film, we will notice that it consists of a series of pictures arranged in order. Each of these pictures, or *frames*, measures about four-fifths of an inch wide and three-fifths of an inch high. If we study the frames in relation to one another, we will see that even though each frame may seem to show exactly the same scene, the position of the objects in the separate frames changes slightly. When this film, which contains sixteen frames per foot of film, runs on a projecting device and passes before a light source at the rate of twenty-four frames per second (sixteen to eighteen frames per second for silent films), the frames printed on it are enlarged through the use of a magnifying lens, projected on a screen, and appear to show movement. However, the motion picture does not really move but only seems to. This results from an optical phenomenon called *persistence of vision*, which according to legend was discovered by the astronomer Ptolemy sometime around the second century C.E. The theory behind persistence of vision maintains that the eye takes a fraction of a second to record an impression of an image and send it to the brain. Once received, the eye retains the impression on the retina for about one-tenth of a second after the actual image has disappeared. The film projector has built into it a device that pulls the film between the light source and a lens in a stop-and-go fashion, the film pausing long enough at each frame to let the eye take in the picture. Then a shutter on the projector closes, the retina retains the image, and the projection mechanism pulls the film ahead to the next frame. Holes, or *perforations*, along the right-hand side of the filmstrip enable the teeth on the gear of the driving mechanism to grasp the film and not only move it along frame by frame but also hold it steady in the gate or slot between the light source and the magnifying lens. This stop-and-go motion gives the impression of continuous movement; if the film did not pause at each frame, the eye would receive only a blurred image.

The motion picture, originally invented as a device for recording and depicting motion, quickly realized this goal. Artists then discovered this machine could also record and present stories—in particular, stories that made use of the unique qualities of the medium of film.

Our formal response to cinema recognizes three basic techniques of presentation: narrative cinema, documentary cinema, and absolute cinema.

NARRATIVE

Narrative or fictional cinema tells a story; in many ways it uses the technique of theatre. Narrative film follows the rules of literary construction in that it usually begins with expository material, adds levels of complications, builds to a climax, and ends with a resolution of all the plot elements. As in theatre, it portrays personages in the story by professional actors under the guidance of a director; the action of the plot takes place within a setting designed and constructed primarily for the action of the story but that also allows the camera to move freely in photographing the action. Many

narrative films are genre films, constructed out of familiar literary styles—the western, the detective story, and the horror story, among others. In these films, the story elements are so familiar to the audience that it usually knows the outcome of the plot before it begins. The final showdown between the good guy and the bad guy, the destruction of a city by an unstoppable monster, and the identification of the murderer by the detective are all familiar plot elements that have become clichés or stereotypes within the genre; their use fulfills audience expectations. Film versions of popular novels and stories written especially for the medium of the screen are also part of the narrative-cinema form, but because cinema is a major part of the mass-entertainment industry, the narrative presented is usually material that will attract a large audience and thus ensure a profit. In some instances, the "narrative" in narrative film exists merely to serve as a shell for showcasing movie stars (Fig. 8.1).

FIGURE 8.1 *Movie still of George Clooney from "Ocean's Twelve."*
Source: Ralph Nelson/Picture Desk, Inc./Kobal Collection

DOCUMENTARY

Documentary cinema attempts to record actuality using primarily either a sociological or journalistic approach. It normally does not use reenactment by professional actors and often is shot as the event is occurring at the time and place of its occurrence. The film may use a narrative structure, and some of the events may be ordered or compressed for dramatic reasons, but its presentation gives the illusion of reality. The footage shown on the evening television news, television programming concerned with current events or problems, and full coverage either by television or film companies of a world-wide event, such as the Olympics, are all kinds of documentary film. All convey a sense of reality as well as a recording of time and place (example: Leni Riefenstahl [REEF-ehn-shtahl]; http://www.german-way. com/cinema/rief.html).

ABSOLUTE

Absolute or avant garde film exists for its own sake, for its record of movement or form. It does not tell a story, although documentary techniques can be used in some instances. Created neither in the camera nor on location, absolute film is built carefully, piece by piece, on the editing table or through special effects and multiple-printing techniques. It tells no story but exists solely as movement or form. Absolute film rarely runs longer than twelve minutes (one reel)

in length, and it usually has no commercial intent but is meant only as an artistic experience. Narrative or documentary films may contain sections that can be labeled absolute, and these sections can be studied either in or out of the context of the whole film. An example of absolute film is Figure 8.2, Fernand Léger's (lay-ZHAY) *Ballet Méchanique* (may-kah-NEEK; http://www.english.uiuc. edu/mardorossian/DOCS/films/filmpages/ ballet.html). (For a historical perspective on experimental film visit http://search. britannica.com/bcom/eb/article/2/0,5716, 119922+6+110698,00.html and http://www. sva.edu/MFJ/.)

HOW IS IT PUT TOGETHER?

EDITING

Artists rarely record cinema in the order of its final presentation. They film it in bits and pieces and put it together after all the photography finishes, as one puts together a jigsaw puzzle or builds a house. The force or strength of the final product depends on the editing process used, the manner in which the director handles the camera and the lighting, and the movement of the actors before the camera. Naturally, the success of a film depends equally on the strength of the story presented and the ability of the writers, actors, directors, and technicians who have worked on the film. However, this level of success depends on

A Question to Ask

What genre does the film represent, and how does it explore the characteristics of the genre?

the personal taste of the audience and the depth of perception of the individual, and therefore does not lie within the boundaries of this discussion.

Perhaps the greatest difference between cinema and the other arts discussed within this volume remains the use of *plasticity,* the quality of film that enables it to be cut, spliced, and ordered according to the needs of the film and the desires of the filmmaker. If twenty people were presented with all the footage shot of a presidential inauguration and asked to make a film commemorating the event, we would probably see twenty completely different films; each filmmaker would order the event according to his or her own views and artistic ideas. The filmmaker must be able to synthesize a product out of many diverse elements. This concept of plasticity is, then, one of the major advantages of the use of the machine in consort with an art form.

The editing process, then, creates or builds the film, and within that process exist many ways of meaningfully joining shots and scenes to make a whole. Let's examine some of these basic techniques. The *cut* is simply the joining together of shots during the editing process. A *jump cut* is a cut that breaks the continuity of time by jumping forward from one part of the action to another part that obviously is separated from the first by an interval of time, location, or camera position. It is often used for shock effect or to call attention to a detail, as in commercial advertising on television. The *form cut* cuts from an image in a shot to a different object that has a similar shape or contour; it is used

FIGURE 8.2 Ballet Méchanique *(1924). A film by Fernand Léger. Pictures of a girl's eyes with makeup on them.*
Source: © 2004 Artists Rights Society (ARS), New York/ ADAGP, Paris.

primarily to make a smoother transition from one shot to another. For example, in D. W. Griffith's silent film *Intolerance*, attackers are using a battering ram to smash in the gates of Babylon. The camera shows the circular frontal area of the ram as it advances toward the gate. The scene cuts to a view of a circular shield, which in the framing of the shot reveals exactly the same position as the front view of the ram.

Montage can be considered the most aesthetic use of the cut in film. Handled in two basic ways, first, it acts as an indication of compression or elongation of time, and, second, as a rapid succession of images to illustrate an association of ideas. A series of stills from Léger's *Ballet Méchanique* (Fig. 8.2) illustrates how images are juxtaposed to create comparisons. As another example, a couple goes out to spend an evening on the town, dining and dancing. The film then presents a rapid series of cuts of the pair—in a restaurant, then dancing, then driving to another spot, then drinking, and then more dancing. In this way, the audience sees the couple's activities in an abridged manner. Elongation of time can be achieved in the same way. The second use of montage allows the filmmaker to depict complex ideas or draw a metaphor visually. Sergei Eisenstein, the Russian film director, presented a shot in one of his early films of a Russian army officer walking out of the room, his back to the camera and his hands crossed behind him. Eisenstein cuts immediately to a peacock strutting away from the camera and spreading its tail. These two images are juxtaposed, and the audience is allowed to make the association that the officer is as proud as a peacock.

CAMERA VIEWPOINT

Camera position and viewpoint are as important to the structure of film as is the editing process. How the camera is placed and moved can be of great value to filmmakers as an aid in explaining and elaborating on their cinematic ideas. In the earliest days of the silent film, the camera was merely set up in one basic position; the actors moved before it as if they were performing before an audience on a stage in a theater. However, watching an action from one position became dull, and the early filmmakers were forced to move the camera in order to add variety to the film.

The Shot

The *shot* is what the camera records over a particular period of time and forms the basic unit of filmmaking. The *master shot* is a single shot of an entire piece of action, taken to facilitate the assembly of the component shots of which the scene will finally be composed. The *establishing shot* is a long shot introduced at the beginning of a scene to establish the interrelationship of details, a time, or a place, which will be elaborated on in subsequent shots. The *long shot* is a shot taken with the camera a considerable distance from the

A Question to Ask

What kinds of cuts are used most frequently, and how do they affect the overall mood and motion of the film?

FIGURE 8.3 *Still from an unidentified film. Upward view of men on a sand dune in uniform with rifles.*

subject (Fig. 8.3). The *medium shot* is taken nearer to the subject. The *close-up* is a shot taken with the camera quite near the subject. A *two-shot* is a close-up of two persons with the camera as near as possible while keeping both subjects within the frame. A *bridging shot* is a shot inserted in the editing of a scene to cover a brief break in the continuity of the scene.

An important aspect of any shot is its framing, or the amount of open space within the frames. In general, the closer the shot, the more confined the figures seem. We call these *tightly framed*. Longer, loosely framed shots suggest freedom. Julianne Moore makes use of tight framing in *The Prize Winner of Defiance Ohio* (2005) to suggest nurturing intimacy in her film based

on a true story about an Ohio housewife in the 1950s.

Like some pictures and like some forms of theatre, movies can employ open or closed composition in its framing. In closed form films, the shot acts like the proscenium arch in a proscenium theatre (see Chapter 7). All the information in the shot appears carefully composed and self-contained. In open form film images, the frame is deemphasized, suggesting a temporary masking. The dramatic action tends to lead the camera; so we have a sense that the camera follows the actors. This creates fluidity of movement. Gillian Anderson, director of *Mrs. Soffel* (1984), uses this technique to add a greater sense of realism to her historical film.

profile

D. W. Griffith

D. W. Griffith (1875–1948) was the first giant of the motion picture industry and a genius of film credited with making film an art form. As a director, D. W. Griffith never needed a script. He improvised new ways to use the camera and to cut the celluloid, which redefined the craft for the next generation of directors.

David Lewelyn Wark Griffith was born on January 22, 1875, in Floydsfork, Kentucky, near Louisville. His aristocratic Southern family had been impoverished by the American Civil War, and much of his early education came in a one-room schoolhouse or at home. His father, a former Confederate colonel, told him battle stories that may have affected the tone of Griffith's early films.

When Griffith was 7, his father died and the family moved to Louisville. He quit school at 16 to work as a bookstore clerk. In the bookstore, he met some actors from a Louisville theatre. This acquaintanceship led to work with amateur theatre groups and to tours with stock companies. He tried playwrighting, but his first play failed on opening night in Washington, D.C. He also attempted writing screenplays, but his first scenario for a motion picture also met with rejection. While acting for New York studios, however, he did sell some scripts for one-reel films, and when the Biograph Company had an opening for a director in 1908, Griffith was hired.

During the five years with Biograph, Griffith introduced or refined all the basic techniques of moviemaking. His innovations in cinematography included the close-up, the fade-in and fade-out, soft focus, high- and low-angle shots, and panning (moving the camera in panoramic long shots). In film editing, he invented the techniques of flashback and crosscutting—interweaving bits of scenes to give an impression of simultaneous action.

Griffith also expanded the horizon of film with social commentary. Of the nearly 500 films he directed or produced, his first full-length work was his most sensational. *The Birth of a Nation* (first shown as *The Clansman* in 1915; see Fig. 8.4) was hailed for its radical technique but condemned for its racism. As a response to censorship of *Birth of a Nation*, he produced *Intolerance* (1916), an epic integrating four separate themes.

After *Intolerance*, Griffith may have turned away from the epic film because of the financial obstacles, but his gifted performers more than made up for this loss, for they were giants in their own right. Among the talented stars he introduced to the industry were Dorothy and Lillian Gish, Mack Sennett, and Lionel Barrymore.

In 1919, Griffith formed a motion picture distribution company called United Artists with Mary Pickford, Charlie Chaplin, and Douglas Fairbanks.

Griffith's stature within the Hollywood hierarchy was one of respect and integrity. He became one of the three lynchpins of the ambitious Triangle Studios, along with Thomas Ince and Mack Sennett.

He died in Hollywood, California, on July 23, 1948.

FIGURE 8.4 *Still photo from* The Birth of a Nation *(1915). Director D. W. Griffith. View of soldiers out of a bunker.*
Source: The Metropolitan Museum of Art/Film Stills Archive.

Objectivity

An equally important variable of camera viewpoint consists of whether the scene reflects an objective or subjective viewpoint. The *objective viewpoint* reflects an omnipotent viewer, roughly analogous to the technique of third-person narrative in literature. In this way, filmmakers allow us to watch the action through the eyes of a universal spectator. However, filmmakers who wish to involve us more deeply in a scene may use the *subjective viewpoint*: They present the scene as if we were actually participating in it, and present the action from the filmmaker's perspective. Analogous to the first-person narrative technique, this technique usually reflects in the films of the more talented directors.

CUTTING WITHIN THE FRAME

Directors use cutting within the frame as a method to avoid the editing process. They create it through actor movement, camera movement, or a combination of the two. It allows the scene to progress more smoothly and is used most often on television. In a scene in John Ford's classic, *Stagecoach*, the

coach and its passengers have just passed through hostile Indian territory without being attacked; the driver and his passengers all express relief. Ford cuts to a long shot of the coach moving across the desert and *pans,* or follows it, as it moves from right to left on the screen. This movement of the camera suddenly reveals in the foreground, and in close-up, the face of a hostile warrior watching the passage of the coach. In other words, the filmmaker has moved from a long shot to a close-up without the need of the editing process. He has also established a spatial relationship. The movement of the camera and the film is smooth and does not need a cut to complete the sequence.

Cutting within the frame presents a particularly effective means by which a film director can frustrate later attempts to tamper with his or her original product. When transitions occur using this method, it is impossible to cut out or add in material without destroying the rhythm of the scene. Utilization of this technique also means that the acting and action must be flawless and seamless, with no room for error from beginning to end. The effect, of course, creates a smooth structural rhythm in the film, in contrast to inserting close-ups or utilizing jump cuts, for example. In the original production of *Jaws,* effective use of cutting within the frame allowed the director, in beach scenes, to move from distant objects off shore to faces in the foreground and, finally, including them both within the same frame. He could also pan across the beach, from foreground to background, seamlessly.

Directors choose to cut or to cut within the frame because the results of each option create psychological overtones that cause responses in the viewer. In the arena scene from *Gladiator* (Dream Works Pictures, 2000), Russell Crowe's gladiator character confronts another gladiator and a tiger.

Director Ridley Scott cuts back and forth from Russell Crowe to the tiger and the other gladiator to create suspense. When he combines them all in one shot, however, he produces the maximum sense of danger.

DISSOLVES

During the printing of the film negative, transitional devices can be worked into a scene. They usually indicate the end of one scene and the beginning of another. The camera can cut or jump to the next scene, but the transition can be smoother if the scene fades out into black and the next scene fades in. We call this a *dissolve.* A *lap dissolve* occurs when the fade-out and the fade-in are done simultaneously and the scene momentarily overlaps. A *wipe* is a form of optical transition in which a line moves across the screen, eliminating one shot and revealing the next, much in the way a windshield wiper moves across the windshield of a car. In silent film the transition could also be created by closing or opening the aperture of the lens; we call this process an *iris-out* or an *iris-in.* Writer/Director George Lucas uses the iris-out as a transitional device dramatically in *Star Wars: Episode I, the Phantom Menace.* Although this episode contains fewer evidences of subtextual reference to old films than the original, *Episode IV,* Lucas employs the iris-in/iris-out in such an obvious way in the "prequel" that we think he wants us to remember the device, which was very prominent in early silent film.

Dissolves, then, whether lap dissolves, wipes, or iris-in/iris-out, give the film director and editor a means by which to create a smoother transition between scenes than can occur when they employ cuts. Our task, as participants in the film, remains to develop an awareness of how the director

A Question to Ask

What kinds of dissolves appear in the film, and how do they create a response in me?

articulates movement from one section to another and how that particular form of articulation contributes to the rhythm and style of the film, overall. We will find, eventually, that we will be able to notice details of film composition in passing, without letting them interfere with our enjoyment of the details of the story or mood. In fact, we will find our basic ability to process several layers of perception at the same time quite remarkable and enjoyable.

MOVEMENT

Camera movement also plays a part in film construction. The movement of the camera as well as its position can add variety or impact to a shot or a scene. Even the technique of lens focus can add to the meaning of the scene. If the lens clearly shows both near and distant objects at the same time, the camera uses *depth of focus*. In the beach scenes in *Jaws*, foreground and background show equal focus. In this way, actors can move in the scene without necessitating a change of camera position. Many TV shows photographed before an audience usually use this kind of focus. If the main object of interest appears clearly while the remainder of the scene blurs or appears out of focus, the camera reflects *rack* or *differential focus*. With this technique, the filmmaker can focus the audience's attention on one element within a shot.

Many kinds of physical (as opposed to apparent) camera movement have a bearing on a scene. The *track* is a shot taken as the camera moves in the same direction, at the same speed, and in the same place as the object being photographed. A *pan* rotates the camera horizontally while keeping it fixed vertically. The pan is usually used in enclosed areas, particularly TV studios. The *tilt* is a shot taken while moving the camera vertically or diagonally; it helps add variety to a sequence. A *dolly shot* moves the camera toward or away from the subject. Modern sophisticated lenses can accomplish the same movement by changing the focal length. This negates the need for camera movement and is known as a *zoom shot*.

LIGHTING

Of course, the camera cannot photograph a scene without light, either natural or artificial. Most television productions photographed before a live audience require a flat, general illumination pattern. For closeups, stronger and more definitively focused lights highlight the features, eliminate shadows, and add a feeling of depth to the shot. Cast shadows or atmospheric lighting (in art, *chiaroscuro*) help to create a mood, particularly in films made without the use of color (Fig. 8.3). Lighting at a particular angle can heighten the feeling of texture, just as an extremely close shot can. These techniques add more visual variety to a sequence.

If natural or outdoor lighting is used and the camera is hand-held, an unsteadiness in movement results; this technique and effect, called *cinema veritée* (cih-nay-MAH

veh-ree-TAY), along with natural lighting, appears more often in documentary films or in sequences photographed for newsreels or television news programming. It constitutes one of the conventions of current events reporting and adds to the sense of reality necessary for this kind of film recording.

Filmmakers use these techniques and many others to ease some of the technical problems in making a film. They can be used to make the film smoother or more static, depending on the needs of the story line, or to add an element of commentary to the film. One school of cinematic thought believes that camera technique is best when not noticeable; another, more recent way of thinking believes the obviousness of all the technical aspects of film adds meaning to the concept of cinema. In any case, camera technique occurs in every kind of film made and adds variety and commentary, meaning and method, to the shot, the scene, and the film.

HOW DOES IT STIMULATE THE SENSES?

The basic aim of cinema, as with any art, is to involve us in its product, either emotionally or intellectually. Of course, nothing exceeds a good plot with well-written dialogue delivered by trained actors to create interest. But other ways exist in which filmmakers may enhance their final product, techniques that manipulate us toward a deeper involvement or a heightened intellectual response. Figure 8.4 illustrates how angles and shadows within a frame help create a feeling of excitement and variety. An in-depth study of the films of Rosellini, Fellini, Hitchcock, or Bergman may indicate how directors can use some of the technical aspects of film to underline emotions or strengthen a mood or an idea in their films.

Perception is most important in the area of technical detail. We should begin to cultivate the habit of noticing even the tiniest details in a scene, for often these details may add a commentary that we may otherwise miss. For example, in Hitchcock's *Psycho,* when the caretaker of the motel (Tony Perkins) wishes to spy on the guests in cabin 1, he pushes aside a picture that hides a peephole. The picture is a reproduction of *The Rape of the Sabine Women.* Hitchcock's obvious irony emerges. Thus perception becomes the method through which viewers of film may find its deeper meanings as well as its basic styles.

VIEWPOINT

Very shortly (page 227) under the heading of "Direct Address," we will discuss the term *camera look.* Sounding similar to the "look" but not at all similar is what has over the years been called "the male gaze" or just "the gaze." It concerns the viewpoint of the film, and that viewpoint plays a significant role in how our senses respond to the film. Louis Giannetti (*Understanding Movies,* page 482) describes the film's viewpoint and "the gaze" as it appears in Mira Nair's film *Vanity Fair* (2004) like this:

> The term ["the gaze"] refers to the voyeuristic aspects of cinema—sneaking furtive glances at the forbidden, the erotic. But because most filmmakers are males, so too is the point of view of the camera: Everyone looks at the action through male eyes. The gaze fixes women in postures that cater to male needs and fantasies rather than allowing women to express their own desires and the full range of their humanity. When the director is a woman, the gaze is often eroticized from a female point of view, offering us fresh

perspectives on the battle between the sexes. Becky Sharp, the heroine of Thackeray's nineteenth-century English novel *Vanity Fair*, is a calculating, manipulative social climber, determined to enter the world of the rich and powerful no matter what the cost. This movie version is more sympathetic, more feminist: Becky is portrayed as a shrewd exploiter of the British class system, which is male-dominated, imperialistic, and hostile to women. A gutsy, clever woman like Becky ([Reese] Witherspoon) clearly deserves to triumph over such a rigid and corrupt social system.

CROSSCUTTING

Filmmakers can use many techniques to heighten the feeling they desire their film to convey. The most familiar and most easily identified is that of *crosscutting*. Crosscutting alternates between two separate actions related by theme, mood, or plot but usually occuring within the same period of time. Its most common function creates suspense. Consider this familiar cliché: Pioneers going west in a wagon train are besieged by Indians. The settlers have been able to hold them off, but ammunition is running low. The hero has been able to find a cavalry troop, and they are riding to the rescue. The film alternates between views of the pioneers fighting for their lives and shots of the soldiers galloping to the rescue. The film continues to cut back and forth, the pace of cutting increasing until the sequence builds to a climax—the cavalry arriving in time to save the wagon train. The famous chase scene in *The French Connection*, the final sequences in *Wait Until Dark*, and the sequences of the girl entering the fruit cellar in *Psycho* are built for suspense through techniques of crosscutting.

A more subtle use of crosscutting, *parallel development*, occurs in *The Godfather, Part I*. At the close of that film, Michael Corleone acts as godfather for his sister's son; at the same time his men destroy all his enemies. The film alternates between views of Michael at the religious service and sequences showing violent death. This parallel construction draws an ironic comparison by juxtaposing actions. By developing the two separate actions, the filmmaker allows us to draw our own inferences and thereby add a deeper meaning to the film.

TENSION BUILDUP AND RELEASE

If the plot of a film is believable, the actors competent, and the director and film editor talented and knowledgeable, a feeling of tension will be built up. If this tension becomes too great, we will seek some sort of release, and an odd-sounding laugh, a sudden noise, or a loud comment from someone else may cause us to laugh, thus breaking the tension and in a sense destroying the atmosphere so carefully created. Wise filmmakers therefore build into their film a *tension release* that deliberately draws laughter from the audience, but at a place in the film where they wish them to laugh. This tension release can be a comical way of moving, a gurgle as a car sinks into a swamp, or merely a comic line. It does not have to be too obvious, but it should exist in some manner. After a suspenseful sequence the audience needs to relax; once the tension release does its job, we can be drawn into another suspenseful or exciting situation.

Sometimes, to shock us or maintain our attention, a filmmaker may break a deliberately created pattern or a convention of film. In *Jaws*, as noted in Chapter 7 for example, each time the shark is about to appear, a four-note musical *motif* plays. We thereby grow to believe we will hear this warning before each appearance, and so we relax. However, toward the end of the film

A Question of Style

Neorealism

neorealism (nee-oh-REE-uh-lihz-uhm). Post–World War II movement in art, film, and literature. In film, it used hidden cameras and emphasized an objective viewpoint and documentary style. It followed in the tradition of **verismo**, in which superficially naturalistic works are informed by a degree of populism and sentimentality.

The neorealist movement in film began with Roberto Rosselini's *Open City* (1945). It deals with the collaboration of Catholics and Communists in fighting against the Nazi occupation of Rome in World War II. The film has a gritty textural quality that gives it a sense of immediacy, as if it were filmed as a journalistic documentary. Whatever qualities of enhanced realism this characteristic adds to the film came about by pure accident, however. Rossellini could not get good quality film stock, and so he had to use standard newsreel film. Practically the entire movie was shot in actual locations under normal lighting conditions, and, like documentary film, used nonprofessional actors (the exceptions being the leading characters). The plot moves episodically rather than causally and consists of a series of vignettes depicting the reactions of Rome's citizenry to the Nazi occupation. "This is the way things are," said Rossellini in describing the film, and those words became a mantra for neorealist filmmakers.

the shark suddenly appears without benefit of the motif, shocking us. From that point until the end of the film we can no longer relax, and our attention is fully engaged.

DIRECT ADDRESS

Direct address represents another method used to draw attention. It constitutes a convention in most films that the actors rarely look at or talk directly to the audience. However, in *Tom Jones*, while Tom and his landlady argue over money, Tom suddenly turns directly to the audience and says, "You saw her take the money." The audience's attention focuses on the screen more strongly than ever after that. This technique has been effectively adapted by television for use in commercial messages. For example, a congenial person looks at the Camera (and

us) with evident interest and asks if we are feeling tired, run-down, and sluggish. He assumes we are and proceeds to suggest a remedy. In a sense, the aside of nineteenth-century melodrama and the soliloquy of Shakespeare were also ways of directly addressing an audience and drawing them into the performance.

Of course, silent films could not use this type of direct address to the audience; they had only the device of titles. However, some of the silent comedians felt they should have direct contact with their audience, and so they developed a *camera look* as a form of direct address. After an especially destructive moment in his films, Buster Keaton would look directly at the camera, his face immobile, and stare at the audience. When Charlie Chaplin achieved an adroit escape from catastrophe, he might turn toward the

camera and wink. Stan Laurel would look at the camera and gesture helplessly (Fig. 8.5), as if to say, "How did all this happen?" Oliver Hardy, after falling into an open manhole, would register disgust directly to the camera and the audience. These represented ways of commenting to the audience and letting them know the comedians knew they were there. Some sound comedies adapted this technique. In the road pictures of Bob Hope and Bing Crosby, both stars, as well as camels, bears, fish, and anyone else who happened to be around, would comment on the film or the action directly to the audience. However, this style may have been equally based on the audience's familiarity with radio programs, in which the performer usually spoke directly to the home audience.

MAGNITUDE AND CONVENTION

In considering the magnitude of a film, we must be aware of the means through which the film communicates. In other words, was the film made for a television showing or for projection in a large screen theatre? Due to the size of the television screen, large panoramas or full-scale action sequences do not translate effectively—they become too condensed. TV films, to be truly effective, should be built around the close-up and around concentrated action and movement because the TV audience is closer to the image than the viewers in a large theater. Scenes of multiple images with complex patterns of movement or scenes of great violence become confusing because of the

FIGURE 8.5 You're Darn Tootin' *(1928) A Hal Roach Production for Pathe Films. Director: Edgar Kennedy. Laurel & Hardy film still from* Help Mates. *Photo by Hal Roach/MGM. Picture Desk, Inc./Kobal Collection.*

intimacy of television, and seem more explicit than they really are. On the contrary, when close shots of intimate details are enlarged through projection in a theatre, they may appear ridiculous. The nuance of a slightly raised eyebrow, so effective in the living room, appears either silly or overly dramatic when magnified on a 60-foot screen. Today's moviemakers, when creating a film, must be aware of how it will appear if translated to the home screen or enlarged in a theatre; their work ought to be designed to accommodate the size of either medium.

In considering a film's magnitude, we must also consider its settings. Gone are the days when all movie sets were constructed like stage settings with large street scenes or studio sets—or even panoramic landscapes. Today much of this can be done by computer imaging. Even traditional animation, employing time-consuming hand-drawn cel images now largely has given way to computer images created digitally. Animated features, like *Shrek 2* (Fig. 8.6), directed by Andrew Adamson and Vicky Jenson, combine computer animation with heightened (computer-enhanced) reality. The resultant characters and backgrounds have tremendous three-dimensionality and, hence, reality.

The film, as with theatre, has certain conventions or customs that we accept without hesitation. When an exciting chase scene takes place, no one asks the location of the orchestra playing the music which enhances

FIGURE 8.6 *Scene from "Shrek 2" (2004). Directed by Andrew Adamson, Kelly Asbury, Conrad Vernon. Shown: Princess Fiona's parents, The Queen (Julie Andrews) and King (John Cleese), Donkey (Eddie Murphy).*
Source: Photo courtesy of Dream Works Pictures/Photofest.

the sequence; we merely accept the back-ground music as part of the totality of the film. We accept a film photographed in black and white as a recording of reality, even though we know the real world has color although this particular reel world does not. When a per-former sings and dances in the rain in the middle of a city street, no member of the audi-ence worries if the orchestra is getting wet or wonders if the performer will be arrested for creating a public spectacle. The conventions of the musical film are equally acceptable to an audience conditioned to accept them.

This consideration of conventions applies especially importantly to the accep-tance of the silent film as a form of art. We should not think of the silent film as a sound film without sound but as a separate entity with its own special conventions. These con-ventions revolve around the methods used to indicate sound and dialogue without actually using them. The exaggerated pantomime and acting styles, the use of titles, character stereo-typing, and visual metaphors represent con-ventions acceptable during the silent era but ludicrous today because of changes in style and taste and improvements in the devices used for recording and projecting film. The silent film recorded action and presented it at a speed of sixteen to eighteen frames per sec-ond; when that action screens today on a pro-jector that operates at twenty-four frames per second, the movement becomes too fast and appears jerky and disconnected. However, once we learn to accept these antiquated con-ventions, we may find the silent film an equally effective form of cinematic art.

STRUCTURAL RHYTHM

Much of the effectiveness of a film relies on its success as a form as well as a style. Filmmakers create rhythms and patterns based on the way they choose to tell their stories or that indicate deeper meanings and relationships. The *structural rhythm* of a film reflects the manner in which the various shots join together and juxtapose with other cinematic images, both visual and aural.

Symbolic images in film range from the very obvious to the extremely subtle, but filmmakers use them all in directing our attention to the ideas inherent in the philo-sophical approach underlying the film. This use of symbolic elements can be found in such clichés as the hero dressed in white and the villain dressed in black, in the more sub-tle use of water images in Fellini's *La Dolce Vita* (Lah-DOHL-chay VEE-tah), or even in the presence of an X whenever someone is about to be killed in *Scarface*.

Sometimes, symbolic references can be enhanced by form cutting—for example, cutting directly from the hero's gun to the villain's gun. Or the filmmaker may choose to repeat a familiar image in varying forms, using it as a composer would use a motif in music. Hitchcock's shower sequence in *Psycho* builds around circular images: the shower head, the circular drain in the tub, the mouth open and screaming, and the iris of the unseeing eye. In *Fort Apache*, John Ford uses clouds of dust as a curtain to cover major events; the dust also indicates the ultimate fate of the cavalry troop. Grass, cloud shapes, windblown trees, and patches of color have all been used symbolically and as motifs. Once they perceive such elements, serious students of film will find the deeper meanings of a film more evident and their appreciation of the film heightened.

Another part of structural rhythm is the repetition of certain visual pat-terns throughout a film. A circular image positioned against a rectangular one, a movement from right to left, an action repeated regularly throughout a sequence— all can become observable patterns or even thematic statements. The silent film made extreme use of thematic repetition.

A Question of Style

Symbolism

symbolism (SIHM-buh-lih-zuhm). In visual art, theatre, film, and literature from the late nineteenth to mid-twentieth centuries. Also known as neo-Romanticism, idealism, or impressionism. It held that truth can be grasped only by intuition, not through the senses or rational thought. Thus, ultimate truths can be suggested only through symbols, which evoke in the audience or reader various states of mind that correspond vaguely with the playwright's or writer's feelings.

Symbols (see Chapter 1) imply relatively clear additional meanings, and the use of symbols occurs frequently in movies. A good example, is how Akira Kurosawa, in *The Seven Samurai* (Japan, 1954), uses flames as a changing symbol. The film tells the story of a young samurai warrior and a peasant girl, attracted to each other but separated by strict class distinctions. The two accidentally meet late at night. Kurosawa keeps each of them in separate frames separated by a raging fire that suggests an actual barrier. Their attraction to each other is so strong, however, that they come together. The director places them in the same shot. At this point, the fire continues to symbolize the seemingly insurmountable obstacle between them, but it also shifts to suggest the tremendous passion that consumes them. They come together and Kurosawa moves the fire to the side of the frame where it suggests sexuality. As the scene continues, the couple go inside a hut to make love, and the fire filters through the reeds of the hut's walls stippling their bodies with light. Then the girl's father discovers them, and the fire morphs into a symbol for his moral outrage. As other samurai restrain the father, Kurosawa shows them all washed out by the fire's light. Later, after the young samurai has left the scene in despondence, rain falls, extinguishing the fire.

In *Intolerance*, D. W. Griffith develops four similar stories simultaneously and continually crosscuts between them. This particular use of form enabled him to develop the idea of the similarity of intolerance throughout the ages. In their silent films, Laurel and Hardy often built up a pattern of "you do this to me and I'll do that to you"; they called it "tit for tat." Their audience would be lulled into expecting this pattern, but at that point the film would present a variation on the familiar theme (a process quite similar to the use of *theme and variation* in musical composition). The unexpected breaking of the pattern would surprise the audience into laughter.

Parallel development, discussed earlier, can create form and pattern throughout a film. For example, Edwin S. Porter's *The Kleptomaniac* alternates between two stories: a wealthy woman caught shoplifting a piece of jewelry, and a poor woman who steals a loaf of bread. Each sequence alternately shows crime, arrest, and punishment; the wealthy woman's husband bribes the judge to let her off; the poor woman goes to jail. Porter's final shot shows the statue of justice holding her scales, one weighted down with a bag of gold. Her blindfold is raised over one eye, which is looking at the money. In this case, as in others, the form is the film.

AUDIO TECHNIQUES

When sound films became practicable, film-makers found many ways of using the audio track, in addition to just recording dialogue. This track could be used as symbolism, as a motif that reinforced the emotional quality of a scene, or for stronger emphasis or structural rhythm.

Some filmmakers believe a more realistic feeling can be created if the film is cut rather than dissolved. They feel that cutting abruptly from scene to scene gives the film a staccato rhythm that in turn augments the reality they hope to achieve. A dissolve, they think, creates a slower pace and tends to make the film *legato* and thus more romantic. If the abrupt cutting style is done to the beat of the sound track, a pulsating rhythm is created for the film sequence; this in turn communicates to us and adds a sense of urgency to the scene. In Fred Zinnemann's *High Noon*, the sheriff waits for the noon train to arrive. The sequence uses *montage* (mahn-TAHZH), showing the townspeople as well as the sheriff waiting. The shot changes every eight beats of the musical track. As the time approaches noon, the shot changes every four beats. Tension mounts. The feeling of rhythm enlarges by shots of a clock's pendulum swinging to the beat of the sound track. Tension continues to build. The train's whistle sounds. A series of rapid cuts of faces turning and looking occurs, but only silence on the sound track remains, which serves as a tension release. This last moment of the sequence provides a transition between the music and silence. In other films, the track may shift from music to natural sounds and back to the music again. Or a pattern may arise of natural sound, silence, and a musical track. All depends on the mood and attitude the filmmaker is trying to create. In Hitchcock's films, music often acts as a tension release or an afterthought, as Hitchcock usually relies on the force of his visual elements to create structural rhythm.

Earlier in this chapter, we mentioned the use of motif in *Jaws*. Many films make use of an audio motif to introduce visual elements or convey meaning symbolically. Walt Disney, particularly in his pre-1940 cartoons, often used his sound track in this manner. For example, Donald Duck is trying to catch a pesky fly, but the fly always manages to elude him. In desperation, Donald sprays the fly with an insecticide. The fly coughs and falls to the ground. But on the sound track we hear an airplane motor coughing and sputtering and finally diving to the ground and crashing. In juxtaposing these different visual and audio elements, Disney is using his track symbolically.

John Ford often underlines sentimental moments in his films by accompanying the dialogue of a sequence with traditional melodies; as the sequence comes to a close, the music swells and then fades away to match the fading out of the scene. In *The Grapes of Wrath*, when Tom Joad says good-bye to his mother, "Red River Valley" plays on a concertina; as Tom walks over the hill, the music becomes louder, and when he disappears from view, it fades out. Throughout this film, this familiar folk song serves as a thematic reference to the Joad's home in Oklahoma and also boosts feelings of nostalgia for some of us. In *She Wore a Yellow Ribbon*, the song of the same name underlines the title of the film, but through the use of different tempos and timbres the mood of the song changes each time it appears. As the cavalry troop rides out of the fort, the song plays in a strong 4/4 meter with a heavy emphasis on the brass; the sequence cuts to the beat of the track. In the graveyard sequences, the same tune plays using strings and reeds in 2/4 time and in a

FIGURE 8.7 *American actor and director Orson Welles (1915–1985) in the film "Citizen Kane," which he wrote, produced, directed, and acted in. The film is based on the life of newspaper tycoon William Randolph Hurst.*
Source: Getty Images Inc. — Hulton Archive Photos

much slower tempo, which makes the song melancholy and sentimental. In the climactic fight sequence in *The Quiet Man*, John Ford cuts to the beat of a sprightly Irish jig, which enriches the comic elements of the scene and plays down the violence.

Nora Ephron, in *Sleepless in Seattle* (1993), uses the soundtrack of her film to juxtapose contemporary and traditional issues by taking classic popular tunes of the 1940s and presenting them as sung by contemporary singers. At other times, old songs are sung by the original singers. In this case, the movie's musical score became a best-selling album (produced by Sony Music).

Our discussion in these last few paragraphs touches only the surface of the techniques and uses of sound in film; of course, directors can use sound in other ways as well as the other elements discussed thus far. But part of the challenge of the film as an art form is our discovery of the varying uses to which film technique can be put, and this in turn enhances further perceptions.

Sample Outline and Critical Analysis

The following very brief example illustrates how we can use a few of the terms explained in the chapter to form an outline and then develop a critical analysis of a work of cinema. Here is how that might work regarding Orson Welles's film *Citizen Kane* (1941; Fig. 8.7).

Outline	Critical Analysis
Genre Narrative (fictional) film	The film is a narrative (fictional) film that tells the story of a powerful publisher, Charles Foster Kane. The plot progresses chronologically through the events of the central character's life, beginning in childhood.
Camera viewpoint Shots	The shots of the film suggest a variety of styles, particularly angles and lighting of great theatricality. All of the film's shots are extremely careful in their composition. They use deep focus, low-key lighting, long shots, close-ups, and crane shots with numerous special effects. The predominant type of shot, the long shot, gives the film a more theatrical tone. Most of the images of the film are tightly framed in closed form. Welles uses the settings often to enclose the actors in a scene and to suggest that the people are in ways trapped by their environment. Welles also uses the shot to comment on the quality of Kane's marriage. Early on, he includes the couple in the same frame. Later on, they appear in separate frames even though they are seated together at the same table, for example.
Lighting	Over the duration of the film, the quality of the lighting changes from highly keyed at the beginning to very murky and harsh at the end. This change emphasizes the structural rhythm of the film and comments on the nature of Charles Foster Kane's life as it progresses. The effects create startling images due to unnatural angles and contrasts.
Camera movement	Camera movement, like the lighting, changes as the film progresses from Kane's youth to old age. As if to suggest the vitality of youth, the camera moves with agility early in the film. Later, to underscore the stiffness and immobility of old age, and, ultimately, death, the camera becomes static.
Audio techniques	The film's sound track follows closely all the other aspects of the film's composition, and each shot appears to have its own quality of sound. There seems to be a direct relationship between the visual qualities of the scenes and their aural qualities.

Additional Study and Cyber Sources

1900–1955

http://www. filmsite.org/pre20sintro.html
http://www. filmsite.org/20sintro.html
http://www. filmsite.org/30sintro.html
http://www. filmsite.org/40sintro.html
Méliès—*A Trip to the Moon*
Griffith—*The Birth of a Nation*
Chaplin—*Easy Street*
Wiene—*The Cabinet of Dr. Caligari*
Porter—*The Great Train Robbery*
Von Stroheim—*Greed*
Eisenstein—*Potempkin*
Crossland—*The Jazz Singer*
Disney—*Steamboat Willie*
Hitchcock—*The Thirty-nine Steps*
Ford—*Stagecoach*
Selzinick—*Gone with the Wind*
Welles—*Citizen Kane*
Desica—*The Bicycle Thief*
Koster—*The Robe*

1955–present

http://www. filmsite.org/50sintro.html
http://www. filmsite.org/60sintro.html
http://www. filmsite.org/70sintro.html

http://www. filmsite.org/80sintro.html
http://www. filmsite.org/90sintro.html
Bergman—*The Seventh Seal*
Lean—*The Bridge on the River Kwai*
Godard—*Breathless*
Clayton—*Room at the Top*
Hitchcock—*Psycho*
Fellini—*8½*
Penn—*Bonnie and Clyde*
Kubrick—*2001*
Altman—*MASH*
Coppola—*The Godfather*
Spielberg—*Jaws*
Fosse—*All That Jazz*
Allen—*Manhattan*
Scorsese—*Age of Innocence, The*
Blair—*Bad Behavior*
Leigh—*Naked*
Campion—*The Piano*
Amelio—*The Stolen Children*
Yimou—*The Story of Qiu Ju*
Saute—*Un Coeur en Hiver*
Mingella—*The English Patient*
Singer—*The Usual Suspects*

Dance

Every December, Tchaikovsky's *Nutcracker* ballet rivals Handel's *Messiah* and television reruns of the Jimmy Stewart movie *It's a Wonderful Life* as a holiday tradition. Dance represents one of the most natural and universal of human activities. In virtually every culture, regardless of location or level of sophistication, we find some form of dance. Dance appears to have sprung from humans' religious needs. For example, scholars maintain that the theatre of ancient Greece developed out of that society's religious tribal dance rituals. Without doubt, dance forms part of human expression at its most fundamental level. We can see this expression even in little children who, before they begin to paint, sing, or imitate, begin to dance.

Carved and painted scenes from antiquity to the beginning of the era of film give us only the scantiest means by which to study the history of dance, an ephemeral art of movement. Dance also represents a social activity, but in this chapter we limit ourselves to what we call "theatre dance"—dance that involves a performer, a performance, and an audience.

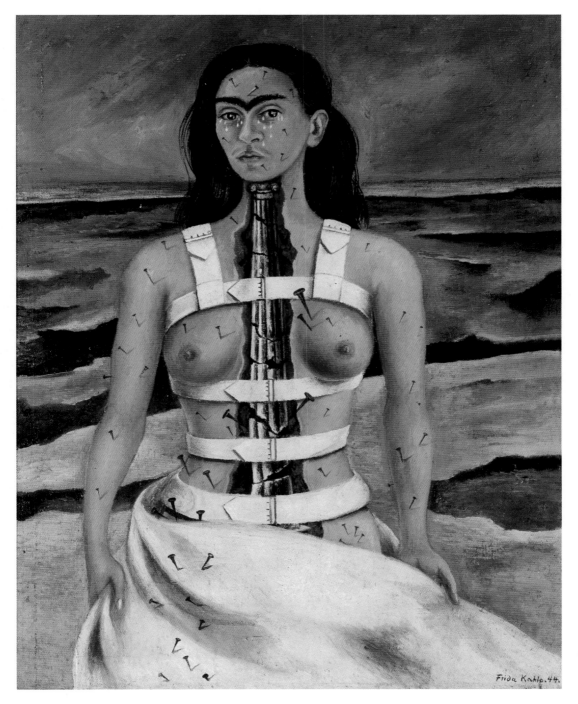

Plate 15 Frida Kahlo, *The Broken Column*, 1944. Fundacion Dolores Olmedo, Mexico City, Mexico. Schalkwijk/Art Resource, NY. ©2003 Banco de Mexico Diego Rivera & Frida Kahlo Museums Trust. Av. Cinco de Mayo No. 2, Col. Centro, Del. Cuauhtemoc 06059, Mexico, D.F. Reproduction authorized by the Instituto Nacional de Bellas Artes y Literatura. Photo by Bob Schalkwijk.

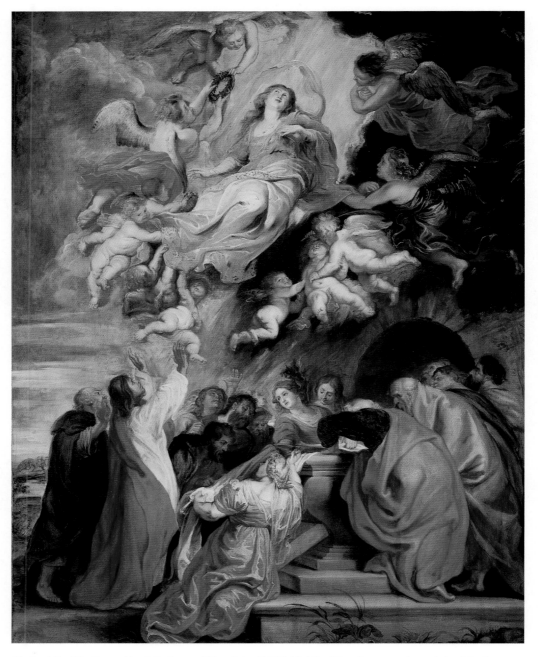

Plate 16 Sir Peter Paul Rubens (Flemish, 1577-1640), *The Assumption of the Virgin*, c.1626. Oil on panel, 1.254 x .942 (49 3/8 x 37 1/8); framed: 1.575 x 1.257 x .082 (62 x 49 1/2 x 3 1/4). National Gallery of Art, Washington, D.C. Samuel H. Kress Collection.

Plate 17 Georgia O'Keeffe (American), *Dark Abstraction*, 1924. Oil on canvas, unsigned. 25 3/8 x 21 1/8 in. (64.5 x 53.7 cm). Gift of Charles E. and Mary Merrill, 187:1955, The Saint Louis Art Museum (Modern Art), ISN 11327. ©2004 The Georgia O'Keeffe Foundation/Artists Rights Society (ARS), New York.

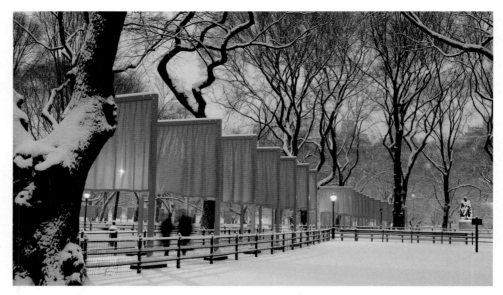

Plate 18 Christo & Jeanne-Claude, *The Gates, New York City*. 1979-2005. After the snow, Central Park, New York City, NY. Photo by Wolfgang Volz. Redux Pictures.

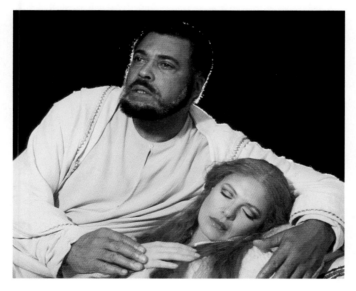

Plate 19 James Earl Jones and Dianne Wiest in a 1981 production of Shakespeare's *Othello* (c.1990). Photo by Martha Swope. Martha Swope Studio.

WHAT IS IT?

Dance focuses on the human form in time and space. It can follow numerous directions and traditions, including ballet, modern, world concert/ritual, folk, jazz, tap, and musical comedy. The discussion that follows treats five of these: ballet, modern, world concert/ritual, folk, and jazz dance.

BALLET

Ballet comprises what we call "classical" or formal dance. Its rich tradition rests heavily upon a set of prescribed movements and actions. In general, ballet comprises a highly theatrical dance presentation consisting of solo dancers, duets, and choruses, or the *corps de ballet* (kohr-duh-bah-LAY). According to Anatole Chujoy in the *Dance Encyclopedia*, the basic principle in ballet is "the reduction of human gesture to bare essentials, heightened and developed into meaningful patterns." The great choreographer George Balanchine saw the single steps of a ballet as analogous to single frames in a motion picture. Ballet, then, became a fluid succession of images, existing within specialized codes of movement. As with all dance and indeed all the arts, ballet expresses basic human experiences and desires.

MODERN DANCE

Modern dance as a category covers a broad variety of highly individualized dance works limited to the twentieth century, American in derivation, and antiballetic in philosophy. It began as a revolt against the stylized and tradition-bound elements of ballet. The basic principle of modern dance could be stated as an exploration of natural and spontaneous or uninhibited movement, in strong contrast with the conventionalized and specified movement of ballet. The earliest modern dancers found stylized ballet incompatible with their need to communicate in twentieth-century terms. As the remarkable choreographer Martha Graham characterized it, "There are no general rules. Each work of art creates its own code (Fig 9.1)." Nonetheless, in its attempts to be nonballetic, it has accrued certain conventions and characteristics. While narrative elements occur in many modern dances, choreographers emphasize them less than happens in traditional ballet. Modern dance also uses the body (particularly in angularity of line), dance floor (which in modern dance becomes more interactive with the dancer rather than a surface from which to spring and to which to return), and interaction with the visual elements.

WORLD CONCERT/RITUAL DANCE

Out of a plethora of scholarly arguments about how to label and define certain types of dance emerged the term *world dance*. This name describes dances specific to a particular country. Within or alongside the category of world dance exists another label: *ritual dance*. In other words, among the dances classified as "world" exist dances based in ritual—dances having ceremonial functions, formal characteristics, and particular prescribed procedures—which pass from generation to generation. Perhaps complicating the definition further, some of the dances falling in such a category have public presentation as their objective, and some have both ritualistic and public performance aims. Further, some ritual dances would never be performed for an audience because of their sacredness.

World concert/ritual dances typically center around topics important to single

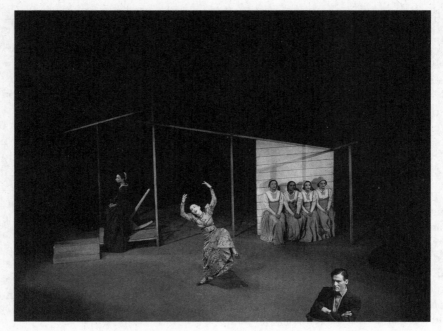

FIGURE 9.1 *Martha Graham in a scene from* Appalachian Spring.
Source: Getty Images

A Question of Style

Romantic Ballet

romantic ballet (roh-MAN-tihk ba-LAY). A nineteenth-century turning against the often cold formality of **classicism** and **neoclassicism** in pursuit of a more subjective viewpoint and emotional feeling. Romantic ballet became "beautiful forms in graceful attitudes"— living sculpture, with a focus on ballerinas. Romantic ballet developed the basic "attitude" of standing on one leg with the other brought up behind at a 90-degree angle with the knee bent.

Two sources help to explain Romantic ballet: the writings of Théophile Gautier (tay-uh-FEEL goh-tee-YAY; 1811–1872) and Carlo Blasis (BLAH-zees; 1803–1878). Gautier, a poet and critic, held first of all that beauty was truth, a central Romantic conception. Gautier believed that dance acted as visual stimulation to show "beautiful forms in graceful attitudes." Dancing for Gautier created a living painting or sculpture—"physical pleasure and feminine beauty." This exclusive focus on ballerinas placed sensual enjoyment and eroticism squarely at the center of his aesthetics. Gautier had significant influence

and accounted for the central role of the ballerina in Romantic ballet. Male dancers were relegated to the background, strength being the only grace permissible to them.

The second general premise for Romantic ballet came from *Code of Terpsichore* (tuhrp-SIHK-kuh-ree) by Carlo Blasis. Blasis, a former dancer and more systematic and specific than Gautier, held principles covering training, structure, and positioning. Everything in the ballet required a beginning, a middle, and an ending. The basic "attitude" in dance comprised standing on one leg with the other brought up behind at a 90-degree angle with the knee bent. The dancer needed to display the human figure with taste and elegance. If the dancer trained each part of the body, the result would be grace without affectation. From Blasis came the turned-out position still fundamental to ballet today. These broad principles provided the framework, and, to a great extent, a summary, of objectives for Romantic ballet: delicate ballerinas, lightly poised, costumed in soft tulle, and moving *en pointe*, with elegant grace.

Choreographers of Romantic ballet sought magic and escape in fantasies and legends. Ballets about elves and nymphs enjoyed great popularity, as did ballets about madness, sleepwalking, and opium dreams. Women appeared not only as performers and as subjects of the dance, however. They also began to come to prominence as choreographers. From this tradition come the ever-popular *Nutcracker* and *Swan Lake*, the scores for both composed by Tchaikovsky.

cultures—for example, "religion, moral values, work ethics, or historical information relating to a culture" (Nora Ambrosio, *Learning About Dance*, p. 94). Some of the dances involve cultural communication, and others—such as those in the Japanese *Noh* and *Kabuki* traditions—are theatrical. World concert/ritual dance forms an important element of many African and Asian cultures. At least in general terms, we can differentiate world concert/ritual dance from the next category, *folk dance*, although the boundaries often blur.

FOLK DANCE

Folk dance, somewhat like folk music, represents a body of group dances performed to traditional music. Like folk music, we do not know the artists who developed it. Folk dances began as a necessary or informative part of certain societies, and their characteristics remain stylistically identifiable with a given culture. They developed over a period of years, passing from one generation to another. They have prescribed movements, prescribed rhythms, and prescribed music and costume. At one time or another they may have become formalized: committed to some form of record. They typically do not spring from the creative action of an artist or a group of interpretative artists. Likewise, they usually exist more to involve participants than to entertain an audience (Fig. 9.2).

Folk dancing establishes an individual sense of participation in society, the tribe, or a mass movement. The members of the group experience a sense of oneness with the group, whether in conscious strength, purpose, or heightened power, through the collective dancing.

FIGURE 9.2 *The Csárdás, a traditional Hungarian folk dance. Courtesy of Csárdás Hungarian Dancers, Austin, TX.*

A Question of Style

Modern Dance

modern dance (mah-duhrn dans) formed late-nineteenth-century reaction against the Romantic tradition in ballet. Begun by Isadora Duncan, the tradition grew through the efforts of choreographers like Ruth St. Denis and Martha Graham. Modern dance utilizes angularity and asymmetry, barefoot dancers, and interaction with the dance floor: "a graph of the heart," according to Martha Graham.

Modern dance had its beginnings in the controversial dances of Isadora Duncan (1878–1927). Although an American, Isadora achieved her fame in Europe. Her dances formed emotional interpretations of moods suggested to her by music or by nature. Her dance was personal. Her costume was inspired by Greek tunics and draperies, and, most significantly, she danced in bare feet. This break with convention continues to this day as a basic condition of the modern dance tradition she helped to form.

Despite the notoriety of the young feminist Isadora Duncan, her contemporary Ruth St. Denis (1878–1968) and her husband Ted Shawn (1891–1972) laid more substantial cornerstones for modern dance in their Denishawn school. Ruth St. Denis numbered among her favorite books Immanuel Kant's *Critique of Pure Reason* and Alexandre Dumas's *Camille.* Her dancing began as a strange combination of exotic, oriental interpretations, and Delsartian poses. (Delsarte is a nineteenth-century system of gestures and postures that transmit feelings and ideas, originated by François Delsarte [1811–1871].) Ruth St. Denis was a remarkable performer with a magnificently proportioned body. She manipulated it and various draperies and veils into presentations of line and form in such a graceful manner that the fabric appeared an extension of the dancer's body.

The Denishawn school took a totally eclectic approach to dance including all traditions, from formal ballet to oriental and American Indian dances. The touring company presented wildly varied fare, from Hindu dances to the latest ballroom crazes. Branches of the school formed throughout the United States, and the touring company occasionally appeared with the *Ziegfield Follies.* By 1932, St. Denis and Shawn had separated, and the Denishawn Company ceased to exist. Nonetheless, it left its mark on its pupils, one of whom was Martha Graham.

JAZZ DANCE

Jazz dance traces its origins to Africa prior to the arrival of African slaves on the American continent. Today it exists in a variety of forums including popular theatre, concert stage, movies, and television. The rhythms of African music found their way into dances performed for enjoyment and entertainment. The foundations they provided led to the minstrel show in which white entertainers in blackface performed dances. By the late twentieth century, jazz dance had evolved into a variety of styles of movement, lacking a precise definition other than that of a vital, theatrical dance footed in jazz and the African heritage. Jazz dance relies heavily on improvisation and syncopation.

HOW IS IT PUT TOGETHER?

Dance, an art of time and space, utilizes many of the elements of the other arts. In the setting and in the line and form of the human body, it involves many of the compositional elements of pictures, sculpture, and theatre. Dance also relies heavily on the elements of music—whether or not music accompanies the dance presentation. The essential ingredient of dance, however, remains the human body and its varieties of expression.

A Question to Ask

What genre of dance does the work represent, and how does it express the characteristics fundamental to the genre?

profile

Martha Graham

Martha Graham (1893–1991) arguably contributed more to the art of modern dance as an innovative choreographer and teacher than any other individual. Her techniques were rooted in the muscular and nerve-muscle responses of the body to inner and outer stimuli. She created the most demanding body-training method in the field of modern dancing.

Born in Pittsburgh on May 11, 1893, Graham spent her early years there and in Santa Barbara, California. As a teenager she began studying dance at Denishawn, a dance company founded by Ruth St. Denis and Ted Shawn. Martha's dance debut came in *Xochitl* (ZOH-chee-tuhl), a ballet choreographed by St. Denis and based on an Aztec theme. It proved a great success both in vaudeville and concert performances.

Graham left Denishawn in 1923 to become a featured dancer in the Greenwich Village Follies. She also taught for a time at the Eastman School of Music in Rochester, N.Y. She debuted in New York City as an independent artist in 1926. One year later, her program included the dance piece, *Revolt*, probably the first dance of protest and social comment in the United States.

Social criticism as an artistic message came in with the Great Depression, and Graham began to pursue topical themes. Her interest in the shaping of America led to her renowned dance piece, *Appalachian Spring* (1944), set to the music of Aaron Copland. *Appalachian Spring* deals, among other things, with the triumph of love and common sense over the fire and brimstone of American Puritanism. Martha Graham, herself, danced the principal role of The Bride. Other roles included The Revivalist, The Husbandman, The Pioneering Woman, and The Followers. Perhaps the best known and best loved of Graham's works, and the one with the finest score, *Appalachian Spring* takes as its pretext a wedding on the American frontier. The dance is like no actual ceremony or party, however. The movement not only expresses individual character and emotion, but it has a clarity, spaciousness, and definition that relate to the open frontier, which must be fenced and tamed. During the dance, the characters emerge to make solo statements; the action of the dance suspends while they reveal what is in their hearts. The Bride's two solos suggest not only joy but trepidation for the future.

In a career spanning 70 years, Martha Graham created 180 dance works. Some of these were based on Greek legends: *Night Journey*, first performed in 1947, about Jocasta, the mother of Oedipus; *Clytemnestra* (kly-tehm-NEHS-trah; 1958); and *Cave of the Heart* (1946), about the tragedy of Medea. *Letter to the World* (1940) was based on the life of poet Emily Dickinson. *Seraphic Dialogue* (1955) dealt with Joan of Arc, and *Embattled Garden* (1962) took up the Garden of Eden legend. Among her other works were *Alcestis* (1960); *Acrobats of God* (1960); and *Maple Leaf Rag* (1990). Graham announced her retirement in 1970, but she continued to create new dances until her death from cardiac arrest in New York City on April 1, 1991.

FORMALIZED MOVEMENT

Ballet forms the most obvious repository of formalized movement in dance. All movement in ballet emanates from five basic leg, foot, and arm positions. In the first position (Fig. 9.3A), the dancer stands with weight equally distributed between the feet, heels together, and toes open and out to the side. In ballet, all movement evolves from this basic "open" position; the feet never parallel to each other, with both pointing straight forward. The second position (Fig. 9.3B) opens the first position by the length of one's foot, again with the weight placed evenly on both feet. In the third position (Fig. 9.3C), the heel of the front foot touches the instep of the back foot; the legs and feet must be well turned out. The heel of the front foot opposes the toe of the back foot in the fourth position (Fig. 9.3D). The feet are parallel to each other separated by the length of the dancer's foot, again with weight place evenly on both feet. The fifth

position (Fig. 9.3E) is the most frequently used of the basic ballet positions. The feet remain close together with the front heel touching the toe of the back foot. The legs and the feet must be well turned out to achieve this position correctly, and the weight stays evenly placed on both feet. As Figure 9.3 illustrates, each position changes the attitude of the arms as well as that of the legs and feet. From these five basic positions a series of fundamental movements and poses develops, and they form the core of every movement of the human body in formal ballet.

Many variations can emerge from the five basic positions. For example, the *grande seconde* (grahnd seh-KAWND; Fig. 9.4) varies the second position by elevating one leg to full height. The *demi-hauteur* (deh-MEE-oh-TUHR; Fig. 9.5) or "half-height" also elevates one leg. Full height requires extension of the leg at a 90-degree angle to the ground; half-height requires a 45-degree extension.

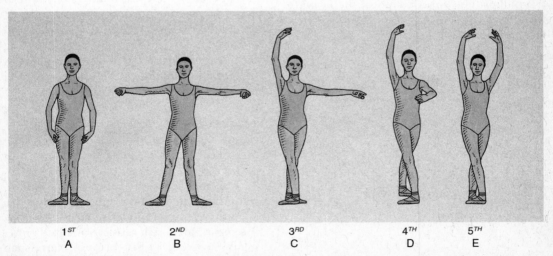

FIGURE 9.3 *The five ballet positions. Dorling Kindersley Media Library. Rob Shone © Dorling Kindersley.*

FIGURE 9.4 *Grande seconde.*

FIGURE 9.6 *Ronds de jambe à terre.*

Movements carry the same potential for variety. For example, in the *ronds de jambe á terre* (ruhn duh zhahmb ah tair; Fig. 9.6), the leg from the knee, to and including the foot, rotates in a semicircle. As we develop expertise in perceiving dance, we note that in formal ballet, and to a lesser degree in modern dance, we see a limited number of movements and poses, turns and leaps, done over and over again. Thus, these bodily compositions form a kind of theme with variations, and in that respect alone, they form a focus of interest.

FIGURE 9.5 *Demi-hauteur.*

In addition, we can find a great deal of excitement in the bodily movements of formal ballet for no other reason than the physical skills required for their execution. Just as in gymnastics or figure skating, the strength and grace of individuals in large part determine their qualitative achievement. Yet the ballet remains far more than just a series of gymnastic exercises.

Perhaps the most familiar element of ballet is the female dancer's toe work or dancing on point (Fig. 9.7). A special kind of footgear is required (Fig. 9.9). Dancing on point comprises a fundamental part of the female dancer's development, but it usually takes a minimum of two years of thorough training and development before a dancer can begin. Certain kinds of turns cannot occur without toe shoes—for example, spinning on point or being spun by a partner.

As we have just seen, we easily can illustrate the formalized movement basic to ballet, and we can let modern dance pass by in this regard because it resists formalized movement altogether. Other forms of dance such as world concert/ritual dance and folk dance have a myriad of formalized movements

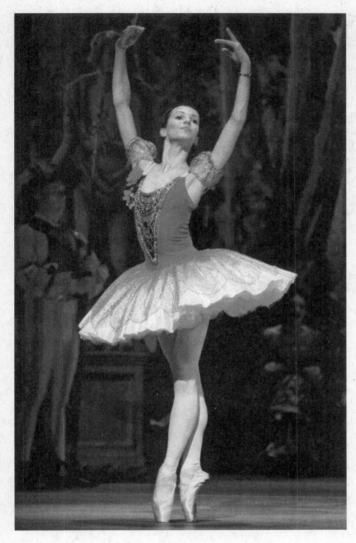

FIGURE 9.7 *On point.*

depending principally upon the customs of the culture involved. So it is difficult to illustrate the range here. We can, however, note one particularly popular approach to folk dance, and that is Irish step dancing as exhibited by the "Lord of the Dance" productions seen on television, on tour, and in Las Vegas. Here dancers dressed in conventionalized costume execute the intricate, physically demanding, and energetic steps of this form of dancing (Fig. 9.8).

LINE, FORM, AND REPETITION

The compositional elements of line, form, and repetition apply to the use of the human body in exactly the same sense that they apply to those elements in painting and

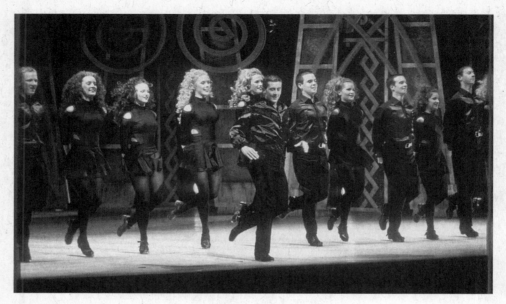

FIGURE 9.8 *Performers in a scene from Lord of the Dance.*
Source: Dorling Kindersley Media Library

sculpture—the latter especially. The body of the dancer represents, for analysis purposes, a sculptural, three-dimensional form which reflects the use of line, even though the dancer remains continually in motion. The body as sculptural form moves from one pose to another, and were we to take a stop-action movie of a dance, we could analyze, frame by frame or second by second, the compositional qualities of the human body. Each choreographic work represents a kaleidoscope of compositional arrangements in line and shape. Dance, therefore, exists at two levels: first, as a type of pictorial communication employing symbols that occur only for a moment and, second, as the design of transition with movement between those moments.

Because dancers move through time, the concept of repetition emerges as an important consideration in analyzing how a dance work is put together. The relationship of

FIGURE 9.9 *Toe shoes. Linda Rich photo.*

movements to each other as the dance progresses shows us a repetitional pattern very similar to theme and variation in music. Choreographers plan these patterns using individual dancers' bodies as well as combinations of dancers in duets, trios, or the entire corps de ballet (kawr-duh-bah-LAY; Figs. 9.10 and 9.11, and color insert Plate 9). Watching a dance should focus on how movements, ensembles, scenery, and individual bodies explore diagonal, curved, or asymmetric lines in the same sense that responding to a painting or work of sculpture involves perceiving and evaluating how those same elements of composition have been explored by the artist.

RHYTHM

As we watch a dance we can see that the steps relate to each other with coherence. Dance phrases hold together by their rhythm, in the same sense as in musical rhythm. Sequences of long and short motions occur which are highlighted by accents. In a visual

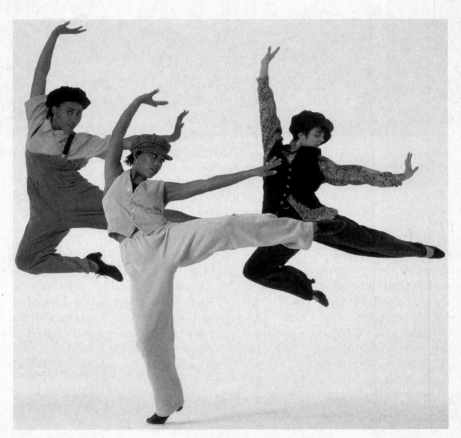

FIGURE 9.10 *Three members of the British company, Jazz Exchange, performing Jazz steps. Photograph by Dave King. Dorling Kindersley Media Library. Dave King © Dorling Kindersley.*

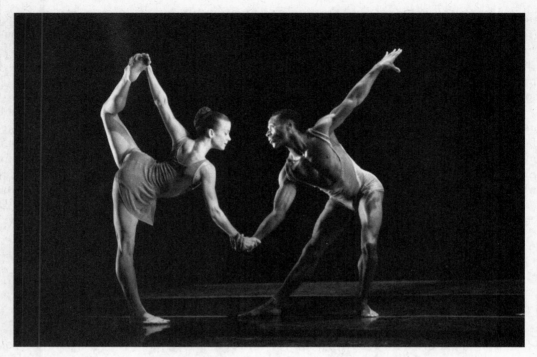

FIGURE 9.11 *Post Modern Ballet Dancers—Elizabeth Parkinson and Michael Blake during a performance of Donal Byrd's* Still *at the Joyce Theater. Photo by Julie Lemberger.*
Source: Corbis/Bettmann.

sense, dance rhythms occur in spatial arrangements, up and down, back and forth, curved and linear, large and small. We can also perceive rhythmic relationships in the ebb and flow of dancers' energy levels. Energy, of course, calls to mind dynamics in the same sense as occurs in music and theatre, and the rhythms of dynamics in dance often create a pyramidal form, rising to a peak and tapering to a resolution.

MIME AND PANTOMIME

Within any dance form we find elements of bodily movement that we call mime and pantomime. Bodily movement is mimetic whenever it suggests the kinds of movements we associate with people or animals. Mimetic movement also appears when the dance employs any of the forms of conventional sign language, such as the Delsarte system.

A Question to Ask

In what ways has the choreographer's use of line, form, and repetition made the dance's meaning clear?

When narrative elements appear in the dance and the dancer actually portrays a character in the theatrical sense, we have pantomimic action. Pantomime consists of "acting out" dramatic action without words. In the Romantic style of ballet, for example, pantomime helps to carry forward the story line. We sense the emotions and character relationships in the dancers' steps, gestures, movements, and facial expressions. Only when the movement of the dance retains a purely emotional expression of the dancer can we say that it does not contain mime or pantomime.

THEME, IMAGE, AND STORY LINE

Our consideration of the presence or absence of mime leads us to a consideration of how dance communicates its ideas. Three general possibilities exist. First, the dance may contain narrative elements—it may tell a story. Second, the dance may communicate through abstract ideas—a specific theme but no story line: Ideas relate to some aspect of human emotion or the human condition. Modern ballet (twentieth-century ballet) has dealt increasingly with abstract ideas. Modern dance, especially, tends to explore human psychology and behavior. Social themes occur frequently, as do impressions or expressions from plays, poems, and novels. Religious and folk themes exist as well. A variation of abstract idea content in dance comprises ethnic influence. Often elements of dance reflect sociocultural background. Jazz dance, for example, may stimulate us to consider various aspects of the African American heritage in the United States. The third possibility encompasses dances that have no narrative or abstract communication. In other words, the dance may be a *divertissement* (dee-vair-TEES-mawn; French for "diversion").

Participating as an audience member for dance requires active involvement, and determining the meaning involved in the themes, images, and story line of a dance requires evaluation of the feeling the choreographer tries to establish. In addition, we should attempt to discover what the choreographer intends to say through the dance. Do the dancers portray characters, transmit emotions, or some combination?

MUSIC

Music and dance relate as a matter of course. Most of the time music serves as a basis for the bodily movement of the work, although dance need not have music as an accompaniment. Dance, however, must always contain one element of music: rhythm. Every action of a dancer's body has some relationship in time to every other movement, and those relationships establish rhythmic, musical, patterns regardless of the presence or absence of sound.

When we hear music accompanying a dance, we can respond to the relationship of the dance to the musical score. The most

A Question to Ask

Does the dance contain elements of mime or pantomime? If so, how do those elements work to communicate the content of the dance to me?

obvious link we see and hear comprises that between the gestures and footfalls of the dancer and the beat of the music. Sometimes the two march in strict accord—each beat equals a footfall; sometimes they do not.

Another relationship concerns that of the dynamics of the music and the dynamics of the dance. Here intensity, or force, plays the important role. Moments of great intensity can manifest themselves in rapid movement and forceful leaps. Or they may reflect in other qualities. The same kind of analysis applies in dance as in theatre to plot dynamic levels and overall structure. For maximum interest, one must have variety of intensity. If we chart the relationship of the peaks and valleys of dynamics, we likely conclude that a dance has a similar dynamic structure to that of a play: As noted earlier, it tends toward pyramidal structure, building to a high point and then relaxing to a conclusion. This applies whether or not narrative elements exist.

MISE-EN-SCÈNE

Because dance constitutes a visual and theatrical experience, part of our response must concern those theatrical elements of dance manifested in the environment of the presentation. In other words, we can respond to the mise-en-scène of the dance. We can note elements of lifelikeness and how they reflect or otherwise relate to the aural and visual elements of the dance. Our interest here lies in the interrelationship of the dance with properties, setting, and the floor

of the theatrical environment. Some dances employ massive stage designs. Others have no setting at all; they occur in a neutral environment. A principal difference between formal ballet and modern dance, as noted earlier, lies in the use of the dance floor. In formal ballet, the floor acts principally as an agent from which the dancers spring and to which they return. But in modern dance, the floor assumes an integral role in the performance, and we are likely to see the dancers sitting on the floor, rolling on it—in short, interacting with the floor. Consideration of the floor in dance also concerns how its use relates to the themes and images of the dance.

The choreographer's use of space has a critical relationship to our understanding a dance work. Changing levels, directions, shapes, and floor patterns form a fundamental part of how dance works, and understanding a dance and responding to it involves active perception and evaluation of how the entirety of the physical space and the dancers' space interact and communicate.

In discussing the relationship of costume to dance, we would do well to return to the section on costume design in Chapter 7 to note the purposes of costume, because they apply equally to dance as to theatrical productions. In some dances, costume will be traditional, conventional, and neutral. Little representation of story line or character exists in the tights and tutu (too-too) of the female dancer depicted in Figure 9.12. However, many dances utilize costumes high

A Question to Ask

What themes and ideas—narratives or abstract ideas—does the dance seek to communicate? Or is the dance a divertissement?

in lifelikeness. Such costumes help portray character, locality, and other aspects of the dance (Figs. 9.10 and 9.12).

Costumes must allow the dancers to do whatever the choreographer expects. In fact, sometimes costumes form an integral part of the dance itself. For example, in Martha Graham's *Lamentation*, a single dancer wears what can best be described as a tube of fabric—no arms, no legs, just a large envelope of cloth. Every movement of the dancer stretches the cloth so that the line and form does not reflect a human body but rather a human body enveloped in a moving fabric.

FIGURE 9.12 *Traditional tights and tutu.*

Footgear forms the final element of dance costume we shall consider. Dancers' footgear plays a significant role and ranges from simple, soft, and supple ballet slippers to specialized toeshoes, with a plethora of street shoes, character oxfords, and representational or symbolic footwear in between. Modern dance often goes barefoot. Dance footgear must meet the criteria of comfort and enough flexibility to allow the dancer to dance. Footgear, whether toe shoe, ballet slipper, or character Oxford, must be appropriate to the surface of the stage floor, which must not be too hard, too soft, too slippery, or too sticky. Many companies carry their own floor with them to ensure safe and proper movement capability. Sometimes professional road companies refuse to perform in local auditoria if the stage floor proves unsuitable—and, thus, potentially dangerous—for the dancers.

LIGHTING

Inasmuch as the entire perception of a dance relies on viewing the human body as a three-dimensional form, the work of the lighting designer plays a pivotal role in dance performance. How we perceive the human form in space depends on how the designer lights the body. Lighting affects our emotional and sense response in the way that the design utilizes color, angles, and movement.

HOW DOES IT STIMULATE THE SENSES?

The complex properties of dance make possible diverse and intense communicative stimuli. We can respond at different levels to an artwork—including the level of ignorance. We can achieve levels of understanding, levels of meaning, and levels of potential response whether we have extensive knowledge or little. The more sophisticated a balletomane we become, the fuller our benefit will be.

MOVING IMAGES

Like every other artwork existing in space, dance appeals to our senses through the compositional qualities of line and form, not only in the bodies of the dancers, but also in the visual elements of scenery and costumes. In this regard, and like painting and sculpture, horizontal lines stimulate a sense of calm and repose. Vertical lines suggest grandeur and elegance. Diagonal lines stimulate feelings of action and movement (Fig. 9.10), and curved lines, grace (Fig. 9.12). As we react to a dance work, we respond to how the human body expresses line and form—when standing still and when moving through space. If alert and perceptive, we recognize not only how the choreographer has created lines and forms, but also how those lines and forms repeat

A Question to Ask

How did the lighting design for the dance use color, angles, and movement to enhance perception of the dancers and to help portray emotion and meaning?

from dancer to dancer and from dancer to mise-en-scène.

Often the kind of line created by the body of a dancer forms the key to understanding the work of the choreographer. George Balanchine, for example, insisted that his dancers be almost skin and bone. For him, that reduction to elemental human form helped create the statement he wished to make.

FORCE

We noted in Chapter 5 that the beat of music makes a fundamental appeal to our senses. Musical beat can set our toes tapping and our fingers drumming. Probably, we respond most basically to the dynamics of the dance, its dancers, and its music. A dancer's use of vigorous and forceful action (Fig. 9.10), high leaps, graceful turns (Fig. 9.12), or extended pirouettes appeals directly to us, as does the tempo of the dance. Variety in dynamics—the louds and softs and the highs and lows of bodily intensity as well as musical sound—forms the dancer's and choreographer's way of providing interest, just as does the actor's, the director's, and the painter's.

SIGN LANGUAGE

Dancers, like actors, can stimulate us directly because they are human beings and can employ many symbols of communication.

Most human communication requires us to learn a set of symbols—we can respond to dance at this level only when we have mastered its language. Many systems of sign language, like the Delsarte, use conventionalized arm, hand, and head positions to create meaning. Likewise, a dance like the hula communicates its meaning through hand movement.

Nonetheless, a universal set of bodily communication symbols also exists (so psychologists tell us)—for example, a gesture of acceptance, in which arms extend outward with the palms up. Holding the hands outward with palms out as if to push away signifies rejection. When dancers employ universal symbols, we respond to their appeal to our senses just as we would to the nonverbals or body language in everyday conversation.

COLOR

Although dancers use facial and bodily expressions to communicate some aspects of the human condition, we do not receive as direct a message from them as we do from the words of actors. So, to enhance the dancer's communication, the costume, lighting, and set designers must strongly reinforce the mood of the dance through the environment they create. Color forms their most effective tool in this regard. Because dance does not depend on lifelikeness as much as in the theatre, lighting

A Question to Ask

How does the interaction among dancers, sets, lights, and costumes help to create meaning in the work?

designers can work freely with color. A face or body tinted red, for example, does not create the distraction it would in most theatre productions. So we often see much stronger, more colorful, and more suggestive lighting in dance than in theatre. Designers use more saturated colors, higher intensities, and explore the qualities of the human body, as form, much more strongly by light from various directions. The same occurs in costumes and settings. Because dancers rarely portray roles high in lifelikeness, costumes can communicate through abstract means.

On the other hand, scene designers must exercise caution in utilizing color so that the dancers continue to take focus in the stage environment—unless the choreographer intends to synthesize the dancer and the environment, as the choreographer Merce Cunningham often does. In any but the smallest of stage spaces, the elements of the setting can easily overpower the human body since the setting occupies so much more space. Nevertheless, scene designers use color as forcefully as they can to help reinforce the mood and meaning of the dance.

These examples of how dance affects our senses remain rudimentary. Perhaps more than any other art, dance causes us to ascend beyond our three cognitive questions—What is it? How is it put together? How does it affect the senses?—and dwell on a fourth level of response—What does it mean?

Sample Outline and Critical Analysis

The following very brief example illustrates how we can use some of the terms explained in the chapter to form an outline and then develop a critical analysis of a dance piece. Here is how that might work regarding Martha Graham's *Appalachian Spring*, with music by Aaron Copland and settings by Isamu Noguchi (see Fig. 9.1)

Outline	Critical Analysis
Genre Modern dance Theme and story line Movement	The modern dance, *Appalachian Spring*, treats a number of themes, some of which fall under the category of social criticism. Specifically, *Appalachian Spring* deals with the triumph of love and common sense over the fire and brimstone of American Puritanism. It takes as its pretext a wedding on the American Frontier. The dance is like no actual ceremony or party, however. The movement not only expresses individual character and emotion, but it has a clarity, spaciousness, and definition that relate to the open frontier, which must be fenced and tamed.
Mime and Pantomime	The characters include The Bride, The Revivalist, The Husbandman, The Pioneering Woman, and The Followers. During the dance, the characters emerge to make solo statements; the action of the dance suspends while they reveal the content of their hearts (not unlike the action of the popular musical *A Chorus Line*, which has dance as its

Outline	Critical Analysis
	central core, but with a difference plot and, of course, dialogue). The Bride's two solos, for instance, suggest not only her joy but also her trepidation as she envisions her future. The four Followers rush about together with little steps and hops to provide a visual chorus of exclamations and "Amens." Graham choreographed the work and danced its central role. As the composer, Copland used American motifs in his score, Martha Graham also drew subtly on steps from country dancing to express the frank vigor of these people.
Mise-en-scène	The setting for the work was designed by Isamu Noguchi (1925–1988), an American sculptor noted for his abstract works. Very spare in volume, it, nonetheless, defines the stage with slim timbers that frame a house, a portion of wall, a bench, a platform with a rocker, a piece of fence, and a small, tilted disk. It provides a base from which the characters emerge to dance their dances and to which they retreat.

Additional Study and Cyber Sources

Prehistory–c. 1400

Ancient Greece: http://www.firstnethou.com/annam/dancehis. html/history/index. html

c. 1400–Present

Ballet: http://balletdance.about.com/gi/dynamic/offsite.htm?site=http%3A%2F%2Fwww.ccs.neu.edu%2Fhome%2Fyiannis%2Fdance%2Fhistory.html

Modern: http://click.hotbot.com/director.asp?id=6&target=http://www.encyclopedia.com/articles/08601.html&query=modern+dance&rsource=LCOSW2

(Martha Graham) http:www.pathfinder.com/photo/gallery/arts/morgan/cap02.htm

Films

Ballet with Edward Villella (LCOA). Contains excerpts—*Pas de Deux, Giselle, Apollo,* and *Rubies*—choreographed by George Balanchine.

Dance: Anna Sokolow's "Rooms" (Indiana University)

Dance: Echoes of Jazz (Indiana University)

Dance: Four Pioneers (Indiana University)

Dance: New York City Ballet (Indiana University)

Dance: Robert Joffrey Ballet (Indiana University)

Seraphic Dialogue (Martha Graham) (Indiana University)

Martha Graham Dance Company (Parts 1, 2, and 3) (Indiana University)

Glossary

With Pronunciations

absolute film (ab-suh-LOOT fihlm). A film that exists for its own sake: for its record of movement or form.

absolute music (ab-suh-LOOT myoo-zihk). Instrumental music free of any verbal reference or program.

absolute symmetry (ab-suh-LOOT SIHM-uh-tree). In visual art and architecture, when each half of a **composition** is exactly the same. See **symmetry**.

abstract (ab-STRAKT). Any art that does not depict objects from observable nature or transforms objects from nature into forms that resemble something other than the original model.

abstract expressionism (ab-STRAKT-ehk-SPREH-shuhn-ihz-uhm). A mid-twentieth-century visual art movement characterized by nontraditional brushwork, non**representational** subject matter, and **expressionist** emotional values.

abstraction (ab-STRAK-shuhn). A thing, apart, that is, removed from real life. Also, an early- to mid-twentieth-century art movement that stressed non**representation**.

absurdism (uhb-SUHRD-iz-uhm; uhb-ZUHRD-ihzm). In theatre and prose fiction, a philosophy arising after World War II in conflict with traditional beliefs and values and based on the contention that the universe is irrational and meaningless and that the search for order causes conflict with the universe. See **Theatre of the Absurd**.

accelerando (ah-chehl-uh-RAHN-doh). In music, a gradual increase in tempo.

accent (AK-sehnt). In literature and music, a significant stress on the syllables of a **verse** or **tones** of a line, usually at regular intervals. In visual art and architecture, areas of strongest visual attraction.

accentual-syllabic verse (ak-SEHN-choo-uhl-sih-LAHB-ihk vuhrs). In literature, the most common metrical system in English poetry, based on both the number of stresses, or accents, and the number of syllables in each line of verse.

acrylic (uh-KRIHL-ihk). A synthetic paint with a very fast drying time.

action painting (AK-shuhn PAYNT-ihng). A form of **abstract expressionism** in which paint is applied with rapid, vigorous strokes or even splashed or thrown on the canvas.

adagio (uh-DAH-joh; -jee-oh; -zho; -zhee-oh). In music, a slow tempo.

additive (AD-ih-tihv). In sculpture, those works that are built (see **sculpture**). In **color**, the term refers to the mixing of **hues** of light.

aerial perspective (AIR-ee-yuhl-puhr-SPEHK-tihv). Also known as atmospheric perspective. In visual art, the indication of distance in painting through the use of light and atmosphere.

aesthetic (or esthetic) (ehs-THEHT-ihk). Relating to the appreciation of beauty or good taste or having a heightened sensitivity to beauty: a philosophy of what is artistically valid or beautiful.

aesthetic distance (ehs-THEH-tihk DIHST-uhns). The frame of reference artists create in and around their works to differentiate them from reality. A combination of mental and physical factors.

aestheticism (ehs-THEH-tih-sihs-uhm). A late-nineteenth-century arts movement that centered on the contention that art existed for its own sake, without need for social usefulness.

affective (uh-FEHK-tihv). Influenced by or resulting from the emotions.

aleatory (AY-lee-uh-tawr-ee). Dependent on chance. In music, using sounds chosen by the performer or left to chance. In film, composition on the spot by the camera operator.

allegory (AL-uh-gawr-ee). In literature and drama, a symbolic representation. The representation of abstract ideas or principles by characters, figures, or events in narrative, dramatic, or pictorial form. A fictional narrative that conveys a secondary meaning or meanings not explicitly set forth in the literal narrative.

allegro (uh-LEHG-roh; ah-LAY-). In music, a quick, lively tempo.

alliteration (uh-lih-tuh-RAY-shuhn). In literature, the repetition of consonant sounds in two or more neighboring words or syllables.

anapest (AN-uh-pehst). In literature, a poetic metrical foot of three syllables, the first two being

unstressed and the last being stressed, or the first two being short and the last being long.

andante (ahn-DAHN-tay). In music, a moderately slow tempo.

aquatint (AHK-wuh-tihnt). In printmaking, an **intaglio** process in which the plate is treated with a resin substance to create textured tonal areas.

arcade (ahr-KAYD). In architecture, a series of arches placed side by side and supported by **columns, piers,** or pillars.

arch (ahrch). In architecture, a structural form taking a curved shape.

archaic (ahr-KAY-ihk). A style of art and architecture dating to ancient, preclassical Greece (mid-fifth century B.C.E.), typified by the **Doric order, post-and-lintel** structure, geometric designs (especially in pottery), free-standing statues (**kouros** and **kore**) with stiff, frontal poses.

architrave (AHR-kih-trayv). In **post-and-lintel** architecture, the lintel or lowermost part of an **entablature** resting directly on the **capitals** of the **columns**.

arena theatre (uh-REE-nuh-THEE-uh-tuhr). In theatre, a stage/audience arrangement in which the stage is surrounded on all sides by seats for the audience.

aria (AH-ree-uh). In music, a highly dramatic **solo** vocal piece with musical accompaniment, as in an **opera, oratorio**, and **cantata**.

Art Deco (ahrt-deh-KOH). In visual art and architecture, a style prevalent between 1925 and 1940 characterized by geometric designs, bold colors, and the use of plastic and glass materials.

art for art's sake. A phrase coined in the early nineteenth century that expresses the belief that art needs no justification—that is, it needs to serve no political, didactic, or other end. See **aestheticism**.

art nouveau (ahrt-noo-VOH). In architecture and design, a style prevalent in the late nineteenth and early twentieth centuries characterized by the depiction of leaves and flowers in flowing, sinuous lines (whiplash) treated in a flat, linear, and relief-like manner.

art song (ahrt sawng). In music, a vocal composition, usually a lyric song intended for recital performance, typically accompanied by piano, in which the text is the principal focus.

articulation (ahr-tihk-yuh-LAY-shuhn). In the arts, the manner by which the various components of a work are joined together.

artifact (ahr-tuh-FAKT). A product produced by human craft, particularly one of archeological, artistic, or historical interest.

arts and crafts movement. In architecture and the decorative arts, a movement particularly in England and the United States from about 1870 to 1920 characterized by simplicity of design and the handcrafting of objects from local materials.

assonance (AS-uh-nuhns). In literature, the resemblance of sounds, especially vowels in stressed syllables.

asymmetry (ay-SIHM-uh-tree). In visual art, a sense of balance achieved by placing dissimilar objects or forms on either side of a central axis. Also called "psychological balance." See **symmetry**.

atmospheric perspective (at-muhs-FEER-ihk-puhr-SPEHK-tihv). See **aerial perspective**.

atonality (ay-toh-NAL-ih-tee). In music, the absence of a tonal center and of **harmonies** derived from a **diatonic scale** corresponding to such a center. Typical of much twentieth-century music.

autobiography (aw-toh-by-AHG-ruh-fee). In literature, a work about the writer by the writer, it can take a number of forms from informal to formal.

avant-garde (ah-vahnt-GAHRD). The vanguard or intelligentsia that develops new or experimental concepts, especially in the arts. These concepts and works are usually unconventional, daring, obscure, controversial, or highly personal ideas.

balance (bal-uhns). In visual art, the placement of physically or psychologically equal items on either side of a central axis. Or the compositional equilibrium of opposing forces. In literature, the syntactically parallel placement of similar, contrasting, or opposing ideas—for example, "To err is human; to forgive, divine."

ballet (ba-LAY). In dance, a **classical** or formal tradition resting heavily on a set of prescribed movements, actions, and positions. See **first position; second position; third position; fourth position**, and **fifth position**.

balloon construction (buh-LOON-cuhn-STRUHK-shuhn). In architecture, construction of wood using a skeletal framework. See **skeleton frame**.

baroque (buh-ROHK). A diverse artistic style taking place from the late sixteenth to early eighteenth centuries marked typically by complexity, elaborate form, and appeal to the emotions. In literature, it witnessed bizarre, calculatedly ingenious, and sometimes intentionally ambiguous imagery.

barrel vault (tunnel vault) (BAR-uhl-vawlt). In architecture, a series of arches placed back to back to enclose space.

Bauhaus (BOW-hows). In design and architecture, a twentieth-century German school that consciously attempted to integrate the arts and architecture into a unified statement by seeking to establish links between the organic and technical worlds.

beam (beem). In architecture, a horizontal stone or timber placed across a space to carry the weight of the wall or roof above. Also called a **lintel**.

bearing-wall (BAIR-ihng wahl). In architecture, construction in which the wall supports itself, the roof, and floors. See **monolithic construction**.

beat (beet). In music, the equal parts into which a measure is divided.

bel canto (behl-KAN-toh). In music, as style of operatic singing utilizing full, even tones and virtuoso vocal technique. Italian for "beautiful singing."

bilateral symmetry (by-LAT-uhr-uhl-SIHM-uh-tree). In visual art and architecture, when the overall effect of a composition is one of **absolute symmetry** even though clear discrepancies exist side to side. See **symmetry**.

binary (BY-nuh-ree). In music, having two sections or subjects.

biography (by-AHG-ruh-fee). In literature, a type of **nonfiction**, the subject of which is the life of an individual. See **hagiography**.

biomorphic (by-oh-MAWR-fihk). In visual art, representing life-forms, as opposed to geometric forms.

blank verse (blangk vuhrs). In literature, unrhymed verse, specifically unrhymed **iambic pentameter**.

block printing (blahk PRIHNT-ihng). In visual art, a printmaking image such as a **woodcut** or **wood engraving**, made from a carved wooden block.

bridge (brihj). In music, a section or passage, or in literature and drama a section, passage, or scene that serves as a transition between two other sections, passages, or scenes. In music, it occurs in the **exposition** of the sonata form between the first and second **themes**.

burin (BYUHR-ihn; BUHR-). In printmaking, a metal instrument used to cut lines into the metal plate. The sharp end of the burin is trimmed to give a diamond-shaped cutting point, while the other end is fitted with a wooden handle.

burr (buhr). In visual art, a ridge of metal pushed up by the **engraving** tool when it is pulled across the plate in **drypoint** printmaking, resulting in a rich velvety texture in the print.

buttress (BUHT-rihs). In architecture, a structure, typically brick or stone, built against a wall, vault, or arch for reinforcing support.

Byzantine (BIHZ-uhn-teen). Relating to the Byzantine Empire. In architecture, a style dating to the fifth century characterized by a central dome resting on a cube and by extensive surface decoration. In painting, a **hieratic** style characterized by stylized, elongated frontal figures, rich color, and religious subject matter.

cadence (CAY-duhns). In music, a particular arrangement of chords to indicate the ending of a musical passage. In literature, a rhythmic sequence or flow of sounds in language; a particular rhythmic sequence of a particular author or literary composition. Or, the rising or falling order of strong, long, or stressed syllables and weak, short, or unstressed syllables. Or, an unmetrical or irregular arrangement of stressed and unstressed syllables in prose of free verse that is based on natural stress groups.

calotype (KAL-uh-typ). In photographa, the first process invented to utilze negatives and paper positives. Invented by William Henry Fox Talbot in the late 1830s.

camera obscura (KAM-uh-ruh ahb-SKYUHR-uh). In visual art, a dark room or box with a small hole in one side, through which an inverted image of the view outside is projected on the opposite wall, screen, or mirror. The image, then, can be traced. A prototype for the modern camera.

canon (KAN-uhn). In music, a composition in which a theme is repeated in additional voices with the separation of a phrase. In literature, an authoritative list of books accepted as Holy Scripture. Or the authoritative works of a writer. Or a sanctioned or accepted group or body of related works.

cantata (kuhn-TAH-tuh). In music, a composition in several movements for orchestra and chorus often with a **sacred** text, and utilizing **recitatives, arias**, and choruses.

cantilever (KAN-tih-lee-vuhr). In architecture, a structural system in which an overhanging beam is supported only at one end.

capital (KAP-ih-tuhl). In architecture, the top part of a pillar or column. The transition between the top of a **column** and the **lintel**.

catharsis (kuh-THAHR-sihs). The purging of emotions (especially pity and fear) through art.

chalk (chawk). In visual art, a dry drawing medium made from ocher hematite, white soapstone or black carbonaceous shale.

character (KAIR-ihk-tuhr). In drama, literature, and film, a fictional person. Or, the driving psychological makeup of a fictional person in a drama, film, or work of literature.

character oxfords (KAIR-ak-tuhr-AHKS-fuhrds). In dance, shoes that look like ordinary street shoes, but are actually specially constructed for dance.

charcoal (chahr-kohl). In visual art, a dry drawing medium made from burnt wood.

chiaroscuro (kee-ah-ruh-SKOOR-oh). In visual art, the technique of using light and shade to develop three-dimensional form. In theatre, the use of light to enhance the three-dimensionality of the human body or the elements of scenery.

chord (kohrd). In music, three or more pitches sounded simultaneously.

choreography (kohr-ee-AHGH-ruh-fee). In dance, the art of creation of a dance work. Also, the arrangement of patterns of movement in a dance.

chroma (KROHM-uh). In visual art, the degree of **saturation** or purity of a color or **hue**.

chromatic scale (kroh-MAT-ihk-scayl). In music, a **scale** consisting of 12 **semitones** or half steps.

cinéma vérité (see-nay-MAH-vay-ree-TAY). In film, a style of presentation based on complete **realism** that uses **aleatory** methods, a minimum of equipment, and a **documentary** approach.

cire-perdue (lost wax) (sihr-pair-DOO). In sculpture, a method of casting metal in a mold, the cavity of which is formed of wax, which is then melted and poured away.

classic (KLAS-ihk). A work of art from ancient Greece and/or Rome. A work of art or artist of enduring excellence.

classical (KLAS-ih-kuhl). Adhering to traditional standards. May refer to a style in art and architecture dating to the mid-fifth century B.C.E. in Athens, Greece, or ancient Rome, or any art that emphasizes simplicity, harmony, restraint, proportion, and reason. In Greek classical architecture, **Doric** and **Ionic orders** appear in **peripteral** temples. In vase painting, geometry remains from the **archaic style**, but figures have a sense of **idealism** and lifelikeness. In music, classical refers to a style of the eighteenth century that adhered to classical standards but had no known classical antecedents. See **neoclassicism**.

classicism (KLAS-uh-sihz-uhm). The principles, historical traditions, aesthetic attitudes, or style of the arts of ancient Greece and Rome, including works created in those times or later inspired by those times. Or, **classical** scholarship. Or, adherence to or practice of the virtues thought to be characteristic of classicism or to be universally and enduringly valid—that is, formal elegance and correctness, simplicity, dignity, restraint, order, and proportion.

clerestory (or clearstory) (KLIHR-stawr-ee). The upper portion of a wall containing windows, when it extends above any abutting aisles or secondary roofs: especially in the **nave**, **transcept**, and **choir** of a church. Provides direct light into the central interior space.

climax (KLY-max). In theatre, film, dance, and narrative literature, the highest or most important **crisis**, or the most forceful rhetorical moment. In music, the highest tone or emotional focal point in a **melody** or a larger musical composition.

closed form (klohzd fawrm). In visual art, a composition in which the eye is continually directed back into the frame. Or a self-contained form with a balance of tensions and sense of calm completeness. In music, a form that repeats the introductory theme—for example, in an **ABA** structure. In film, a visual style that inclines toward self-conscious designs and carefully harmonized compositions. The **frame** is exploited to suggest a self-sufficient universe that encloses all the necessary visual information.

coda (KOH-duh). In music, drama, and literature, the concluding portion of a work that typically integrates or rounds off previous themes or ideas.

cognitive (KAHG-nuh-tihv). Facts and objectivity as opposed to emotions and subjectivity. See **affective**.

collage (koh-LAZH). In visual art, a composition of materials and objects pasted on a surface. In literature, a work composed of borrowed and original materials.

colonnade (KAHL-uh-nayd). In architecture, a series of **columns** placed at regular intervals usually connected by **lintels**.

color (KUH-luhr). In visual art, the appearance of surfaces in terms of **hue**, **value**, and **intensity**. In music, the quality of a tone—also called **timbre**. In literature, the vividness or variety of emotional effects of language—for example, sound and image. See also **complementary color**; **primary color**; **secondary color**; **tertiary color**.

column (KAHL-uhm). In architecture, a supporting pillar consisting of a base, cylindrical shaft, and **capital**.

comedy (KAHM-uh-dee). The genre of dramatic literature that deals with the light or the amusing or with the serious and profound in a light, familiar, or satiric manner. See **tragedy**.

comedy of manners (KAHM-uh-dee uhv MAN-uhrz). A witty and cerebral form of **comedy** that satirizes the manners and fashions of a particular social class or set.

comic opera (KAH-mihk-AHP-uh-ruh). An **opera** or **operetta** with a humorous plot, spoken dialogue, and a happy ending.

complementary color (kahm-pluh-MEHN-tuh-ree-kuh-luhr). In visual art, a hue that, when combined in equal quantities with a second hue, produces gray. For example, red and green are complementaries. In light, complementary colors produce white.

complication (kahm-pluh-KAY-shuhn). In theatre, literature, and film, a major part of a dramatic

plot—along with **exposition** and **dénouement**—in which **crises** arise leading to a **climax**. Also a situation or a detail of **character** that enters into and complicates the main thread of a plot.

composition (kahm-poh-ZIH-shuhn). In visual art and architecture, the arrangement of line, form, mass, and color. Also, the arrangement of the technical qualities of any art form.

compressive strength (kuhm-PREHS-ihv-strehngth). In architecture, the ability of a material to withstand crushing. See **tensile strength**.

concert overture (KAHN-suhrt OHV-uhr-chuhr). In music, an independent composition for orchestra in one movement, typically in **sonata form** and from the **Romantic** period.

concerto (kuhn-CHAIR-toh). In music, an extended composition for orchestra and one or more soloists, typically in three movements: fast, slow, and fast.

concerto grosso (kuhn-CHAIR-toh-GHROH-soh). In music, a composition for orchestra and a small group of instrumental soloists, typically late **baroque**.

concrete (KAHN-kreet). In architecture, a type of building material invented by the Romans made from lime, sand, cement, and rubble mixed with water and poured or molded when wet.

concrete poetry (kahn-KREET POH-uh-tree). In literature, poetry in which the poet's intent is conveyed by graphic patterns of letters, words, or symbols rather than by the meaning of words in conventional arrangement. The poet uses typeface and other typographical elements in such a way that chosen units—letter fragments, punctuation marks, graphemes (letters), morphemes (any meaningful linguistic unit), syllables, or words—and graphic spaces form an evocative picture. See also **musique concrète**.

conjunct melody (KAHN-juhngkt; kuhn-JUHNGKT MEHL-oh-dee). In music, a melody comprising notes close together in the scale.

consonance (KAHN-soh-nuhns). In music, tones that sound agreeable or harmonious together, as opposed to **dissonance**. In literature, repetition of identical or similar consonants. In all arts, a feeling of comfortable relationship. Consonance may be both physical and cultural in its ramifications.

content (KAHN-tehnt). The subject matter or theme of a work of art as well as the artist's intent. Also the work's meaning to a respondent.

context (KAHN-tehkst). In architecture, the setting surrounding a building.

contrapuntal (kahn-truh-PUHN-tuhl). In music, relating to **counterpoint** or **polyphony**.

convention (kuhn-VEHN-shuhn). In all the arts, a generally accepted practice, technique, or device.

Corinthian order (kaw-RIHN-thee-uhn-AWR-duhr). One of three ancient Greek architectural orders (along with **Doric** and **Ionic**). Corinthian is the most ornate and is characterized by slender **fluted columns** with an ornate, bell-shaped **capital** decorated with **acanthus** leaves.

counterpoint (KOWN-tuhr-point). In any art, the use of contrast in major elements. In music, the use of **polyphony** as a texture. In literature, the term refers to metrical variation in poetry.

cover shot (KUHV-uhr shaht). In film, extra shots of a scene that can be used to **bridge** transitions in case the planned footage fails to edit as planned.

crescendo (kreh-SHEHN-do). In music, a gradual increase in volume or intensity.

crisis (KRY-suhs). In fictional literature, film, and theatre, a decisive moment in the action.

criticism (KRIHT-ih-sihz-uhm). The act of analyzing a work of art or literature that may or may not involve evaluation of quality and expression of judgment.

crosscut (KRAWS-cuht). In film, the technique of alternating between two independent actions that are related thematically or by **plot** to give the impression of simultaneous occurrence.

cross-hatching (kraws-HACH-ihng). In visual art, specifically printmaking and drawing, a technique in which a series of parallel lines (hatches) are created to cross from an angle another series of parallel lines creating a sense of **tone** and shadowing.

cubism (KYOOB-ihz-uhm). An art style originated by **Picasso** and **Braque** around 1907 that emphasizes **abstract** structure rather than **representationalism**. Objects are depicted as assemblages of geometric shapes. The early mature phase (1909–1911) is called analytical cubism. A more decorative phase called synthetic or **collage** cubism appeared around 1912. In literature, cubist writing uses abstract structure to replace the narrative.

cut (kuht). In film, the joining of shots together during the editing process. Examples are: **jump cut, form cut, montage, crosscut**, and **cutting within the frame**.

cutting within the frame. In film, a **cut** that changes the viewpoint of the camera within a shot by moving from a long or medium shot to a close-up, without cutting the film.

cyber art (SYB-uhr-ahrt). A late-twentieth-century development that created artificial environments that viewers experienced as real space. It is also known as cyberspace, hyperspace, or virtual reality.

cycle (SY-kuhl). A group or series of works (plays, poems, novels, or songs) that embrace the same theme. In literature, the complete series of poetic or prose narratives (typically of different authorship) that deal with, for example, the actions of legendary heroes and heroines.

Dada or Dadaism (DAH-dah; DAH-dah-ihz-uhm). A nihilistic movement in the arts from around 1916 to 1920.

daguerreotype (duh-GHAIR-uh-typ). In photography, a process (or photograph made from it) using a light-sensitive, silver-coated metallic plate.

deconstruction (dee-kuhn-STRUHK-shuhn). A theory of criticism associated with French philosopher **Jacques Derrida** that maintains that words can only refer to other words and tries to demonstrate how statements about any text subvert their own meanings, leading to the conclusion that there is no such thing as a single meaning in a work of art, nor can it claim any absolute truth.

decrescendo (day-kruh-SHEHN-doh). In music: gradually diminishing loudness or force.

dénouement (day-noo-MAHN). In theatre, film, and literature, the final resolution of a dramatic or narrative plot—that is, the events following the climax.

dentil (DEHN-tihl). In architecture, small rectangular blocks projecting like teeth from a **molding** or beneath a **cornice**.

depth of focus (dehpth uhv FOHK-uhs). In film, when both near and distance objects are clearly seen.

development (dih-VEHL-uhp-muhnt). In music, in **sonata form**, the second section in which the **themes** of the **exposition** are freely developed. See also **recapitulation**.

diatonic (dy-uh-TAHN-ihk). In music, relating to the seven tones of a standard scale without chromatic alterations.

diatonic minor (dy-uh-THAN-ihk-MY-nuhr). In music, the standard minor **scale** achieved by lowering by one half step the third and sixth of the diatonic or standard major scale.

dimeter (DIHM-uh-tuhr). In literature, a poetic line consisting of two metrical feet.

direct address (dih-REHKT-uh-DREHS). In theatre and film, when a character addresses the audience directly.

discovery (dih-SKUHV-ree). In theatre, film, and narrative literature, the part of **plot** comprising revelation of information about **characters**, personalities, relationships, and feelings.

disjunct melody (dihs-JUHNKT MEHL-uh-dee). In music, **melody** characterized by skips or jumps in the scale. The opposite of **conjunct melody**.

dissolve (dih-ZAHLV). In film, a transition from one **shot** to another by fading out and fading in.

dissonance (DIHS-uh-nuhns). In music or visual art, any harsh disagreement between elements of the composition—that is, discord. In music, a combination of sounds used to suggest unrelieved tension. See **consonance**.

divertissement (duh-VUHR-tihs-munt; dee-vair-tees-MAHN). In dance, a short balletic performance presented as an interlude in a play or opera or any short dance or musical work designed strictly as an amusement.

documentary film (dahk-yuh-MEHN-tuh-ree-fihlm). In film, a work that presents its subject factually, often with interviews and narration.

dome (dohm). In architecture, a circular, vaulted roof.

Doric order (DAWR-ihk-AWR-duhr). In architecture, the oldest and simplest of the three Greek architectural orders (along with **Ionic** and **Corinthian**). It is characterized by heavy **columns** with plain, saucer-shaped **capitals** and no base.

drama (DRAHM-uh). A verse or prose composition portraying life or character or telling a story involving conflicts and emotion usually for presentation in the theatre.

dramatic monologue (druh-MAT-ihk mahn-uh-lawgh). In literature and theatre, a poem in the form of a speech by a **character** to an imaginary audience.

dramatic unities (druh-MAT-ihk YOON-uh-teez). In theatre, a **classical** and **neoclassical** convention requiring that a play reflect a *time* period not greater than a day, a *place* restricted to that within a day's travel, and a single *action* or **plot** line. See **unity**.

drypoint (DRY-poynt). In visual art, an **intaglio** print-making process in which a metal plate is scratched with a sharp needlelike tool called a **stylus**.

duple (DOO-puhl). In music, two or multiples of two beats per measure.

dynamics (dy-NAM-ihks). In music, the various levels of loudness and softness of sounds; the increase and decrease of **intensities**.

editing (EHD-iht-ihng). In film, the composition of a finished work from various **shots** and sound tracks.

edition number (eh-DIHSH-uhn NUHM-buhr). In printmaking, the number of prints in an **edition**. Typically found at the bottom of a print, in pencil, and may consist of a single number or a fraction.

embossing (ehm-BAHS-ihng). The creation of raised designs in the surface of, for example, paper, leather, or metal.

empathy (EHM-puh-thee). Identification with another's situation. In theatre and film, a physical reaction to events witnessed on the stage or screen.

engaged column (ehn-GHAYJ-d KAHL-uhm). A **column**, often decorative, which is part of, and projects from, a wall surface.

engraving (ehn-GRAYV-ihng). In printmaking, an **intaglio** process in which sharp, definitive lines are cut into a metal plate.

en pointe (ahn-pwant). See **on point**.

ephemeral (ih-FEHM-uhr-uhl). In visual art, a work designed to last only a short time.

epic (EHP-ihk). In literature, a long narrative poem in elevated style celebrating heroic achievement. In film, a **genre** characterized by bold and sweeping themes and a **protagonist** who is an ideal representative of a culture.

essay (EHS-ay). In literature, a short composition treating a single subject usually from the personal point of view of the author.

establishing shot (eh-STAB-lihsh-ihng shaht). In film, a long shot at the beginning of a scene to establish the time, place, and so forth. See **master shot**.

etching (EHCH-ihng). In visual art, a type of **intaglio** printmaking in which the design comprises lines cut into a metal plate by acid.

exposition (ehk-spoh-ZIH-shuhn). In theatre, film, and literature, the aspect of **plot** in which necessary background information, introduction of **characters**, and current situation are detailed. In music, the first section of **sonata form**, in which the first **subject** (in the **tonic** key) and second subject (in the **dominant** key), also sometimes further subjects, are played and often repeated. See **development** and **recapitulation**. Also, the first thematic statement of a **fugue** by all players in turn.

expressionism (ek-SPREHSH-uh-nihz-uhm). An artistic movement of the late nineteenth and early twentieth centuries that stresses the subjective and subconscious thoughts of the artist and seeks to evoke subjective emotions on the part of the respondant. The struggle of life's inner realities are presented by techniques that include abstraction, distortion, exaggeration, **primitivism**, fantasy, and **symbolism**.

fade (fayd). In film, the fade-out is the moving of an image from normal brightness to black; a fade-in is the opposite.

farce (fahrs). In theatre, a light, comic work using improbable situations, stereotyped characters, horseplay, and exaggeration.

feminine rhyme; also called double rhyme (FEHM-ih-nuhn rym). In literature, a **rhyme** having two syllables—sometimes applied to three syllable rhyme.

fenestration (fehn-ih-STRAY-shuhn). In architecture, an opening such as a window in a structure.

ferroconcrete (FAIR-oh-kahn-kreet). See **reinforced concrete**.

fiction (FIHK-shuhn). In literature, a work created from the imagination of the writer.

fifth position (fihth puh-ZIH-shuhn). In dance, a basic **ballet** position with the feet close together with the front heel touching the toe of the back foot. The legs and feet are well turned out and weight is evenly distributed on both feet.

figurative (FIHGH-yuhr-uh-tihv). In literature, language characterized by **figures of speech**, such as **metaphor** and **simile**, or elaborate expression, as opposed to literal language.

figure of speech. In literature, language used to convey meaning or heighten effect, particularly by comparison.

fine art (fyn-ahrt). Those disciplines that create works (or the works themselves) produced for beauty rather than utility.

first position (fuhrst puh-ZIH-shuhn). In dance, a basic **ballet** position with the weight equally distributed between the feet, heels together, and toes open and out to the side.

fluting (FLOO-tihng). In architecture, vertical grooves cut in the shaft of a **column**.

flying buttress (fly-ihng-BUH-truhs). A semidetached **buttress**.

focus (focal point; focal area) (FOH-kuhs). In visual art and architecture, an area of attention. In photography and film, the degree of acceptable sharpness in an image.

foil (foyl). In theatre, film, and literature, a character presented as a contrast to another character so as to point out or show to advantage some aspect of the second character.

folk dance (fohk dans). In dance, a body or group of dances performed to traditional music that is stylistically identifiable with a specific culture, for which it serves as a necessary or informative part.

foot (fuhwt). In literature, the basic poetic unit of verse meter consisting of any of various fixed

combinations or groups of stressed and unstressed or long and short syllables.

foreground (FAWR-grownd). In two-dimensional art, an area of a picture, usually at the bottom, that appears closest to the viewer.

foreshadowing (fahwr-SHAD-oh-ihng). In visual art, the illusion depicted on a two-dimensional surface, in which figures and objects appear to recede or project sharply into space, often using the rules of **linear perspective**. In fictional film, theatre, and literature, the organization and presentation of events that prepare the viewer or reader for something that will occur later.

foreshortening (fahwr-SHOHWR-tuhn-ihng). Something that is compact, abridged, or shortened. In visual art, the compacting of three dimensions by **linear perspective** in order to show depth of space.

form (fahwrm). In any art, a type or genre. Or, the shape, structure, configuration, or essence of something. Or, the organization of ideas in time or space.

form cut (fawrm-kuht). In film, a **cut** that jumps from one image to another, both of which have a similar shape or contour.

formalism (FAHWR-muh-lihzm). Marked attention to arrangement, style, or artistic means (as in art or literature), usually with corresponding de-emphasis of **content**. Also applied to critics of literature who emphasize the formal aspects of a work.

forte (FAWR-tay). In music, loud and forceful.

found sculpture or object (fownd). In visual art, an object taken from life that is presented as an artwork.

fourth position (fawrth puh-ZIH-shuhn). In dance, a basic ballet position with the heel of the front foot directly in front of the toe of the back foot with weight evenly distributed and the feet well turned out.

fresco (FREHS-koh). In painting, a work done on wet plaster with water-soluble paints. The image becomes part of the wall surface as opposed to being painted on it. Also known as *buon fresco,* or "true fresco." See **fresco secco.**

fresco secco (FREHS-koh SEHK-oh). In painting, a work done on dry plaster.

frieze (freez). In architecture, a plain or decorated horizontal part of an **entablature** between the **architrave** and **cornice**. Also, a decorative horizontal band along the upper part of a wall.

fugue (fyoog). In music, a **polyphonic** composition in which a **theme** or themes are stated successively in all voices.

full round (fuhl-rownd). In sculpture, works that explore full three-dimensionality and are meant to be viewed from any angle. See **sculpture.**

futurism (FYOO-chuh-rihz-uhm). An artistic movement that began in Italy around 1909 and espoused rejection of tradition so as to give expression to the dynamic energy and movement of mechanical processes.

genre (ZHAHN-ruh). A distinctive type or category of art, drama, literature, music, etc. characterized by a particular style, form, or content. Also, a style of painting representing an aspect of everyday life, such as a domestic interior, a still life, or a rural scene.

geodesic dome (jee-uh-DEHS-ihk). In architecture, a domed or vaulted structure of lightweight straight elements made up of interlocking polygons.

gesamtkunstwerk (guh-ZAHMT-kuhnst-vairk). A complete, totally integrated artwork; associated with the music dramas of **Richard Wagner** in nineteenth-century Germany.

glyptic (GHLIHP-tihk). In sculpture, works emphasizing the qualities of the material from which they are made.

Gothic (gothic) (GHAHTH-ihk). In architecture, painting, and sculpture, a medieval style based on a pointed-**arch** structure and characterized by simplicity, verticality, elegance, and lightness. In literature, a style of fiction of the late eighteenth and early nineteenth centuries characterized by medieval settings, mysterious, and violent actions. In the mid-twentieth century, the term *Southern Gothic* was used to describe literary works characterized by grotesque, macabre, or fantastic incidents in an atmosphere of violence and decadence.

Gothic revival (GHAHTH-ihk). In architecture, a style that imitates the elements of **Gothic** architecture, popular in the United States and Europe from the late eighteenth to early twentieth centuries.

gouache (gwahsh). In visual art, a watercolor medium in which gum is added to ground opaque colors and mixed with water.

grande seconde (ghrahnd-seh-KAWND). In dance, a ballet pose with the leg in second **position** in the air.

graphic arts (GHRAF-ihk ahrts). In visual art, a term referring to those media that use paper as a primary vehicle.

graphite (GHRAF-yt). In visual art, a dry drawing medium made from carbon, as in pencil leads.

Greek revival (ghreek ree-VYV-uhl). In architecture, a style that imitates the elements of ancient Greek temple design. Popular in the United States and Europe during the first half of the nineteenth century.

Greek tragedy (ghreek TRAJ-uh-dee). The form of drama written by the three great Athenian

tragedians, **Aeschylus, Sophocles,** and **Euripides.** See also **Tragedy.**

Gregorian chant (ghrih-GHAWR-ee-uhn-chant). In music, an unaccompanied, vocal, monophonic, and **consonant** liturgical chant named for Pope Gregory I (540–604 C.E.) and comprising a body of sacred—that is, religious— music. Chants were sung in a flexible **tempo** with unmeasured **rhythms** following the natural **accents** of normal Latin speech. Also called chant, plainchant, or plainsong.

groin vault (ghroyn vawlt). In architecture, a ceiling formation created by the intersection of two **tunnel** or **barrel** vaults.

hagiography (ha-jee-AHGH-ruh-fee; hay-). In literature, writings about or study of the lives of the Saints. A sacred form of **biography.**

hard-edge (HAHRD-ehj). In painting, an **abstract** style begun in the 1950s and characterized by clearly defined geometric shapes and flat color areas with sharp edges.

Harlem Renaissance (HAHR-luhm). Also called the New Negro Movement. A period of outstanding artistic vigor centering in the African American enclave of Harlem in New York City during the 1920s.

harmony (HAHR-muh-nee). In music, the arrangement and progression of chords. In visual art, the relationship of like elements such as colors and repeated patterns. In literature, an arrangement of parallel passages for the purpose of showing agreement. See **consonance** and **dissonance.**

hatching (HACH-ihng). In drawing and printmaking, a technique of placing lines parallel to each other to darken the **value** of an area. See **cross-hatching.**

Hellenistic (hehl-uh-NIHS-tihk). In visual art, architecture, and theatre, a style dating to the fourth century to the second century BCE that encompassed a diversity of approaches reflecting an increasing interest in the differences between individual humans and characterized by emotion, drama, and interaction of sculptural forms with the surrounding space. In architecture, it reflected a change in proportions from the **classical** and introduced the **Corinthian order.**

hexameter (hehk-SAM-uh-tuhr). In literature, a poetic line of six metrical feet.

high comedy (hy KAHM-uh-dee). Comedy characterized by an appeal to the intellect and written with grace and wit—for example, **comedy of manners.**

high relief or haut-relief (HY ruh-leef; OH reh-LEEF). In sculpture, **relief** works in which the figures protrude from the background by at least half their depth.

High Renaissance (hy REHN-eh-sahns). A movement dating to the late fifteenth to early sixteenth centuries that followed **classical** ideals and sought a universal ideal through impressive themes and styles. In visual art, figures became types rather than individuals.

historical novel. In literature, a novel set in a particular historical period and which tries to convey as accurately as possible the details and sense of that historical period.

homophony (huh-MAH-fuh-nee). In music, a **texture** characterized by chordal development supporting one melody. See **monophony** and **polyphony.**

horizon line (huh-RYZ-uhn-lyn). In visual art, a real or implied line across the picture plane, which, like the horizon in nature, tends to fix the viewer's vantage point.

hue (hyoo). In visual art, the spectrum notation of color; a specific pure color with a measurable wavelength. There are **primary hues, secondary hues,** and **tertiary hues.**

humanities (hyoo-MAN-ih-teez). The areas of learning (art, music, theatre, literature, film, dance, philosophy, and sometimes history) that investigate the human condition, its situations and concerns, as opposed to natural processes (the sciences).

iambic (y-AM-bihk). In literature, one of the four standard feet in poetry. A light syllable is followed by a stressed syllable. See **foot** and **meter.**

icon (Y-kahn). Greek for "image." An artwork whose subject matter includes idolatry, veneration, or some other religious content. Specifically, in visual art, an image or representation of a sacred personage.

idealism (y-DEE-uh-lihz-uhm). Artistic and literary theory or practice that values ideal or subjective visions of beauty rather than formal or realistic ones. Compare **realism.**

idée fixe (ee-day-FEEX). In music and literature, a recurring **motif** or **theme.**

imagery (IHM-ihj-ree). In literature, depiction of objects, ideas, and feelings literally or through symbols or figurative language.

implied line (ihm-PLYD lyn). In visual art, a line in a composition that is not actually drawn but suggested by factors such as alignment of edges of objects.

impressionism (ihm-PREHSH-uh-nihz-uhm). A mid- to late-nineteenth-century style originating in France. In painting, commit it sought spontaneity, harmonious colors, subjects from everyday life, and faithfulness to observed lighting and atmospheric effects by seeking to capture the psychological perception of reality in color and motion. It emphasized the presence of

color within shadows and the result of color and light making an "impression" on the retina. In music it freely challenged traditional tonality with new tone colors, oriental influence, and harmonies away from the traditional. Gliding chords—that is, repetition of a chord up and down the scale—were a hallmark.

inciting incident (ihn-SYT-ing Ihn-suh-duhnt). In theatre, an event or decision that creates a complication leading to the resolution of the drama.

intaglio (ihn-TAHL-yo; -TAL-). A printmaking process in which ink is transferred from the grooves of a metal plate to paper by extreme pressure. It includes **engraving, etching**, and **drypoint**.

intensity (ihn-TEHN-siht-ee). In visual art, the degree of purity of a **hue**. In music, theatre, dance, and film, that quality of **dynamics** denoting the amount of force used to create a sound or movement.

International style (ihn-tuhr-NASH-uh-nuhl-styl). In architecture, a style, related to **De Stijl** in painting, emerging in Europe around 1910–20, in which structure and exterior design were joined into a form based on rectangular geometry and emerging from the basic function of the building. See **modernism**.

interval (IHN-tuhr-vuhl). In music, the difference (usually expressed in number of steps) between two pitches.

Ionic (Ionic order) (y-AHN-ihk). Relating to Ionia in ancient Greece. In architecture, one of three orders of Greek architecture (along with **Doric** and **Corinthian**), characterized by two opposed **volutes** in the **capital**. In literature, a foot of verse that comprises either two long and two short syllables or two short and two long syllables.

iris (Y-ruhs). In film, a masking device that blacks out portions of the screen, allowing only part of an image to be seen. The device is usually circular or oval in shape and can be expanded or contracted.

irony (Y-ruh-nee). In literature, words used to express something other than, and particularly the opposite of, the literal meaning.

jazz (jaz). In music, a form of music native to America and calling on the African American heritage characterized by strong, flexible *rhythms*, **syncopation**, and improvisation.

jazz dance (jaz dans). In dance, a form arising partly from African dance customs, and with a strong improvisational nature, that developed into American social and entertainment dances.

jump cut (juhmp-cuht). In film, the instantaneous **cut** from one scene to another or from one **shot** to another; often used for shock effect.

juxtapose (juhk-stuh-POHZ). Place side by side.

kabuki (kah-BOO-kee). A form of Japanese theatre that blends **realism** and **formalism**, music, dance, **mime**, and spectacular staging and costumes.

key (kee). In visual art, the relative lightness or darkness of a picture or the colors employed in it. See **value**. In architecture, the **keystone** in an **arch**. In music, a tonal system consisting of seven **tones** in fixed relationship to a **tonic**.

kouros (KOO-rohs). In sculpture, an archaic Greek statue of a standing nude male youth. See **kore**.

labanotation (lab-uh-noh-TAY-shuhn). In dance, a system for writing down movements.

lap dissolve (lap-dih-ZAHLV). In film, the simultaneous fade in and fade out of two scenes so that they briefly overlap. See **dissolve**.

largo (LAHR-goh). In music, a very slow tempo, with great dignity.

legato (lih-GAH-toh). In music, a smooth, even style without break between the notes.

leitmotiv or leitmotif (lyt-moh-TEEF). In music and literature, a dominant recurring theme, phrase, or sentence often associated with a character, situation, or element, as in Wagnerian opera.

lento (LEHN-toh). In music, in a slow tempo.

libretto (lih-BREHT-oh). In music and theatre, the text of an opera or any other kind of musical theatre.

line (lyn). In visual art, a long, thin mark, a color edge, or an implication of continuation. In music, a melody. In literature, a unit in the rhyming structure of verse formed by grouping a number of the smallest units of the rhythm—for example, syllables, stress groups, metrical feet—according to some principle characteristic of that type of verse.

line engraving (lyn-ehn-GRAYV-ihng). In printmaking, an **intaglio** plate on which lines have been cut by hand.

linear perspective (LIHN-ee-uhr-puhr-SPEHK-tihv). In two-dimensional art, the creation of the illusion of distance through the convention of **line** and **foreshortening**.

linear sculpture (LIHN-ee-uhr-SKUHLP-chuhr). In sculpture, works that emphasize two-dimensional materials such as wire.

linoleum cut (lih-NOHL-ee-uhm kuht). In printmaking, a **relief** process, in which an artist cuts away negative spaces from a block of linoleum, leaving raised areas to take ink for printing.

lintel (LIHN-tl). In architecture, a horizontal structural member typically of stone that spans the space between uprights such as **columns**.

lithography (lih-THAHGH-ruh-fee). In printmaking, a **planographic** process using an image rendered on a flat surface, such as a stone, and treated to retain ink while non-image areas are treated to repel ink. See also **chromolithography**.

long shot (lawng shaht). In film, a **shot** that includes an area within the image that corresponds approximately to the audience's view of the area within the **proscenium** arch in the live theatre.

lost-wax (lawst-wax). See **cire-perdue**.

low comedy. In drama or literature, a **comedy** with no purpose other than laughter-producing entertainment through sight gags, buffoonery, etc.

low relief (loh-ruh-LEEF). Also called bas-relief. In sculpture, a **relief** work in which figures and forms project only slightly from the background. See **high relief**.

lyric (LIHR-ihk). In literature, a verse or poem that could be sung to the accompaniment of a musical instrument (in ancient times, a lyre).

madrigal (MAD-rih-ghuhl). In music, a secular part song, originating in Italy, for two or three unaccompanied voices. In literature, a medieval short lyrical poem specifically about love. Common in the **Renaissance**.

magnitude (MAG-nuh-tood). In theatre and film, the scope of universality of the theme.

major scale (MAYJ-uhr skayl). In music, a series of seven different **tones** within an **octave**, with an eighth tone repeating the first tone an octave higher and comprising a specific pattern of whole and half steps.

manipulation (muh-nihp-yoo-LAY-shuhn). In sculpture, a technique in which materials such as clay are shaped by skilled use of the hands.

mannerism (MAN-uhr-ihz-uhm). A mid- to late-sixteenth-century art movement that takes its name from the mannered or affected appearance of the subjects in paintings. It has an intellectual component that distorts reality, alters space, and makes obscure cultural allusions. It contains anticlassical emotionalism and abandons classical balance and form while employing formality and geometry. In architecture, it utilized discomfiting designs of superficial detail and unusual proportions with strange juxtapositions of curvilinear and rectilinear items.

masculine rhyme. A monosyllabic rhyme in poetry, or a rhyme occurring only in stressed final syllables. Compare **feminine rhyme**.

masonry (MAY-suhn-ree). In architecture, stone or brickwork.

mass (mas). In visual art and architecture, three-dimensional form having physical bulk. Also the illusion of such a form on a two-dimensional surface.

Mass (or mass) (mas). The liturgy of the Roman Catholic Eucharist (Mass). In music, a mass is a choral setting of the Mass. The Mass or mass each contains five sections: **Kyrie**, **Gloria**, **Credo**, **Sanctus**, and **Agnus Dei**.

master shot (MAST-uhr shaht). In film, a single shot of an entire piece of action. See **establishing shot**.

measure (MAY-zhuhr). In music, a basic rhythmic division of a composition marked in the score by vertical lines (bar lines) and containing a fixed number of **beats**.

medium (MEED-ee-yuhm). The process used by an artist. Also, in visual art, the binding agent that holds pigments together.

melodrama (MEHL-oh-drahm-uh). In theatre, a genre characterized by stereotyped characters, implausible plots, and emphasis on spectacle.

melody (MEHL-uh-dee). In music, a succession of individual tones that create a recognizable whole.

metaphor (MEHT-uh-fawr). In literature, a **figure of speech** that substitutes one word or phrase for another, suggesting a likeness between them. Or an implied comparison between two otherwise unlike elements, meaningful in a figurative rather than literal sense.

meter (MEE-tuhr). In music, the regular succession of rhythmical impulses or beats. In literature, a systematically arranged and measured rhythm in verse. Also in literature, a fixed metrical pattern or a verse form.

mime (mym). In theatre, a type of Greek and Roman **farce**; or a performance using only body movement and gestures without the use of words. In dance or theatre, actions that imitate human or animal movements.

minimalism (MIHN-uh-muh-lihz-uhm). A style in visual art and music dating to the 1950s and 1960s. In visual art, it comprises a school of abstract art emphasizing simplification of form and concentrating on nonsensual, impersonal, geometric shapes and forms with no communication passing between artist and respondent. Interpretation is solely the province of the respondent. In music, minimalism is a school or mode of contemporary music characterized by simplified rhythms, patterns, and harmonies. It was a reaction against the complexity of **serialism** and the randomness of **aleatory** music. In literature, use of the fewest and barest essentials.

minor scale (MYN-uhr-skayl). In music, a **diatonic scale** with a half step between the second and third degrees and any of several intervals above the fifth.

minuet (mihn-yoo-EHT). In music, compositional form, typically a movement, derived from a dance, in $\frac{3}{4}$ time and moderate tempo. Usually the third of four movements in a **symphony**, string quartet, and other works. Also called minuet and trio, it comprises three parts: minuet (A); trio (B); and minuet (C).

mise-en-scène (meez-ahn-sehn). In theatre, film, and dance, the complete visual environment of the production, including scenery, lighting, properties, costumes, and physical structure of the theatre.

modeling (MAHD-lihng). In sculpture, the manipulating of a pliable material such as clay. In painting, the appearance of depth and three-dimensionality of form.

moderato (mahd-uh-RAH-toh). In music, a moderate tempo slower than **allegretto** but faster than **andante**.

modern (MAHD-uhrn). See **modernism**.

modern dance (MAHD-uhrn-dans). A form of concert dance relying on emotional use of the body, as opposed to formalized or conventional movement such as **ballet**, and stressing human emotion and the human condition.

modernism (MAH-duhr-nihz-uhm). In the arts, modernism developed as a wide-ranging reaction to **Romanticism** and **realism**. It rejected conventional narrative content and conventional modes of expression to depict a world seen as althogether new and constantly in flux. In architecture, a twentieth-century style characterized by the glass and steel rectangular skyscraper (also called **International Style**) but including a variety of explorations of space and line, including curvilinear treatments and highly symbolic exploration of form. In visual art, a variety of approaches following the introduction of **cubism** and other "modernist" works at the International Exhibition of Modern Art (called the Armory Show) in 1913. In dance, it characterizes the non**ballet** tradition emphasizing angularity and asymmetry.

modulate (MAHJ-uh-layt). In music, to change **pitch**, intensity, or tone or to move from one **key** to another.

monolithic construction (mahn-oh-LIH-thihk-kuhn-STRUHK-shuhn). In architecture, a variation of **bearing-wall** construction in which the wall material is not jointed or pieced together.

monologue (or monolog) (MAHN-uh-lawg). In drama and literature, an extended speech by one person.

monophony (muh-NAHF-uh-nee). In music, a texture comprising a single melodic line. See **homophony; polyphony**.

monoprint (MAHN-oh-prihnt). In visual art, a single print pulled from a hard surface prepared with a painted design. Each print comprises an individual artwork.

montage (mahn-TAHZH). In the visual arts, the process of making a single composition by combining parts of other pictures so the parts form a whole and yet remain distinct. In film, montage is a type of **cut** handled either as an indication of compression or elongation of time, or as a rapid succession of images to illustrate an association of ideas.

monumental (mohn-yoo-MENT-uhl). In visual art and architecture, works actually or appearing larger than life size.

motet (moh-TEHT). In music, a **polyphonic** composition for choir based on a sacred Latin text (other than the **Mass**) and typically sung without accompaniment.

motif (or motive) (moh-TEEF; MOH-tihv). In visual art, music, theatre, film, dance, or literature, a short, recurring theme, idea, melody, or other element.

movement (MOOV-muhnt). In music, a self-contained section of an extended composition such as a **symphony**.

musical comedy (MYOO-zih-kuhl-KAHM-uh-dee). In music, theatre, and film, a comedic piece that intersperses dialogue with songs.

musique actuelle (myoo-ZEEK-ak-CHWEHL). In music, an approach from the 1990s that comprises **improvised** music freely drawing on **jazz** and rock and eliciting vibrancy, liveliness, and personal expression. Its literal translation means "current," and it represents a number of subfactions from various localities, always seeming to involve a strain of humor.

musique concrète (moo-ZEEK-kahn-KREHT). In music, a twentieth-century approach in which conventional and recorded sounds are altered electronically or otherwise and recorded on tape to produce new sounds.

myth (mihth). A narratively expanded **symbol** or a traditional story of historical events that serves to illustrate a cultural worldview, practice, or belief.

narrative verse (NAIR-uh-tihv vuhrs). In literature, a **verse** or **poem** that tells a story. Its main forms are the **epic** and the **ballad**.

naturalism. (NACH-uhr-uhl-ihz-uhm). In the arts, a style dating to the late nineteenth century that rests on accurate, nonemotional re-creation of elements from real life. It is related to **realism**.

negative space (NEHGH-uh-tihv spays). In sculpture, any empty space or opening in a Work. In film, any empty or unfilled space in the **mise-en-scène**, often acting as a **foil** to the more detailed elements in a shot.

neo-abstraction (nee-oh-ab-STRAK-shuhn). From the mid-1980s, a conglomerate style, like **postmodernism**, comprising mostly individualistic approaches. It borrows freely from others by modifying or changing the scale, media, or color of older works to give them a new framework and, hence, new meaning, including sarcasm and satire typically aimed at the decadence of American society in the 1980s.

neoclassicism (nee-oh-CLAS-uh-sihz-uhm). Adherence to or practice of the ideals and characteristics of classical art, literature, and music. In painting, it emerged in the eighteenth century; in theatre, the sixteenth; in music, the eighteenth century as **classicism;** and in the early twentieth century, as neoclassicism. In architecture, it was eclectic; in painting, it reflected a perception of grandeur in antiquity with classical details, starkness of outline, and strong geometric composition. Likewise in sculpture. In theatre, the "**unities**" of time, place, and action were reinterpreted from the writings of Aristotle. In music, eighteenth-century **classicism** rejected the excessive ornamentation of the **baroque** seeking instead to achieve order, simplicity, and careful attention to **form** through variety and contrast in mood, flexibility of **rhythm, homophonic** texture, memorable **melody**, and gradual changes in dynamics. Twentieth-century neoclassicism in music is marked by emotional restraint, balance, and clarity.

neo-expressionism (nee-oh-ehk-SPREHSH-uhn-ihz-uhm). In painting, a controversial late-twentieth-century movement that tends to record images society tends to repress. It seeks to force the viewer to confront what might be considered repulsive images in order, like **expressionism**, to evoke a particular response in the viewer.

neorealism (nee-oh-REE-uh-lihz-uhm). Post–World War II movement in art, film, and literature. In film, it used hidden cameras and emphasized an objective viewpoint and documentary style. It followed in the tradition of **verismo**, in which superficially naturalistic works are informed by a degree of populism and sentimentality.

New Wave (noo wayv). In film, a group of young French directors who came to prominence in the 1950s, the most widely known of whom are François Truffaut, Jean-Luc Godard, and Alain Resnais.

Nō. Or Noh drama (noh). Classic Japanese dance-drama with an heroic theme, chorus, and stylized acting, costumes, and scenery.

nocturne (NAHK-tuhrn). In painting, a night scene. In music, a pensive, dreamy instrumental composition, usually for piano.

nonfiction (nahn-FIHK-shuhn). In literature, works based on fact rather than imagination, although nonfiction can contain some fictional elements.

nonobjective (nahn-uhb-JEHK-tihv). Without reference to reality; may be differentiated from **abstract**.

nonrepresentational (nahn-rehp-ree-zehn-TAY-shuhn-uhl). Without reference to reality; including **abstract** and **nonobjective**.

novel (NAH-vuhl). In literature, a lengthy and complex **fictional** prose **narrative** dealing imaginatively with the human condition using a connected series of events and a group of **characters** in a specific setting.

objective camera (ahb-JEHK-tihv KAM-uh-ruh). In film, a camera position based on a third-person viewpoint.

octave (AHK-tihv; -tayv). In music, eight **tones** comprising a **scale**. The **interval** between two **pitches**, one of which is double the frequency of the other. In literature, a stanza of eight lines.

ode (ohd). In literature, a ceremonious **lyric poem** uniting emotion and general dedication. The form usually exhibits an exaltation of feeling and style and has lines of varying lengths along with complex **stanza** forms.

oil (oyl). In painting, a medium using oil (usually linseed oil) as a pigment binder.

omniscient point of view (ahm-NIHSH-uhnt poynt uhv vyoo). In film, an all-knowing narrator who provides the spectator with all the necessary information.

onomatopoeia (ahn-uh-maht-uh-PEE-uh). In literature, the use of words whose sounds suggest their nature. Or naming something by a vocal imitation of the sound associated with it.

on point (ahn point). In dance, a ballet technique utilizing special shoes in which the dancer dances on the points of the toes.

op art (ahp-ahrt). A painting style from the late twentieth century that plays on the possibilities offered by optics and perception. Intellectually oriented and systematic, it uses perceptual tricks and misleading images to attract the viewer into a conscious exploration of what the optical illusion does and why it does it.

open form (OHP-uhn fawrm). In art, composition that allows the eye to escape the frame or a form with irregular contours leaving a sense of unresolved tension. In music, composition that does not return to the initial theme—for example, **fugue** and **canon**. In film, stress on informal compositions and apparently haphazard design. The frame acts as a temporary masking that arbitrarily cuts off part of the action.

opera (AHP-uh-ruh; AHP-ruh). A theatrical presentation with drama set to music.

opera buffa (AHP-uh-ruh BOO-fuh; AHP-ruh-; OH-pair-uh-BOOF-fah). Comic opera that usually does not have spoken dialogue and typically uses satire to treat a serious topic with humor.

opéra comique (AHP-uh-ruh-kah-MEEK; AHP-ruh-; oh-pay-rah-kah-MEEK). Any opera, regardless of subject matter, that has spoken dialogue.

opera seria (AHP-uh-ruh-SIHR-ee-uh; OHP-air-uh-SAIR-). Serious opera, usually grand in scale and tragic in tone. Highly stylized and treating heroic subjects such as gods and heroes of ancient times.

operetta (ahp-uh-REHT-uh). A type of opera that has spoken dialogue but usually characterized by popular themes, a romantic mood, and often a humorous tone. Frequently considered more theatrical than musical, its story line is usually frivolous and sentimental.

oratorio (awr-uh-TAWR-ee-oh; -TOH-). In music, a semidramatic work, without acting, scenery, or costumes, often on a religious theme, for **orchestra**, choir, and soloists.

orchestra (AWRK-ih-struh). In music, a large instrumental ensemble divided into sections such as strings, woodwinds, brass, and percussion. In theatre, the section of seats on the ground floor of the auditorium directly in front of the stage. Also, the circular playing area of an ancient Greek theatre.

order (AWR-duhr). In architecture, one of the systems used by the Greeks and Romans to decorate and define their buildings. See **Corinthian order, Doric order**, and **Ionic order**.

overture (OH-vur-chuhr). In music, a short instrumental composition intended as an introduction to a larger work. Or, as in **concert overture**, an instrumental composition intended as a stand-alone performance piece.

palette (PAL-eht). In visual art, the composite use of color by an artist in an artwork. Or, a flat piece of board or other material that a painter holds and on which pigments can be mixed. In music and literature, the range of qualities employed by a composer or writer in a particular work.

pan (pan). In film, to follow a moving object with the camera.

pantomime (PAN-tuh-mym). In theatre, a genre of Roman drama in which an actor played various parts, without words, with a musical background. In dance, the transmission of emotions and meaning through gesture.

pas de deux (pah-duh-DUH). In dance, a dance for two individuals, especially in **ballet**.

pastel (pa-STEHL). In visual art, a dry drawing medium of dried paste comprising pigments and a water-based binder made into crayons. Also, a soft, delicate, or pale **hue**.

pediment (PEHD-uh-muhnt). In architecture, a wide, low-pitched **gable** atop the façade of a Greek-style building. Also, a similar triangular element used above window or door openings.

pen and ink (pehn-and-ihngk). In visual art, a wet drawing medium.

pendentive (pehn-DEHN-tihv). In architecture, a triangular section of vaulting used to anchor a dome to the rectilinear structure below it.

pentameter (pehn-TAM-uh-tuhr). In literature, a poetic line of five metrical feet.

performance art (puhr-FAWRM-uhns ahrt). A genre of art comprising a multidisciplinary, live, theatrical presentation, usually involving the audience. Typically involves nontheatre artists and a nontheatre environment.

performing arts (puhr-FAWR-mihng-ahrts). The arts, such as dance, theatre, and music, that are performed before an audience.

persistence of vision (puhr-SIHST-uhns uhv VIHZH-uhn). In film, the continuance of a visual image on the retina for a brief time after the removal of the object.

perspective (puhr-SPEHK-tihv). In two-dimensional art, the representation of distance and three-dimensionality on a two-dimensional surface. See **aerial perspective** and **linear perspective**.

Petrarchan sonnet (pih-TRAHR-kuhn; peh-; pee-). In literature, a poem of 14 lines divided into an octave rhyming *abbaabba* and a sestet with a variable rhyme scheme—it can be *cdecde, cdcdcd*, or *cdcdce* or some other variation that never ends in a final couplet.

phrase (frayz). In music, part of a melody.

piano (pee-AN-oh). In music, commit softly or quietly.

picaresque novel (pihk-uh-REHSK). In literature, a type of **novel** dealing with the episodic adventures of a rogue.

pigment (PIHGH-muhnt). In visual art, any substance used as a coloring agent.

pitch (pihch). In music, the quality of a sound—its highness or lowness—which is governed by a specific number of vibrations per second. In architecture, the angle of a roof.

plainchant (PLAYN-chant). See **Gregorian chant**.

plainsong (PLAYN-sawng). See **Gregorian chant**.

planography (pluh-NAHG-ruh-fee). In print-making, a process that prints from a smooth surface—for example, **lithography**.

plastic (PLAS-tihk). In visual art and film, commit capable of being shaped or molded; or, three dimensional.

plate (playt). In printmaking, a sheet of metal or other material prepared for use as a printing surface. In photography, a light-sensitive sheet of glass or metal on which a photographic image can be recorded. In architecture, in wood-frame construction, a horizontal member that caps the exterior wall studs and on which the rafters rest.

platemark (PLAYT-mahrk). In printmaking, a ridged or embossed effect created by the pressure used in transferring ink to paper from a metal plate in the **intaglio** process.

plot (plaht). In theatre, film, and narrative literature, the structure of the work comprising **crisis, climax, exposition, complication, and denouement, foreshadowing, discovery**, and **reversals**.

poem (POH-uhm). In literature, a composition in verse.

poetry (POH-uh-tree). One of the major divisions or **genres** of literature. A work designed to convey a vivid and imaginative sense experience through the use of condensed language selected for its sound and suggestive power and meaning, and employing specific technical devices, such as **meter, rhyme**, and **metaphor**. There are three major types of poetry—**narrative**, dramatic, and **lyric**.

point of view. In literature and film, the perspective from which a story is related to the reader or viewer.

pointe (pwahnt). See **on point**.

polyphony (puh-LIHF-uh-nee). In music, a texture comprising two or more independent melodic lines sounded together. See **monophony** and **homophony**.

pop art (pahp-ahrt). A style of art that portrays everyday life and uses techniques from commercial art and popular illustration.

position (puh-ZIH-shun). In ballet, one of five basic positions of the arms and legs. See **first position; second position; third position; fourth position**; and **fifth position**.

post and beam (pohst-and-beem). See **post-and-lintel**.

post-and-lintel (pohst-and-LIHNT-uhl). In architecture, a structural system in which horizontal pieces (**lintels**) are held up by vertical columns (posts); similar to post and beam structure, which usually utilizes wooden posts and beams held together by nails or pegs.

postimpressionism (pohst-ihm-PREHSH-uh-nihz-uhm). In visual art, a diverse style dating to the late nineteenth century that rejected the objective **naturalism** of **impressionism** and used form and color in more personal ways. It reflects an "**art for art's sake**" philosophy.

postmodern (pohst-MAHD-uhrn). In visual art, architecture, dance, and literature, a diverse, highly individualistic style that rejects **modernism** and its principles. It is distinguished by eclecticism and anachronism, in which works may reflect and comment on a wide range of stylistic expressions and cultural–historical viewpoints, including breaking down the distinctions between "high art" and popular culture. Self-reference is often at the center of creation and presentation. One common theme appears to be a basic concern for how art functions in society. In architecture, it seeks social identity, cultural continuity, and sense of place.

post-tensioned concrete (pohst-TEHN-shuhnd-KAHN-kreet). In architecture, concrete using metal rods and wires under stress or tension to cause structural forces to flow in predetermined directions.

prairie style (PRAIR-ee-styl). In architecture, an early-twentieth-century movement created by **Frank Lloyd Wright** that relies on strong horizontal lines, in imitation of the flatness of the American prairies and insists on integrating the context of the building and creating indoor space that is an extension of outdoor space.

precast concrete (pree-kast-KAHN-kreet). In architecture, concrete cast in place using wooden forms around a steel framework.

precisionism (pree-SIH-zhuhn-ihz-uhm). In painting, an early to mid-twentieth-century movement that arranged real objects into abstract groupings often using the strong, vibrant colors of commercial art.

pre-Columbian (pree-kuh-LUHM-bee-uhn). Originating in the Americas prior to the arrival of Columbus in 1492.

prelude (PRAY-lood). In music, a piece or movement serving as an introduction to another section or composition and which establishes the **key**—for example, one that precedes a **fugue**. Also, a similar but independent composition for piano. Also, the **overture** to an **opera, oratorio**, or **act** of an opera. Also, a short composition from the fifteenth and early sixteenth centuries, usually for keyboard.

Pre-Raphaelites (pree-RAHF-ee-uh-lyts; -RAYF-). A group of young British painters who rebelled against what they considered the unimaginative and artificial historical painting of the Royal Academy in the mid-nineteenth century. The name evokes the direct and uncomplicated portrayal of nature in Italian painting

prior to the **High Renaissance** (one of whose titans was **Raphael**).

prestressed concrete (pree-strehst-KAHN-kreet). See **post-tensioned** concrete.

primary color (PRY-mair-ee-CUH-luhr). In visual art and theatre design, any color that cannot be made by mixing other colors—that is, in pigment: red, blue, and yellow. In light: red, blue, and green.

primary structures (PRYM-air-ee-STRUHK-chuhrs). From the late twentieth century, a movement in sculpture that pursues extreme simplicity of shapes and a kinship with architecture. Viewers are invited to share an experience in three-dimensional space in which they can walk around and/or through the works. Form and **content** are reduced to their most minimal qualities.

print (prihnt). An original, hand-produced picture that has been transferred from a printing surface to a piece of paper. Personally prepared and directed by an artist. The printing surface—that is, block or plate—is usually destroyed after the desired number of prints in the edition has been made. A print differs from a reproduction, which is a copy and not an original.

program music (PROH-gram-MYOOZ-ihk). Music intended to depict or suggest nonmusical ideas or images through a descriptive title or text. See **absolute music**.

property (PRAHP-uhr-tee). In theatre, film, and dance, any object other than scenery and costumes that appears onstage during a theatrical production, film, or dance. Set props are used to decorate the scenery. Hand props are used by the actors and dancers as part of their actions.

proportion (pruh-PAWR-shuhn). In visual art and architecture, the relation, or ratio, of one part to another and of each part to the whole with regard to size, height, width, length, or depth.

proscenium (proh-SEE-nee-uhm). In theatre, a form of theatre architecture in which a frame (arch) separates the audience from the stage (picture frame stage); also, the frame or arch itself; also, in the Greek **classical** theatre, the area between the background (**skene**) and the **orchestra**.

prose (prohz). In literature, a **genre** distinguished from **poetry** by its use of irregular **rhythms** and greater adherence to the patterns of everyday speech.

protagonist (proh-TAG-uh-nihst). In theatre, film, and literature, the leading actor or personage in a play or narrative work—that is, the major **character** around whose decisions and actions the **plot** revolves.

pyramidal structure (peer-uh-MIHD-uhl-STRUHK-chuhr). In theatre, dance, film, and narrative literature, the rising of action to a peak which then tapers to a conclusion.

quadruple meter (kwah-DROOP-uhl MEET-uhr). In music, patterns of four **beats** to the **measure**.

rack focus (rak FOH-kuhs). Also called differential focus (dihf-uh-REHN-shuhl). In film, when an object is clearly shown while the remainder of the scene is out of focus.

radial symmetry (RAY-dee-uhl-SIHM-uh-tree). In visual art, the **symmetrical** arrangement of elements around a central point.

realism (REE-uhl-ihz-uhm). In visual art and theatre, a mid-nineteenth-century style seeking to present an objective and unprejudiced record of the customs, ideas, and appearances of contemporary society through spontaneity, harmonious colors, and subjects from everyday life with a focus on human motive and experience.

recapitulation (rih-cuh-pihch-uh-LAY-shuhn; ree-). In **sonata form**, the third section in which the **exposition** is repeated, often with variations. See **development**.

recitative (rehs-ih-tuh-TEEV; rehch-). In music (in **opera**, **cantata**, and **oratorio**), a vocal line that imitates the **rhythms** and **pitch** fluctuations of speech and often serving to lead into an **aria**.

reinforced concrete (ree-ihn-FAWRST; -FOHRST; -KAHN-kreet). In architecture, poured concrete containing steel reinforcing bars or mesh to increase its **tensile strength**.

relief (rih-LEEF). See **sculpture**.

relief printing (ruh-LEEF-PRIHNT-ihng). In printmaking, a process by which the ink is transferred to the paper from raised areas on a printing block.

Renaissance (rehn-uh-SAHNS). The humanistic revival of **classical** art, architecture, and literature originating in Italy in the fourteenth century and lasting through the sixteenth century that marked the transition from medieval to modern times. Painting had gravity and monumentality, using deep perspective and modeling, spatial naturalism, and strong, detailed, very human figures. Freestanding sculpture exhibited a focus on anatomy.

repetition (rehp-eh-TIH-shuhn). Reiteration of elements in a work of visual art, architecture, theatre, dance, film, music, and literature so as to create a sense of **unity**.

representational (rehp-rih-zehn-TAY-shuhn-uhl). In visual art and theatre, having the appearance of observable reality. See **abstract** and **nonrepresentational**.

requiem (REHK-wee-uhm). In music, a composition for a **mass** for the dead.

reversal (ruh-VUHRS-uhl). In theatre, film, and narrative literature, the part of **plot** comprising a turn of fortune.

rhyme (or rime) (rym). In literature, an echoing by two or more words with similar sounding final syllables.

rhythm (RIHTH-uhm). The relationship, either of time or space, between recurring elements of a **composition**. The regular or ordered **repetition** of dominant and subordinate elements or units within a design or composition.

ribbed vault (rihbd-vawlt). In architecture, a structure in which arches are connected by diagonal as well as horizontal members.

ritardando (rih-tahr-DAHN-doh). In music, a decrease in tempo.

ritornello form (rih-tohr-NEHL-oh fawrm). In music, a type of composition usually in a **baroque concerto grosso**, in which the **tutti** plays a **ritornello**, alternating with one or more soloists playing new material.

ritual dance (RIH-choo-uhl dans). In dance, a group of dances that perform some religious, moral, or ethical purpose in a society.

Rococo (ruh-KOH-koh; roh-koh-KOH). An eighteenth-century style in architecture and visual art, developed in France from the **baroque** and characterized by elaborate and profuse ornamentation, often in the form of shells, scrolls, and the like. In architecture, it manifested itself in interior design and furniture. In painting and sculpture, a decorous style exhibiting intimate grace, charm, and delicate superficiality.

Roman classicism (ROHN-uhn-KLAS-uh-sihz-uhm). From the turn of the Common Era and the reign of Augustus Caesar, it copied **classical** Greek forms but added, in architecture, the round or **Roman arch**.

Romanesque (roh-muhn-EHSK). A style in visual art and architecture from the eleventh through early twelfth centuries in Europe characterized by rounded (Roman) arches on doorways and windows. It is massive, static, and comparatively lightless. In sculpture, it was fairly diverse, typically attached to Romanesque buildings, stone, and monumental.

Romanticism (roh-MAN-tuh-sihz-uhm). A philosophy as well as a style in all the arts and literature, dating to the late eighteenth through nineteenth centuries. In architecture, it borrowed styles from previous eras while experimenting with modern materials. It also sought an escape to the past. In painting, the style turned to emotionalism, the picturesque, and nature. It fragmented images and dramatized with personal subjectivity. In theatre, the style resulted in dazzling scenery. In literature, music, and ballet, it sought the subjective and the colorful reflecting great diversity.

rondo (RAHN-doh; rahn-DOH). In music, a composition based on the alternation of a principal recurring theme and contrasting episodes—that is, a main theme (A) that returns several times in alternation with other themes (A B A C A, etc.). Often the last movement of a classical **symphony**, string quartet, and **sonata**.

round (rownd). In music, a vocal piece in which the same **melody** is sung at the same **pitch** but at different times. See **canon**.

rubato (roo-BAH-toh). In music, played or sung with rhythmic flexibility.

satire (SA-tyr). In literature and drama, the use of ridicule, **irony**, or sarcasm to hold up to ridicule and contempt vices, follies, abuses, and so forth. Also, a work of literature that uses satire.

saturation (sach-uh-RAY-shuhn). In visual art, the degree of white present in a hue. The more white, the less saturated is the hue.

scale (skayl). In visual art and architecture, a building's size and the relationship of the building and its decorative elements to the human form. In music, an ascending or descending arrangement of pitches.

sculpture (SKUHLP-chuhr). A form of visual art or a three-dimensional artwork. Among the major types of sculpture are *full-round*, which is freestanding and fully three dimensional; *relief*, which is attached to a larger background (see **low-relief** and **high-relief**); and linear, which emphasizes linear materials like wire. Among the methods of execution are *cast* which is created from molten material in a mold (see **substitution**); *built* or assembled (see **additive**), which is created by the addition of, often, prefabricated elements; *carved* (see **subtraction**); and *manipulated*—that is, constructed by manipulating soft materials such as clay.

second position (SEHK-uhnd puh-ZIH-shuhn). In dance, a ballet position with the feet spread apart the length of the foot, weight evenly distributed, and the feet well turned out.

secondary (SEHK-uhn-dair-ee). In visual art, colors that result from mixing equal proportions of **primary** hues.

sentimental novel. In literature, a **novel** that seeks to exploit the reader's sense of tenderness, compassion, or sympathy through disproportionately unrealistic views of the subject.

serialism (SIHR-ee-uh-lihz-uhm). In music, a mid-twentieth-century type of composition based on the **twelve-tone system**. In serialism, the techniques of the twelve-tone system are used to organize musical

dimensions other than pitch, for example, rhythm, dynamics, and tone color.

serigraphy (suh-RIHGH-ruh-fee). In printmaking, a process in which ink is forced through a piece of stretched fabric, part of which has been blocked out—for example, **silk-screening** and stenciling.

Shakespearean sonnet (or English sonnet) (shayk-SPIHR-ee-uhn). Poem of 14 lines grouped into three quatrains and a couplet with the rhyme scheme *abab cdcd efef gg*. See **Petrarchan sonnet; sonnet.**

short story. In literature, a brief **fictional prose narrative** usually concerning a single effect portrayed in a single episode or scene and with a limited number of **characters** focusing on unity of characterization, **theme**, and effect.

shot (shaht). In photography, a view or exposure or a developed photographic image. In film, the images recorded continuously from the time the camera starts to the time it stops—that is, an unedited piece of film.

silk-screen (also silkscreen) (SIHLK-skreen). In printmaking, a type of stenciling using a screen of silk or other mesh on which a design is imposed and through which ink is forced with a squeegee onto the printing surface.

simile (SIHM-uh-lee). In literature, a **figure of speech** involving a comparison between two unlike entities explicitly made using the work *like* or *as.*

skeleton frame (SKEHL-uh-tuhn-fraym). In architecture, construction in which a skeletal framework supports the building. See **balloon construction** and **steel cage construction**.

sonata (suh-NAH-tuh). In music, an instrumental piece, usually in three or four movements and usually for one or two players.

sonata form (suh-NAH-tuh-fawrm). In music, a type of structure usually used in the first movement of a **sonata**. The three parts are the **exposition, development**, and **recapitulation.**

song cycle (sawng-SY-kuhl). In music, a group of **art songs** combined around a similar text or theme.

sonnet (SAHN-uht). In literature, a fixed **verse** form of Italian origin comprising 14 lines usually of five-**foot** iambics rhyming according to a prescribed scheme. See also **Petrarchan sonnet; Shakespearean sonnet.**

sonority (suh-NAWR-ih-tee). In music, the characteristic of **texture** resulting from chordal spacing.

spectrum (SPEHK-truhm). In visual art, the visible range of hues as measured by wavelength. Or, the colored bands of visible light occurring when sunlight passes through a prism. In music, the audible range of sound as measured in vibrations per second.

spine (or superobjective) (spyn). In the theatre, the motivating aspect of a character's persona that an actor seeks to reveal by physical means.

steel cage construction. (steel-kayj-kuhn-STRUHK-shuhn). In architecture, construction using a metal framework. See **skeleton frame**.

stream of consciousness. In literature, a **narrative form** in **fiction** that attempts to capture the whole range and flow of a **character's** mental processes.

stress (strehs). In music and literature, an **accent** or emphasis on a **tone** or syllable. In architecture, the force applied by structure or gravity to a particular part of a building.

structuralism (STRUHK-chuhr-uh-lihz-uhm). A form of criticism associated with **Roland Barthes** that applies to artworks a broader significance, insisting that they can be understood only within the context of the overall structures—that is, universal sets of meaning—of which they are a part.

style (styl). The individual characteristics of a work of art that identify it with a particular artist, nationality, historical period, or school of artists.

stylus (STY-luhs). In visual art, a sharp, usually metal, pointed instrument for scribing or engraving.

substitution (suhb-stih-TOO-shuhn). In sculpture, a technique utilizing materials transformed from a plastic, molten, or fluid into a solid state.

subtraction (suhb-TRAK-shuhn). In sculpture, works that are carved. In color, the mixing of pigments as opposed to the mixing of light.

suite (sweet). In music, an instrumental composition, typically in two parts, arising from the **baroque** period and comprising a set of dance-inspired movements written in the same key but differing in tempo, meter, and character. Can employ **solo** instruments, small **ensembles**, or an **orchestra**.

superobjective (soo-puhr-ahb-JEHK-tihv). See **spine**.

suprematism (soo-PREHM-uh-tihz-uhm). In visual art, a school and theory of **geometric**, **abstract** art originating in Russia in the early twentieth century.

surrealism (suhr-REE-uh-lihz-uhm). A movement in art developed in the 1920s in which artists and writers gave free rein to the imagination, expressing the subconscious through the irrational **juxtapositions** of objects and themes. The movement took two directions: **representational** and **abstract**.

symbol (SIHM-buhl). A form, image, or subject standing for something else.

symbolism (SIHM-buhl-ihz-uhm). The suggestion through imagery of something that is invisible or intangible.

Symbolist movement (SIHM-buh-lihst). In visual art, theatre, and literature, from the late nineteenth to mid-twentieth centuries. Also known as neo-Romanticism, idealism, or **impressionism**. It held that truth can be grasped only by intuition, not through the senses or rational thought. Thus, ultimate truths can be suggested only through symbols, which evoke in the audience or reader various states of mind that correspond vaguely with the playwright's or writer's feelings.

symmetry (SIHM-ih-tree). In visual art, balancing of elements in design by placing physically equal objects on either side of a central axis. See **asymmetry**.

sympathetic vibration (sihm-puh-THEHT-ihk-vy-BRAY-shuhn). In music, a phenomenon in which one vibrating body is set in motion by a second vibrating body.

symphonic poem (sihm-FAHN-ik-POH-uhm). In music, a composition comprising an extended **movement**, based on an extramusical theme, for **symphony orchestra**. Also called a tone poem.

symphony (SIHM-fuh-nee). In music, an extended musical composition for **orchestra** usually consisting of three or four **movements**. See **orchestra**.

syncopation (sihng-kuh-PAY-shuhn). In music, the displacement of **accent** from the normally accented **beat** to the offbeat.

tempera (TEHMP-uh-ruh). In painting, an opaque watercolor medium, referring to ground pigments, and their color binders such as gum, glue, or egg.

tempo (TEHMP-oh). In music, the rate of speed at which a composition is performed. In theatre, film, and dance, the rate of speed of the overall performance.

tensile strength (TEHN-suhl-strehngth). In architecture and sculpture, the ability of a material to withstand twisting and bending.

ternary (TUHR-nuh-ree). In music, a three-part structure.

tertiary color (TUHR-shee-air-ee). In visual art, colors that result from mixing **secondary hues** in equal proportions.

tetrameter (teh-TRAM-uh-tuhr). A line of four metrical units.

texture (TEHKS-chuhr). In painting and sculpture, the two-dimensional or three-dimensional quality of the surface of a work. In music, the melodic and harmonic characteristics of a composition. In literature, the elements—for example, metaphors, imagery, meter, and rhyme—that are separate from the structure or argument of the work.

Theatre of the Absurd. A style of drama that emphasizes the absurdity of human existence through illogical plots, and so on.

theatricalism (thee-AT-rih-kuh-lihz-uhm). A movement in theatre away from the realism and naturalism of the nineteenth century.

theatricality (thee-ya-trih-KAL-uh-tee). Exaggeration and artificiality. The opposite of lifelikeness.

theme (theem). The dominant idea of a work of art, music, film, dance, and literature. In music, a principal melodic phrase in a composition.

theme and variations (theem and vair-ee-AY-shuhns). In music, a form that takes a basic musical idea (theme) and repeats it over and over, each time making changes in the **melody, rhythm, harmony, dynamics**, or **tone color**. Can be an independent composition or part of a larger work.

third position (thuhrd puh-ZIH-shuhn). In dance, a basic ballet position with the heel of the front foot touching the instep of the back foot with legs and feet well turned out.

thrust stage (thruhst-stayj). In theatre, a production arrangement in which the audience sits on three sides of the **stage**.

timbre (TAM-bur). In music, the quality of a tone that distinguishes it from other tones of the same pitch. Also called color or tone color.

tint (tihnt). A color or **hue** that has been modified by the addition of a small amount of another color.

toe shoe (toh-shoo). In dance, a ballet slipper with a reinforced, hardened toe designed to allow the ballerina to dance **en pointe**.

tonality (toh-NAL-ih-tee). In music, the specific key in which a composition is written. See **key**. In the visual arts, the characteristics of **value**.

tone (tohn). In visual art, the overall degree of brightness or darkness of a work. In music, sound that has a definite pitch, or frequency.

tone cluster (tohn-KLUHS-tuhr). In music, a dissonant group of closely spaced notes played at the same time. Common in twentieth-century music.

tone color. (tohn KUHL-uhr). In music, the **timbre** of a voice or instrument.

tonic (TAHN-ihk). In music, the root tone (do) of a **key**.

tragedy (TRAJ-uh-dee). A serious drama or other literary work in which conflict between a **protagonist**

and a superior force (often fate) concludes in disaster for the protagonist.

tragic flaw. A flaw that brings about a hero's downfall.

tragicomedy (traj-ih-KAHM-uh-dee). A drama combining the qualities of **tragedy** and **comedy**.

trimeter (TRIHM-uh-tuhr). In literature, a poetic line of three feet or pairs of feet.

triple meter (TRIHP-uhl MEET-uhr). In music, a pattern of three **beats** to the **measure**.

trompe l'oeil (trawmp-LOY). French for "trick the eye" or "fool the eye." A two-dimensional artwork, executed in such a way as to make the viewer believe that a three-dimensional object is being perceived.

tunnel vault (TUHN-uhl vawlt). See **barrel vault**.

tutu (TOO-too). In ballet, a sort skirt typically made of layers of sheer fabric.

twelve-tone (twehlv-tohn). In music, relating to or based on an arrangement of the 12 chromatic tones. Also an atonal system of composition based on use of the twelve tones, invented in the 1920s by Arnold **Schoenberg**, who preferred the term *pan tonal*.

two-part form (too-pahrt fawrm). Also AB form. In music, form that presents a statement (A) and a counterstatement (B).

unity (YOO-nuh-tee). The combination of the parts of a work of art, literature, or building that creates a sense of completeness or undivided total effect.

value (VAL-yoo). Also value scale or **key**. In the visual arts, the range of tonalities from white to black or dark to light.

vanishing point (VAN-ihsh-ihng poynt). In **linear perspective**, the point on the horizon toward which parallel lines appear to converge and at which they seem to vanish.

variation (veh-ree-YAY-shuhn). Repetition of a theme with minor or major changes.

vault (vawlt). See **barrel vault**.

veduta (vedute) (vay-DOO-tah; vay-DOO-tay). In painting, a work depicting expansive city or harbor scenes.

verisimilitude (vair-ih-sih-MIHL-ih-tood). In the arts and literature, the semblance of reality—that is, nearness to truth.

verismo (vay-REEZ-moh). In literature, **realism** as it developed in Italy in the late nineteenth and early twentieth centuries. Also a style of opera utilizing realistic librettos and production style.

verse (vuhrs). In literature, a line of metrical writing. Also, a unit such as a **stanza** of metrical writing larger than a single line. Also, the shortest division of chapters of the Bible. Also, **poetry**. Also, metrical writing that is distinguished from poetry especially by its lower level of intensity.

video art (VIHD-ee-oh-ahrt). A wide-ranging, late-twentieth-century **genre** that emerged from the rebellions of the 1960s as a reaction against conventional broadcast television and is characterized by experiments exploiting new dimensions in hardware and imagery.

wash and brush (wahsh and bruhsh). In visual art, a wet drawing medium similar to **watercolor** in painting.

watercolor (WAH-tuhr-kuhl-uhr). In visual art, a paint made up of pigment in a water-soluble binder.

wet-plate collodion process (weht playt cuh-LOHD-ee-uhn PRAH-sehs). In photography, a process, developed around 1850, that permitted short exposure times and quick development of the print.

whole step (hohl stehp). In music, an **interval** twice as large as a **half-step**.

wipe (wyp). In film, a line that passes across the screen eliminating one scene as it reveals the next.

wood engraving (wud ehn-GRAYV-ihng). In printmaking, a **relief** printing technique in which the work is printed from a design cut into the butt (end) of the grain of a piece of wood.

woodcut (WUD-kuht). In printmaking, a **relief** printing technique in which the work is printed from a design cut into the plank (side) of the grain of a piece of wood.

zoom shot (zoom shaht). In film, a change, in one continuous movement, from wide angle to telephoto, and vice versa.

For Further Exploration

Abcarian, Richard, and Marvin, Klotz, eds. *Literature and the Human Experience*. New York: St. Martini's Press, 1998.

Acton, Mary. *Learning to Look at Paintings*. London: Routeledge, 1997.

Ambrosio, Nova. *Learning About Dance*. Dubuque, IA: Kendall-Hunt, Inc., 1997.

Arnheim, Rudolph. *Art and Visual Perception: A Psychology of the Creative Eye*. Berkeley: University of California Press, 1989.

———. *Film as Art*. Berkeley: University of California Press, 2006.

Bacon, Endmund N. *Design of Cities*. New York: Viking Press, 1976.

Benbow-Pfalzgraf, Taryn. *International Dictionary of Modern Dance*. New York: St. James Press, 1998.

Bordwell, David, and Kristin Thompson. *Film Art: An Introduction*. Reading, MA: Addison-Wesley, 1996.

Brockett, Oscar Gross, and Robert J. Ball. *The Essential Theatre*. New York: Holt Rinehart & Winston, 2007.

Cameron, Kenneth M., Patti P. Gillespie, and Kenneth M. Camerson. *The Enjoyment of the Theatre* (7th ed.). Boston, MA: Allyn & Bacon, 2007.

Canaday, John. *What is Art?* New York: Knopf, 1990.

Cass, Joan. *Dancing Through History*. Upper Saddle River, NJ: Prentice Hall, 1993.

Ching, Frank D. K., and Francis D. K. Ching. *Architecture: Form, Space, and Order*. New York: John Wiley & Sons, 2007.

Cook, David A. *A History of Narrative Film*. New York: Norton, 1996.

Davis, Phil. *Photography*. Dubuque, IA: William C. Brown, 1996.

Dean, Alexander, and Lawrence Carra. *Fundamentals of Play Directing*. New York: Holt, Rinehart and Winston, 1990.

Finn, David. *How to Look at Sculpture*. New York: Harry N. Abrams, 1989.

Frampton, Kenneth. *Modern Architecture: A Critical History* (3rd ed.). London: Thames and Hudson, 1992.

Giannetti, Louis. *Understanding Movies* (11th ed.). Upper Saddle River, NJ: Prentice Hall, 2008.

Giedion, Sigfried. *Space, Time and Architecture: the Growth of a New Tradition*. Cambridge, MA: Harvard University Press, 2003.

Hartnoll, Phyllis, and Peter Found, eds. *The Concise Oxford Companion to the Theatre* (2nd ed.). New York: Oxford University Press, 1992.

Highwater, Jamake. *Dance: Rituals of Experience* (3rd ed.). New York: Oxford University Press, 1996.

Hyman, Isabelle, and Marvin Trachtenberg. *Architecture: From Prehistory to Post-Modernism/The Western Tradition*. New York: Harry N. Abrams, 1986.

Kramer, Jonathan D. *Listen to the Music: A Self-Guided Tour Through the Orchestral Repertoire*. New York: Schirmer Books, 1992.

Lacy, Susan. *Mapping the Terrain: New Genre Public Art*. Bay Press, 1994.

Le Corbusier, Charles-Édouard Jeaneret. *Towards a New Architecture*. New York: Dover, 1986.

Nesbitt, Kate, ed. *Theorizing a New Agenda for Architecture: An Anthology of Architectural Theory 1965–1995*. New Haven, CT: Princeton Architectural Press, 1996.

Rasmussen, Steen Eiler. *Experiencing Architecture*. Cambridge, MA: MIT Press, 1997.

Ryman, Rhonda. *Dictionary of Classical Ballet Terminology*. Princeton, NJ: Princeton Book Company, 1998.

Sayre, Henry M. *A World of Art* (5th ed.). Upper Saddle River, NJ: Pearson Prentice Hall, 2007.

Simonds, John Ormsbee. *Landscape Architecture: A Manual of Site Planning and Design* (3rd ed.). New York: McGraw-Hill, 1997.

Sporre, Dennis J. *The Art of Theatre*. Upper Saddle River, NJ: Prentice Hall, 1993.

———. *The Creative Impulse* (7th ed.). Upper Saddle River, NJ: Prentice Hall, 2006.

———. *Reality Through the Arts* (6th ed.). Upper Saddle River, NJ: Prentice Hall, 2007.

Sporre, Dennis J., and Robert C. Burroughs. *Scene Design in the Theatre*. Upper Saddle River, NJ: Prentice Hall, 1990.

Stanley, John. *An Introduction to Classical Music Through the Great Compsers & Their Masterworks*. New York: Readers Digest, 1997.

Steinberg, Michael. *The Symphony: A Listener's Guide*. New York: Oxford University Press, 1995.

Vacche, Angela Dalle. *Cinema and Painting: How Art Is Used in Film*. Austin: University of Texas Press, 1996.

Yenawine, Philip. *How To Look at Modern Art*. New York: Harry N. Abrams, 1991.

Yudkin, Jeremy. *Understanding Music* (5th ed.). Upper Saddle River, NJ: Pearson Prentice Hall, 2008.

Zorn, Jay D. *Listening to Music*. Upper Saddle River, NJ: Prentice Hall, 1994.

Index